PIET MONDRIAN IN THE USA

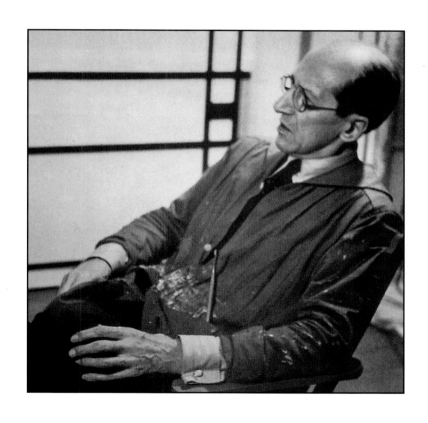

THE ARTIST'S LIFE AND WORK

PIET MONDRIAN
IN THE USA

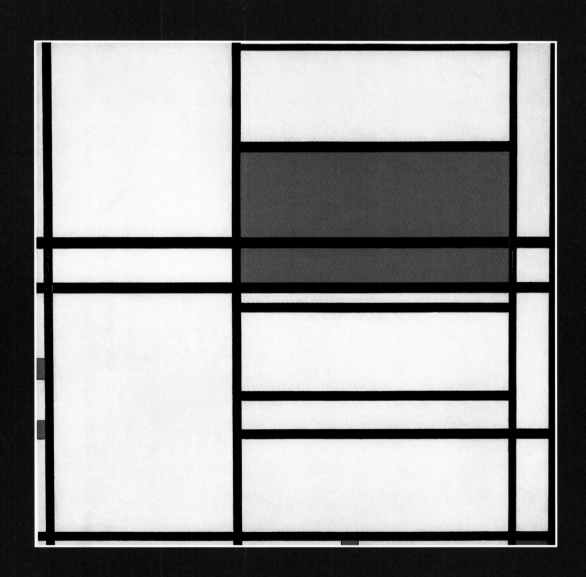

Publishing Director: Jean-Paul Manzo
Text: Virginia Pitts-Rembert
Editor: Aurélia Hardy
Designed by: Oliver Hickey
Cover and jacket : Julien Depaulis
Layout : Cédric Pontes

©Parkstone Press LTD, USA, 2002
Printed and bound in India.
ISBN 1 85995 718 8

The publisher is very grateful to : Mrs Balcomb Greene, Barbara Schwartz, Agnes Martin, Mr Peter Halley, John MacCracken, Charles Biederman, Otto E.Nelson, Andrew Bolotowsky and the Henry Moore Foundation for their kind permission of reproduction. We are also grateful to anybody esle who helped us to get the copyright of the other works : Heather Domencic, Carnegie Museum of Art ; Virginia Guntersen, Salender O'Reilly Gallery ; Renee Osburn and Ann M.Garfinkle, Garfinkle & Associates ; Marianne Kilby, Hudson and Kilby ; Tracey Williams, David Zwirner Gallery ; Halley Harrisburg, Michael Rosenfeld Gallery ; Cécile Brunner, Kunsthaus, Zurich ; Janet Hicks, ARS ; Laura Muesig, Weisman Art Museum ; John Mason, Wildenstein Gallery ; George P. Lynes ; Carroll Janis, Sidney Janis Gallery ; Jo Mattern, *Fortune*.

CONTENTS

PREFACE

To acknowledge all those who gave inspiration and unstinting aid to this work would be impossible, but I owe too great a debt not to try. First, there was my late husband John, who quickened my imagination when he remarked of a Mondrian in a New York apartment that "it wouldn't stay on the wall." This was my first hint of the force behind a seemingly austere art, although I had already heard the paradoxical stories from Eleanor Lust and Jimmy Ernst, whom we knew in the late 1940s, that Mondrian — internationally famous for a dry classicism when he came to this country — loved to look at soft pretty things, like ladies' scarves, in Fifth Avenue store windows.

Then, there was Carl Holty who responded volubly to my questions with his generous and wise answers. These included his insights on life, Mondrian, and Holty's own artistic biography. Holty is dead now but, like the elder artist, much revered by those whose lives he touched. My dependence on him and the many others who shared willingly their knowledge of Mondrian is inherent in the text.

Raymond MacMahon, my colleague at Birmingham-Southern College when this was begun, directed me to Michel Seuphor's monograph on the artist and demonstrated by his own example the value of Mondrian's mediation for American painters. Theodore Reff, consulting with Meyer Schapiro at Columbia University, proposed both the topic and method of procedure. Reff continued to be encouraging in the longer process of turning the dissertation into a book.

I am indebted to the American Association of University Women for a national fellowship grant; to the Department of Art History at Columbia University for a traveling fellowship grant; to Birmingham-Southern College for two faculty research grants; to colleagues and students there, the University of Alabama at Birmingham, and the University of Arkansas at Little Rock for sharing my interest; to members of the Donaghey Foundation at UALR and the administrators there and at the University of Alabama for supporting me so generously with grants for travel and research; and to the UA colleagues and students from whom I continued to learn. I also owe a great deal to my many skilled and durable typists, most notably Janice May and Angela Bramlett.

To my friends, who will forget that I forgot them, and to my patient and helpful family, who neither realized nor expected to collect from my indebtedness to them, I dedicate this work. In recent years, I am thankful to my husband Raeford Liles for his unfailing interest and support in bringing this manuscript to publication. In addition I owe much to my intelligent American and English editors Myra Baker, Suzanne Wolfe and Mike Darton. The success of this publication will be directly attributable to their efforts as well as those of my gracious and accomplished senior editor Aurélia Hardy and publishing editors Jean-Paul Manzo and Cornélia Sontag of Parkstone Press, in Paris.

Finally to Mondrian, who has already inspired me to spend thirty years of involvement with his life and work, including teaching, writing, and speaking before many audiences, I am indeed grateful — if apologetic for making his life too particular and for stressing too strongly its progress in temporal terms. As he wrote: "We must always follow life, but let us try to follow 'life' and not its events."*

* Piet Mondrian, *Essay #28*, trans. Harry Holtzman and Martin James, June 1932, left unpublished in Mondrian's handwriting at his death.

N.N Birthday card with Mondrian Design, 1971. (courtesy Hallmark cards, Kansas City, Missouri.)

INTRODUCTION

IN SEARCH OF MONDRIAN

Aldous Huxley once proposed an anthology of masters who created "Later Works." He did not mean artists who lived long without ever departing from their youthful styles, but those who "lived without ever ceasing to learn of life." To qualify for Huxley's pantheon, the works an artist produced when middle-aged or elderly had to be significantly different from earlier ones. Huxley mentioned the "astonishing" and often "disquieting treasures" among the later works of Beethoven, Verdi, Bach, Yeats, Shakespeare, Goethe, Francesca, El Greco, and Goya. To the artists on Huxley's list we could add Michelangelo, Rembrandt, Picasso, Moore, and Mondrian.

In their later works, these artists were often thought to have fallen below the creations of their mature periods when, actually, they had moved on to attenuated, or expanded versions of their previous styles. Often, the late works could not be understood even by those whose tastes were formed by their mentors' mature works, but only by followers in a later time. Piet Mondrian was surely such a master. During his final three years and four months of life spent in the United States during World War II, he launched into a far less fathomable version of his consummate modernist oeuvre. With his final, unfinished painting *Victory Boogie-Woogie* the artist may have adumbrated Postmodernism, a style (or anti-style) that was to follow his death by some thirty years.

Yet, his late works are still relatively misunderstood, particularly in Europe. Frank Elgar, the French author of a popular monograph on Mondrian, found it unfortunate that he "did not resist the temptation to transmit to his ill-named neo-plasticism the joys so amply provided by American life." Elgar was referring to the usual interpretation of works done by the artist toward the end of his life in New York as being literally descriptive of the city and the popular "boogie-woogie" jazz form. Mondrian's chief biographers, the Belgian Michel Seuphor (a pseudonym for Ferdinand Berckelaers) and the Dutch Hans Jaffe, saw no diminution of quality nor discontinuity of theory in his late works; nonetheless, both men stressed their illustrative implications.

The artist was obviously stimulated by his new environment in America, which he had reached so full of hope on October 3, 1940.(1) His immigration resulted from World War II, but the ideal that brought him to the United States reached back to World War I, when Mondrian first formulated a theory

1 Piet Mondrian's first studio-homesite in New York, at 353 East 56th Street – no longer in existence: view south from southwest corner of 56th and First Avenue.

of his place in the modern world and a message for its future inhabitants. By the advent of World War II, the idealism had become inseparable from his dream of America, which was where he thought the new world of future humanity would flourish. The artist saw "freer" in this country, as he said Americans did, and the paintings began to change in keeping with his new vision. When he altered the color and tempo of his new canvases, the feeling of continuous movement, or change, overcame the stasis of his former ones.

3 Mondrian, *Victory Boogie-Woogie*, 1943–44, oil on canvas (hereafter oc) with colored tape and paper, Gemeentemuseum, The Hague.

2 Mondrian, *Broadway Boogie-Woogie*, 1942–43. Oil on canvas, 50 x 50" (127 x 127 cm). The Museum of Modern Art, New York. Given anonymously. Photograph © 2001 The Museum of Modern Art, New York.

The final *Boogie-Woogies* were dynamic, indeed.(2, 3) They were a remarkable achievement for a man of Mondrian's age — he died just prior to his seventy-second birthday. Yet, because the paintings do not seem to fit his standard set in Paris, they are thought by many to fall short of the Parisian mode. In these late works, however, can be seen both the inspiration of the artist's new environment and the culmination of theory that he had developed long before coming to this country. I have therefore considered the paintings according to place and philosophy, hoping the reader will not think of these as being mutually exclusive.

When examining Mondrian's roots in late nineteenth-century Holland as they contributed to his artistic formation, I did not attempt to be comprehensive. This was because the artist's realistic period in Holland and his Cubist and De Stijl periods in France and Holland had been treated authori-

tatively by Jaffe, Seuphor, Welsh, and Joosten. My study overlapped theirs only because it was necessary to relate Mondrian's De Stijl theory to his earlier works in order to demonstrate the continuity that led to his final achievements in America.

Whenever possible, I found it advantageous to allow the artist to speak in his own words. His writings had seldom been used because, as translated from Dutch into other languages, they were repetitious, convoluted, and imprecise, and thus difficult for readers to follow. Nevertheless, Mondrian had found it imperative to write and had made a laborious effort to explain himself. Harry Holtzman gave me a copy of the manuscript that he and Martin James were preparing of the writings for publication, so I have used this version in excerpting some of the artist's statements. Especially when Mondrian's words clarified his intentions better than anyone else's, I thought he deserved to be heard.

Next, I looked into the circumstances that brought the artist to America and their impact on him, as well as on those who understood his significance. In a middle section that is pivotal to the entire study, I turned back to Mondrian's theory, this time in terms of its pragmatic relationship to his work. Also, I showed how his paintings differed from the amalgam of European styles followed by the American abstract artists until some of them began to understand his logic and to be affected by it in individual ways.

When treating Mondrian's followers, I first turned to the few artists who were closest to him and, then, to the larger number who were indirectly but irrevocably changed by contact with him. I had the opportunity to meet numerous associates of Mondrian or his followers, chiefly in the late 1960s (although some of the friendships continued beyond that time). The timing was fortunate, because most of them have since died, including: Alfred Barr, Ilya Bolotowsky, Fritz and Lucy Glarner, Carl Holty, Harry Holtzman, Hans Jaffe, Sidney Janis, Lee Krasner, Richard Paul Lohse, Kenneth Martin, Alice Trumbull Mason, Henry Moore, George L. K. Morris, Robert Motherwell, Barnett Newman, Winifred Nicholson, Silvia Pizitz, Ad Reinhardt, Mark Rothko, Emily Tremaine, Charmion von Wiegand, Vaclav Vitlacyl, and Paule Vezelay.

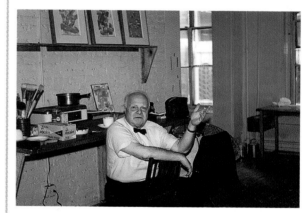

4 Carl Holty in his studio on Mercer Street, 1968.
© Virginia Pitts Rembert

Carl Holty was the most informative. Although he never followed Mondrian's orthodoxy, he understood it fully and helped me to understand, too, not just the theory but how to see the older artist's paintings. Under Holty's tutelage, I began to view artistic space not just as a concept, but as a concrete reality, which is exactly the way Mondrian intended it to be. The elder artist's influence on Holty was of the marginal type that he passed on to the Abstract Expressionists; nevertheless, I gained much information and understanding from Holty on Mondrian himself, as well as his influence on other American artists.

I visited Holty in two of his New York studios. His paintings – the ones leaning outside their racks for him to view and the one always in progress on a horizontal platform – had a lovely glow induced by the artist's command of color.(4, 5) The sense of surface and underlying form that controlled the tendency to lyricism in his late work had come from Mondrian, he said, but the color was his own and to Holty's gratification, the older artist admired openly the color in one of his paintings at a New York exhibition.(6)

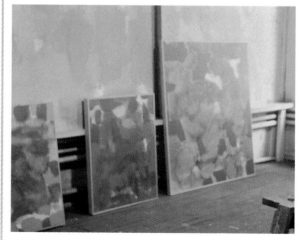

5 Holty's Mercer Street studio.
© Virginia Pitts Rembert

6 Holty, *Of War*, 1942–43, third version of the original: destroyed by fire in Chattanooga, Tennessee, 1952; repeated
 in 1962, 1$^{1/2}$ size from memory and water color sketches made when the original was done.
 Carnegie Institute, Museum of Art.

At first, Holtzman would not comment on his own work, of which there was only one example publicly available, at the Yale University Art Museum. Finally, he consented to discuss the four works that he showed in the exhibition of *Abstract Painting and Sculpture in America, 1927–1944*, hung at the Whitney Museum in the summer of 1984. In the summer of 1985, I visited the artist's home in a reconverted barn in Connecticut.(7) He was proud of the current work that could be seen in his spacious top floor studio — work that was "standing on the brink of history," he said. This was because in the new, "open reliefs," he had integrated painting, sculpture, and architecture, which was an unrealized ideal of Mondrian's.(8) At age 73, Harry Holtzman was ready to emerge from his mentor's shadow. He died at age 75, however; his work was shown posthumously in New York City, in 1990.

7 Holtzman's reconverted studio-home, Lyme, Connecticut, 1985.
Below: Harry Holtzman in New York, 1985. © Virginia Pitts Rembert

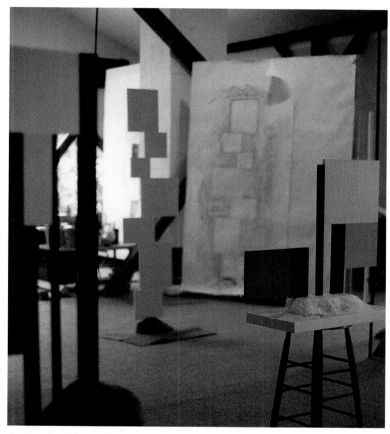

8 View in Holtzman's Connecticut studio, 1985. © Virginia Pitts Rembert

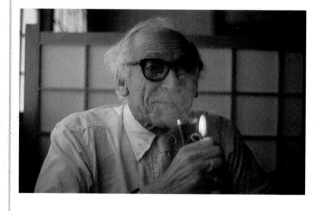

I had met Ilya Bolotowsky years before, when he came from Black Mountain College to lecture at the University of North Carolina. Twenty years later, he remembered the time we met in Chapel Hill and invited me to meet him in his mother's New York City apartment. He and his wife Meta lived at Sag Harbor, near where the artist taught at Long Island University at Southampton. The apartment, on Thiemann Place, was a convenient point from which to tour the galleries on weekends. The artist's mother was elderly by that time (the late 1960s) and had to pull herself around the rooms by way of a railing attached to the walls. Nevertheless, she stood by Bolotowsky's side when he sat at the table and inquired deferentially from time to time: "What will the man have?"

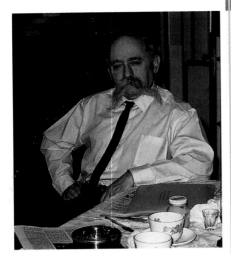

9 Ilya Bolotowsky in his mother's apartment on Thiemann Place, 1967.
© Virginia Pitts Rembert

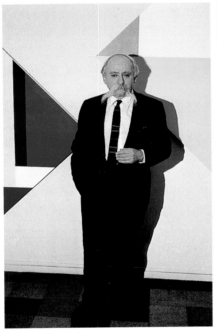

10 Bolotowsky at his exhibition in the Grace Borgenicht Gallery, 1968.
© Virginia Pitts Rembert

11 Fritz Glarner's studio-home, Huntingdon, Long Island, 1967. © Virginia Pitts Rembert

His long gray moustachios that moved rhythmically with an unflagging current of words provided a distinction that belied Bolotowsky's short stature.(9) I could imagine him in the scarlet greatcoat and high fur hat of a Cossack, wielding a saber from horseback. What infinite patience he called upon to explain the subtleties of Neoplasticism, however. He allowed me to photograph his work of that time and, later, at one of his exhibitions at the Borgenicht Gallery.(10) I last visited the artist in his loft on Spring Street and photographed him among his columnar constructions that were in all stages of completion. We ascended to the loft in an ancient elevator, the one that was the scene of his fatal accident less than a year later.

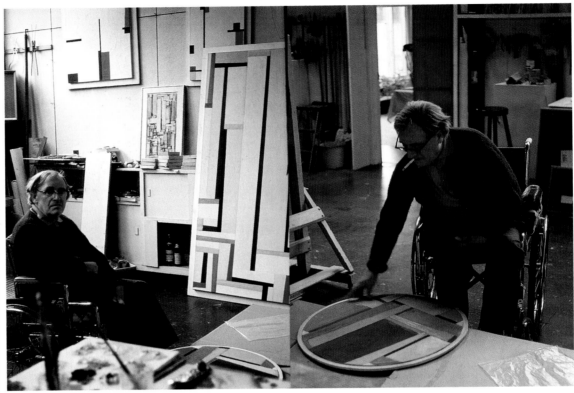

12 Glarner in his Long Island studio, 1967.
© Virginia Pitts Rembert

13 Glarner in his Long Island studio, 1967.
© Virginia Pitts Rembert

My meeting with Fritz Glarner was shortly after a near-fatal accident had sent him to the Rusk Rehabilitation Center in New York City. He was there for more than a year while recuperating from a brain injury suffered during a storm when he was thrown against a bulkhead as the artist and his wife were returning on the liner *Michelangelo* from one of their annual trips to Switzerland. Lucy Glarner agreed to my visits, which she thought would be a diversion for her husband while he was in the hospital. She did most of the talking, because he had difficulty in articulating his thoughts. Glarner was withdrawn most of the time, but he became animated when his theories and works were mentioned. He seemed to think more clearly when he tried, with the help of his wife, to discuss them. After he was well enough to return from Rusk to their studio home on Long Island (11), the artist was able to continue a limited amount of work, even though he was in a wheelchair and completely dependent on his wife.(12, 13) The Glarners later moved permanently to Locarno, where both of them died, Fritz preceding his wife by only a few years.

Another follower, Charmion von Wiegand, was a delightful resource person. She could talk endlessly on Mondrian and loved to recall his little jokes that she would deliver with her lips pursed in imitation of a Dutch accent.

14 Charmion von Wiegand at the Buddhist shrine in her apartment-studio on East 33rd Street, 1967.
© Virginia Pitts Rembert

15 Von Wiegand's Exhibition at the
Birmingham Museum of Art in 1980.
© Virginia Pitts Rembert

It was obvious that she had been affected personally as well as profession-
ally by the artist. He had a strong physical appeal for her, although he was a
"touch-me-not" type of person, she said. Von Wiegand spoke of Mondrian's
(not at all effeminate) "fineness and delicacy" of gesture and of his piercing
eyes that he kept averted, "because they had the power of a whiplash," she said.

By the time I knew her, von Wiegand had digressed far from the older
artist's direct influence, albeit in a direction that actually stemmed from his
interest in Theosophy. She had studied Madame Blavatsky's writings and had
become interested in all of the Eastern theological and philosophical sources

that led that amazing woman to found Theosophy.(14) The brilliant color and variety of imagery in von Wiegand's late work was influenced by the abstract art of Tantric Buddhism. This was palpable in a 1970 exhibition of her work at the Birmingham Museum of Art.(15)

Before she died, von Wiegand was honored by the National Women's Caucus of Art; she was puckishly senile by that time (16) and refused to attend the ceremony. Her award was accepted by one of the Nepalese Buddhists whom she had befriended and who took care of her in her final illness.

Burgoyne Diller died in 1965, so I did not have the opportunity to meet him. My interest in the artist dated from a 1963 exhibition of his work that was organized for Birmingham-Southern College by Silvia Pizitz, one of his chief patrons. I had several conversations with Pizitz about his work, as well as one with Kenneth Preston, who had organized a posthumous Diller exhibition for the Newark Museum of Art. On two occasions, I was able to visit Diller's home in New Jersey. With the help of his widow and her son, I photographed the artist's work before more than a few of his paintings and sculptures (no drawings at all) were brought out of his home and exhibited in New York City.(17,18) The leads that I followed on Mondrian beyond the immediate followers took me in many fascinating directions. Eventually, I interviewed some of the most important American Abstract Expressionists, such as Ad Reinhardt, Barnett Newman, Mark Rothko, Robert Motherwell, and Lee Krasner. I corresponded with Charles Biederman and met many other artists, historians, critics,

16 Von Wiegand in her apartment-studio in 1980. © Virginia Pitts Rembert

17 Paintings in Ruth LaCrone Diller's home,1967. © Estate of Burgoyne Diller/ Licensed by VAGA, New York, NY

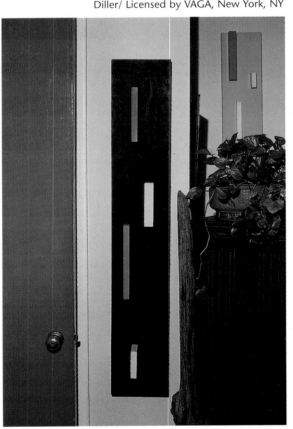

18 A Diller construction in the New Jersey home, 1967.

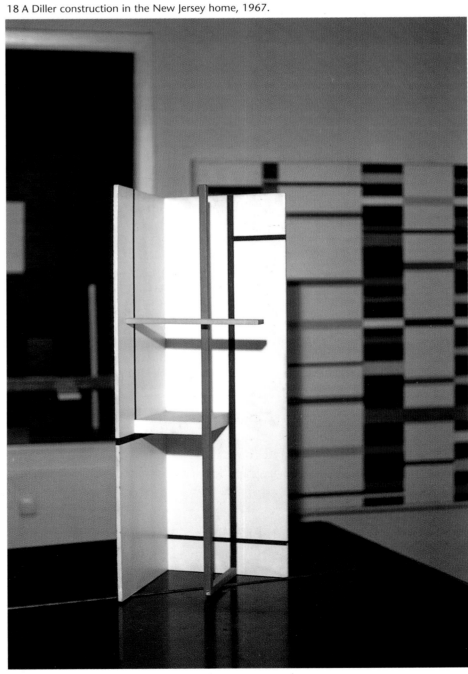

collectors, and dealers in this country who were associated with Mondrian in one way or another. Among them were: Leon Polk Smith, Alice Trumbull Mason, George L. K. Morris, Kenneth Noland, Alfred Barr Jr, Robert Welsh, Milton Brown, Sidney Janis, and Rose Fried.

At her gallery, Rose Fried introduced me to Marcel Duchamp, but I was too awed to ask him a single question – I wondered if the same thing would have happened had I met Mondrian.

One of the most helpful of the dealers was Arnold Glimcher, who had been my student at the Massachusetts College of Art in the late 1950s. Founder of the Pace Gallery in New York City, Glimcher became my mentor as he interpreted the abstract art that followed Abstract Expressionism in the 1960s. He also introduced me to people who were important to my quest, such as Emily Tremaine, owner (with her husband Burton) of Mondrian's *Victory Boogie-Woogie*. I met Michel Seuphor and César Domela in France; Alan Bowness, Nicolette Gray, and Kathleen Stephenson in England; and Hans Jaffe, Enno Develing, Joop Joosten, Robert Oxenaar, and Piet Zwart in Holland. One day, I spent an afternoon and evening in Amersfoort, despite Professor Jaffe's objection that it was "only a little Dutch Protestant town," because I wanted to see the place where Mondrian had spent his first years of life.(19)

In England during the summer of 1978, I attended a recreation of the original *Unit One* exhibition at the Portsmouth Museum of Art.(20) Alan Bowness (then Reader in the History of Art at the Courtauld Institute – later Director of the Tate Gallery)

19 View of Amersfoort, Holland – Mondrian's birthplace – in 1967.

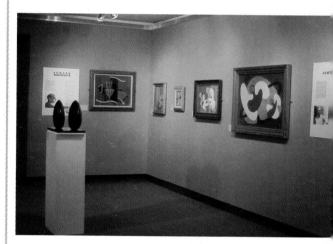

20 Reconstruction of original Unit One Exhibition (held at Mayor Gallery, London, 1934), in Portsmouth, southern England, 1978.

21 Winifred Nicholson's home-studio, Carlisle, northern England, 1980. © Virginia Pitts Rembert

had told me about the exhibition, which was important for the development of abstract art in England. Bowness also suggested that I visit Winifred Nicholson, with whom I spent a most charming afternoon.

The granddaughter of an earl, Nicholson still lived on her ancestors' land. The old Norman wall ran along the road in front of her stone cottage in Cumberland.(21) She invited me to have tea with her and her grandson in the kitchen where, over sun-ripened tomatoes and brown bread spread with wild honey, we talked about how she helped Mondrian flee Paris for London when war threatened in 1938. (22) Nicholson gave me a copy of an eloquent piece she had written on her experiences as a young art student living in Paris during the years between the two world wars.

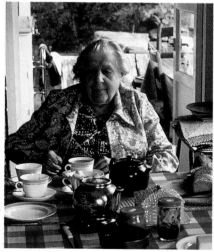

22 Nicholson in the Carlisle cottage, 1980. © Virginia Pitts Rembert

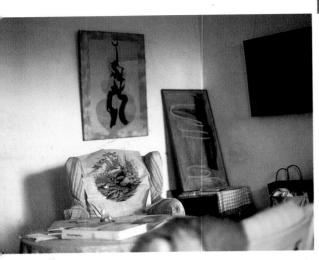

23 Nicholson's living room in the cottage in Carlisle, 1980.
© Virginia Pitts Rembert

Nicholson also recounted the frustrating reactions she received to abstractions she painted after she had returned home to a largely unreceptive England. She never stopped painting, though. The results were all around us on the walls of her house in Cumberland, along with paintings by her former husband Ben Nicholson and their children and grandchildren.(23)

Paule Vezelay was just as interesting a person and energetic an artist as Winifred Nicholson (although neither acknowledged the existence of the other). Ronald Alley, curator of the Modern Foreign Collection at the Tate Gallery, showed me one of Vezelay's works and suggested that I visit her, which I did in the artist's tiny townhouse in the London suburb of Barnes.(24) Vezelay's studio included almost all of her works: the paintings done in England until the late 1920s when she settled in Paris, the ones done in Paris where she became one of the original members of Abstraction-Création, and the ones done after her return to England at the start of World War II.(25)

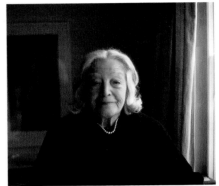

The artist's stories, of Paris between the two wars as well as of England during both wars, were gripping. She had shown great courage during World War II by organizing a women's group that launched air balloons ("the size of a house," she said), to intercept low-flying bombers. From Vezelay, I learned what it must have been like to live through the terrible bombings, which Mondrian also endured when he lived in Hampstead.

24 Paule Vezelay at her home-studio in Barnes, south London suburb, 1979.
© Virginia Pitts Rembert

25 Vezelay Barnes studio, 1979. © Virginia Pitts Rembert

Another glimpse into Mondrian's life during wartime came from the Henry Moores who told about their memories of Mondrian in Hampstead. They had moved into the mall studio that Ben Nicholson and Barbara Hepworth abandoned as they fled from London during the bombings. When that studio was bombed, in the same raid that destroyed the house next door to Mondrian's and brought on his decision to depart for America, the Moores

left the city, too. They rented part of a farmhouse at Much Hadham, a village north of London. Later, they bought the farmhouse and all of the surrounding land, which Moore turned into a national sculpture park of his work for the British people.(26,27)

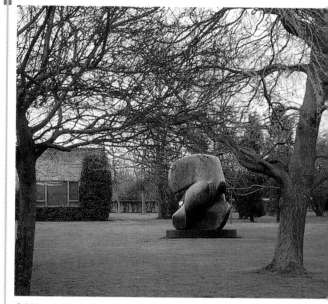

26 Henry Moore's garden sculpture park, Much Hadham, England.

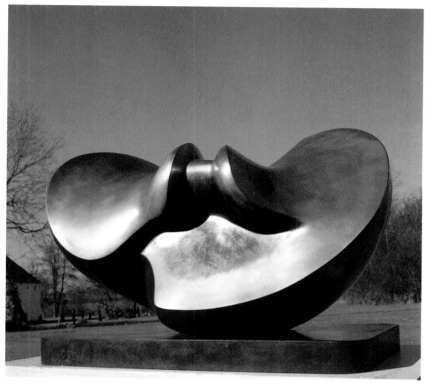

27 Henry Moore, *Butterfly*,1967, bronze edition, length 91.4 cm.

At an earlier time, I went to Hampstead to photograph Mondrian's house (28) and, behind it, the studio mall where the Nicholsons had lived.(29) The only one of the Hampstead pre-war colony still there when I visited was Kathleen Stephenson. She told me how all of the members of the colony had revered Mondrian. The Nicholsons had tried to get him to leave London when they did, but he was only persuaded to leave,.later, by the severity of subsequent bombings. By that time, most of the other Hampstead artists had dispersed. I followed the route taken by the Nicholsons to St Ives, but by the time I got there, Ben Nicholson had long since left and Barbara Hepworth had died.

28 Mondrian's apartment house in Hampstead, north London suburb, 1967.

Among other abstractionists of the post-war generation in England whom I met were Victor Pasmore and Anthony Hill.(30) Each told me about the period after the War when experimental art collapsed and they worked alone and unsupported until stimulated by Charles Biederman's *The Evolution of Visual Knowledge*. Guided by Biederman's rationale for the development of abstract art to Mondrian and beyond, they began the abstract movement in English art. I talked by telephone with Kenneth Martin, another

30 Anthony Hill in his Charlotte Street apartment-studio, London, 1978. © Virginia Pitts Rembert

29 Studio mall behind Mondrian's apartment house in Hampstead.

artist of this movement, and in the summer of 1985, photographed his posthumous exhibition at the Serpentine Gallery, London.(31) Also, I talked by telephone with Sir Leslie Martin, the architect who became a spokesman for the modern English movement.

32 Richard Lohse in his apartment-studio in Zurich, 1979.
© Virginia Pitts Rembert

31 Kenneth Martin's posthumous exhibition at Serpentine Gallery, London, 1985.

33 Lohse's studio in Zurich.
© Virginia Pitts Rembert

In Switzerland, I met Max Bill and Richard Paul Lohse, who followed a branch of Constructivism called Concrete Art that finds its roots in Mondrian and Malevich. Bill brought to my hotel many catalogues of his work and articles about his activities, but Lohse was wary of me until he realized that I understood the background of his distinctive style. Then, he discussed freely the glowing paintings in his studio.(32,33) It seemed that wherever I met artists who were influenced by Mondrian, they received me graciously, as if anxious to share their knowledge with someone of equal devotion to their master and their cause. We seemed to agree tacitly that all of our lives had been touched, perhaps even directed, by that remarkable man.

Exhibitions of more recent years, such as *Pier + Ocean*, held in 1980 at the Hayward Gallery in London (34) and the Kroller Muller Museum in Otterlo, and *Constructivism and the Geometric Tradition* and *Concepts in Construction: 1910–1980*, which traveled to several American institutions in 1979–1980 and 1983–1985, have presented Constructivism (usually interpreted by then to include Neoplasticism) as a world-wide phenomenon.

I had turned to Europe whenever it seemed appropriate, because the international phenomenon that Mondrian represented could not be confined to American shores. Nevertheless, since the culmination of his life and art took place in the United States, I focused these pages on his American years and his subsequent influence in America. My interest in the critical study concentrated on the symbol as well as the changing attitudes toward the artist as his name became something of a household word. On the popular

level, either his name or a logo fashioned from the most obvious characteristics of his style turned up on everything from a birthday card to an advertisement for a California hotel so "contemporary" in its appointments that it was named le Mondrian. (35, N.N. p.VIII)

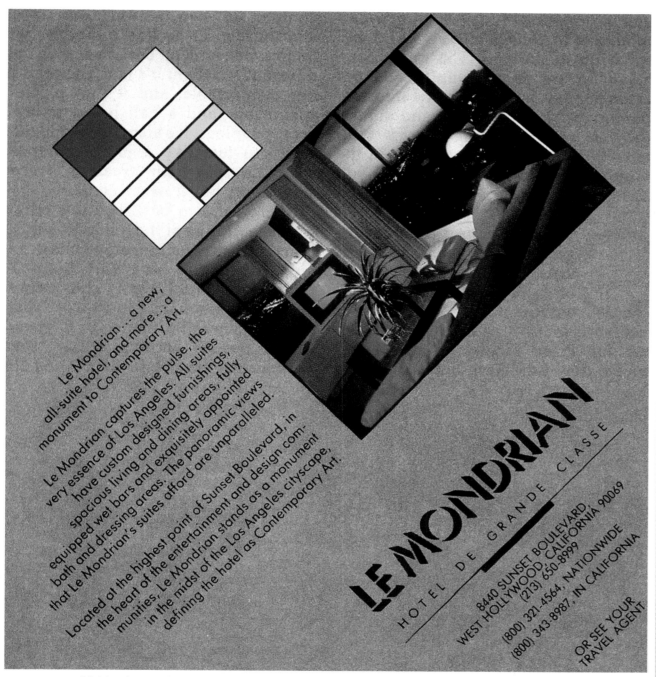

35 Advertisement for Le Mondrian Hotel, Los Angeles, 1987.

34 View of Pier + Ocean Exhibition, showing Lohse's and Martin's paintings, Hayward Gallery, London, 1980.

Even in art publications, the artist's influence on design was emphasized long after he died. Over the years, however, as his standard in painting was invoked to measure or judge all subsequent American movements that either stemmed from his style or ran counter to it, Mondrian changed in the literature from a mere designer to a classical artist. Eventually, he became the lodestone of Modernism.

Only now can it be seen that in his "later works," Mondrian was more. In these works, he created the paradigm for extending the rules of art when

they can no longer carry the artist's message. Every generation needs its examples of intellectual and creative courage. I believe that Piet Mondrian is such a model for artists of his adopted country.(36)

A final note. I consider there to be a great deal of mythology surrounding Mondrian, with reference to his "spirituality," his personality, his working methods, his relation to followers and theirs to one another. I have attempted to cut through this mythology by presenting a holographic image of the artist, as represented not only by his own statements and writings but by the views of many people who were close to him or who have interpreted him rationally. The spiritual motivation to his art I have discussed in the first chapter, but then I have let it alone. There are two reasons for this: one, his connection with Theosophy has been thoroughly treated by Jaffe and Welsh, particularly the latter; and two, I do not believe that Mondrian translated his spiritualism directly, that is, illustratively, into his work. There is no doubt that his original impetus for adapting abstraction-ism was motivated by spiritualism, but it was also motivated by logic. After achieving "the style," I believe that the artist allowed it to follow, with variation, its logical course. Never would I agree that he intended to illustrate religious symbols, such as cosmic eggs or crosses. None of his writings nor any evidence of his working procedures would support such an idea.

I do believe that Mondrian absorbed specific spiritual tenets into an aesthetic system which he practiced in the same way that any artist approaches a canvas, with a combination of pragmatism and intuition. He might have meditated before making a painting (one photograph does show him in a meditative stance), but his studio methods were those of an aware artist, not one in the throes of an out-of-the-body experience. I hope to have demonstrated this by lengthy discussion of his working methods.

Additionally, I have chosen to stay clear of the petty jealousies and in-fighting that went on among Mondrian's followers. Perhaps because he gave the appearance of being vulnerable, those who were closest to the artist felt protective of him, which caused some strong-arming and jockeying of position among them. Mondrian seemed to have been above all that kind of pettiness, however. In a human sense, he was grateful to those who were most helpful to him and rewarded them accordingly. The fact that some associates benefited more from the association than others need not imply calculation on his part nor on theirs. At any rate, since such stories came to me in hearsay, I preferred to ignore the insinuations that might be drawn from them. Of far greater importance, I think, is the artistic inheritance.

In the words of Carl Holty, only one of the artist's friends and artistic legatees, we are all his "heirs, without equity."

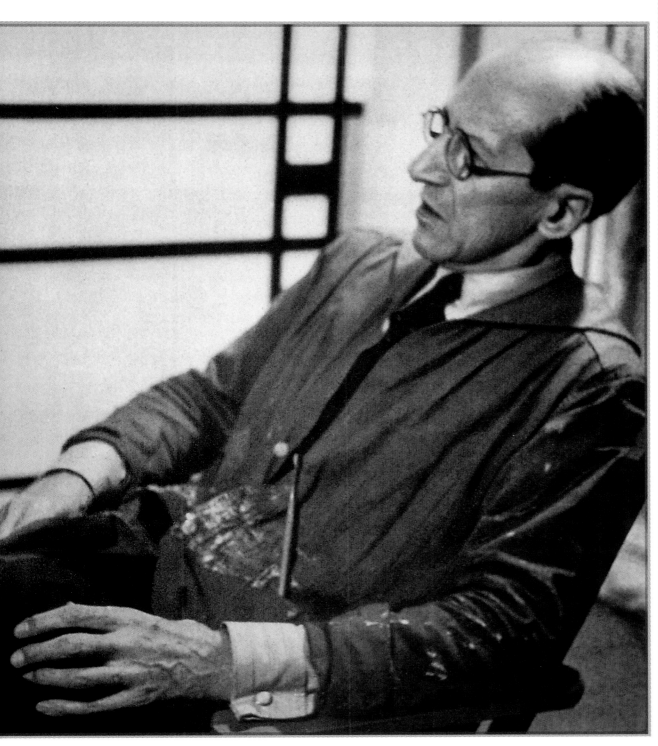

36 Last photograph of Mondrian in New York, 1944, by Fritz Glarner © 2001 by the Estate of
Fritz Glarner, Kunsthaus Zurich. All rights reserved

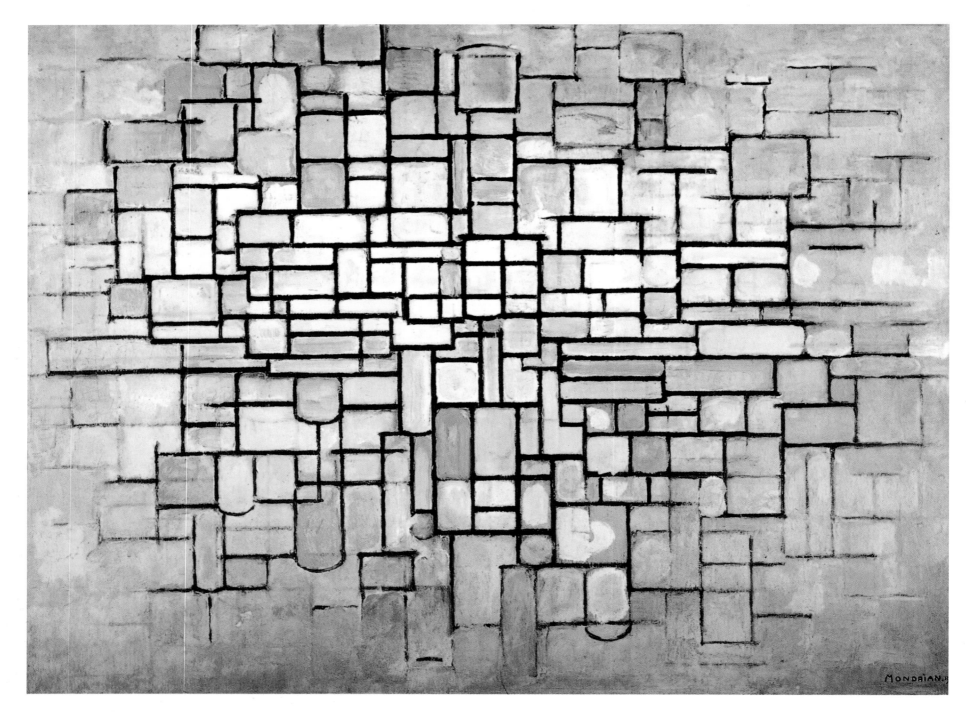

Mondrian, *Composition with Blue, Gray and Pink*, 1913. Kröller-Müller Museum, Otterlo.

ONE

THE BEGINNING: 1872–1925

By the centenary anniversary of his birth in Holland on March 7, 1872, Piet Mondrian had become a celebrated international figure There were major exhibitions of his work in the United States and abroad, beginning with a retrospective at New York's Guggenheim Museum in the fall of 1971.(37) The artist's life and work were extolled in papers and articles published in more than 30 symposia, books, and periodicals.

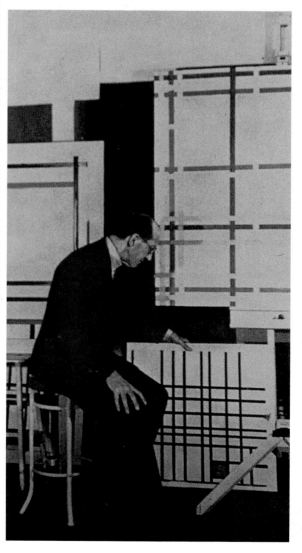

38 Mondrian in his first New York studio.

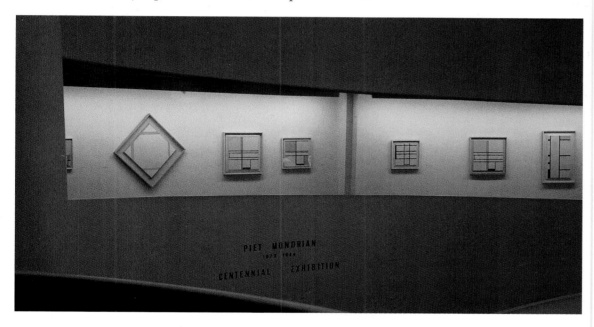

37 View of Mondrian's Centennial Exhibition at the Guggenheim Museum, 1971.

It is appropriate that most of these tributes originated in America, where Mondrian lived as a war refugee during the last four years of his life. He had long held a dream of the United States as the land of the future and designed his paintings as harbingers of a "new world image."(38) The image changed in America yet the theory remained basically as formed in Europe. It was rooted in Holland, as were many aspects of the artist's personality and artistic philosophy. Although he became known as the ultimate abstractionist, he always thought of himself as a realist – an idea that emanated from the Dutch concept of reality.

Since the late Middle Ages Dutch art had revealed a preoccupation with realism of a sort that was bound up with moral content. And so it was that the landscape painting genre that began in vistas through windows of religious settings in early Flemish altarpieces was fully developed as an independent medium from 1870 to 1890 in The Hague. The city was surrounded by a variety of landscape types that were both illumined and greyed by a silver light cast from the sea, the perfect setting for a renewed interest in landscape. Also, the theme was amply represented there in idealized paintings by seventeenth-century Dutch artists as well as in later examples by nineteenth-century French artists.

Mondrian had no direct contact with The Hague landscape school, and in fact was not born until a year or two after its inception, but his father and uncle were both trained under its influence. The father attained diplomas in drawing, French, and headmastership in The Hague and taught there for several years before being appointed headmaster of a school in Amersfoort. During the ten years that he and his wife Christina Kok lived there, they had the first four of their five children. They named their second child and eldest son (according to the Dutch spelling) Pieter Cornelis Mondriaan, Jr. (39-42).

39 P. C. Mondriaan, Sr, from photograph in archives of Mondrian Collection, Gemeentemuseum, The Hague.

40 Christina Kok Mondriaan, Mondrian's mother.

41 Canal scene in the Centrum area of Amersfoort, near where Mondrian was born (photograph by author).

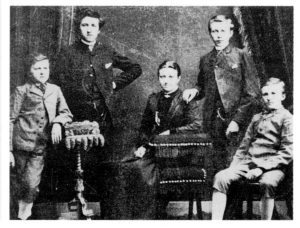

42 Mondrian photographed with his sister and brothers; he stands at the upper left.

The school in Amersfoort belonged to a Christian special education movement that was organized politically as well as theologically.[1] As head-master P. C. Mondriaan, Sr, became an outspoken advocate for the political coalition that was formed by various Protestant factions to foster religious education as the national norm. When the movement failed to win constitutional sanction, however, the father sensed that his support among the local activists had eroded. Soon afterwards, he moved his family to Winterswijk.

In his new position as headmaster of a school in that town, Mondrian continued to be politically active. He published articles in the local papers and distributed prints as pamphlets that lauded unification of the Netherlands under the rule of the House of Orange. The centers of his compositions usually depicted prominent members of the Orange family, while to one side a Medusa's head symbolized "revolution."(43) Years later, in America, his son reminisced of these days:

> My father was always drawing, . . . though it was only a hobby with him, and I began like everybody else. My father taught me at first, and then my uncle, who was a professional painter, gave me lessons. My serious drawing dates from the time I was about 14 years old.[2]

Uncle Frits Mondriaan had not become an artist until after retiring from the family wigmaking business.(44) A critic who called him a "self-made" artist also praised his "good technique" and the spontaneity of his sketches drawn from life. Sometimes, they were still-lifes but more often scenes executed in character with The Hague landscape school.(45) Frits often visited his brother's family when he worked in the vicinity of Winterswijk. There, and later in Amsterdam, he took his nephew on sketching expeditions into the surrounding countryside.

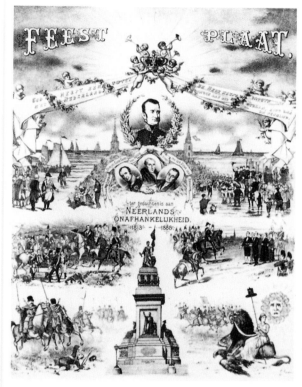

43 P. C. Mondriaan, Sr's print extolling the House of Orange.

44 Frits Mondriaan at his easel.

45 Landscape drawing by Frits Mondriaan.

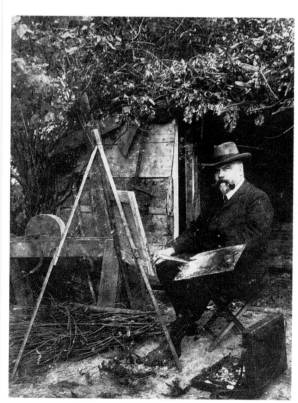

46 Frits Mondriaan, *Still Life with Fish*, 1893.

47 Piet Mondrian, *Still Life with Herrings*,
 1893.

Piet acquired technical skill from his uncle, if not his sense of composition. Any comparison of canvases by the two makes clear that the younger artist's understanding of spatial relationships far exceeded that of the elder. In two still-life paintings with fruit, fish and bowls, Frits Mondriaan's is a mere representation of objects whereas Piet's is an arrangement that placed the objects in visual relationship with one another and the area they occupied. The nephew's work was also more painterly than the uncle's.[3](46,47)

A family friend paid for young Piet's studies at the Amsterdam Academy of Fine Art, which he attended from the ages of 19 to 22.(48) His father's concern over his ability to support himself was allayed somewhat when Piet took certificates in the teaching of both primary and secondary drawing. In the decade and a half that followed his schooling, the young man did some teaching but preferred other art work, such as making "bacteriological drawings used for textbooks and in schoolrooms, portraits, [and] copies of pictures in museums" (Bradley, 18).(49,50)

48 Photograph of Mondrian at about the age of 20, *c.*1892.

50 Mondrian, *Portrait of a Woman*, *c.*1905 (this and the following undesignated paintings, all oc, were photographed by the author in 1979 or 1980 at the Gemeentemuseum, The Hague, either on view in the galleries or, with permission, in the storage vaults).

49 Mondrian, *Chrysanthemum*, 1908–09, charcoal on gray paper, Smith College Museum of Art.

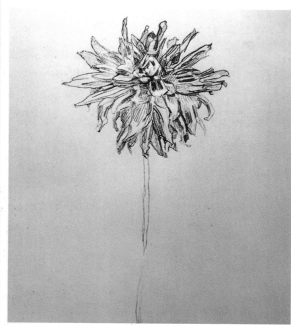

51 Mondrian, *Landscape in Moonlight*, before 1908.

52 Detail of landscape, right.

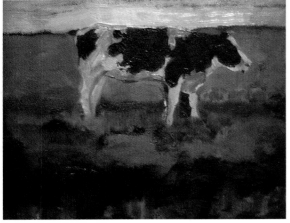

53 Mondrian, *Cow*, c.1902–03.

54 Mondrian, *Sheepfold, 1906*, Gemeentemuseum, The Hague

While he continued to paint landscapes, and occasionally to sell them, Piet's artistic interests gradually turned away from those of his father and uncle. His formal tendencies were closer to the more prominent painters of The Hague, whose works were said to satisfy "the northerners' evident need for simplicity and clarity," while uniting all details in "an overriding harmony" (de Gruyter, 13, 75). Piet Mondrian wrote in his only autobiographical essay:

I preferred to paint landscape and houses seen in grey, dark weather or in very strong sunlight, when the density of atmosphere obscures the details and accentuates the large outlines of objects. I often sketched by moonlight – cows resting or standing immovable on flat Dutch meadows, or houses with dead, blank windows. I never painted those things romantically, but from the very beginning, I was always a realist.

("*True Vision*", 10) (51-54)

This statement notwithstanding, he became less and less a realist in the modes of The Hague or Amsterdam, to which Dutch art had shifted in the late 1880s as its artists turned from landscape to city themes. While he continued to use the same painterly strokes as before, the young Mondrian began to heighten his color, influenced by Impressionist and Post-Impressionist works brought back by friends from Paris.(55-60)

55 Mondrian, *Dune*, c.1910

56 Mondrian, *Dune*, c.1910.

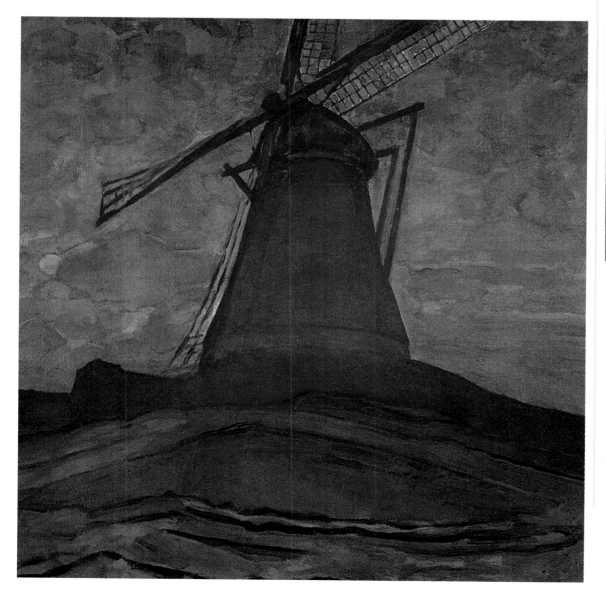

57 Mondrian, *Mill at Domburg*, 1909.

58 Mondrian, *The Mill*, 1907–08,
Stedelijk Museum, Amsterdam.

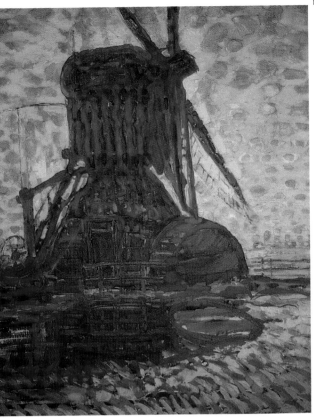

59 Mondrian, *Windmill in the Sunlight*, c.1911.

60 Detail of above.

The artist explained his transitional work of this time in a *Dialogue on Neo-Plasticism* (1920, written in 1919) by saying that he had "increasingly allowed color and line to speak for themselves" in order to create beauty "more forcefully . . . without verisimilitude."[4] Greater freedom of color and line meant that the subject matter had to be chosen "harmoniously." In his flower studies, for example, Mondrian found that intimacy could be expressed by subdued color and small enclosing shapes, and in his dune landscapes that vastness and extension could be expressed by strong color and wide sweeping curves. (61-63)

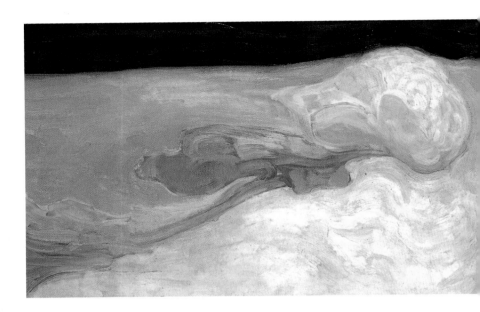

Through consistent abstraction, he realized that the straight line had greater tension than the curved line and could therefore express a concept like vastness better than a natural line. Change was gradual, as he first "abstracted the capricious, then the freely curved, and finally the mathematically curved." The artist's theories on these exclusions came after his experimentation had led him to understand that "abstraction alone is not enough to eliminate the naturalistic from painting. Line and color must be composed otherwise than in nature."

Mondrian traced advancement in artistic form from Impressionism – which he thought of as too much dominated by the "natural," thus causing a "disequilibrium between individual and universal"[5] – to Cézanne, who increasingly stressed "that everything visible has a geometric basis, that painting consists solely of color oppositions." Cézanne had "cleared the way for Cubism,"[6] the artist wrote, but he gave most credit to Picasso:

61 Mondrian, *Dying Chrysanthemum*, c.1907–08.

62 Detail of above.

Picasso is the great artist who in his extraordinarily gifted way . . . still starts from the natural but plastically represents only what is valuable to him. When he does not find something relevant, he does not represent it as subordinate to what he does (as in older art) but he leaves it out or breaks it up. Like the old art, he constructs by oppositions of forms and colors, but he selects them and remodels them in his own way. Thus he obtains more inward power and a deeper naturalness.

("*Natural*", footnotes 14–16)

63 Mondrian, *Dune*, c.1910.

Mondrian saw his own style of painting, which he called "abstract-réal," as the necessary consequence of what had been initiated by Picasso and others, but gave credit to Cubism as "the highest form of painting"[7] before his own. He had been so inspired by the French Cubist paintings exhibited in the fall of 1911 in Amsterdam that he left for Paris the following spring in order to confront their sources more directly. The artist was thoroughly committed to Picasso's and Braque's theory of Cubism but preferred not to meet these artists, fearing that he might be overwhelmed by their strong personalities. His Dutch stubbornness and individualism might have played a part in this self-imposed isolation, as he himself suggested:

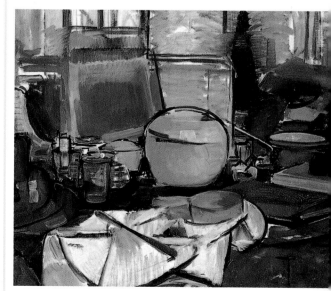

64 Mondrian, *Still Life with Ginger Pot*, 1911–12.

There was also a little opposition, of course. The Cubists thought they had found a way and it was not pleasant when another went a little out of that way as I was doing. And so I found my own way. I got rid of all other influences. I have always been alone . . .

(Bradley)

As Mondrian worked to suppress the solids and voids of natural subjects in favor of their flat, geometric equivalents, he began to resolve the inconsistencies of three-dimensional natural space and two-dimensional artistic space. At first, he flattened objects, figures, trees, and façades into webs of contours, as in the paintings of 1911–1914.(64-71) Then he treated the

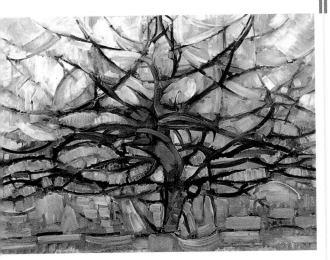

66 Mondrian, *Gray Tree*, 1911. Detail 67 below

65 Mondrian, *Nude*, c. 1912.

68 Mondrian, *Flowering Apple Tree*, c. 1912.

69 Detail of 68, right

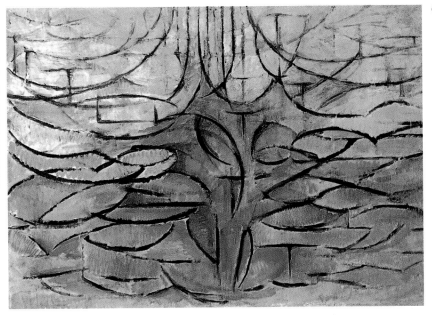

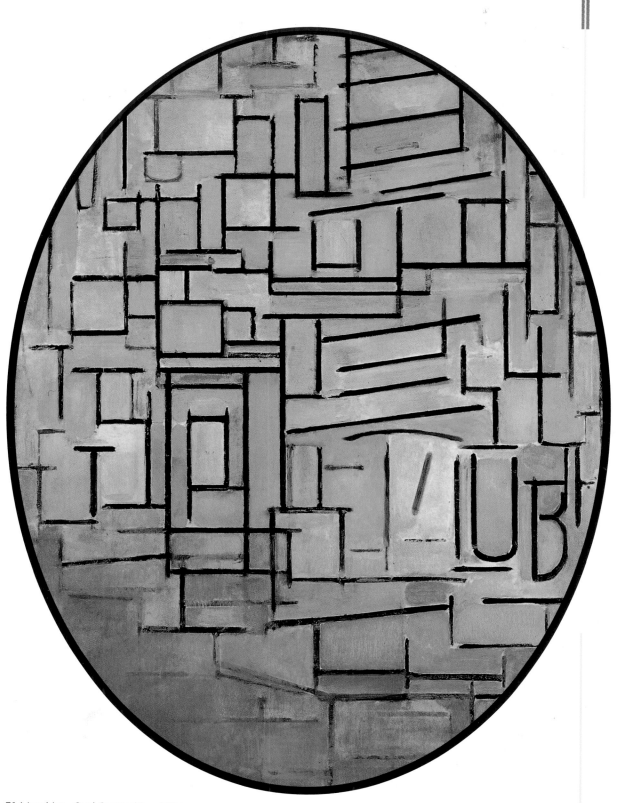

71 Mondrian, *Oval Composition*, 1914.

70 Mondrian, *Composition #6*, 1914.

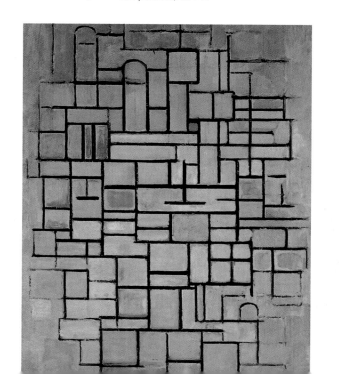

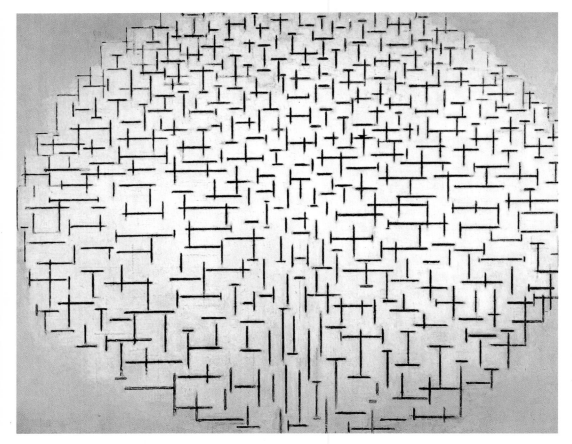

webs and later the crossings of their verticals and horizontals as independent members, unattached to the interstitial areas, as in the "Oceans" and "Compositions" of 1914–1916.(72,73)

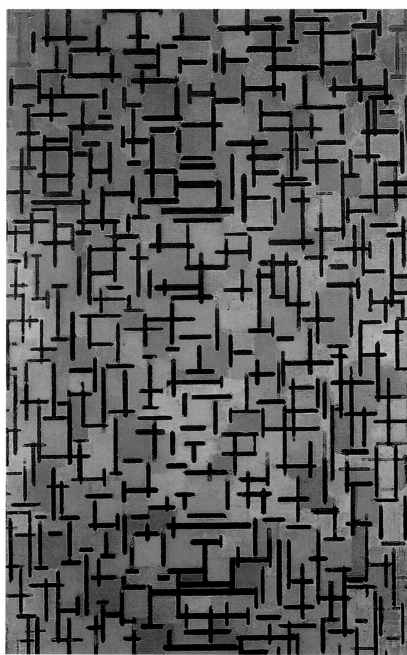

72 Mondrian, *Pier and Ocean*, 1915, Kröller-Müller Museum, Otterlo (photographed by the author).

73 Mondrian, *Composition*, 1916, Guggenheim Museum, New York (photographed by the author).

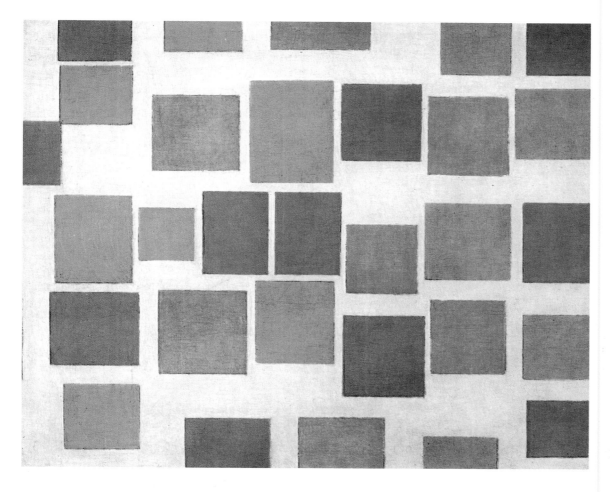

74 Mondrian, *Composition #3 with Color Planes*, 1917.

In subsequent works, the artist stressed these inner areas and eliminated their interconnections, as in the "Compositions" of 1917–1919.(74) The elements were no longer identifiable as belonging in nature yet were still vaguely natural in form and color. This equivocation brought him to a turning-point:

> Gradually I became aware that Cubism did not accept the logical consequences of its own discoveries; it was not developing abstraction toward its ultimate goal, the expression of pure reality. . . . It took me a long time to discover that particularities of form and natural color evoke subjective states of feeling, which obscure pure reality. The appearance of natural form changes, but reality remains constant.
>
> (*True Vision*)

Mondrian lived in Paris for two years before he was called home in 1914 by the illness of his father. He expected to stay in Holland only a fortnight, but World War I erupted while he was there and the Dutch borders were closed. This forced him to remain for five years. What seemed at first a depressing turn of events, however, became a fortunate hiatus. During the years 1914 to 1919 he met several other painters, sculptors, designers, architects, and writers who were either native to the country or found themselves

in it because of war. Among the painters was Bart van der Leck, whose technique Mondrian admired — indeed, he may have modified his own still Cubist style to make it more "exact," in the manner of van der Leck.(75)

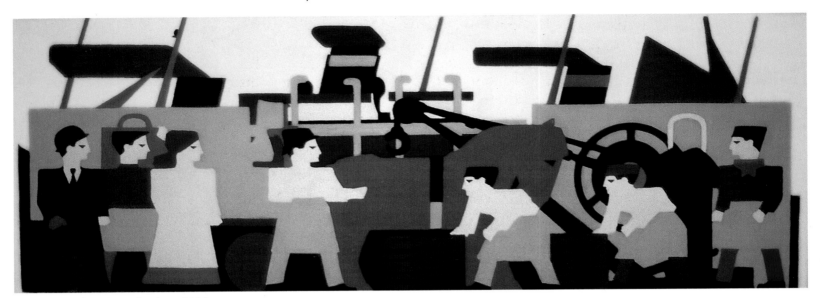

75 Bart van der Leck, *Dock Labour*, 1916, Kröller-Müller Museum, Otterlo (photographed by the author).

Of greatest importance to the artist's development was Theo van Doesburg, about whom he commented:

> Full of vitality and zeal for the already international movement called "abstract" and sincerely appreciating my work, he asked me to collaborate on a periodical he intended to publish under the name *de Stijl* ['Style']. I was happy to publish the ideas on art which I was then in the process of formulating; I saw the possibility of contact with homogeneous efforts.
>
> (Homage)

Van Doesburg may not have intended to found a movement when he began his periodical, but he did propose in the introduction to its first issue that artists who were willing to sacrifice their "ambitious individuality" should form a "spiritual community." Their purpose would be to try and understand the true spirit of the age and thus confront its apparent "archaistic confusion" (the "modern baroque") with a more appropriate organic expression.[8] The artists whom van Doesburg drew into his plan came from what he called "the various branches of plastic arts." They pledged to search for the logical principles in each of their art forms that would meld with those of their colleagues to form a "universal language" of art, or "style." The result would be both an artistic style and an aesthetic lifestyle — a model of the Utopia that, with typical wartime idealism, everyone expected to appear when the conflict was over.

Mondrian took the name for the style he sought in painting from the concept in the Dutch term *nieuwe beelding* ("new image").[9] In his essays for *De Stijl* he attempted to clarify the meaning behind the term and later translated *nieuwe beelding* into other languages as *le néo-plasticisme, die neue Gestaltung,* and "Neo-Plasticism." Recent translators call it "the new plastic."[10] Perhaps "the new world beauty" is also appropriate, since the artist considered the visual form this concept should take in painting as a prescription for the "changed

consciousness" of a future time when there would be no more need for art because all in life would be perfectly harmonious.

The problem had always been, Mondrian believed, that life and art were irreconcilable in their external states. Capricious, disjointed, and confusing, external nature was reflected by the traditional artist in its most "tragic" form. Only the "really modern [i.e. conscious] artist" would be capable of seeing through the conflicting particularities of nature to its balanced relationships. These particularities occupied opposable dualities that had their counterparts in art – matter v space, volume v contour, light v dark, color v value, verticality v horizontality, balance v rhythm, *ad infinitum*. If life and art were turned inward, life to its essential nature and art to its essential form, or style, all of their incompatibilities could be resolved in a single image that combined entity and essence, fragment and entirety. Then life would lose none of its virility and art none of its cerebration but would join at the teleological ground where they became one.

All of the cultural, philosophical, and religious *corpora* that were in the artist's background contributed to this ideal. Hans Jaffe wrote that Mondrian followed throughout his life the two imperatives contained in the Dutch word *schoonheid*, meaning "beauty" and "purity," but as the word implied, the artist's goals went beyond art in that he aimed toward enlightening mankind and preparing for his future well-being.

Mondrian cited only rarely the philosophic sources that underlay his theory, but his debt to Plato is evident. He referred occasionally to Aristotle as having identified the abstract with the mathematical,[11] and substance with the "deepest universal element" that is manifested outwardly only by "accidents of size [and] form."

In tracing the theoretical sources of De Stijl, Jaffe pointed out that van Doesburg based many of his articles on Kandinsky's book *The Spiritual in Art*, and that the spiritual, being basic to De Stijl philosophy, led its artists to Hegel's notion of the spirit's urge to free itself. Thus, they saw in their search for "style" a revolution of the spirit's liberation.

Michel Seuphor saw Mondrian's belief in evolution as represented by a passage the artist had marked in a book by Krishnamurti found among his few possessions when he died. The gist of the passage is that religion's importance lies in its revelation of God's plan for evolution. If man knows that plan, he will work "for progress and not for his own interests."

Calvinism, the religion of Mondrian's childhood, was founded on belief in an essential truth, a deeper-than-life law that subsumed all idiosyncratic incidents or ideologies. The artist accepted the law while rejecting Calvin's credo "that by an eternal and immutable counsel God has once for all determined both whom he would admit to salvation and whom he would condemn to destruction." At the same time, he retained Calvin's inexorable logic and the authoritarian attitude of those who were chosen – in the artist's case, to understand.

Significantly, when Mondrian left Calvinism, it was not for atheism but Theosophy. The order was not so much a specific religion as a set of verities derived from other religions but belonging exclusively to none of them. Mondrian's acceptance of Theosophy was not a complete denial of his father's religion because his new beliefs were close to the old ones in certain basic ways. Foremost was the belief in an absolute deity, more personified by the pronoun "He" in Calvinism than by the "infinite essence" of Theosophy,

but just as incomprehensible in both. There was also the belief in a spiritual aristocracy from whom a rigorous piety was exacted as a test that Calvinists were worthy of election and Theosophists of receiving the "divine mysteries." Both creeds eschewed idolatry and favored a humble form of worship stripped of excessive ritual or creed, and both looked toward a Utopia to be enjoyed by a brotherhood of believers.

There were differences, of course, and the artist was eventually drawn toward the less sectarian, less regularized, less dogmatic, and less intolerant Theosophy that recognized not an anthropomorphic God but a universal divine principle. This allowed Madame Blavatsky to say somewhat smugly: "Being well-occupied people, we can hardly afford to lose time in addressing verbal prayers to a pure abstraction."

Undoubtedly Mondrian welcomed Theosophy's idea of God as pure abstraction: his religion contributed to an aesthetic ideation which was finally integrated and given substance at a time coinciding "with the decisive years of his evolution," according to Jaffé, by contact with Dr M.H.J.Schoenmaekers's "utopian conclusions" (*De Stijl*, 61). Like Schoenmaekers, the artist believed that the "positive mysticist" who has been redeemed from a particular personality to an "all-embracing" one will create a new world, a "new plastic expression [*nieuwe beelding*] . . . born from light and sound. . . .it is a new earthliness, an earthly heaven."[12]

Mondrian called this condition a state of "full-humanity" and noted that it could not be brought about by "faith" alone, which "demands a superhuman abstraction in order to experience harmony in life." Nor, the artist said, could it be brought about by science, which "can only produce harmony intellectually." The supreme state, then, was a natural concomitant of art, which could enable us ". . . to experience harmony with our whole being." Art, he said, "can so infuse us with beauty that we become one with it. We then realize beauty in everything: the external environment can be brought into equivalent relationship with man" (*Realization*, par.7).

The time when art would be thus "transformed into real life" was far in the future, because an artist could not yet produce art as life. He could, however, achieve a most sensitive relationship with life by creating "something which expresses life but which is not yet life itself." Thus, Mondrian transposed the principle of gain through destruction – a principle basic to most major religions – into "an evolution toward non-art" which, he wrote, involved "the end of art," but was really "only a beginning" (*Rationality*, footnote 5).

Mondrian made an emphatic distinction between the new structure and past art with its "corporeality," "antiquated form," and "descriptive expression." The artist wrote in 1925, that: "The new structure still remains to be created. Born from the atmosphere of the past, it can express itself only in the living reality of the abstract." While vague in describing this "completely different reality" of the future, Mondrian was assiduous in attempting to justify and clarify the visual expression that would be its harbinger – "a definitive aesthetic which will present to the future a pure image of beauty, which will transform both our surroundings and life now dominated by the natural into an equilibrium between nature and non-nature."[13]

By 1917, when he began to write essays for van Doesburg's publication, the artist had established his theory intellectually, but it took much longer for him to develop a consistent paradigm. Joop Joosten observed that in

76 Detail of Mondrian, *Composition on White Ground, A*, 1917, Kröller-Müller Museum, Otterlo (photographed by the author).

paintings of 1916 and 1917, such as an unfinished *Composition in Line* and the *Composition in Color A* (76,77) and *Composition in Color B* (78), Mondrian first succeeded in separating line and color, as elements, from the motifs of a church façade and the sea and pier of Domburg. By distributing these elements evenly over the paintings' surfaces, Joosten said, he "finally won his battle for an 'abstract-real' art freed from the last restraints of particularized natural appearance." The breakthrough that these paintings represented undoubtedly inspired other works in rapid succession, Joosten believed, because the artist sent eight new paintings of 1917 to the Hollandsche Kunstenaarskring of 1918.

77 Mondrian, *Composition on White Ground, A*, 1917, Kröller-Müller Museum, Otterlo

The last paintings he completed in Holland and the others done after he returned to Paris in 1919, through the first two or three years of the 1920s, represent successive attempts to define the new image visually. Mondrian carried the paintings through various stages in which, at first, he turned the elements into uniform planes colored in muted versions of the primaries.(74) He separated the planes so that they seemed to float against a white background, but concluding that this effect was still too "natural," he then connected the planes in a regular grid covering either a rectangular or a diamond format.(79-82)

74 Mondrian, *Composition #3 with Color Planes*, 1917.

80 Mondrian, *Checkerboard, Bright Colors*, 1919. See 81, detail below.

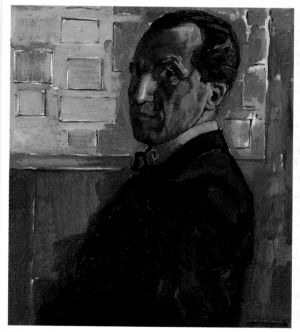

79 Mondrian, *Self-Portrait*, 1918.

Opposite page
78 Mondrian, *Composition on White Ground, B*, 1917, Kröller-Müller Museum, Otterlo (called *Composition in Blue* in *Tout l'oeuvre peint de Mondrian*, Paris, 1976, p.107 – photographed by the author).

19

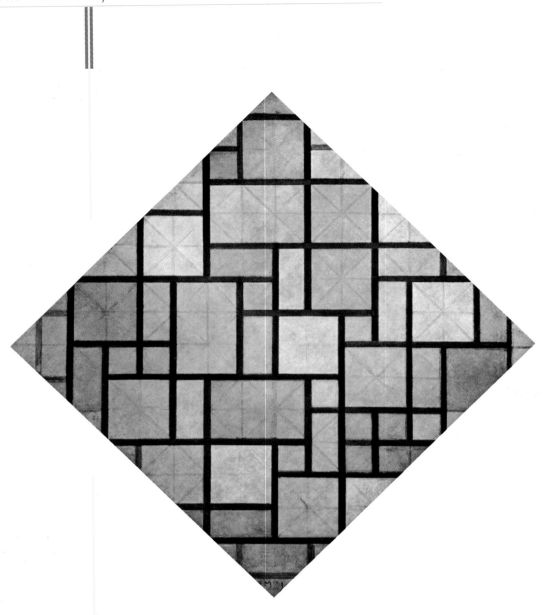

82 Mondrian, *Composition: Bright Color Planes with Gray Lines*, 1919, Kröller-Müller Museum, Otterlo (photographed by the author).

83 Detail of above.

While the planes were still connected, in the next phase the artist made them larger and unequal in size and colored them in primaries or in values of black, white and gray. (83) He attenuated the black planes to make them extend alongside the colored and non-colored planes. The blacks then served as structural bars holding the other planes together while at the same time making them more discrete. (84) Now he used means that belonged solely to painting while attempting to make of each canvas an aesthetic cosmos which would subsume space, matter, and structure within an "exactly defined" expression (*General Principle*, 11).

The canvas, or "rectangular prism" (as the artist once, very significantly, called it), was both a form in space and a form of space. Whatever he placed upon it should demonstrate the principle that "reality reveals itself by substantial, palpable forms, accumulated or dispersed in empty space ... that these forms are part of that space and that the space between them appears as form, a fact which evidences the unity of form and space" (*New Realism*, 18) To illustrate this principle, Mondrian divided the entire surface of the canvas into smaller rectangles that individually conformed in shape to the whole and cumulatively created the whole. He thus made the canvas consonant in part and in sum.

20

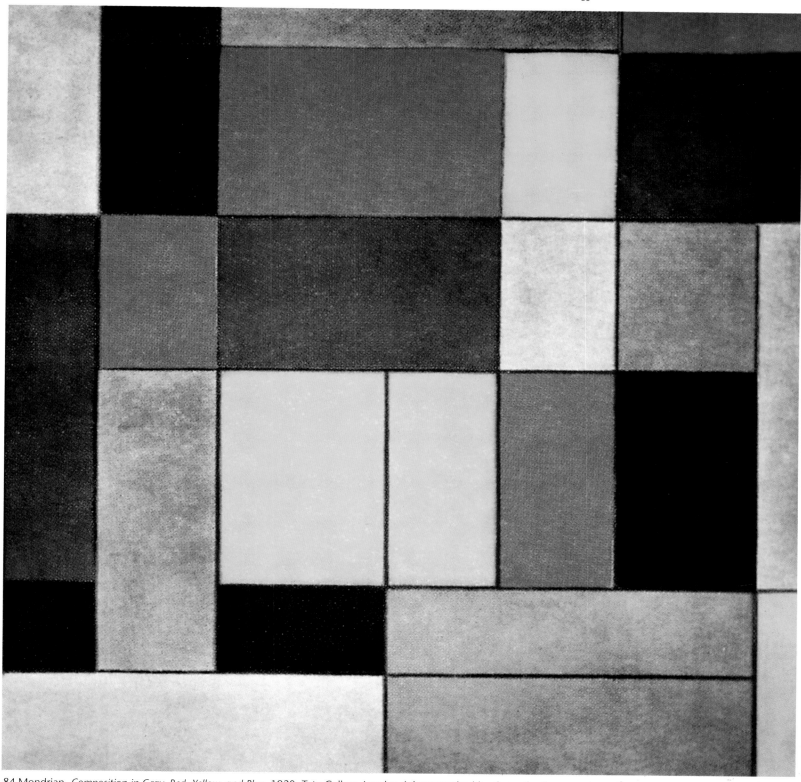

84 Mondrian, *Composition in Gray, Red, Yellow, and Blue*, 1920, Tate Gallery, London (photographed by the author).

Like the canvas, the smaller rectangles or planes represented both form and space; they also represented matter, or the materials of nature that had been rectified, tautened, and expanded to their most outward, extensive capacities. Since the planes were nature's artistic counterparts, or the means of art, the artist regulated, controlled, and condensed them to their most inward, intensive capacities. The colors of these planes stood for the intensities and values of nature, cleansed and rendered to their primal color states

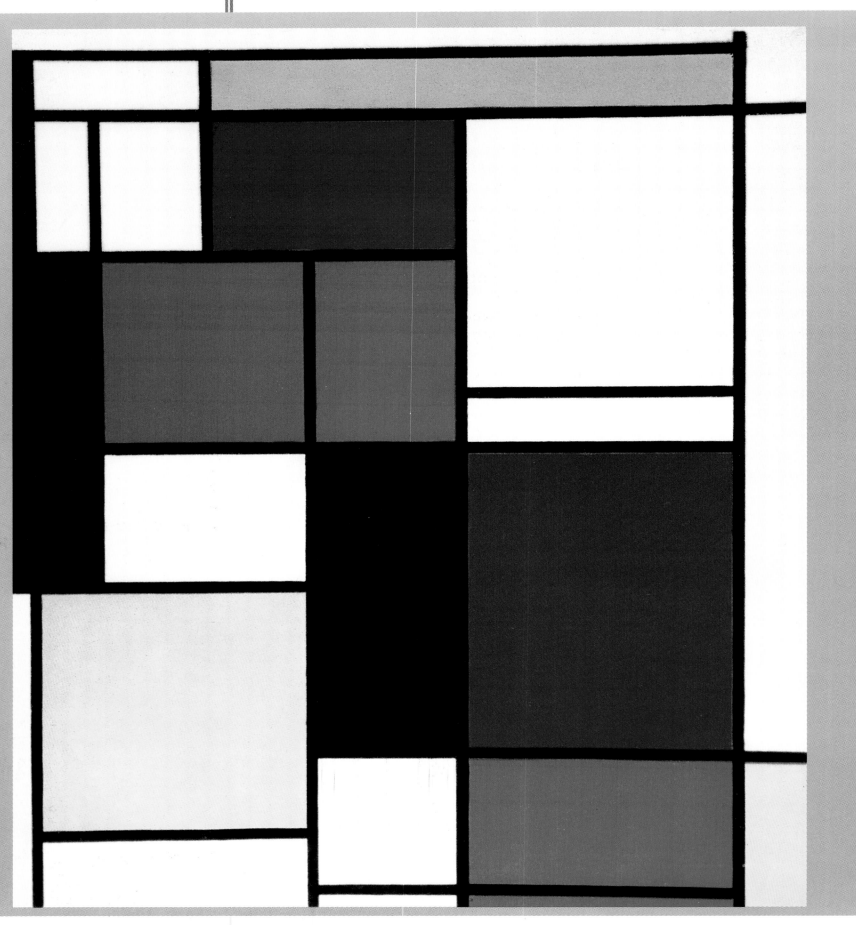

85 Mondrian, *Tableau II*, 1921–25, Max Bill
Collection, Zurich.

– red, yellow, and blue – and primal noncolor states – black, white, and gray. Mondrian applied the paint, as he explained, so that color in its purest form emphasized the flatness of the planes and was enhanced, in turn, by the lack of modulation and nuance on the surface of the planes.

Black planes performed multiple roles. In addition to their noncolor function, they were structural, determinate, and active – that is, when placed alongside other planes, they aligned them with the vertical/horizontal system established by the boundaries of the overall canvas. They also extended the edges of inner planes to connect them with one another and the edges of the canvas. Consequently, the partial spaces as well as the total space became palpable, or measureable – exact and nonillusionistic. By creating paths of movement for the eye, black planes also added a sense of energy.

Although the parts were important, the artist wanted always to emphasize their subordination to the harmony of the whole. Different in size and color, they had equal value, or equivalence because of their similar nature. Even when smaller areas of color were balanced against larger areas of noncolor, they had the feel of equal weight, or equilibrium when the proportions were right.

Composition, 1921 exemplifies the artist's principles at work.(85) He summed up matter, or means, with the colored and non-colored rectangular planes, and structure with the black linear planes that separate and organize the rectangular planes into the same vertical/horizontal system of the canvas. By stopping the blacks short of color planes that continue around the canvas edges, he demonstrated that means and structure are discrete elements.

87 Detail of *Composition II,* left.

86 Mondrian, *Composition II,* 1929 (original date partly obliterated; mistakenly repainted 1925 by Mondrian when he restored the painting in 1942). Oil on canvas, 15 7/8 x 12 5/8" (40.3 x 32.1 cm). The Museum of Modern Art, New York, Gift of Philip Johnson. Photograph © 2001 The Museum of Modern Art, New York.

The small *Composition II,* 1929 offers an example of the same principles in the simplest possible terms.(86) The artist painted color and white planes over the sides of the surface to show that a painting's space is contained not only on the canvas but is completed by its carefully finished edges.(87) A black plane at the top stops short of the others, proof in at least one part of the painting that its parts are discrete.(88)

88 Detail of *Composition II,* left.

So there could be no confusion with the usual implication of space receding behind the frame, Mondrian had mounted the canvas *on* the frame, thereby projecting the painting's actual space *into* the room. This simple act – suggestive of an entirely new attitude toward painting – did not imply a "negation of reality," as he explained in his *Bauhaus Book* essay, which was published in the same year (1925) that this painting was completed. By removing the painting from nature, the artist assumed the role of nature and his painting the role of art.

Working, therefore, in the "manner of art," Mondrian had created a "new structure" that in contrast to life was "exact": the fact that it was "real" did not mean that the painting was a material thing only – actually, the artist associated the reality of the work with a super-reality or universal ideal. By objectifying the absolute, Mondrian created an equivalence rather than a resemblance of life, and he had done so not by avoiding life but by experiencing it profoundly. "It would be a great mistake to think of Neo-Plastic work as totally abstracted from life," he wrote:

> Precisely through its relationships and pure plastic means it can express life more intensely. Abstract art does not transcend the limits of the plastic, nor does it lead to pure abstraction in the realm of thought. Abstract art is expressed by a most concrete image – by the most reduced and elementary form.
>
> (*The New Plastic Expression*, par. 11)

Here was the artist's ultimate duality – an object seemingly devoid of life, yet conceived as life itself – not in the sense of a deficient or incomplete fragment but a finite particle that contains within its structure the promise of its infinitude. By creating this particle of life, Mondrian had not illustrated pure reality or pure beauty. He had made the painting *be* that reality He had thus presented art in its most vital form, and life in its most unified form.

As Mondrian stated, succinctly (*Natural*, par. 5): "Unity, in its deepest essence, radiates: it *is* Life and art must therefore be radiation."

CHAPTER ONE – REFERENCES

1 This information and that immediately following was taken from Herbert Henkels' essay in the catalogue of an exhibition at The Hague's Gemeentemuseum, and Amersfoort's Museum Flehite, 1979–80 (private translation).

2 As quoted by Jay Bradley in an interview conducted shortly before Mondrian's death and published posthumously, "Piet Mondrian, 1872–1944, 'Greatest Dutch Painter of Our Time'". The phrase "greatest Dutch painter of our time" was quoted from the address made by Alfred H. Barr, Jr, at Mondrian's funeral following his death in New York on February 1, 1944.

3 Because of the similarities of their oil studies, Henkels supposed that the two worked very closely together in the early years, and that in the way Piet finished his works and in their meaning to him, the nephew was drawing apart from the uncle as early as the 1890s.

4 Piet Mondrian, "Dialogue on Neo-Plasticism," *De Stijl*, II.4 (1920; written in 1919), questions 4, 10, 11, 12, 13, 14, 15. These quotations are from the manuscript translated by Harry Holtzman and Martin James for their subsequent publication of Mondrian's essays written for the Dutch publication *De Stijl* and his further writings in Dutch, French, German, and English. Other citations from the same sources will be listed by title of essay.

5 *Neo-Plasticism, General Principle of Plastic Equivalence*, np.

6 Mondrian, "D. From the Natural...," X, "The New Plastic in Painting," in *De Stijl*, par. 32 ("The New Plastic..." is the long essay published by chapters in *De Stijl* from Oct. 1917 to Dec. 1918).

7 "The New Plastic Expression...," *Cahiers d'Art*, par. 2.

8 "Introduction, Manifestoes, etc.," in catalogue called *De Stijl*, 5.

9 I had assumed that Mondrian took the *De Stijl* term *nieuwe beelding* from *Het nieuwe wereldbeeld* ("The New World Image"), the title of a book published in 1915 by the Dutch Theosophist Dr M. H. J. Schoenmaekers, whom the artist met when he was on his hiatus in Holland. Later, however, the Dutch scholar Joop Joosten clarified the issue for me:

Beelden means basically "to make an image", but we use it normally in the sense of expressing by means of an image – i.e. by means of the quality of the form of the used/made image. ... *beelding* is [the] gerund form. With *nieuwe beelding* Mondrian wanted to indicate his new concept of expressing by means of the images' abstracted forms. ... Not only did Mondrian not need Schoenmaekers' title for his term *nieuwe beelding*, he simply could not use it. Schoenmaekers' *beeld* is a passive concept – the image you get from something; Mondrian's *beelden*, *beelding* is an active concept: the image you are making.

Nowadays, we use the terms *beeldende kunsten* and *beelden kunstenaar* also when we are speaking about complete abstract art (concrete art as van Doesburg called it – abstract forms not derived from figurative images). Mondrian's realism is, as far as I can see, a painterly realism. His conception of the reality is the conception of the painter; his realism is a realism in terms of the realism conceived in the art, the *beeldende kunsten*, by the artist, the *beelden kunstenaar*.

In 1932 when Mondrian started his experiments with double lines, his art additionally took on a *concrete* character. Mondrian's conception of [his] art dated from long before he met Schoenmaekers. In Schoenmaekers' ideas he found an affirmation of his own ideas, as he did – and much more so – in Theosophy.

(Letter from Joosten dated June 19, 1991)

10 The first was the name Mondrian gave the term in the French title of the essay *Le Néo-Plasticisme: Principe Géneral de I'Équivalence Plastique*, published by the Léonce Rosenberg Gallery soon after he returned to Paris (title given in English in note 5 above); this was his first attempt to translate the Dutch concept into another language. The second was the German translation for the title of *The New Structure*, published as a Bauhaus Book, Munich, 1925. The third was the English translation first used in the essay *Plastic Art and Pure Plastic Art*, published in *Circle*, London, 1937. The fourth is the translation given by Holtzman and James to Mondrian's term, as in "The New Plastic in Painting." I prefer to use the term Neoplasticism.

11 Mondrian, unpublished manuscript in his handwriting, dated June 1932, trans. Holtzman and James.

12 The marked phrases in this sentence are from a quotation Jaffe took from Schoenmaekers' book (whose title Jaffe translated as *New Image of the World*). In the light of Joosten's rebuttal of Schoenmaekers' title as the source of Mondrian's *niewe beelding* (note 9 above), it is interesting to note that Jaffé also drew the conclusion of a source in Schoenmaekers.

13 Mondrian, "Neo-Plasticism," *Merz*, August, 1923, par.2.

Mondrian, *Tree*, 1912,
Carnegie Institute,
Museum of Art, Pittsburg.

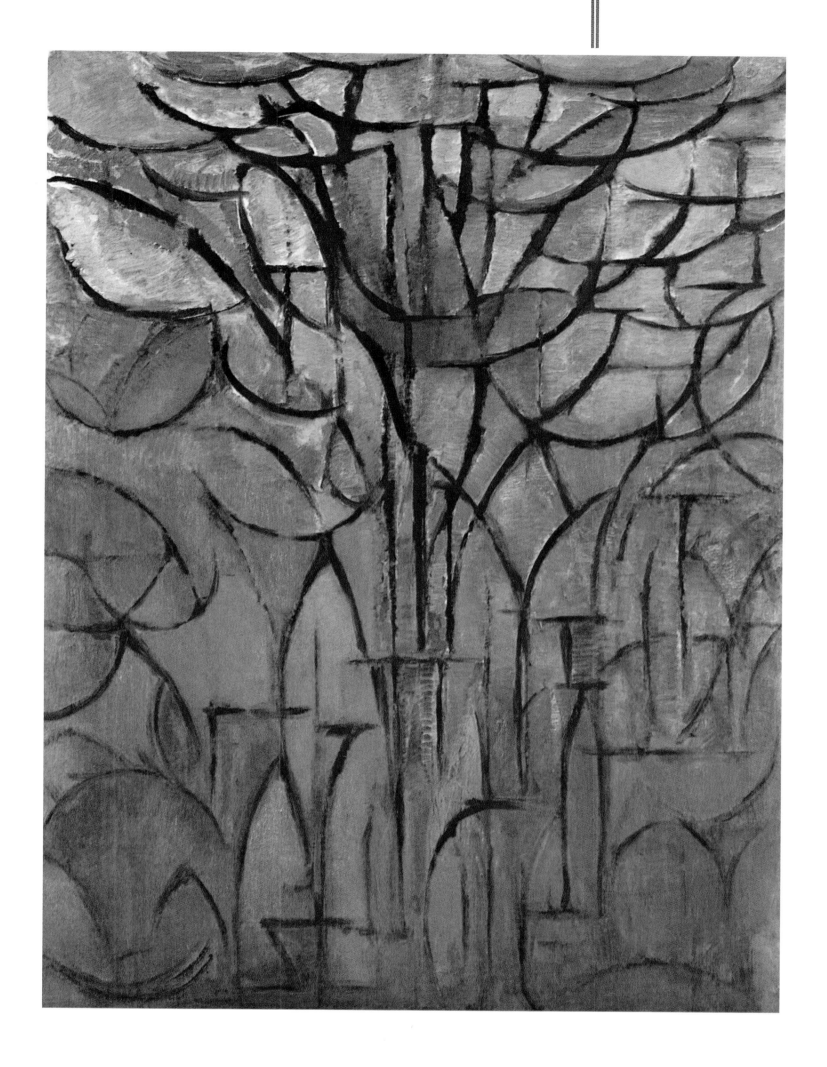

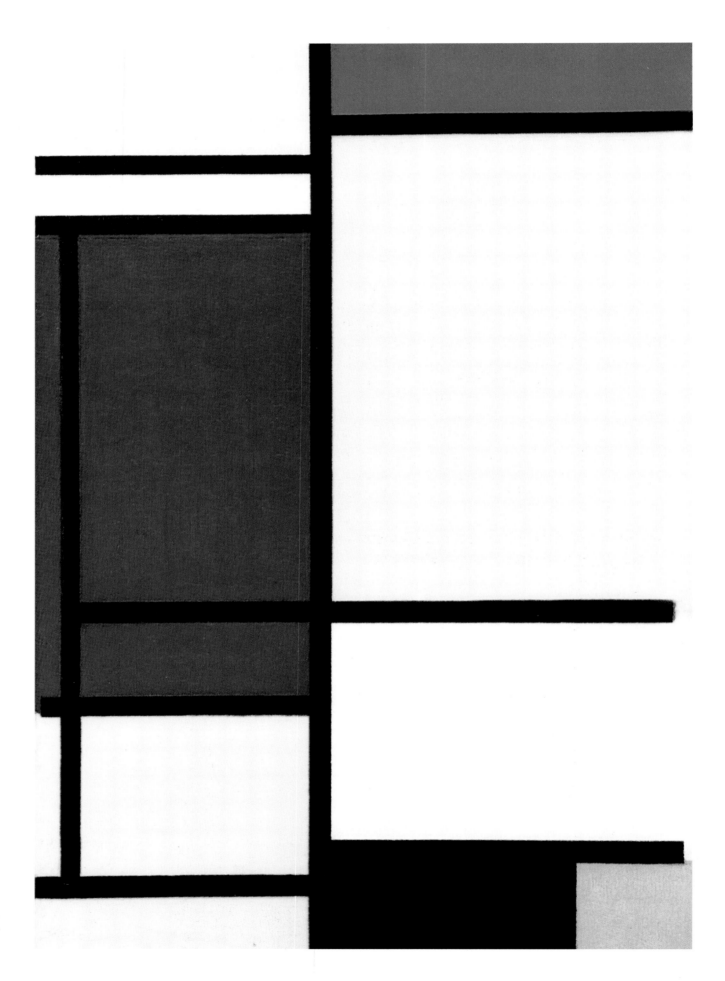

89 Mondrian, *Composition I*, 1921,
Gemeentemuseum, The Hague.

TWO

THE YEARS BETWEEN: 1925–1940

Die neue Gestaltung, or "The General Principle of Balanced Structure," which was the longest essay in Mondrian's book published by the Bauhaus in 1925, summarized the writings he had done for *De Stijl*. This essay represented the consummation of the artist's theory; he would add only a few refinements in later efforts. Mondrian was in Paris at this time and would remain there until 1938, when a new war directly threatened the city.

Since returning to France from Holland in 1919, the artist had been at work on a series of "Neo-Plastic" canvases. Once he had begun to achieve the visual counterpart for his "new reality," its variations within the rules seemed endless. By eliminating some elements, he made those that remained seem monumental, as in *Composition I*, 1921, and *Composition*, 1921.(89,90)

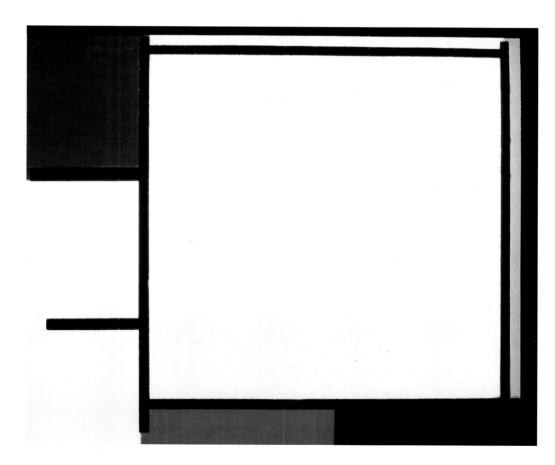

90 Mondrian, *with Red, Yellow and Blue*, 1922, Stedelijk Museum, Amsterdam.

91 Mondrian, *Composition with Yellow Lines*, 1933, Gemeentemuseum, The Hague.

82 Mondrian, *Composition with Yellow Lines*, 1933, Gemeentemuseum, The Hague.

By suppressing others, Mondrian proved that he could maintain the canvas's integrity with fewer elements. In *Composition*, 1925 (88), he not only reduced the painting's parts to two color planes and four non-color, or black, linear-planes but eliminated gray as an impure mixture. At least once, in *Composition with Yellow Planes*, 1933 (91), the artist reduced the elements to four linear planes of a single color, obviously yellow. This was a square canvas turned diagonally. He had first done these "lozenge" or "diamond" paintings in 1918 and 1919 (82) in order to create tension between the external format and the internal elements. They later seemed to form a distinct body of works in which the progress of his search for harmony can be read as well as in the conventional ones.

The Neoplastic paintings were generally too stringent for the French. Mondrian was never invited to have a one-artist exhibition nor was any of his works acquired for a French collection until years after his death.[1] Even though Paris was the international center of art, the French did not take to pure abstraction. This indifference was the reason abstract artists turned to one another for support and organized groups like Cercle et Carré, in the late 1920s, followed by Abstraction-Création, in the early 1930s. The English artist Paule Vezelay, one of the original members of the latter group, remembered that they had to hire a garage for the first Abstraction-Création exhibition,

held in 1932. Despite their difficulties, she said, they were fired by the conviction that abstract art was "creative" rather than reproductive. It was thus a "new Renaissance."

At first, Abstraction-Création had only 30 members. Eventually, the movement grew to several hundred as artists joined from other countries. Some of them had come to Paris to study, others to visit. Mondrian was already a member of the older generation when he returned to Paris, and for this reason he remained outside the circle of younger artists. Nevertheless, his reputation grew among them, and occasionally they visited him in his studio.

Mondrian did not share himself easily with others, but neither did he live entirely as a recluse. From 1921 until 1936 the artist lived in a building on the Rue du Départ, a street that ran parallel to the east side of Gare Montparnasse. The front window of his studio looked down onto the street, and the back one onto the tracks that branched out from the station's rear. A recent study revealed that Mondrian's quarters were actually comprised of two rooms in adjoining buildings[2]. The studio itself was on the third floor of the atelier building but could be entered only from a stairwell in the adjoining building. At the entrance from the stairwell there was a small, dark room containing a bed and chairs that could be drawn up around a chest where the artist sometimes set a meal for friends. He kept his meagre kitchen equipment on the window side. Max Bill, who was taken to this studio by Hans Arp, said that Mondrian had to go to the basement for water.

In contrast to the entryway, the studio was high and light and seemed spacious because of its irregular shape. The direction of the floorboards seen in photographs indicate that this room had five walls.(92) It was rectangular at the end where Mondrian painted and where he stacked his paintings beneath the colored cardboard squares on the wall behind.(93) Two wall segments projected diagonally from the walls parallel to the entrance wall and caused the irregularity in shape.(94)

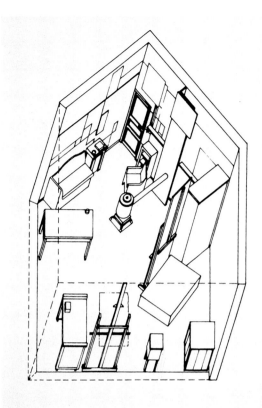

92 Nancy J. Troy's diagram of Mondrian's Rue du Départ studio in Paris.

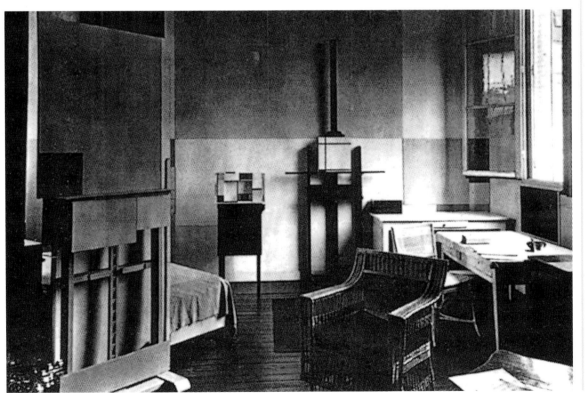

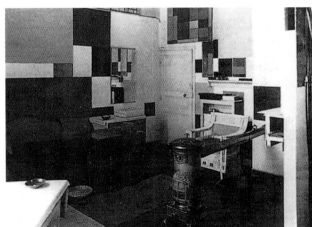

93-94 Mondrian's Rue du Départ studio.

96 Mondrian photographed in his Rue du Départ studio.

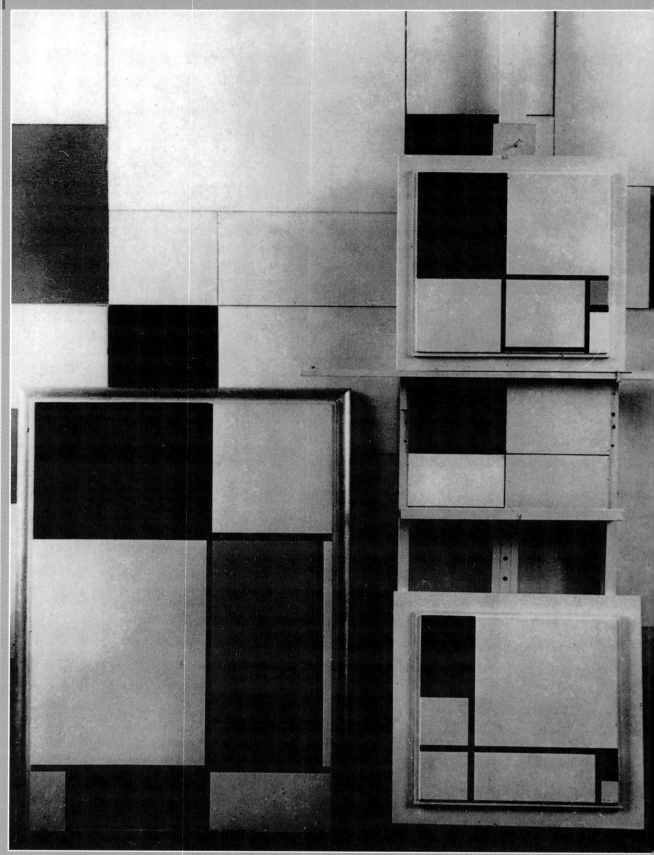

95 Mondrian's Rue du Depart studio.

The room's simple furnishings consisted of a bed, two wicker armchairs, two rugs, two chests, two easels for display, and two tables for work. In his monograph, Seuphor credited the changing appearance of the artist's studio to his "Neo-Plastic virtuosity." Its distinctiveness belonged to a careful adjustment of contents and colors painted to coordinate with the white and gray walls and the colored cardboard squares that were pinned onto them. Mondrian frequently rearranged these squares as background and extension to paintings that stood on the two easels or against one long wall.(95,96)

Undoubtedly, the spareness of this studio (and others to follow) was dictated by economy, the whiteness by need for light and cleanliness in accordance with the artist's innate "Dutchness," but there were other factors at work. De Stijl theory equated such amenities with moral values, as illustrated by Theo van Doesburg's statement of 1929:

> The studio of the artist must be like a glass bell or a crystal crucible, the paint white, the palette glass, the paint brush square and with no slack, pure as a surgical instrument. The studios of artists would habitually make an ape sick. The modern painter's studio must have the atmosphere of 3,000 meters of height: the eternal snow on the summit. Cold kills microbes.
>
> (Doesburg, 39)

Mondrian himself expressed his conviction that a "present-day artist should show preference for the trend of his age in all matters," even his studio:

> To satisfy us continually from the aesthetic point of view, a room should not be an empty space, limited by six empty planes which are merely opposite each other: a room should be a divided space, hence a space already partly filled, limited by six surfaces which are also divided, and which balance each other in their relations of position, dimension, and color. . . . The distribution of the space should not be effected primarily by objects brought into the room from outside: everything should contribute to the harmony.

Several visitors had vivid recollections of their first encounters with Mondrian's Rue du Départ studio and with the artist himself. During the years 1931–1934, when Ben Nicholson and Barbara Hepworth (who was to become Nicholson's second wife) were moving toward abstraction in their work, they frequently took trips abroad to visit artists whom they wished to emulate.[3] Both gave glowing accounts of their first experience of Mondrian's studio. Nicholson described the room as being "very high and narrow," and went on:

> The paintings ... were merely for me a part of the very lovely feeling generated by his thought in the room. I remember after this first visit sitting at a café table on the edge of the pavement almost touching all the traffic going in and out of the Gare Montparnasse and sitting there for a very long time with an astonishing feeling of quiet and repose (!) – the

thing I remembered most was the feeling of light in his room and the pauses and silences during and after he'd been talking. The feeling in his studio must have been not unlike the feeling in one of those hermit's caves where lions used to go have thorns taken out of their paws.[4]

Such almost idolatrous attitudes (Hepworth later referred to Mondrian as a saint) were brought back into human focus by friends he had in France. His relationship with Theo van Doesburg began in Holland during World War I, while van Doesburg was married to his first wife Lena, and continued until van Doesburg's death in 1931, ten years after he married his second wife, Nelly. During the period from the mid-late 1920s, Nelly and Theo were often with the artist, either in Paris or at their homes in the environs of the city. Contrary to myth, the friendship continued even after van Doesburg created his own version of Neoplasticism – Élementarism – which resulted from the "differences in intellectual outlook" of the two, according to Nelly van Doesburg (*Memories*, 67,68).

Nelly also wished to dispel certain myths about Mondrian. She said he was a far more assertive individual, personally, than usually pictured to be: he could be cool, even cutting (though "expressed with a mordant wit"), to those with whom he felt an antipathy – although he never matched van Doesburg in aggressive irritability. She thought the fact that he never married "came as close as anything could to constituting a personal tragedy," thus throwing more light than anyone else on Mondrian's relation to women:

Although he was in his fifties when I knew him in Paris, the subject of women was ever on his lips. He would interrupt any type of conversation in order to comment with boyish enthusiasm upon the physical attractiveness of some admired example of the opposite sex. His taste was catholic in this respect, ranging from the refined beauty of a number of female acquaintances to the more direct appeal of pin-up posters. ... [His] ideal wife would have been [a] kind of youthful love goddess, whose chief virtue of character would be the patience to spend long hours in a corner of his pristine studio knitting or watching him paint – a Mae West in crinolines, so to speak. Perhaps Mondrian himself realized that these two ideals were difficult to combine, as his often repeated disappointments in love graphically illustrated . . . In any case, it would have taken an extraordinary type of woman to adapt to the life provided by Mondrian.

Partly from his interest in "purifying diets," and partly from sheer necessity, Mondrian ate sparingly, although he claimed to follow the "Haye diet" – which he described as based largely on vegetables, fruit, and milk, with little meat and farinaceous products, no sugar at all – in letters to his brother Carel and to his follower Jean Gorin.

The Dutch sculptor Cesar Domela sometimes stayed with the artist for short periods when he came to Paris. On one of his routine visits in the late summer of 1938, Domela was startled to find him packing to leave Paris because war was already threatening France. Mondrian's decision might have

seemed precipitate, but he had apparently held the idea for some time. He had written to an Englishwoman named Vera Moore, who had once bought one of his paintings, asking if he might come and stay with her in England. Mrs Moore was touched, since she had seen him only twice, and was in France at the time, prevented herself from leaving. Because she was in a dangerous position as an English alien in France, she and her son had to be hidden by French friends in a small village for the duration of the war.

The artist had also thought of going to America and had written American friends to ask for the necessary invitations but had not as yet received any answers. He decided to go to England on hearing that Naum Gabo, an acquaintance in Paris, had left to join Ben Nicholson and his group in London. Besides, Mondrian knew Nicholson and thought that joining his group would also be appropriate for him.

He left Paris on September 21, 1938, in the company of Winifred Nicholson. It was a wrench for the artist to leave his adopted city, and he was subdued on the trip from Paris. As they rode on the train toward Calais, Nicholson thought Mondrian was commenting on the lush countryside when he finally spoke: "Isn't it wonderful?" he murmured. "Yes, isn't it." I said. "Look," he continued (speaking of telegraph poles, not countryside), "how they pass, they pass, they pass, cutting the horizon here, and here, and here."

In England the modernist movement had been slow to awaken. An early periodical called *Vorticism*, which first emerged in about 1914, did not survive World War I. By the late 1920s, there were two British societies that espoused "a cosmopolitan but largely conservative modernism" (Harrison). One was the London Group, and the other The Seven and Five Society. The latter, led by Ben Nicholson, who had been interested in Cubism since the early 1920s, included Winifred Nicholson, Christopher Wood, Ivor Hitchens, and David Young. Victor Pasmore spoke of these and others he called the "classical abstractionists" (one of them was Paule Vezelay, who lived and worked in Paris between the two wars, and was thus isolated from the English group). Pasmore did not join them until after World War II. According to him, Nicholson, Henry Moore, and John Piper were influenced in the Abstraction-Création movement in Paris – John Piper by Hélion, Moore by Brancusi and Arp, and Nicholson by Mondrian and Braque.

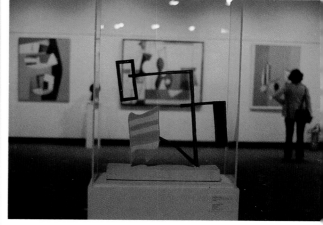

97 View of Unit One Exhibition (first shown at Mayor Gallery, London, 1934) as reconstituted at the Portsmouth Art Gallery, Portsmouth, England, 1978.

In 1933, Ben Nicholson, Barbara Hepworth (who was Nicholson's companion by then), and Henry Moore joined an organization called Unit One. Its artists were divided in their interests, one group said to be leaning toward "the pursuit of the soul," Surrealism, and the other toward "the pursuit of form," abstract art (Harrison). This polarization would eventually cause the movement's disintegration, but not before it produced an exhibition in 1934 at the Mayor Gallery, London, that attracted wide attention and controversy.(97) Unit One broke up soon afterwards, but its factions went on to achieve noteworthiness in the Surrealist Exhibition and the Abstract and Concrete Exhibition, two important events of 1936 in London. Herbert Read, already distinguished as a professor and critic, said that if they had a common principle, it was best put forward by Paul Nash (Unit One's founder) in their first publication as "Nature we need not deny, but art, we feel, should control."[5]

Poor and as yet unknown, the Moores and the Nicholsons lived near the intersection of Parkhill and Tasker Roads in Hampstead, a suburb north of

99 Mondrian's apartment house at 60 Parkhill Road, Hampstead.

98 Map of Hampstead, London, area where Mondrian joined artists' group; according to Alan Bowness, the map is not entirely accurate as to the location of several studios (i.e., Mondrian's studio was in the second house from the intersection, northeast corner, of Parkhill and Tasker Roads).

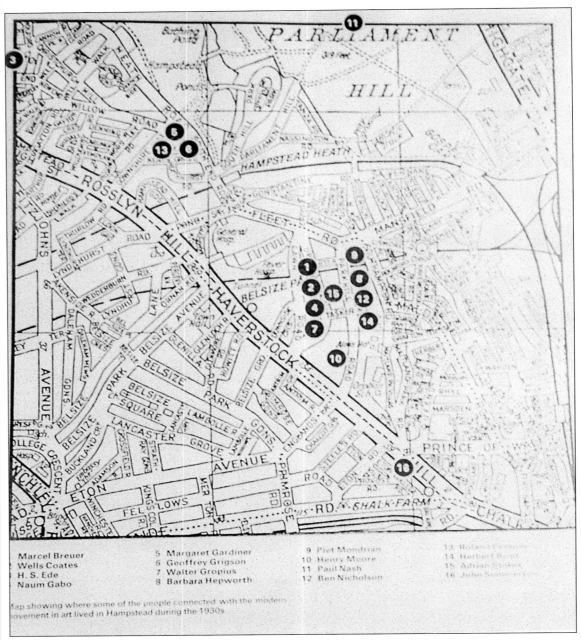

Marcel Breuer	5 Margaret Gardiner	9 Piet Mondrian	13 Roland Penrose
Wells Coates	6 Geoffrey Grigson	10 Henry Moore	14 Herbert Read
H. S. Ede	7 Walter Gropius	11 Paul Nash	15 Adrian Stokes
Naum Gabo	8 Barbara Hepworth	12 Ben Nicholson	16 John Summerson

Map showing where some of the people connected with the modern movement in art lived in Hampstead during the 1930s.

London.(98,99) Other members of the group who lived in the neighborhood were Naum Gabo, Marcel Breuer, Walter Gropius, Herbert Read, Roland Penrose, Paul Nash, Adrian Stokes, John Summerson, Cecil Stephenson, and their families. They were already working purposefully when some of the very artists who had influenced them began to filter in from the continent. The presence of Gropius, Gabo, and Mondrian, above all, undoubtedly focused and energized the native effort.

Mondrian took a room on the first floor of a drab three-and-a-half story building, next to the house at the intersection on Parkhill Road, from which he could look down over Nicholson's studio in the back garden. Hepworth's sculpture studio was one of several in the mall that opened from Tasker Road and ran behind the garden.(100,101) By now, the Nicholsons had triplet children, who lived with their nurse in another of the studios.

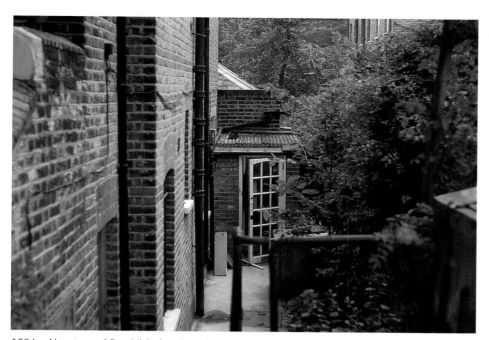

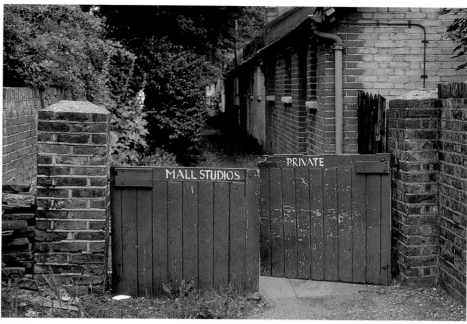

100 Looking toward Ben Nicholson's studio in the garden behind Mondrian's apartment house.

101 The mall behind Mondrian's house containing studios of Barbara Hepworth, Herbert Read, Cecil Stephenson, and others of the "British Circle."

Hepworth referred to Mondrian's room as "dreary," but said that he soon "turned it into his Montparnasse studio" ("Reminiscences: Hepworth"). The artist described the room in a letter to his brother Carel as measuring "7 x 4m x 3m [meters]" (23 x 15 x 11 feet), with floor-length windows on the long side from which he could step out onto a balcony.[6] In addition to a bed and mattress that Nicholson loaned him, Mondrian congratulated himself on finding a "small high table" in the room to which he added another small folding table to write on and a couple of unpainted stools. He made charming allusions to characters from Walt Disney's movie *Snow White* in reference to the friends ("squirrels," "birds," and "dwarfs") who solved his need for a worktable by bringing a trestle to which he could add a board for a top. Friends, probably Gabo and his wife, also provided warm bedding by "flying" over with a "brand-new blue stitched quilt."

The artist reported being more comfortable ("everything cooks much quicker and the room is delightfully warm") than in his last room in Paris ("where it only began to be bearable on Nov. 1, when the central boiler was lit"). He bathed from a washbasin in his room, preferring to use only the WC of the communal bathroom off the first floor hall. Mondrian explained in his letter that "for a start it's warmer that way, and also you never know how clean a shared washbasin is, and if you clean it yourself you're just doing this for someone else to make it dirty." As in Paris, he discreetly hid the washing and cooking facilities behind a curtain.

Although costs were higher than in Paris, money seemed to go just as far in London. The artist found his health to be "vastly improved" because of the cleaner air and more spacious, less frenetic character of London as compared with Paris. Most of the other artists treated him with reverence mingled with protectiveness and even a little pity – attitudes that were somewhat patronizing. But a general malaise, undoubtedly related to feelings about the War and his own uprootedness, seems to have prevailed, and may explain why Mondrian acquiesced when Gabo called him a Constructivist for an exhibition catalog. This was a label to which the artist would have objected

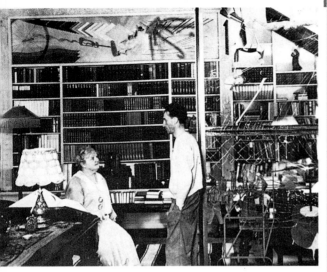

102 Katherine Dreier and Marcel Duchamp in Dreier's living room, 1936–37.

later on, because in his essay *A New Realism* (written in New York) he rejected Constructivism as a term that was open to misunderstanding. "Abstract Art," he wrote, "requires destruction of particular form."

When Mondrian began to paint in London, he confined himself primarily to works already begun in Paris. Herbert Read found him "during a period of two or three visits," always engaged in painting the black lines in the same picture and asked whether it were a matter of "the exact width of the line." The artist answered that it was "a question of its intensity, which could only be achieved by repeated applications of the paint." His British paintings are rarely noted as such, but Lawrence Alloway, who saw them hanging in the Whitechapel Gallery exhibition of 1955, characterized those done after 1937 as having a "mounting intricacy" due to the multiplication of lines and shrinking color areas.(104)

The artist had a few collectors in London who included (in addition to Ben and Winifred Nicholson, Barbara Hepworth, and Nicolette Gray, wife of the Keeper of the British Museum, Basil Gray) Marcus Brumwell, of Cornwall; Helen Sutherland and Nan Roberts, of London; and Margaret Gardiner, of Hampstead. Most of them preferred the calmer Paris paintings to the more complex London ones.

Despite the fact that Mondrian continued to paint in London, he would later write back to a friend that work was too difficult for him there.[7] The artist evidently stopped painting altogether in June, 1940, because he wrote to Winifred Nicholson in July that he had done no creative work since Paris fell. Her invitation for him to come to Cumbria when the bombing of England started later that summer brought an unexpected response:

> No, I cannot come to Cumberland. It is too green. I must go to America. My pictures were nearly bombed. I must protect them. But you in England will win in the end —however hard it may be — for we are fundamentally right.

Mondrian's desire to go to America went back a long way, probably as far as Paris in the mid-1920s when he first began to sell his works to Americans. He had few patrons in Paris; in addition to the English they were mostly Dutch, German, and Swiss,[8] who like the English were buyers of single works. The first American collector to visit the artist was Katherine Dreier, who came in 1926. Together with Duchamp and Man Ray in 1920, Dreier had founded the Société Anonyme in New York as an "International Organization for the promotion of the study in America of the Progressive in Art."(102) After her two colleagues left for Europe the following year, Dreier continued almost alone to arrange lectures and exhibitions and to build a collection that eventually matched the Armory Show and Alfred Steiglitz's Gallery in providing Americans with the opportunity to study modern art.

Under the auspices of the Société Anonyme, Dreier inaugurated the first major exhibition of modern art in America since the Armory Show. It was held at the Brooklyn Museum in 1926.(103) Duchamp had helped her organize the exhibition in Europe, but she also acknowledged the help in Italy of Bragaglia and Panaggi, in Germany of Campendonk and Kurt and Helma Schwitters, and in Paris of Léger, Kandinsky, and Mondrian. Dreier visited the latter's studio and acquired one of his diamond compositions, *Painting I,* 1926(105), for the exhibition. Her statement by the artist's entry in her

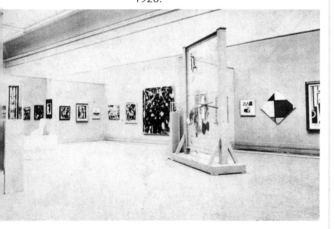

103 Installation of International Exhibition of Modern Art at Brooklyn Museum, 1926.

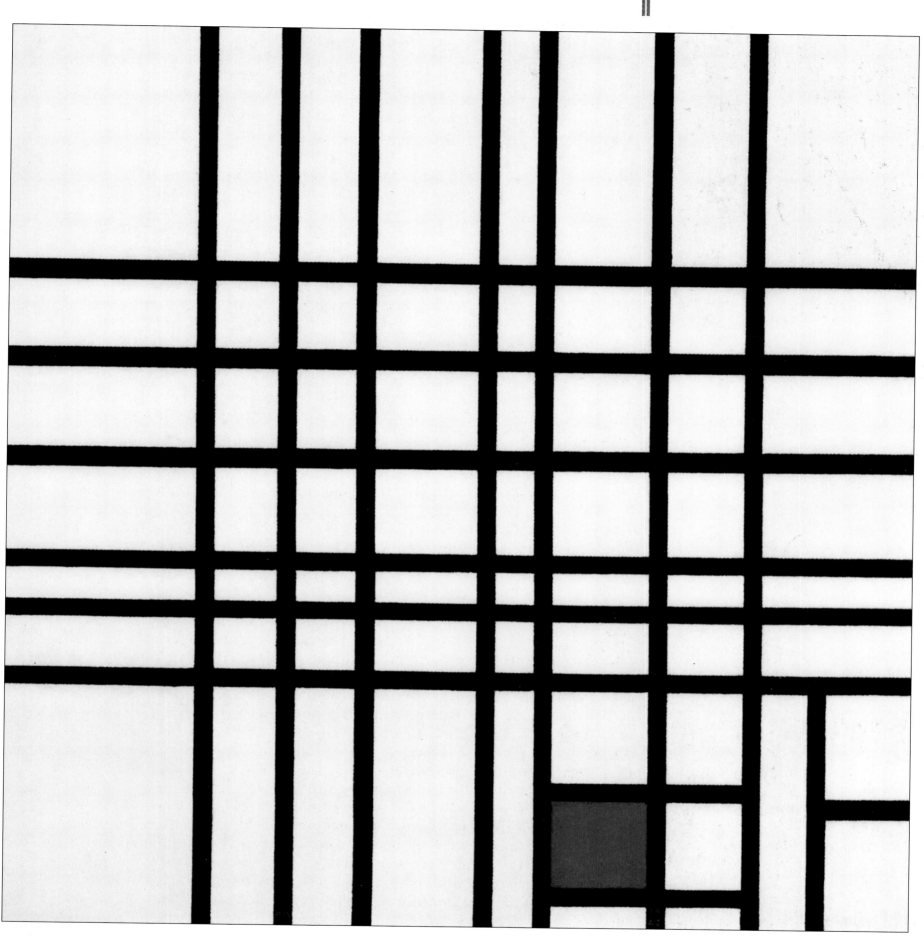

104 Mondrian, *Composition II with Blue Square*, oc, 1936–42, National Gallery of Canada, Ottawa.

catalogue undoubtedly seemed overblown at the time: "Holland has produced three great painters who, though a logical expression of their own country, rose above it through the vigor of their personality – the first was Rembrandt, the second was Van Gogh, and the third is Mondrian."(106) For her foresight, though, Dreier was later called "perspicacious" and "courageous" by Michel Seuphor.

105 Mondrian, *Painting I*, 1926, Oil on canvas, diagonal measurements, 443/4x 44"(113.7 x 111.8 cm). The Museum of Modern Art, New York. Katherine S.Dreier Bequest. Photograph © 2001 The Museum of Modern Art, New York.

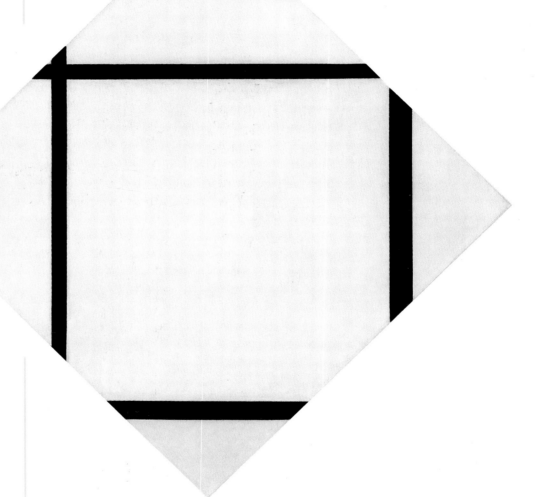

106 Mondrian entry pages in Katherine Dreier's catalog for Brooklyn Exhibition, New York, 1926.

The exhibition represented a monumental effort on Dreier's part and probably had a more salutary effect on the acceptance of modern art than its mixed critical coverage would indicate.[9] Her hope was that the exhibition would help overcome the provincialism she referred to in the foreword of her catalogue. This was the most modern country in the world, "the one modern expression of life without a past," yet it had, she complained, "a smaller appreciative audience for modern art than any other country," which was responsible for the "tragic illusion of the average modern European artist, who desires not only to come to America but to bring his work."

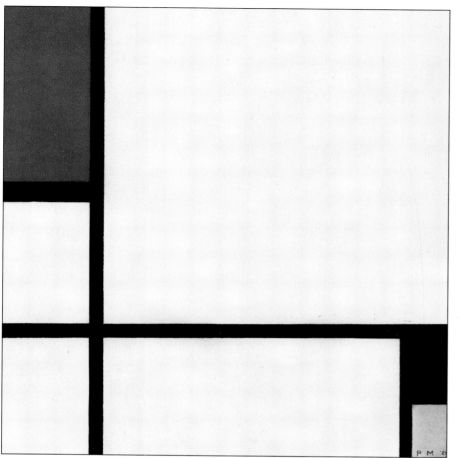

107 Mondrian, *Composition*, 1929, Kunsthaus, Basle, Switzerland.

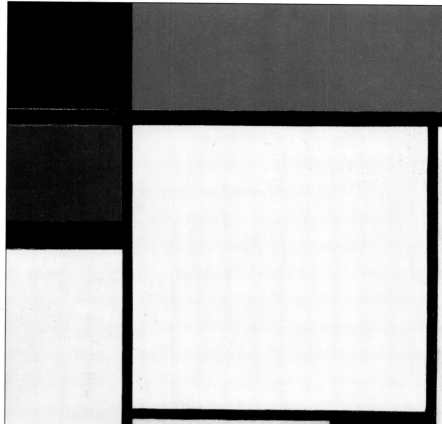

108 Mondrian, *Fox Trot B*, 1929, Société Anonyme Collection, Yale University Art Gallery.

Dreier's exhibition was more productive than she could possibly have foreseen, for she introduced many artists to America, including Mondrian, and the exhibition was visited by young Americans who long afterwards remembered its influence on them. She returned to Mondrian's studio during the next few years and acquired three more canvases for the Société Anonyme: *Composition*, 1929; *Fox Trot B*, 1929; and *Fox Trot A*, 1930.(107-109) The artist made a gift of the latter painting to the Société collection, which was later bequeathed in its entirety to Yale University.

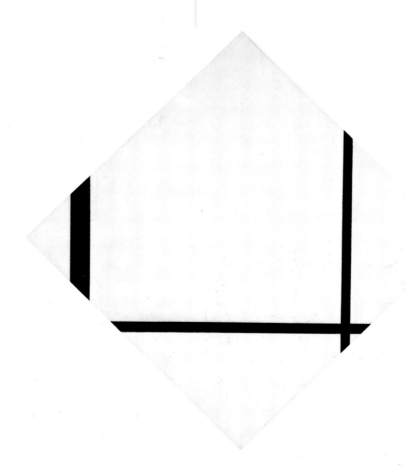

109 Mondrian, *Fox Trot A*, 1930, Société Anonyme Collection, Yale University Art Gallery.

110 Albert Eugène Gallatin.

The next American to visit Mondrian's studio was A. E Gallatin, who like Dreier was an artist-collector.(110) Gallatin housed his collection in a study hall of New York University in Washington Square and kept it there for fifteen years until, needing the space, the University required him to move it. Afterwards, he bequeathed the paintings to the Philadelphia Museum of Art. The collection was first opened to the public on December 12, 1927, two years before the Museum of Modern Art mounted its inaugural exhibition in the Heckscher Building. Gallatin acquired works by all of the major living European artists as well as many Americans to whom he gave one-artist exhibitions.[10] His compilation remained the most comprehensive and qualitative public display of twentieth-century art in America for many years

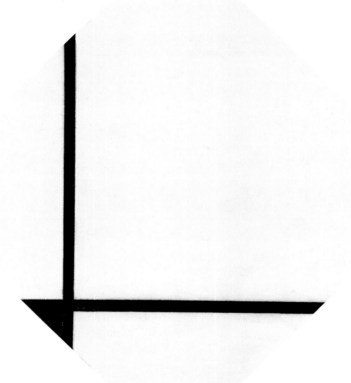

112 Mondrian, *Composition with Blue*, 1926, Gallatin Collection, Philadelphia Museum of Art.

111 Mondrian, *Composition with Blue and Yellow*, Gallatin Collection, Philadelphia Museum of Art.

In Gallatin's first catalogue, entitled *Gallery of Living Art*, he explained his desire to provide the public with an opportunity to study the progressive aspects of twentieth-century painting. Not published until 1933, this catalogue listed only one Mondrian painting, *Composition with Blue and Yellow*, 1932.(111) The subsequent catalogue of 1940, entitled *Museum of Living Art*, indicated Gallatin's intention to give more permanent status to his collection. Three more Mondrians were listed in this catalogue: *Composition with Blue*, 1926; *Composition with Red*, 1936; and *Opposition of Lines: Red and Yellow*, 1937.(112-114)

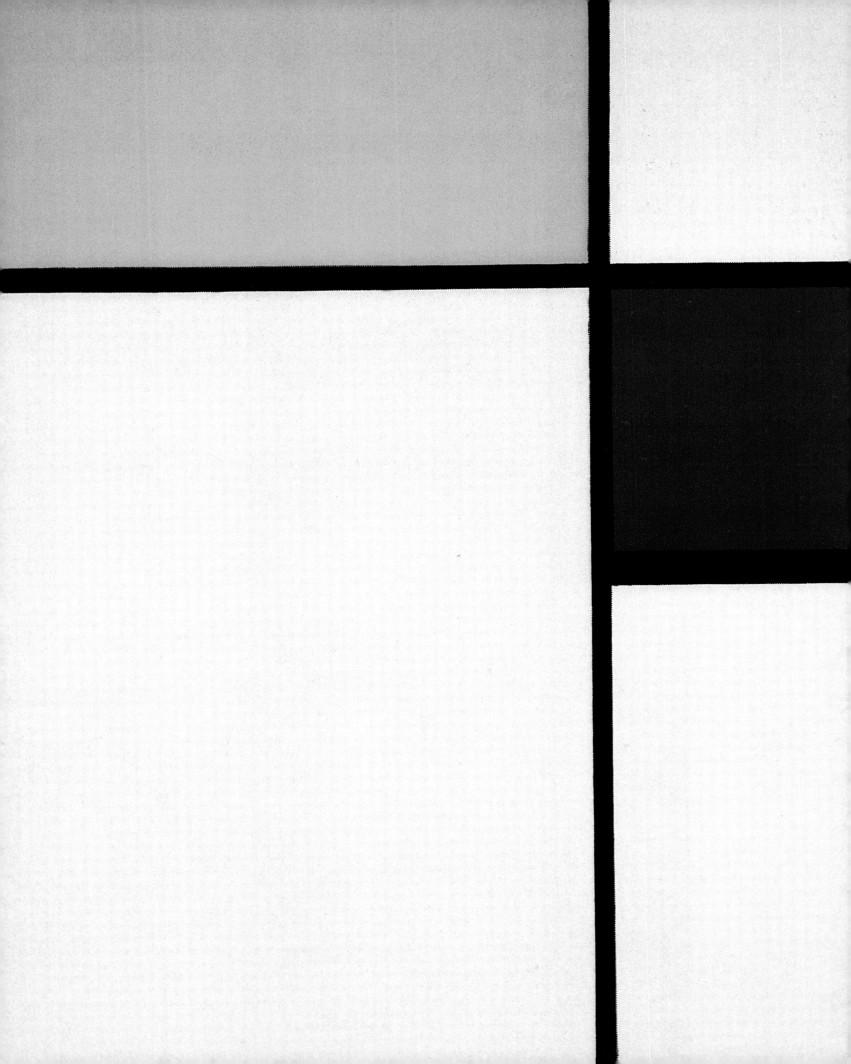

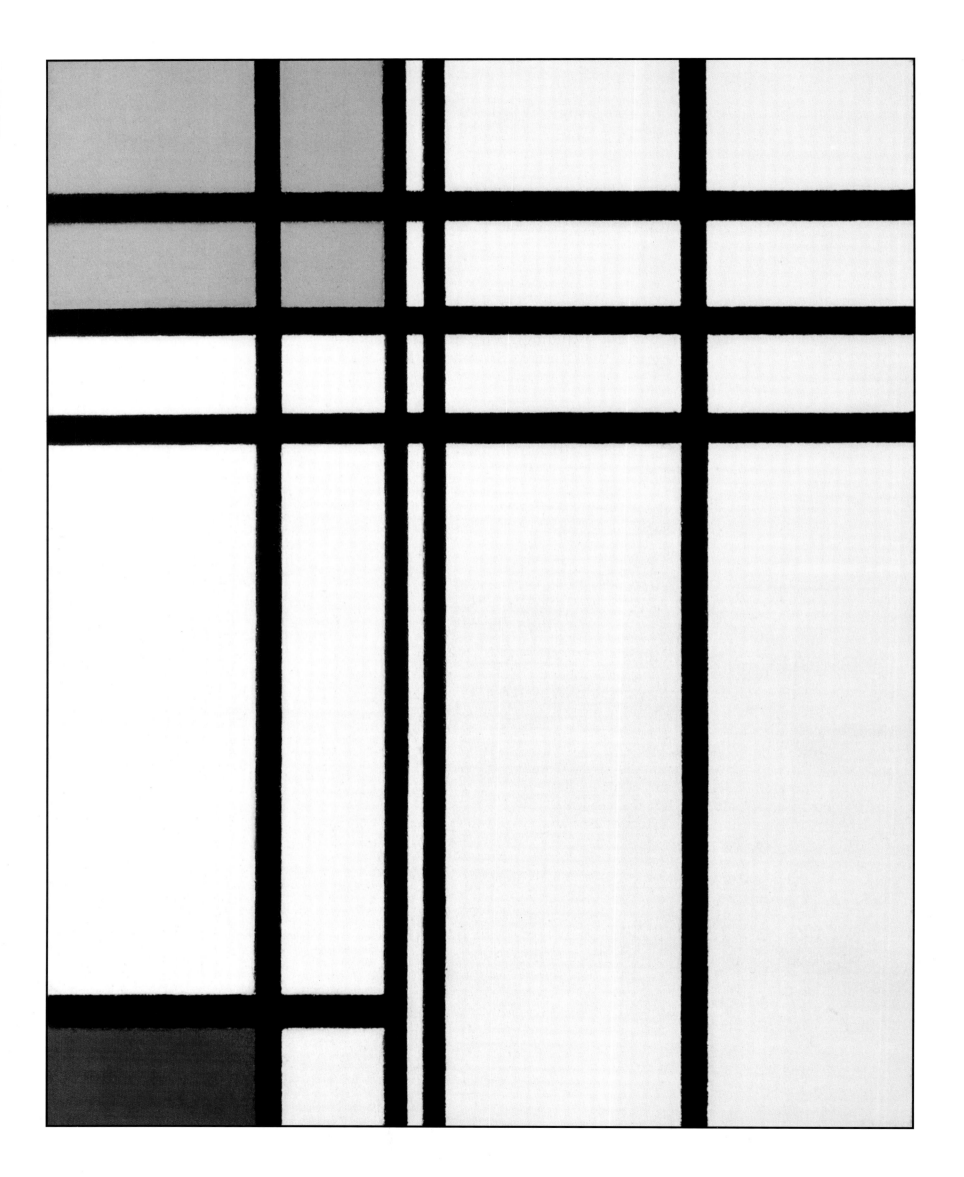

44

A statement by Gallatin in the later catalogue implied that exiled artists were already in the United States or on the way. Such, indeed, was the case: Ozenfant, Chagall, Tanguy, Dalí, Berman, Tchelitchew, Seligman, Hofmann, and Grosz were in the United States. Mondrian would come in October and Léger in December of 1940. Max Ernst and Andre Masson would arrive in 1941 after enduring great hardships: Max Ernst had spent two terms in a concentration camp before accompanying the collector Peggy Guggenheim, soon to be his wife, to New York. Andre Masson and his family, after fleeing the invasion in northern France, waited six months in Marseilles for passage and finally arrived in Connecticut by way of Martinique. In 1942 the Addison Gallery exhibited works by fourteen "artists teaching in America." Added to those already cited, but not including Dalí or Grosz (who had come, as had Hofmann, in the early 1930s), were Breton, Lipchitz, Matta, and Zadkine. And by that time, or later, Miró, Gabo, and Feininger had arrived.

Neither the incoming artists nor those who received them could have imagined the reciprocal influences they would exert on one another. This was particularly true of Mondrian, who would be cited first for his influence on architecture and design. The seeds were already laid, however, for the more lasting effect he would have on "fine" art.

At least two young Americans, Burgoyne Diller and Harry Holtzman, had been greatly impressed on encountering their first Mondrian paintings. Diller had seen a copy of *De Stijl* in Michigan before 1928, when he came to New York as an art student and entered the Art Students League. He continued to read European publications but did not see an actual painting by Mondrian until 1933 or 1934. When he did so, at Gallatin's Gallery of Living Art, the experience was something like a "religious conversion" for him, according to several people who knew him.[11]

Harry Holtzman, who had attended Katherine Dreier's International Exhibition in Brooklyn at age fourteen, said he did not remember much about the exhibition until the following year when a knowledgeable high school art teacher made the recollection of certain works he had seen there meaningful. He went from high school to the Art Students League, which was at that time split between modernist and conservative views. He led the modernist group in a battle to bring Hans Hofmann to teach at the League in 1932. Holtzman became Hofmann's student and teaching assistant there and for a while later after he left the League.

Holtzman spoke about the effect of Hofmann – and ultimately, Mondrian – on his mind and work:

> My experience with Hofmann was clarifying to me. His coming to New York in 1932 was very important, because he propagated such a strong structural approach – largely through the type of structure Cézanne and Matisse achieved. I had gone through a kind of expressionist phase – Abstract Expressionism it would later be called. My probing to Expressionism led me to insistently structural views. The only person like me was Burgoyne Diller (by chance, we lived on the same block) – not only did he have a like view but Diller had a broader orientation. He was more sophisticated in his knowledge of what was going on in Europe.

Opposite page:
114 Mondrian, *Opposition of Lines: Red and Yellow*, 1937, Gallatin Collection, Philadelphia Museum of Art.

One week, early in 1934, Diller asked me if I had seen Mondrian's work; I hadn't. Three of his paintings were hanging in the Gallatin Collection at New York University, so I went to see them. I was utterly astonished. My own work had a parallel structure, but it was independently taken. When I saw Mondrian's paintings, I thought he had achieved the insight I was tending toward at the time. I had evolved a set of assumptions, but saw that he had worked them out extensively. I thought: "He's done it not by denying the structural, fundamental to all art, but by making it more dynamic and vital." I decided then that I must meet Mondrian.

Ten days later (by now, fall of 1934), I was on a freighter. I didn't know a soul in Paris. I went to the Café du Dôme because Hofmann had told me about it. Two Europeans came by, speaking broken English. I knew they must speak different languages, and English was a common tongue. Since they, too, were foreigners, I wasn't afraid to approach them. I invited them to have a beer – said that I had just come to Paris, and hoped they would help me. I asked for an inexpensive place to live, and told them that I was looking for a painter named Mondrian. One asked, "Why would you want to see that funny old man?" When I bristled, the other said, "Don't get mad." I answered, "You find his address for me, and I'll buy you another beer." The two of them agreed to come back the next day.

They did and told me his address. It wasn't far. I waited two weeks and planned. I was acting from months of an obsessive need to test my assumptions, to see if I was insane. First, I had to get a place to live. My rent was one dollar a day. I couldn't afford more than $10 a month without giving up one meal a day.

When the day came, I got to Mondrian's place, went up the steps, and knocked. He opened the door. All I could see was a silhouette, glasses, and a hat. I said, "Mr Mondrian, I've come from America especially to see you." There was a moment of hesitation; he could have refused me – but he invited me in. I was pent up – asked, didn't he think this, didn't he think that? He was decent, civilized, spoke half French, half English, was slow at articulating in both. Our talk didn't let up for three hours. We became friends at once. He was in his sixties; I was twenty-two. After that night, we'd spend an evening together at least once or twice a week.

Then it was 1935. Hitler marched into the Rhineland, but England and the United States prevented France from calling his bluff. Aristocratic German students came to Paris with their cameras, and thus began the invasion of France by the Nazis. I was going home. When I was ready, Mondrian said: "If I were younger, I would go with you. *Nous sommes comme frères.*"

Soon after he returned home, Holtzman joined the Art Project of the Federal Works Project Administration, because all of the artists he knew had done so. Diller had been appointed director of the Project's mural division, which he saw as having exciting opportunities to legitimize art as a social tool, as well as the artist's position as a useful member of society. Out of a desire "to transfer the utopian idealism of his Neoplastic principles to a democratic arena,"[12] he also wished to secure a place for abstract art in the system. This was not easy, because government sponsorship almost precluded an art form that was not socially responsible in general opinion.

Although isolated from the mainstream and without any cohesion among themselves, a small number of American artists had turned to abstract styles in the 1920s and 1930s, but they had few, if any, places to exhibit. Nevertheless, they felt rebuffed when their works were excluded from exhibitions of 1935 and 1936 held at the Whitney Museum and the Museum of Modern Art, even though their paintings would not have fit into the curatorial contexts of either. The Whitney Museum had focused on works by older, more conservative Americans in its 1935 exhibition of American Art, and the Museum of Modern Art on European modernists in its 1936 exhibition of Cubism and Abstract Art. George L. K. Morris credited the fact that the abstract artists were excluded from these exhibitions with stimulating those in New York to want to exhibit their work. Art historian Irving Sandler has pointed out that the MOMA exhibition (which included nine Mondrians) and Alfred H. Barr, Jr's catalogue were important in revealing the sources and traditions of the young abstract artists' works, even though they felt themselves removed from these sources.

Holtzman said that Diller asked him to organize the abstract artists on the Project into a separate group, since his works and theirs were so "non-applicable" and "extreme." Although Diller's decision to make a separate section for these artists was commendable in its effort to help them and bring recognition to their genre, it conversely increased their sense of isolation. Thus, when Holtzman realized that several of the artists under his supervision were unhappy, he made plans to bring them together in outside meetings. He found a loft that would serve both for his teaching studio and the group's meeting place and began to prepare it with the help of Willem De Kooning, who lived next door but did not wish to join in.

In addition to Holtzman, those who attended now included Ilya Bolotowsky, Byron Browne, Gertrude and Balcomb Greene, Ibram Lassaw, and George McNeil. Vaclav Vytlacil soon came in and brought Carl Holty. The two artists had met in Milwaukee around the beginning of World War I, when they were both still in their teens. Vytlacil had already finished his studies at the Art Students League in New York, and like every young American artist who was financially able, he was preparing to go to Europe. After Vytlacil had been in Munich for a couple of years, Holty arrived there as a student. When Vytlacil finished his studies and returned to America, he joined the faculty of The University of California at Berkeley and eventually helped in bringing Hofmann to that University. After two or three years in California, Vytlacil left for New York. He became a faculty member of the Art Students League in 1928. A few years later, the artist helped bring Hofmann to the League where, as always, he was an unusually successful teacher.

It was not until the beginning of 1937 when the American Abstract Artists (AAA) first started to record meetings (or, at least, to keep records).

An item in the first set of minutes, for their fourth meeting on January 29, 1937, indicates that they were already planning definitely for an exhibition but had difficulty in acquiring participants: "George McNeil was authorized to first approach those to be invited to join the group, for permission to use their names to make up the forty necessary for getting the use of the entire Municipal Gallery, and, that failing the necessary number of names, he be authorized to use fictitious names."[13]

In the meetings leading up to the first exhibition, members struggled with expenses for gallery space and publicity. Finally arranged to the satisfaction of all, it opened at the Squibb Galleries on April 3, 1937. The critic for *New Masses*, Charmion von Wiegand (who would join AAA in the 1940s and serve as its president in the 1950s), undoubtedly exaggerated the attendance in the group's favor when she referred to the "hundreds of people who thronged the preview." Her sympathy was further reflected in an intelligent review that pinpointed aesthetic issues the artists had wished to be raised by their efforts. Other reviewers, not so sympathetic and far less perceptive, chose to disparage the derivation of abstract art from Europe. The *Art News* critic questioned their use of the term "abstract" over "non-objective," explaining that "these pictures are works of pure imagination, rarely having any objective basis," then added as an afterthought, "but if they are works of the imagination, it is, alas, the imagination of Klee, Kandinsky, Arp, Picasso, Mondrian, Miró, and other European leaders."

The new members mentioned in the 1937 list of artists in the AAA minutes included: Susy Frelinghuysen, Fritz Glarner, Lazlo Moholy-Nagy, I. Rice Periera, and Ad Reinhardt. Some names, such as David Smith and John Ferren were entered and then crossed out. In the spring meetings following the exhibition, the AAA members began planning an even more ambitious showing for the following year. They authorized Vytlacil to arrange for shows in Chicago, San Francisco, or "anywhere else," and unanimously elected Holty as chairman. Their growing confidence was obvious in a request from Holty to Alfred H. Barr, Jr that the Museum of Modern Art present AAA's 1938 Annual Exhibition.

During their first year, the artists had been so preoccupied with problems of exhibiting that they had given little notice to how their works were received. As time went on, they reacted more vigorously to what seemed to be deliberate neglect, not only of abstract art but art in general. Through a letter sent by Holty to New York mayor Fiorello LaGuardia, on February 9, 1938, they expressed surprise that the New York World's Fair Committee, using as an excuse the fact that there were "plenty of galleries and museums around town," had made no provisions for exhibitions of the fine arts. The letter apparently got results; it was recorded in a history of AAA that afterwards, "the World's Fair grounds accepted an exhibit by the members of AAA as well as murals by Schanker, Byron and Bolotowsky and a kinetic relief executed by Lassaw, Gallatin, Shaw and Morris. Holtzman gave lectures there accompanied by art demonstrators McNeill and Reinhardt."

Without public interest, the members had to support their own showings by prorating all expenditures. In order to increase public understanding as well as provide themselves with a forum, they edited a booklet with essays by several artists to serve as the catalogue of their second exhibition, held in the galleries of the American Fine Arts Society from February 14 to 28, 1938. Holtzman expressed a conception that was probably inspired by Mondrian:

"While there is no question that the object proceeds from an individual source of identity, it is most important to emphasize that the object isolates itself, [and] is an independent physical reality, impersonal and environmental" (*Attitude and Means*, V [14]). The members evidently sent their publication to Mondrian in Paris, because he replied with a congratulatory note, written on March 22, 1938, saying it was "*une grande joie*" to see their activity, and wishing them "*la force necessaire à continuer.*"

The AAA also published a booklet in 1939 wherein George Morris alluded to an emigration from France, that would include Mondrian's: "Of all those countries which had previously nurtured the contemporary esthetic revivals, France alone has retained a diminishing grasp on her traditions, yet even in Paris the political and social instability has decimated the number of artists possessed of sufficient energy for the manipulation of new expressive forms it is now England and America which are providing the strongest impulse toward abstraction."

The Fourth Annual Exhibition of the American Abstract Artists was held at the Galleries of the American Fine Arts Society from June 3 to 16, 1940. This time, writing more specifically than others before him, one reviewer still took a patronizing tone toward Holtzman, "whose compositions remind one of a set of dominoes designed, we'll say, by Mondrian," and toward the exhibition itself that he conceded was "an interesting show, with less sensational or crazy work than one would think" (*Art News*, June 8, 1940). The next day's *New York Times* review even suggested that the artists were merely restating old ideas and might as well call themselves "The American Abstract Artists Academy."

Pushed to aggressive action, the AAA brought out in the same month a pamphlet in which, through a strongly stated text, the artists accused the press of waging a "systematic campaign against the most advanced efforts in modern art, and against abstract art in particular." They called the critics "professional amateurs" whose daring to write on art was a "mockery," especially when through "piquant discussions" they questioned the sanity of the "most significant artists of our time"; those mentioned were Seurat, Cézanne, van Gogh, Matisse, Picasso, Kandinsky, and Mondrian. The statement concluded that its authors did not intend to put themselves above criticism save when it was expounded through "personal opinion and prejudice, either for or against . . . unless substantiated by an authentic conception of form relationships."

At a meeting in the following winter, December 1940, Morris discussed his contacts with European artists and advised that because of the war, the possibility of exhibiting the members' works in Paris no longer existed. Declaring that Parisian artists were militant, he said that AAA members should be so, too, and should enter into "more drastic action to force the Museum of Modern Art to exhibit American artists." After his statement, the group carried a motion to form a committee "of militant action." Later, during the war years, AAA was listed among groups that were banded into a Society for Artists in Defense, an organization patterned after a similar one in Great Britain.

Evidently, the members took an active part in helping refugee artists leave Europe and come to America. A motion made in an AAA meeting of February 1941 instructed the Refugee Committee to secure an affidavit of support and a visa for Kurt Schwitters, who was then attempting to reach the United States

from the Isle of Man (Schwitters went to England, instead). The AAA meeting of November 1940 had opened with discussion of the situation of refugee artists in France. Drewes, Peter Greene, Gertrude Greene (wife of Balcomb Greene), Leonore Krasner (later to call herself Lee Krasner), Bolotowsky, and Morris comprised a committee to investigate and report any action by members to help particular artists. At this same session, they moved to invite Léger and Mondrian, who were already in New York, to join them as regular members. The latter replied in English on January 3, 1941. His note to secretary Holtzman said that he appreciated the "wellcome" and would be pleased to join the group and send his work to the next exhibition.

Mondrian had arrived in New York exactly three months before, after enduring several weeks of the terrible bombing attack on London that began in August, 1940. Most of the artists in Hampstead had left by the time the bombing started. The Nicholsons had asked Mondrian to go with them to Cornwall, where a patron had offered them a house. They left London reluctantly when he refused, knowing they would never see him again.

Those who remained bore the siege with the famed British stoicism. "No English person showed fear," said Paule Vezelay, who described her experience after returning from Paris in 1939 to live with her parents in Bristol. "The best music in the world was the first sound from England's anti-aircraft guns," she said. The same sentiment was expressed by Henry Moore, who first heard the guns in London when he was prevented from leaving the subway at Hampstead. Moore found to his surprise that Londoners had invaded the subterranean passages, a quarter of a mile deep near Hampstead, for the sake of safety. People were living in the subway passages as they sought refuge from the bombings; whole families were undressing and bedding down on the floors of those restricted spaces. Moore was astonished that, although fearful, these people could go on about the ordinary tasks of life, and was prompted by these sights to make his famed war drawings.[15]

The Moores lived at 11a Parkhill Road until the Nicholsons left for Cornwall, when they moved into one of the Nicholson's former quarters, at No. 7 Mall Studios. They invited Mondrian to dinner one night, but there was an air alarm during the meal. The artist became agitated and begged to be excused because he had left his papers at home and was worried about being separated from them. "He was afraid he wouldn't be able to go to America," Mrs Moore explained. When asked what they did when Mondrian left, she said, "Why we went on with dinner, of course; there were so many raids we were used to them, and there was nothing else to do."

Mondrian had reason to be frightened because he was twice bombed out of his place. On a very bad night when he had a severe chest cold, he went to his doctor's house only to find it roped off after having been bombed; the doctor was unhurt, however. A time-bomb that totally destroyed the next-door house on the corner of Tasker and Parkhill Roads also damaged his. The explosion broke all of his windows and, much to his embarrassment, ruined a bed that had been loaned to him by Nicholson. After the raids, the artist would go down and have tea in the basement with the Russian janitor because he "knew what suffering was ... he didn't get all excited, and neither did his wife."

Only when Mondrian began to worry about the safety of his works was he willing to accept help to come to America. It came from Harry Holtzman who had kept in touch with the artist ever since returning from Paris. In

1936, Holtzman had married the student friend who sent him a regular check while he was in France. She had some property and soon inherited more, which he managed and turned into a sizable estate for the time. When he was thrust from about $1,300 per year (standard pay on the Federal Art Project) to an income of over $10,000, Holtzman said that the first thing he did was to write Mondrian. He had decided that the best way to help the artist would be to pretend to buy his works, sending a check every month until there was enough for a painting. Mondrian would pick out a painting and send a photograph, but Holtzman would offer an excuse for not taking it. If the artist commented that "Peggy Guggenheim liked this," Holtzman would write back and say "sell it to her."

As early as September 1938, Mondrian had written to Holtzman from Paris, asking him for a letter of introduction that he could show on entering the country. The artist said that he had made the same request of Kiesler and Xceron, in case Holtzman's letter went astray, but then he changed his mind and went to England instead.[16]

After the bombing started, Holtzman wrote that it was time for the artist to come to America. As he told the story:

> My lawyer in New York wangled a flight from Lisbon, but Mondrian wouldn't fly – came by convoy. He kept his life-vest on, never had his clothes off. The trip took a whole month. I took him off the ship, and he was exhausted. Because I lived on 57th Street, near First, I put him in Beekman Tower Hotel, on the north end of what's now the UN Plaza. Also, it had a magnificent view of the whole city from the side, so I got him a high room. He wanted to sleep, but I told him to call me when he got up in the morning, to lift the phone and ask the clerk for my number. He didn't know how to use a phone.
>
> That night, I picked him up and brought him to my house for dinner. I'll never forget. He was long an admirer of real jazz, but had never heard of boogie-woogie, which was fairly new. I had a fine hi-fi set and discs that had just appeared. He sat in complete absorption to the music, saying "Enormous! Enormous!"
>
> I found him two places, one just around the corner and the other a nice studio with skylight, at 56th and Sixth. Mondrian chose the one near my place, on 56th and First. He said that the studio was "*trop cher*," and he'd rather be near me. (I could see his rear window from mine.) That made it easier for me to take good care of him. We went to buy furniture at Bloomingdale's. When I told him to get the bed that felt best, he picked a studio couch, saying, "I've never had such a good bed." He also got a dining-table, canvas deck chairs, and a metal stool with red top and white legs. I told him to choose a record player. He hesitated and said: "Yours is good enough; I'm an old man." He was 68 years old.
>
> I prevailed after several months, and we got him a player and a collection of his favorite discs – all the real blues and boogie-woogie.

CHAPTER TWO - REFERENCES

1 As late as 1968, Denise René noted that "there are many Mondrians in Germany although there isn't a single one in France." More recently, Le Centre Pompidou has acquired several Mondrians and in 1980 exhibited a recreation of Mondrian's last New York studio.

2 Troy, *Atelier*, 82, 83. Troy derived her description partly from visitors to Mondrian's studio such as Mme M. Van Domselaer-Middlekoop, visiting from Holland, and Belgian artist and writer Michel Seuphor, who lived in Paris.

3 Bowness, *Unit I*, catalogue of exhibition reconstructing the 1934 Unit I Exhibition, 5. These trips were in 1932, when Nicholson and Hepworth met Brancusi, Arp, and Picasso, and in 1933, when they "joined the Abstraction-Création group at the invitation of Herbin and Hélion [and] met Mondrian." Barbara Hepworth, 64.

4 Nicholson's description of 1934 visit, in Summerson, *Ben Nicholson*, quoted in catalogue of *Art in Britain*, 65.

5 Quoted by Herbert Read from the original catalogue, Unit I, London, 1934, in his essay entitled "British Art, 1930–40," in *Art in Britain*, 5–6.

6 Hoek, 138. This article on Mondrian's life in London was based largely on letters and postcards written by the artist to his youngest brother Carel and his wife Mary who lived in the Southern Netherlands; the correspondence is now in the Slijper Archive, library of The Hague Gemeentemuseum. The author quotes one long letter containing intimate details of Mondrian's living quarters and of his relations with his artist neighbors; the following information, until noted, comes from this letter, 138,141.

7 Quoted from an anonymous source by Harrison, *Mondrian*, 285.

8 Max Bill told how some Swiss collectors, including himself, acquired Mondrian paintings. He said that Professor Alfred Roth wrote Mondrian, asking to buy a painting of Mondrian's choice, whereupon the artist requested that Roth say what dominant color he'd prefer. Roth then suggested that the color red, after the meaning of his name, was the natural choice. Bill acquired his Mondrian in 1943 from a furniture store that had bought the painting to complement a modern furniture display. He had borrowed the painting without having any idea of whether he could afford it. His wife surprised him by arranging to buy the painting as a gift to him on his birthday. This was *Composition D, 1932 (Die Magic)*.

9 In her book on the exhibition, Ruth Bohan gave a complete coverage of Dreier's zealous attention to gathering the works and attempting to educate the public on their merits and those of modern art in general; Bohan also treated thoroughly the nature of critical reactions to the exhibition.

10 There were some complaints that Gallatin paid too little for his acquisitions, that he bragged about getting some works at a bargain when the extra money he could afford would have helped the artists.

11 The collector Silvia Pizitz, who was closely associated with Diller and collected and sponsored the artist's work until his death in 1965, said that

Diller's experience of seeing Mondrian's paintings when he was a young man was tantamount to a "religious conversion." Artist Carl Holty, who was acquainted with Diller from the early 1930s and remained his close friend while they were colleagues at Brooklyn College, said that Diller's seeing a copy of De Stijl's magazine in 1925 or 1926 was "a great revelation to him." Mondrian's paintings had a similar impact on Holtzman, according to his own version of the story below (unless otherwise stated, information from Harry Holtzman is from several interviews: 1967, 1971, and 1984).

12 Haskell, *Diller*, 62. In this catalogue for the exhibition held at the Whitney Museum of American Art, New York, Sept.13–Nov.25, 1990, the curator Barbara Haskell brought in much material that revealed Diller's actions and influence in pushing for the participation of the abstract artists in the Project to be a key force in establishing the abstract movement in the United States.

13 This and all subsequent quotations and information concerning the American Abstract Artists, unless otherwise stated, were extracted from "Papers relating to the organization American Abstract Artists (founded in 1936), lent by A. T. Mason, George L. K. Morris, and M. B. Coudrey" to The Archives of American Art; recorded on microfilm 59 #11 (quoted by written permission of Mrs Alice Trumbull Mason).

14 The booklet also contained advertisements, including one for the French publication, *Plastique*, said to be "a magazine devoted to the study and appreciation of Abstract Art." Listed as editors were Hans Arp, S. T. Arp, A. E. Gallatin, George L. K. Morris, and C. Domela. Issue 3 was announced as devoted to "the abstract movement in America."

15 Moore said that Sir Kenneth Clark was organizing the artists to make some contribution to the war effort, as they had done in World War I. When Moore saw the scenes in the Underground, he knew this was a unique situation and began to make sketches on the very first night;these would be his contribution. He did not draw in front of people, which would have been like "invading the privacy of a bedroom," he said, but made notes on small pieces of paper, as if he were writing a letter, or went around the corner if he wanted to sketch. Mostly, he made mental notes that he translated soon afterwards into drawings. This went on for about a year until it "became routine."

16 Seuphor included the letter (written in French) in his book, 175. According to Bolotowsky, no one but Holtzman either could, or would, help to bring Mondrian to this country. He said that Xceron, whom Mondrian wrote for help, was working at the Guggenheim and could not afford to vouch for him. Holty commented on the same situation, that when Holtzman wanted to bring Mondrian over: "He tried to collect a sum, asked me for money and Gallatin, but in the end he did it all himself."

THREE

THE METROPOLIS: 1940–1944

Mondrian always had the idea that he would like the United States, especially New York City. He is on record as saying:

> I think that in America there is much more general appreciation for new things than in France and London. I don't know the reason but it may be that Americans see freer — a very good quality. It is often said of America that it is because, being such a young country, there are no hampering traditions here. But I think that is wrong. America is composed of people of other countries. It is not a "young" country in that sense. A real tradition is universal and gives Americans the same quality as Europeans. No, I don't think that is any explanation for the marvelous free American spirit. . . . I feel here is the place to be, and I am becoming an American citizen. Where you live, you belong to it, and when you feel a place is the nearest to you, you should become a part of it.[1]

The artist had arrived in New York on October 3, 1940. It took some time for him to adjust his dream of America to its everyday reality. For the first few weeks after his difficult crossing, he was weak and dispirited. Holtzman and his wife drove him by car to their summer place in the Berkshires, where Mondrian was agreeably surprised by the comfortable quarters and manicured landscape which were "just like Hollywood," he said. Before long, he was restless and bored with the countryside, however, and expressed a desire to return to the city and begin his work again.[2]

After that one episode, the artist never left New York City. He settled into the apartment that Holtzman had found for him, and since it was close by their place, he dined with the younger artist and his wife two or three times a week. Holtzman went to see the newcomer almost daily except when out of town. On his return, "if he looked peaked," Holtzman would take him to the doctor.

As his health and energy returned, Mondrian began to make his way around the city with the help of newfound friends. Leo van Uitenbroek, a Dutch employee of Weyhe's Bookstore, took him to places that he had heard of and wanted to see, such as "The Little Church Around the Corner." The

115 Mondrian, *Composition with Red, Yellow, and Blue*, 1939–42, Holtzman Collection.

artist also began to renew acquaintances made in Europe. He had corresponded with A. E. Gallatin and Jean Xceron from England and had been visited when he was there by James Johnson Sweeney and George L. K. Morris. Through Abstraction-Création in Paris he had known Frederick Kiesler, Carl Holty, and Fritz Glarner, who were now in America.[3]

Because of Holtzman, the American Abstract Artists members felt themselves to be very close to the elder artist. They had followed with interest his movements since Paris and had asked him, as well as Léger, to join their group. Mondrian acknowledged the invitation of membership in AAA by his usual way of communicating – on a postcard, written in early January. Later that month, at the AAA meeting of January 24, 1941, the announcement of his and Léger's acceptance of membership was followed by discussion of a reception that the group wanted to give for the two artists.

The reception was held shortly afterwards at the Sutton Place apartment of George L. K. Morris and his wife Suzy Frelinghuysen, also an AAA member. According to Morris, "Léger swept in with about five girls in tow, spoke only French, stayed just a few minutes, and swept out again."[4] To everyone's surprise, however, Mondrian was "the life of the party." He made an engagement for a few nights later to go dancing with about eight of the members and stayed after the others had left to laugh and talk with his hosts, who found that he greatly enjoyed trying on Mrs Morris's Russian hats. His obvious pleasure in the evening notwithstanding, the artist wrote a sober note of thanks to the group, which was read at its meeting of February 7, 1941.

To comprehend why the AAA members felt so gratified when Mondrian and Léger joined them, it is necessary to remember the group's struggle for recognition, but also to understand how American artists felt at this time, generally. They "touched bottom spiritually," according to Dore Ashton and other chroniclers of mid-twentieth century American art, when the necessary engagements of wartime made art seem trivial. Actually, the artists had never developed a sense of their own, nor of America's, artistic importance. Those who went abroad could see that European museums had no sections devoted to American art and hung examples only occasionally. Even Whistler's works were labeled as English. Some of the Americans who returned from studying abroad turned their backs on Europe and emphasized the American nature of their subjects (for example, Grant Wood's *American Gothic*, and Charles Demuth's *My Egypt*). A few others, many associated with the American Abstract Artists, rejected the idea of a regional aesthetic and insisted that art was international. These artists were more than receptive to the coming of the Europeans. They were gratified to have any of the well-known European artists with them, even the Surrealists with whom they identified less than the Cubists. They were especially excited about Mondrian and Léger, whom they considered in the avant-garde of Cubism.

Mondrian had the most profound effect on the abstract artists. He paid the modest dues of their organization (a mere $4 per year, but the gesture was meaningful, especially since Léger did not do so). He also sat patiently through the meetings, when he attended – which was seldom.[5] Many of the artists admired his humane qualities for, as Holty said, "Mondrian was the only refugee who did not act as if he were slumming; he was wiser, not precious – of a more truly generous nature." AAA members believed, generally, that Mondrian and Léger lent stature to their organization merely by association, but some were unavoidably defensive toward the newcomers. Anxious

to prove themselves equal partners in a "universal" movement, the artists invited the public to their Fifth Annual AAA Exhibition (held at the Riverside Museum from February 9 to February 23).

While the presence of Léger's and Mondrian's paintings hanging among their own brought the Americans more critical respect than before, they found themselves subject to pejorative comparisons – from the very reviewers who, earlier, had questioned the genre as a whole. Edward Alden Jewell observed that the "distinguished new members" had contributed "typical examples" of their works and what "a relief" it was to find that those particular canvases were by Léger and Mondrian "rather than by their admirers."[6] Henry McBride was tactful, if patronizing, when he said that both artists had "a crispness in idea and a force in presentation that the American 'comrades' do not rival."[7] The PM reviewer also meted out reluctant praise when noting that Léger and Mondrian added prestige to the group while improving its "creative production."[8] Magazine reviewers either bypassed the exhibition or passed it off with little comment, but one reviewer referred caustically to the group's pamphlet of the preceding year, noting that it had personally (and anonymously) attacked New York art critics because they "threatened to investigate non-objective painting" – the reviewer also wrote anonymously.

It is not entirely clear which painting Mondrian entered in his first AAA exhibition. At one time Holty remembered it as being *Composition in Red, Yellow and Blue*, 1939–1942. (115) Uncertain, because of changes the artist made to the painting, Holty described it on another occasion as a "40-inch square, with a large square in the middle and other forms around it." He thought it ironic when a museum director admired the painting as "the last word in equilibrium," especially since, later, he

> found Mondrian changing it, after it was on exhibition. Two sides were different. He had added more bars across it. When I asked him about it, he looked at me as if to say, "You're a painter. You should have seen its glaring white surface." He did say: "It's empty as Hell."

Another account of the alterations came from Charmion von Wiegand, who saw the painting in the artist's studio some time after the Riverside Museum show. In memoirs published twenty years afterwards, she described Mondrian's apartment as being in a "row of brownstone walk-ups that faced First Avenue" (116,117) and was entered from a gate into a courtyard and three flights of stairs. The artist ushered her cordially into a tiny foyer containing two stools and a small table, where he ate. His kitchen, just as at the Rue du Départ, was in a corridor between rooms. Von Wiegand observed many early works – "landscapes, nudes, portraits and flowers" – that were tacked up on the walls of the rooms.

The studio itself was a small room with two tall, narrow windows overlooking First Avenue. There was no furniture, "only an easel and a drawing board," she said. "Everything was spotless white, like a laboratory," except for the large primary-colored matboard rectangles that hung in asymmetrical arrangements on the walls (as in Paris). Canvases, turned away from view, were stacked all around the room.[9]

Mondrian told von Wiegand that these works had been sent from England

116 Mondrian's first studio-homesite in New York, at 353 East 56th Street – no longer in existence: view north on First Avenue from southeast side of 56th Street (unless otherwise indicated, photographs are by the author).

117 View east on 56th Street toward Sutton Place (where George L. K. Morris and Suzy Frelinghuysen lived).

just before he left there. They had arrived a few weeks later than he had, in a large roll of canvases and drawings, and included, in addition to the "early" drawings she had observed on the walls, a number of unfinished paintings that the artist had begun in Paris and London. Von Wiegand made notes in her journal about one of these paintings that struck her in particular:

> Mondrian showed me a picture, which had been presented in the Abstract show at the Riverside Museum: a square with black lines. Beside one of the squares, he had traced a thick charcoal line. He explained that when it was hung, he felt the two lines on the outer edges did not carry sufficiently, that they needed widening: he will repaint them a quarter of an inch broader. To my eyes, this made little difference, but he is sensitive to the laws of proportion to a fantastic degree and to him it seemed important.

In later memoirs, von Wiegand described the same painting as:

> a large square canvas, . . . [with] a complex structure of black lines enclosing an inner white square; several charcoal lines were thinly traced beside it on the white. This was the first picture he had exhibited here, at the Riverside. . . . Later this picture was to be changed by the addition of color planes at the bottom [and a colored line added to the black ones] and become *New York City, No. 1*.

(118,119)

118 Detail of *New York*, 1941–42, Henry Diamond Collection.

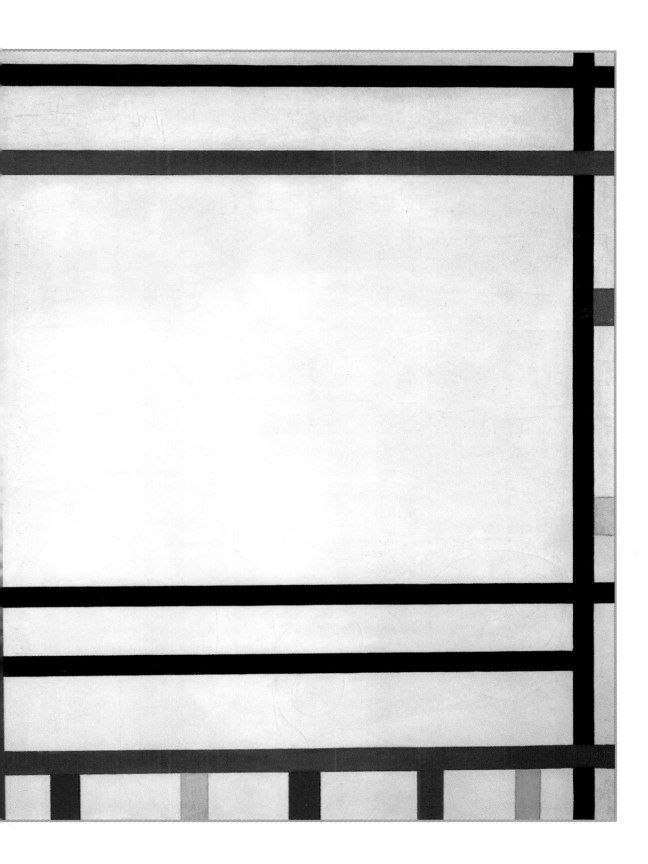

119 Mondrian, *New York*, 1941–42, Henry
Diamond Collection, New York (pho-
tographed by the author in Westkunst
Exhibition, Cologne, 1981).

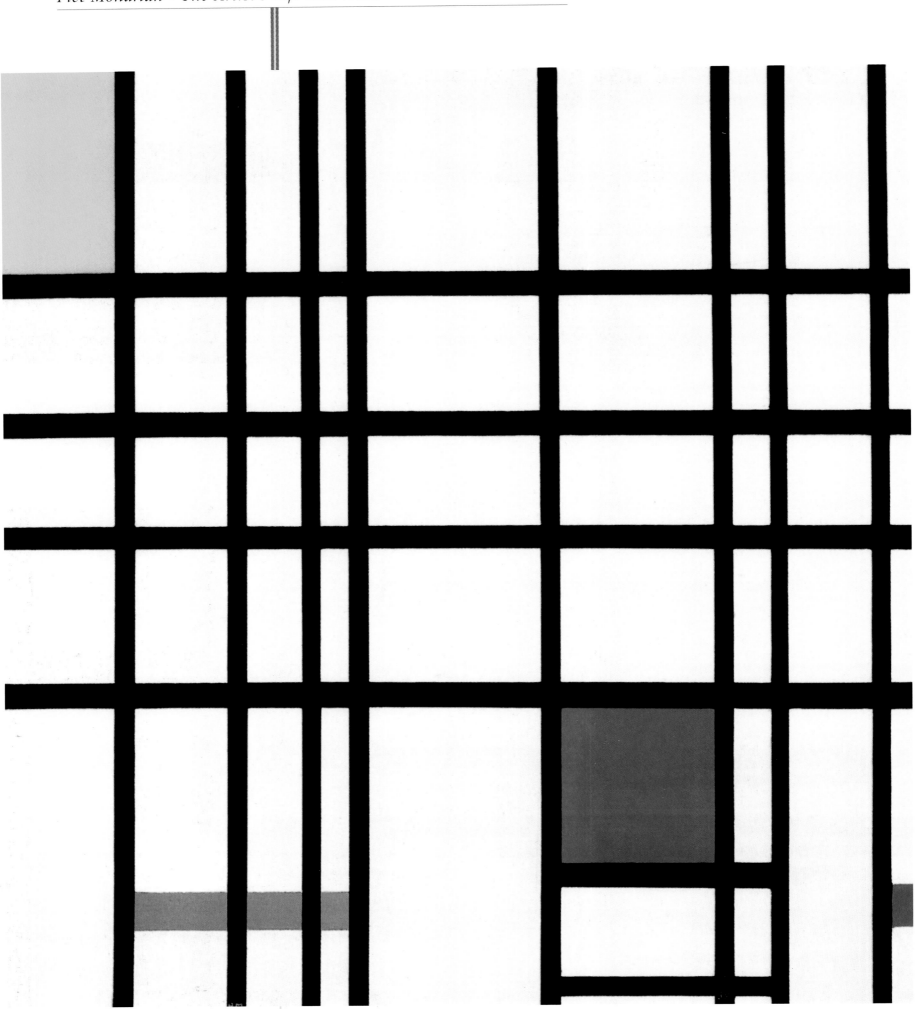

120 Mondrian, *Composition with Red, Yellow, and Blue*,
1939–42, Tate Gallery, London.

121 Reverse of *Composition*, left.

122 Detail of *Composition with Red, Yellow, and Blue*, 1939–42, opposite.

Unaware of their significance, Holty and von Wiegand had witnessed changes that would characterize the artist's New York period from then on.

Mondrian had already found that the multiple lines he added to his paintings in England gave them a sense of life and implied movement. This was because the viewer's eyes followed the directions of the lines and responded to the "optical flicker" that seemed to appear at their crossings. In London, Mondrian apparently added black lines to paintings begun in Paris and then continued to add them to the same paintings in New York. *Composition in Red, Yellow and Blue*, 1939–1942 is an example of a painting on which the artist worked in all three cities.(120) The painting's reverse side shows a dealer's mark from a Parisian firm (121); its 1939 date is from Mondrian's London period, but the 1942 date is from New York. His continuing additions of black lines reflected the artist's sense of the increased complexity and energy of New York City, as compared with London and Paris. The additions of color planes, for the first time unbounded by black, that connected the lines to one another and to the frames (122, 123) had to do with the clearer light of New York, which Mondrian saw as a "Mediterranean" light, rather than the gray, Impressionist light of London and Paris.[10]

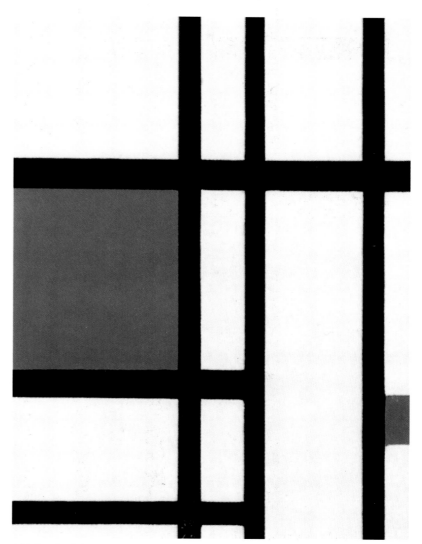

123 Detail of *Composition with Red, Yellow, and Blue*, 1939–42, opposite.

124 Carl Holty, *In Flight*, 1942–63 (destroyed by fire in Chattanooga, Tennessee – repeated in 1968, when photographed by author in Holty's studio; the original painting, of an imaginary apocryphal bird, is the one whose color Mondrian praised). © Virginia Pitts Rembert

Inevitably, the artist began to question any use of black as unnecessary and undesirable. He associated black with the War, for him a tragic "conflict of particulars," but his personal ordeal in that conflagration was ended. Mondrian also related tragedy, or the "tragic," to the past, which he thought of as "cursed by tribal superstition and conflict."[11] Black now represented Europe and the past; color was America and the future. In the larger sense, tragic referred to any particularity – such as objects or natural forms in the earlier paintings. It also meant any imbalance – such as overemphasis on vertical or horizontal directions, or on black, which the artist had proliferated through the black lines of his London paintings. Having departed so far from previously held tenets, there was no reason why he should not go further.

Mondrian had admired Holty's color when he visited that artist's studio in the Master Institute. When he saw one of Holty's paintings hung between two of his own in an AAA exhibition, he asked von Wiegand if she thought his color was as good as Holty's. More of a theorist than Holty, he was impressed with the brilliance that the younger man achieved as a natural colorist (124) and finally decided on adding more color to his own surfaces. The additional color would, he thought, mitigate the insistence of multiple black lines and at the same time retain and even increase their vitality. "Once Mondrian got into the shifting colors, however, black disturbed the equilibrium, so he decided to leave it out entirely," said Holty.

It would have been technically impossible to make a complete change to color, had not Holty and other friends told the artist about Dennison Scotch Tape, which was processed in primary colors. Painting had been a painfully slow process for Mondrian in Europe. Even changing a black line had required that he use paint remover and then build up the surface again. Although the final process of painting below where the tapes had been placed was just as painstaking, now he could plan the picture's composition much more easily, as he began to do with the "New York City" paintings.(125)

125 Mondrian, *New York City (No.2, unfinished)*, 1942, detail (photographed by author when owned by Sidney Janis, at warehouse in New York; the same is true of *New York City*, 1942, and *New York City (No.3, unfinished)* 1942).

130 Mondrian, *New York City*, 1942.

Moving the tapes back and forth allowed him to work "more than ever by intuition and the eye, not by mathematics or formula" (as he insisted to von Wiegand). He still expected to find a logical pattern for deploying the colored tapes. Although they lent themselves well to his present commitment to multiple lines, Mondrian found that beginning a new canvas with a different primary-colored strip on top at each corner and then weaving it under the others was a self-defeating process, since there were four corners and only three colors.(126-128) Finally deciding that logic must give way to practicality, the artist placed red under yellow and over blue in three corners but left the red entirely out of the fourth.(129) On June 5, 1941, von Wiegand recorded in her journal that she had seen

> the new picture, all in tapings like a mummy waiting to come to life. It is different from all the others, for it is made entirely of colored lines. . . . It is more brilliant, as if America had already changed his color.

(130)

Opposite page:
top left:
126 Mondrian, *New York City*, 1942, detail: upper left corner.
bottom left:
127 Detail of *New York City*, 1942: upper right corner.
top right:
128 Detail of *New York City*, 1942: lower right corner.
bottom right:
129 Detail of *New York City*, 1942: lower left corner.

That same day, almost symbolically, Mondrian showed her a new manu-script, entitled *Liberation from Oppression in Art and Freedom in Art and Life*. This was not the first writing he had done in America. On von Wiegand's first visit, the artist had given her "a few sheets of hand-written notes," which she found to be a "little statement about his life and work . . . a succinct, if not altogether idiomatic account of his artistic development." She took it home, made it more legible, and sent him a copy, whereupon he replied:

> Very kind of you to copy off my writing. I did not consider it an article. I have written it only to explain to you my art development, but it is perhaps useful to the public to a bet-ter understanding of Abstract Art.

These notes, she said, "formed the basis of Mondrian's article 'Toward a True Vision of Reality'." It was published to accompany his first exhibition, in which, "for the first and only time, he wrote about Neoplasticism in terms of his personal experience."

Afterwards, von Wiegand said, the artist was delighted with her interest in "these Art problems," because for her, also, art was "not a thing separated from life." He kept sending more material for her to revise, and soon had the idea of publishing some of these writings in America, just as he had in the other countries where he had settled.[12] Throughout the spring and summer of 1941, von Wiegand "shuttled back and forth" between her downtown apartment (shared with her husband, writer and editor Joseph Freeman), Mondrian's studio, and the library, where she read everything available on abstract art, particularly on De Stijl and Neoplasticism. The Holtzmans were in the country that summer but the elder artist had declined to join them as the city was the only place he could work. He decided to devote this time to preparing his essays, said von Wiegand, "so that the public here would come to understand his work."

Just as Seuphor had helped Mondrian in Paris, with his writing in French, von Wiegand and Holtzman helped him in New York, with his writ-ing in English. Von Wiegand translated from French and German, but when she told him she could not translate from Dutch the artist said, "You don't have to; you have me." Holtzman had already helped him with the essay "Liberation from Oppression in Art and Freedom in Art and Life." That essay was begun in England but finished in America when Morris, then editor of *Partisan Review*, asked Mondrian shortly after he arrived to do an article for that publication. He sent it a couple of months later, but was furious when Morris edited the essay to make it more readable, telling him "You can't change it, because that's the way I wanted it. That shows your magazine is not free." Morris argued that "if a writer painted a picture, you wouldn't like the first one, would you?," but Mondrian refused to let him have the essay because, as he told Holtzman, his writing took as long as painting, and he couldn't say it any other way.

It is tempting to read reactions to his new environment in the artist's writings of this period. From his earliest essays, he had expressed an open-ness to ideas that would finally come to fruition in New York City. For instance, in one part of "Natural Reality and Abstract Reality" of 1919–1920, he declared that "a new idea is revealed when things appear differently;" and in another, that:

> As the line must be <u>open, straight</u> [he often underlined for emphasis], to express expansion in definite and exact terms, so color to achieve the same expression must be <u>open, pure, bright</u>. For then it radiates vital force. . . .

The fact that such statements are more prevalent in Mondrian's new essays strongly suggests their relevance to the new paintings as well as to his thoughts during a first spring spent in the city. An example in these writings is when the artist seemed to rationalize his recent use of multiple lines in "Toward the New Vision of Reality" by indicating that in order to subordinate "planes as rectangles," he had suppressed their color. Also, he had increased the lines so that they no longer simply bordered the rectangles but crossed one another, making their own relationships much more active.[13]

Certain passages in "Liberation from Oppression in Art and Freedom in Art and Life" refer directly to the war and to Mondrian's disavowal of its causes and justifications. Although it was difficult not to be overcome by pessimism and find a "true optimism concerning humanity's future,"[14] he wrote, the only hope was in "the conquest of oppression. . . . political, economic, domestic," which requires "continual struggle." Art suffers from the same oppression, he observed, resulting from "the ignorance of the public, educated by incompetent writers, critics, teachers, museum committees, etc." "The past has a tyrannic influence which is difficult to escape." Despite the fact that we carry it with us in memories and dreams and it is all around us in old buildings, however,

> we can also enjoy modern construction, marvels of science, technique of all kinds, as well as modern art. We can enjoy real jazz and its dance; we see the electric lights of luxury and utility; the window displays. Even the thought of all this is gratifying. Then we feel the great difference between modern times and the past. . . . Modern life and art are <u>annihilating the oppression of the past.</u>

He almost implied in this essay that war has a salubrious effect in doing away with old relics. A new environment would evolve, Mondrian wrote, but warned:

> It is important to understand that <u>the new constructions must not be created in the spirit of the past; they should not be repetitions of what has been previously expressed.</u> It must become clear that everything should be the true expression of modern times.

Sidney Janis, who had met the artist earlier in Paris, visited his New York studio in the fall of 1941. Shortly afterwards, he published impressions of Mondrian and his studio in an article written for *Decision*. The author described the "aesthetic experience" to be had from paintings arranged "to fall in line as part of the composition of the room" as "electrifying."[15] He also noted the "new vibrance" in Mondrian's work, due to "a complexity and fresh color distribution." The photograph that illustrated the article, as well as the author's descriptions of the paintings shown in the photograph, are

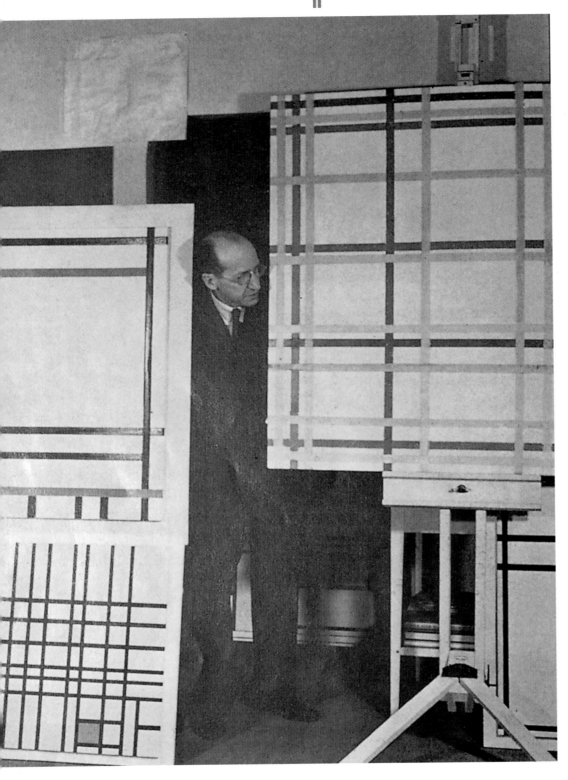

131 Photograph of Mondrian in his first
New York studio, fall 1941.

important in determining their order and titles.[16](131) Below Mondrian on the bottom left of the photograph is one of his London paintings (102); those on the easels were ones that he did entirely in New York. To his comment about the painting shown on the left easel (118), that it was what New York meant to him when he first saw it from the boat, and the one on the right easel (130), the city as it appeared to him after he had been in it for a while, the author added that one should not look for skyscrapers, "for Mondrian tells us the reality he found was not to be expressed in verisimilitude." (pp.90-91)

Included in the article were short writeups on Léger, Ernst, and Matta to represent other "refugee artists" in America. The author also listed Chagall, Tanguy, Masson, Dalí, Seligmann, Ozenfant, Paalen, Man-Ray [sic], Lishitz [sic], and Zadkine. Concluding with a prophetic hope, he recognized the ingredient necessary for his prophecy's fulfillment − that New York's promise of becoming the international art center would depend on encouraging the American public to purchase contemporary works. This prophecy Janis himself was to help fulfill.

That there was public awareness of the importance of the refugees was demonstrated in December 1941, when the broadly circulated magazine *Fortune* featured twelve of the artists, including reproductions of their works and a section devoted to their influences, already perceivable in commercial art. *Composition in Black, White, and Red,* 1936, was reproduced on the first page of the follow-up article on the artists.(133) Beneath the painting, Mondrian was called "an architect's artist" who had an important effect upon typography, layout, architecture, and industrial design. His influence was said to be ubiquitous, "in books, magazines, posters, trademarks, linoleum, offices − even the tabletops at Childs." The entire section concluded with a page designed to resemble one of Mondrian's distinctive compositions.(132) Into a framework of thick black lines that enclosed white and primary-colored rectangles were inserted photographs and drawings of some of the contributions of other exiled artists to American popular culture. Mondrian was represented by widely varying offshoots of his influence, from the first International Style house in America (Walter Gropius's own house in Lincoln, Massachusetts) to a segment of linoleum carpet.

132 Mondrianesque page of the *Fortune* article, right, p.115.

133 First page of article: "Twelve Artists in U.S. Exile,"
Fortune magazine, Vol. XXIV, No. 6, December 1941,
p.103. Reproduced courtesy of *Fortune magazine*.

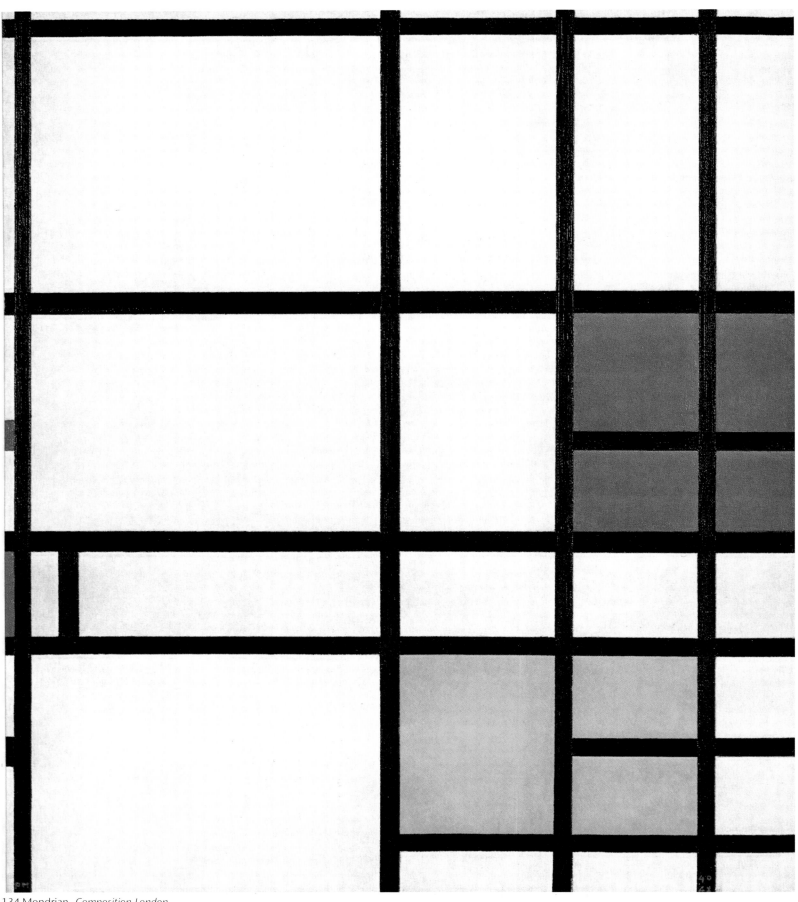

134 Mondrian, *Composition London*,
1940–1942, Albright-Knox Gallery,
Buffalo.

Perhaps the most gratifying event of the artist's first years in New York took place in January, 1942, when the only one-man show of his life was held at Valentine Dudensing's Gallery. There were a few early works in the exhibition, including two paintings with dates of 1915 and 1922–1923, listed as *Transition Period – 1910*, and others as *Number 16–17 – Eucalyptus*. There were also eight drawings, dated around 1912–1914.

Of the twenty-eight works listed in Dudensing's catalogue, thirteen were dated with double numerals: initially, 1930–1938 (Paris) or 1939 (London), and terminally, 1942 (New York). Since the exhibition opened on January 19, 1942, and Mondrian obviously had to allow for drying time, it is unreasonable to assume that he could have done substantial work on so many paintings dated 1942, unless signing his name, or at most adding small colored planes to the canvases constituted terminal work. All of these paintings have "unbounded" colored planes, which identify them with New York City, but only three have beginning dates in the 1940s. One is dated 1940–1942, signifying that the artist had begun the painting before leaving London;[17] it is, in fact, entitled *Composition London*.(134). Two paintings are dated 1941–1942. According to von Wiegand, the one of these that was then called *Boogie-Woogie* and is now called *New York, 1941–1942* (118 – on the left easel in the photograph in Janis's article) was Mondrian's first painting finished in America and the one shown in his first American Abstract Artists Exhibition. The other 1940s work in the exhibition (130 – on the right easel in the Janis photograph) was, and is still, entitled *New York City*.

In the few reviews of the exhibition, the painting called *Boogie-Woogie* received the only specifically sympathetic notice. A magazine writer said of it:

> The latter, a white ground with straight black and red lines and squares of color, seems simple enough at first view. But the eye that rests on it does not rest for long. The thing comes throbbingly to life. Time is required to enjoy the full sensation of Mondrian. The sensation is there.[18]

Other newspaper reviews of the exhibition were brief, non-analytical, and only moderately appreciative. The *Sun* writer called the artist "famous in two hemispheres" and urged everyone to see his work, which the *Times* admitted to be of "outstanding interest." The *Herald-Tribune* reported, however, that his "formula was followed too closely to allow for surprise."

Evidently, Mondrian disappointed many guests who had come just to meet him, because he had heard that artists did not appear at their own openings. He stayed at home to work on a public address for a meeting of the American Abstract Artists. Later in the year, the Dudensing Gallery printed his essay "Toward the True Vision of Reality" as a pamphlet to accompany the catalogue that came out after the exhibition, but it was the essay entitled "A New Realism" that was the one he had prepared for AAA. This essay was presented at the Nierendorf Gallery on the evening of January 23, while the exhibition was still on.

"A New Realism" contains one of Mondrian's clearest expositions of his aesthetic, including his distinction of the term "abstract art" from others that might be employed, his differentiation of the intuitive capacity of artists from the instinctive capacities of primitives and children, his concept of

135 Photograph by George Platt Lynes included in "Artists in Exile Hold Stimulating Show," *The Art Digest*, Vol. 16, No. 3 (1942), p.9. Front, left to right: Matta, Zadkine, Tanguy, Ernst, Chagall, and Leger; back, left to right: Breton, Mondrian, Masson, Ozenfant, Lipchitz, Tchelitchew, Seligman, and Berman. © George P. Lynes II.

space-determination – a key factor in his compositional methods – and the developing rationale for changes he was making in his art.

Shortly after this event, Mondrian participated in AAA's Sixth Annual Exhibition. On the whole, reviewers were more sympathetic, if little more discerning about the works on display. The exhibition was commended, with reservations, by an *Art News* reporter as "the best show of abstract painting seen in some time." That it tended toward "the more static, classical, and geometric sides of abstraction" was the one criticism; only works by Albers and Mondrian were singled out for mention. A commentator in the *Art Digest* described the paintings as "cerebral," and then went on to state imperiously: "Nowhere does sterility show up so badly as here, where creativeness is of vital importance" [Mondrian's name was among those said to be successful]. A reference to some of the same artists who were represented in the Gallatin Collection at New York University stressed for the first time their "international flavor" – not by a real discussion of international aesthetics but by listing the artists' nationalities: Bolotowsky and Slobodkina, Russian; Glarner, Swiss; Holty, American (although born in Germany); Xceron, Greek; Leger and Ozenfant, French; and Mondrian, Dutch.

In its issue of March 15, 1942, *Art Digest* published a photograph of the larger refugee group, showing Mondrian together with Breton, Masson, Ozenfant, Lipchitz, Tchelitchew, Seligman, Berman, Matta, Zadkine, Tanguy, Ernst, Chagall, and Leger.(135) The author of the accompanying article

referred to the "fourteen internationally known European artists now in America . . . all widely publicized here before their arrival," discussed an exhibition in which they were currently showing, and conceded that the exhibition was "impressive."

Mondrian completed the essay "Pure Plastic Art" in March 1942. It was one of several published in the catalogue of an exhibition entitled Masters of Abstract Art, organized by von Wiegand and Stephen C. Lion for the Helena Rubenstein Gallery at the New Art Center, New York. The artist wrote of the tragic nature of life, as he had in "Liberation From Oppression in Art and Freedom in Art and Life," but promised that material existence would not always dominate our lives because science would maintain our physical well-being, and superior technology would fulfill our needs.[19]

In an article for *VVV* in June 1942, Robert Motherwell made one of the first serious efforts in America to assess Mondrian's work. Declaring it to be "scientific," because it employed "a hypothesis about the nature of reality, of which his work is "an attempt at experimental confirmation," he enumerated the artist's important contributions. These were that he had freed other artists from the image and had demonstrated (according to Meyer Schapiro, Motherwell said) the abstraction that they had been unsatisfactorily trying to prove was basic to past representational art. Then Motherwell made a rebuttal to his own statement, that Mondrian's "clinical art" did not satisfy in a time when "men were ravenous for the human" or the "irrational sensual release from the commonsense rationalism and discipline of their economic lives." Motherwell concluded that the artist had failed because his means were too restricted to

> express the felt quality of reality No one can meet hostile reality with the simple proposition that $2 + 2 = 4$. The proposition is true, but is not enough.[20]

Without realizing it, Motherwell had anticipated an argument of the Abstract Expressionists, with whom he would later be identified. After visiting the Masters of Abstract Art exhibition, however, he altered his judgment, saying that the other artists' works seemed "dark and confused," when contrasted with Mondrian's:

> a definite and specific concrete poetry breaks through his bars – a poetry of constructiveness, of freshness, of tenacity, of indomitability, and above all of an implacable honesty, honesty so thorough-going in its refusal to shock, to seduce, to surprise, to counterfeit . . . one thinks of Seurat and Cézanne. Beside Mondrian, the other abstractionists seem dull and grey.

The artist remained in town during the summer of 1942; he was evidently preparing for an exhibition. A Dutch writer who interviewed him for an article in the September issue of *Knickerbocker Weekly* stated confidently that the artist would have another one-man exhibition in the fall. He was quoted in the same article as saying that Americans were not romantic in the same sense as the French; for example, American music, such as Boogie-Woogie, was stronger than the French.

136 Portrait of Mondrian in his first New York studio by photographer Arnold Newman, spring 1942. (Arnold Newman - Liaison Agency)

His emphasis on jazz in this statement would indicate that Mondrian was already at work in the summer on his Boogie-Woogie painting series, whose compositional problems would slow down his production and delay his second exhibition until the spring of 1943. Also, he was still writing, or revising previous writings. In the fall of 1942, von Wiegand invited him on behalf of the book committee for AAA to contribute to its forthcoming publication which, she wrote, would be "the first effort in the United States to correlate the ideas of modern artists and architects in preparation for the post-war reconstruction." Although not published until 1946, the booklet carried Mondrian's essay, "A New Realism." This essay, already delivered at the Nierendorf Gallery, had evidently been edited with the AAA publication in mind because it was dated April 1943.

In November 1942, Peggy Guggenheim published a book entitled *Art of This Century* as a catalogue accompaniment to the opening of her gallery by the same name. The artist's "Abstract Art" was presented in the preface to this book, dated November 1941. It made further references to his new life and attitudes. He said that our vision had been enlarged over the centuries by developments in science and technology, making it possible for us to see art, also, as "consistently progressive" and as evolving into Abstract Art.[21]

This essay was only one of several in the catalogue. Dore Ashton later reported that Breton was responsible for choosing the essays as well as for editing the artists' statements that appeared by their entries in the catalogue. She also observed that the exhibition represented the "meshing of an entire international set of assumptions that flew, like so many iron filings, to the single magnet of New York."

Mondrian had been "the whipping-boy of the Surrealists in the 'dog-eat-dog' atmosphere of Paris," according to Holtzman. Artists who came to New York (including Breton) met Mondrian and liked him but, as Janis said, they paid no attention to his art. After a few years, they changed their minds, though, calling him one of themselves, because he was "so obsessed with his image." The artist told an interviewer that he felt "closer to the Surrealists in spirit, except for the literary art, than to any other modern painters." He thought Dalí was "great in the old tradition," but preferred the "real Surrealists," like Max Ernst, who were "in their way naturalistic but free from the tradition." Ernst told how, when he returned to New York from Arizona in the fall of 1943 with canvases of linear, geometricized forms, Mondrian chided him by saying "I painted those"; Ernst made clear how he felt about the man whom he called "one of the most important painters of our time."[22]

Mondrian tempered his reactions toward contemporaries, sometimes negatively. He said to Holty that Picasso was "too pictorial," Juan Gris was "too cold and intellectual," and a Marcoussis he saw was "terrible." Toward young artists, however, he was kinder. He spoke appreciatively to an interviewer of "all good American painters," particularly of Stuart Davis, describing him as "the most abstract" of the young Americans." Jimmy Ernst overheard Mondrian refer to Jackson Pollock's works as "exciting and unusual." While admitting that he did not understand the paintings, the artist thought they contained something very important and represented the most original work by an American that he had seen.[23] Mondrian made these comments about Pollock in the spring of 1943, while serving with Barr, Sweeney, Duchamp, and James Thrall Soby, on a jury for a salon that Peggy

137 Mondrian and "friends" at Helena Rubenstein's New Art Center, New York, 1942; left to right: Burgoyne Diller, Fritz Glarner, Carl Holty, Charmion von Wiegand.

Guggenheim, and her assistant Howard Putzel organized on Herbert Read's advice. She would eventually hold the first one-artist exhibitions of the "stars" who emerged from the salon – Pollock, Motherwell, and Baziotes – and of her other "discoveries," among them Hofmann, Still, Rothko, Hare, Gottlieb, Sterne, and Reinhardt.

While his New York contemporaries were not so aware of the artist's effect on them at the time, they sought his company.(137) Mondrian also invited new-found friends to dine with him and obviously enjoyed their company. Reacting to his social life in New York, the elder artist once confided to Holtzman: "I've never been happier than here."

Praised for his naturalness and simplicity, Mondrian was not a simple man. Although seemingly humble in bearing, he knew his own greatness: "If a few understand," he said, "that's enough." Called idiosyncratic by reporters

who stressed his unusual actions and habits, Mondrian was nonetheless no Bohemian to his friends. He could certainly be forthright; he informed a dowager that her large Sutton Place apartment smelled old and smiled sardonically at some beads worn by the Soviet Ambassador's wife, saying later that he hated "cultural retrogression." When asked if he had not once been a Socialist, Mondrian said yes, but now he hated "everything that 'levels'."

Mondrian was usually described as a very serious man, his eyes sometimes "shown with internal gaiety," and on occasion he displayed a dry humor. While visiting Gallatin, who lived on Park Avenue where traffic islands sprouted a small tree every two or three hundred yards, the artist remarked that he had no idea Gallatin "lived in a rural district."

Once characterized as "a free spirit, who liked to dance barefoot," he was said to be "morally above most men." He disapproved of self-indulgent artists and obscured his only vice, coffee-drinking, by hiding the pot behind a piece of cardboard. He was chagrined when found out by Holty and admitted that "one has vices!" Von Wiegand, who was drawn to the artist emotionally, said "he had a look like a whiplash, but aware of the power in his eyes, kept them down – he was a passionate, virile man, but a touch-me-not." When asked why he never married, Mondrian replied: "I have not come so far. I have been too occupied with my work." He was reported to have been in love several times but never married because he had "no money – nothing – [his] whole life," but women admired him. Dancing was a substitute for women. The artist was described once as "a perfect dancer [who] danced in a way so perfect it was almost too perfect . . . it was alive." Yet another who danced with him said: "He danced stiffly, with his head thrown back." Despite having a fine sense of rhythm, Mondrian held his partner at a disconcerting distance and his steps were often too complicated to follow.

Mondrian's passion for dancing, not just a sublimating factor, was connected intellectually with his appreciation of American jazz music. He was excited by Boogie-Woogie and would go alone or with groups to places where he could hear the new form of jazz, or dance to it. In fact, the artist liked to dance only to the accompaniment of Boogie-Woogie and once said to von Wiegand while they were dancing: "Let's sit down; I hear melody." "His favorite haunt was Cafe Society, Downtown, where he went especially to hear Albert Ammons, Mead Lux Lewis, and Pete Johnson, the Negro boogie-woogie pianists who played there," according to Harriet Janis. Mondrian believed that Boogie-Woogie, said to be the most technical and least melodic form of jazz, bore the same relationship to music as abstract art did to art in general, and furthermore, that Boogie-Woogie was to jazz what Neoplasticism was to Cubism. "Boogie-Woogie is pure rhythm," he stressed to friends.[24]

As early as 1941, the artist had begun to celebrate jazz on canvas. In 1942, however, he was to come closer to capturing the "liberated rhythm" and "pure vitality"[25] that he wanted in his work, than in either the *New York* or *New York City* paintings. After his 1942 exhibition at Dudensing's, he continued to compose pictures with colored lines, adjusting "the sections of the long colored strips [planes] to relate not only to each other but to the canvas as a whole." Because *New York City* (130) is a finished work, it is generally regarded as the earliest of the paintings Mondrian made by employing tapes as colored lines. The fewer number of taped lines on *New York City, No. 2* (138) and *New York City, No. 3* (139), as well as the presence of a black one on

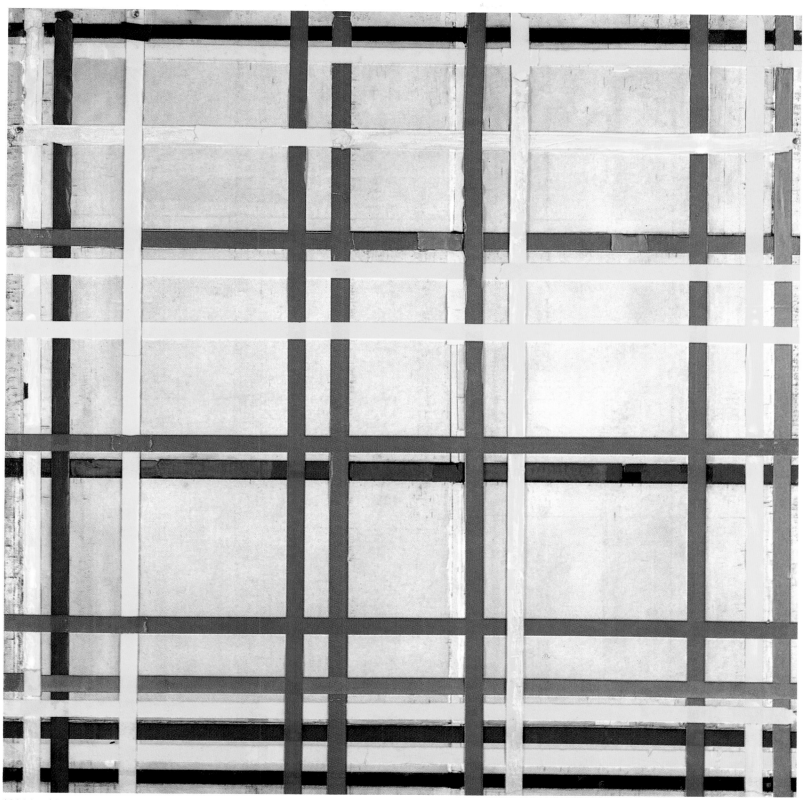

138 Mondrian, *New York City (No. 2, unfinished)*, 1942.

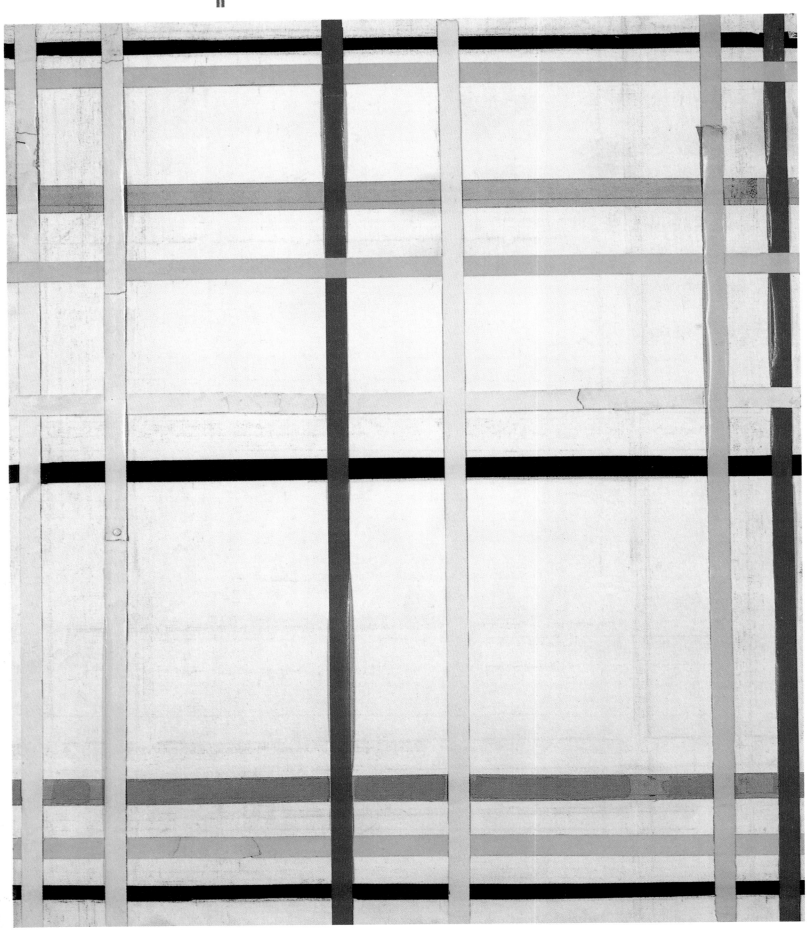

139 Mondrian, *New York City (No. 3, unfinished)*, 1942.

140 Detail of Mondrian, *New York City (No. 3, unfinished)*, 1942.

the latter painting (140) might mean, however, that those were begun before the *New York City*.[26] After he finished one of the three paintings, the artist may have realized that he had to overcome the spatial effect caused by overlapping colored lines and the optical flicker to be observed at their crossings. He may have begun, at this point, to glue small tapes of different colors onto the crossings and along intervals of the taped, multi-colored lines.(141)

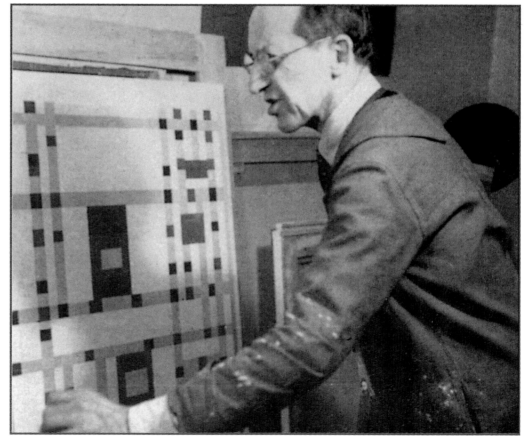

141 Mondrian at work on *Broadway Boogie-Woogie*.

142 Detail of *Broadway Boogie-Woogie*, 1942–43, Museum of Modern Art, New York.

143 Detail of *Broadway Boogie-Woogie*, 1942–43, Museum of Modern Art, New York.

144 Detail of *Broadway Boogie-Woogie*, 1942–43, Museum of Modern Art, New York.

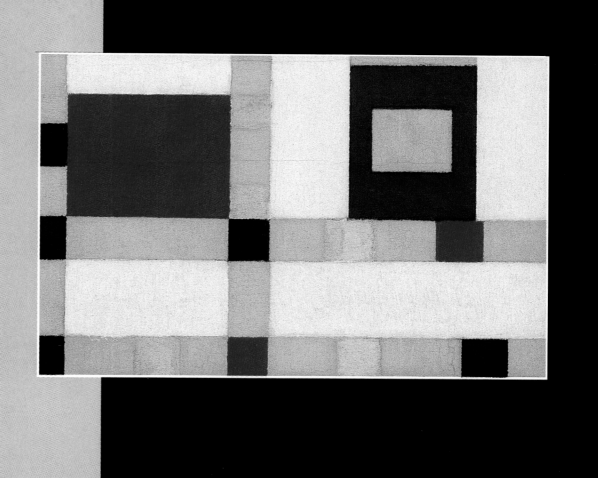

145 Detail of *Broadway Boogie-Woogie*, 1942–43, Museum of Modern Art, New York.

When Mondrian removed the tapes, he painted the small squares they had covered in red, blue, and gray but changed what had been the multi-colored taped lines between the squares to yellow,[27] probably because yellow was closer than the other primaries to the white ground and more likely to integrate the planes and ground.(142) To harmonize them even further, he connected some of the lines by bridging the white spaces between them with larger rectangles.(143,144) If these rectangles seemed too dominant, he painted smaller rectangles in their centers, but the smaller ones then seemed to "float" inside the larger rectangles.(145) The artist looked thoughtful when von Wiegand chided him that this practice did not fit his theory, then said in his thick Dutch accent: "First, I do de painting; den I make de teeory."

The clearest theoretical explanation of these revisions is contained in letters and cards that Mondrian wrote in the spring and fall of 1943 to James Johnson Sweeney, with whom he was in close contact throughout his New York years. Following one of their discussions, he expressed his desire "to destroy these lines [with color in them]," in other words, to make them less dominant by stringing little planes along them or by connecting them through the use of "bridging" planes. The lines, or linear planes, would still be "in equilibrium" but would also seem to be "in dynamic movement," giving a feeling of "vitality in the continual succession of time."[28]

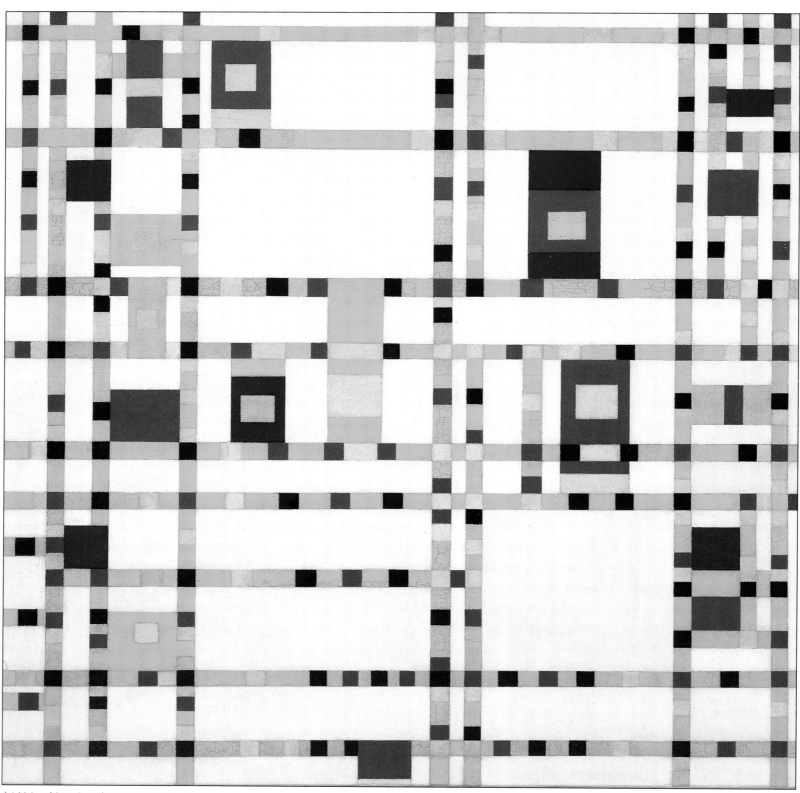

146 Mondrian, *Broadway Boogie-Woogie,*
1942–43. Oil on canvas, 50 x 50"
(127 x 127 cm). The Museum of
Modern Art, New York. Given
anonymously. Photograph © 2001
The Museum of Modern Art, New
York.

In the new painting, which the artist named *Broadway Boogie-Woogie* (146), he came closer to these goals than ever before. By using single-colored lines, he had overcome the "spatial" and "logical" impasses of the *New York City* paintings. Not only had he defined and increased the vibrancy of the hitherto uncontrolled optical flicker by painting squares of contrasting colors at the crossings of lines, but he had "suspended squares along lines in space."[29] With these squares he had created rhythmic synapses that invited spectators' eyes to move in pulsated and syncopated sequences among them.

As Mondrian made clear, his choosing the name *Broadway Boogie-Woogie* for this painting did not mean that he ever intended to present a visual representation of a Boogie-Woogie pianist, or the piano keys, or the notes, or the sounds of the music. He was creating a composition in the spirit of pure abstraction that he saw as the source of the Boogie-Woogie jazz. Also, the choice of title was not "prankish or arbitrary," as he said, "for this music goes with activity and modern life, and it is just what I feel in painting."

The artist shared his second Dudensing exhibition, held from March 22 to April 10, 1943, with the Brazilian sculptor, Maria Martin (wife of the Brazilian ambassador to the USA). Critics were particularly obtuse this time, but perhaps could be excused on account of the contrast in the paired artists' works. Martin exhibited intricate bronzed sculptures that *The Art Digest*'s reviewer said were expressive of "deep interiors, muggy waters and extravagant growths."

Along with a few earlier works, Mondrian exhibited his *Place de la Concorde* (147) and *Trafalgar Square* (148) which had been begun in Europe and finished in America, a progression revealed in the combination of European place-names and unbounded color planes. He also exhibited his newly finished *Broadway Boogie-Woogie*. The *Digest*'s reviewer pronounced that the former two paintings were "as unstirring and as monotonously unemotional as nicely patterned tablecloths," but conceded that the latter, "an essay in jazzed up color, is more exciting, having more checks to the square inch." An article in the *New York Times* was more perceptive, if little more enlightening, noting that

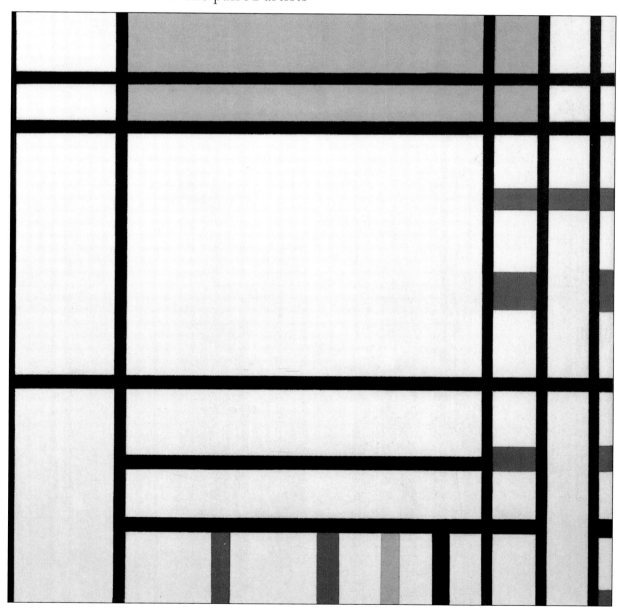

147 Mondrian, *Place de la Concorde*, 1938-43, Clark Collection, Dallas.

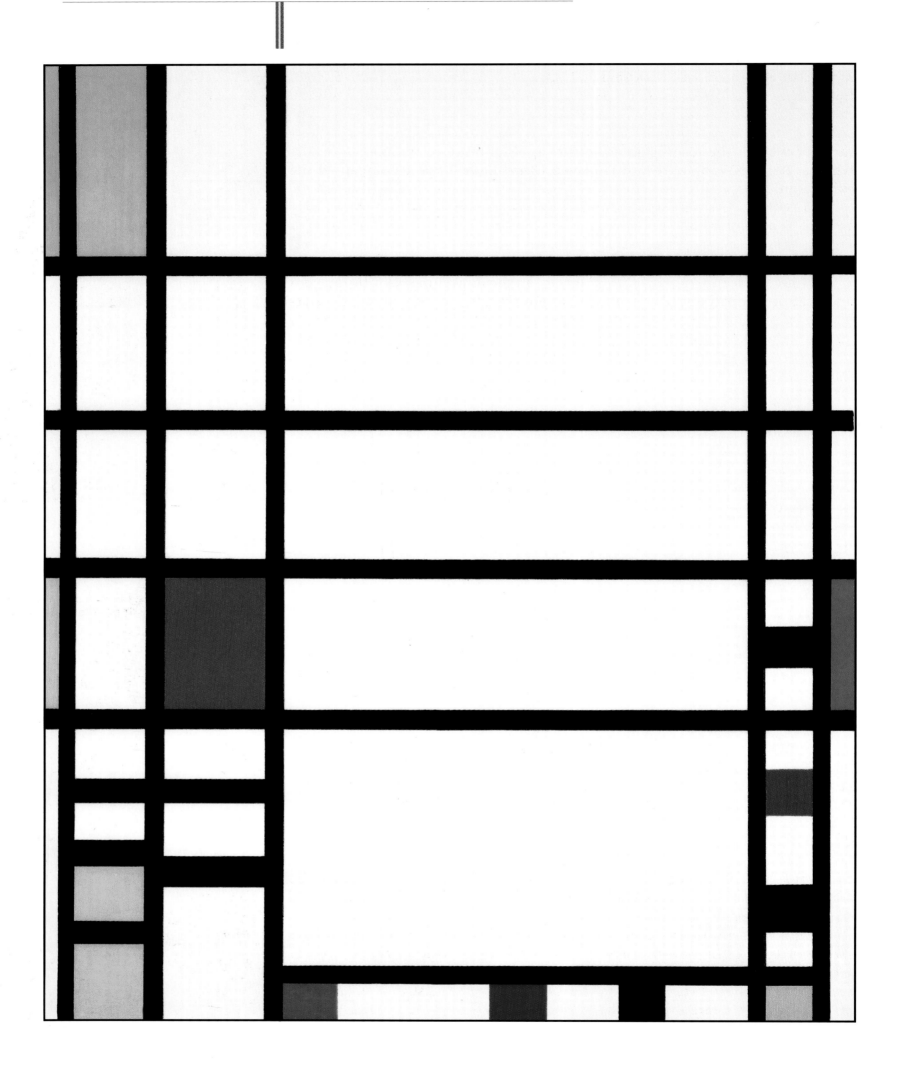

Mondrian exhibited "six paintings, ranging in date from 1936 to 1943, . . . for the most part perfectly typical of the style that has become associated with this brilliant French modernist." The works were "as plain as linoleum pattern, yet in reality very subtle," and the *Broadway Boogie-Woogie* was a "departure" of which "the term 'painted music' appears quite justifiable, especially when a 'Boogie-Woogie' record is played [*Barrel House Boogie* accompanied the exhibition]."

Broadway Boogie-Woogie was acquired by the Museum of Modern Art in May 1943 and exhibited in the museum's Recent Acquisitions Exhibition during the summer of 1943. The painting also received a short notice in *The Museum of Modern Art Bulletin* of October-November, 1943.

Clement Greenberg saw this painting at the museum's exhibition and reviewed it sympathetically, if somewhat equivocally, for *The Nation*. He stated that it fell short of being a great work of art, which he characterized as "a thing possessing simultaneously the maximum of diversity and the maximum of unity possible to that diversity." The critic asserted, however, that the painting was a "radical step forward" because of the imminent break up of Mondrian's "hitherto immutable elements." Still, he had not "yet possessed himself fully of these new configurations, nor yet rendered them controllable to his total purpose." Greenberg concluded that, although a "remarkable accomplishment," the painting was also a "failure" – yet one "worthy only of a great artist, and its acquisition was more than justified; it was mandatory."[30] According to conflicting accounts, the painting had been "given anonymously" to the Museum of Modern Art and the artist had been paid somewhere between $800 and $1,300 for it. Whatever the amount, it was the most money Mondrian had ever received for a single work.[31]

Mondrian again participated in the American Abstract Artists exhibition, its Seventh Annual, held from March 9 to May 2, 1943, at the Riverside Museum. Not all writers mentioned him this time, but those who did used the artist to justify their criticism of discipleship in others.

In the fall of 1943, the artist had moved closer to the center of the city, especially to the gallery district. The new apartment was at 15 East 59th Street (149,150), near Central Park, where despite his reputed aversion to nature he liked to walk. As von Wiegand explained, "Mondrian liked nature as a human being, although . . . because he was so conscious of the structural, he liked trees with no leaves on them."

Von Wiegand had continued to visit the artist and to discuss theory with him. That fall, 1943, she published the first critical study of "the infinite patience of product," but she said that his art contained "sensuousness as rich as that of natural forms." "Devoid of any biological, organic or literary connotation," she continued, "their passionate living is expressed wholly through plastic means." In her article, written for the *Journal of Aesthetics and Art Criticism*, she tied Mondrian to Northern Europe's spiritual aspirations and its traditions of painstaking care, perfection of detail, and declared that the artist took "the first step toward breaking with the whole plastic tradition of the Renaissance."[32]

Mondrian had begun his second painting following the Boogie-Woogie theme in April of the previous spring. He worked throughout the summer of 1943 and told the *Knickerbocker Weekly* reporter, who interviewed him in the fall, that he expected to complete the painting by the first of the year. The artist also made a rare confession:

149 Mondrian's second studio-homesite at 15 East 59th Street (no longer in existence): looking east from Fifth Avenue on 59th Street.

150 Looking west on 59th Street toward the Plaza Hotel and Central Park from the entrance to Mondrian's apartment house.

Opposite page:
148 Mondrian, *Trafalgar Square*, 1939–43. Oil on canvas,
57 1/4 x 47 1/4" (145.2 x 120 cm). The Museum of
Modern Art, New York, gift of Mr and Mrs William A.M.
Burden. Photograph © 2001 The Museum of Modern Art, New York.

151 Mondrian's sketch for *Victory Boogie-Woogie*, c.1943, Holtzman Collection.

I am glad that my paintings bring me enough money so I can live alone. I have had a happy life, for my work. . . . It is so difficult to express, to paint what you feel. It is a great struggle. I know that it would really be torture if I shouldn't get it on canvas. I feel never free – there is always this compulsion driving me on. When a picture is finished, I am satisfied for a short while and then the pressure comes again. (Bradley, 24)

Mondrian may have been driven by his efforts, but he was also exhilarated – a state of mind too often ignored in accounts of an artist's creative "struggles." All of his closest friends were involved in some way or other – watching him paint or giving him advice – and they attested to the eagerness with which Mondrian undertook his final painting. Wearing the carpet slippers Gabo had given him in England, he pattered down the hallway of his building toward von Wiegand and greeted her by saying, "I just dreamed a beautiful composition." Von Wiegand said that the artist held out to her, "as one would hold a butterfly, a tiny sketch containing the genesis of *Victory Boogie-Woogie*." (151)

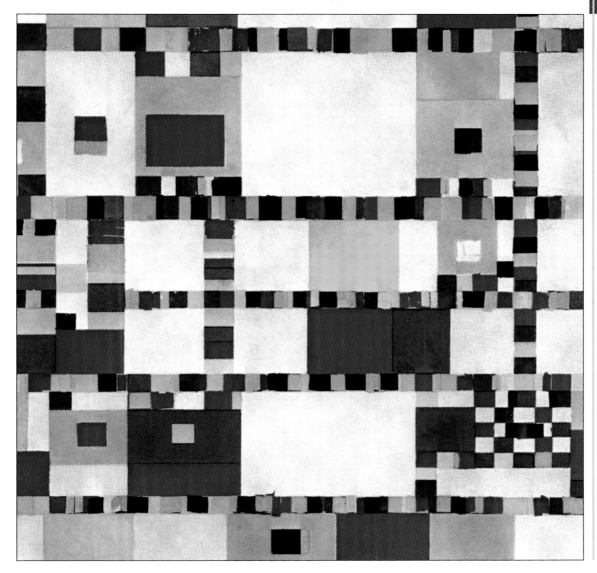

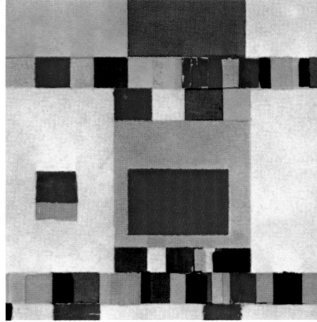

153 *Victory Boogie-Woogie*, 1943–44, oc with colored tape and paper, detail

152 *Victory Boogie-Woogie*, 1943–44, oc with colored tape and paper, detail (now Gemeentemuseum, The Hague – photographs made from original in Tremaine apartment in New York).

Mondrian composed the painting with tapes, this time using neither long strips nor colored squares but small pieces that he tore off jaggedly to use as he needed them.(152,153) Moving repeatedly to and from the easel, he would apply or move a tape and then walk back from the painting to inspect it. When satisfied, he would lay the painting flat, remove the tapes, and begin to paint underneath where they had been placed.(154)

Von Wiegand and Holty both recalled that the artist worked rhythmically and very fast. He was "eternally moving one color after another, always considering the control of the whole surface," said Holty, and commented further that "it was a pleasure to watch the joy he evidenced while working." Holty believed that Mondrian intended the constant changes to make his colors remain "distinct as forces." In other words, he did not want primary colors to blend optically into secondaries, as they did when placed next to one another, because this weakened their "strength brought to life by oppositions." Some of these "errors" of placement, Holty thought, could be found beneath the paper pieces that are still attached to the *Victory Boogie-Woogie*.(155)

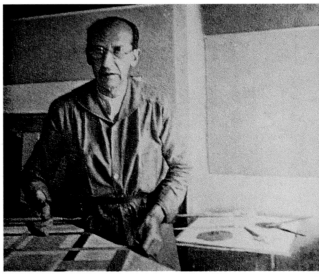

154 Photograph of Mondrian at work on *Victory Boogie-Woogie*.

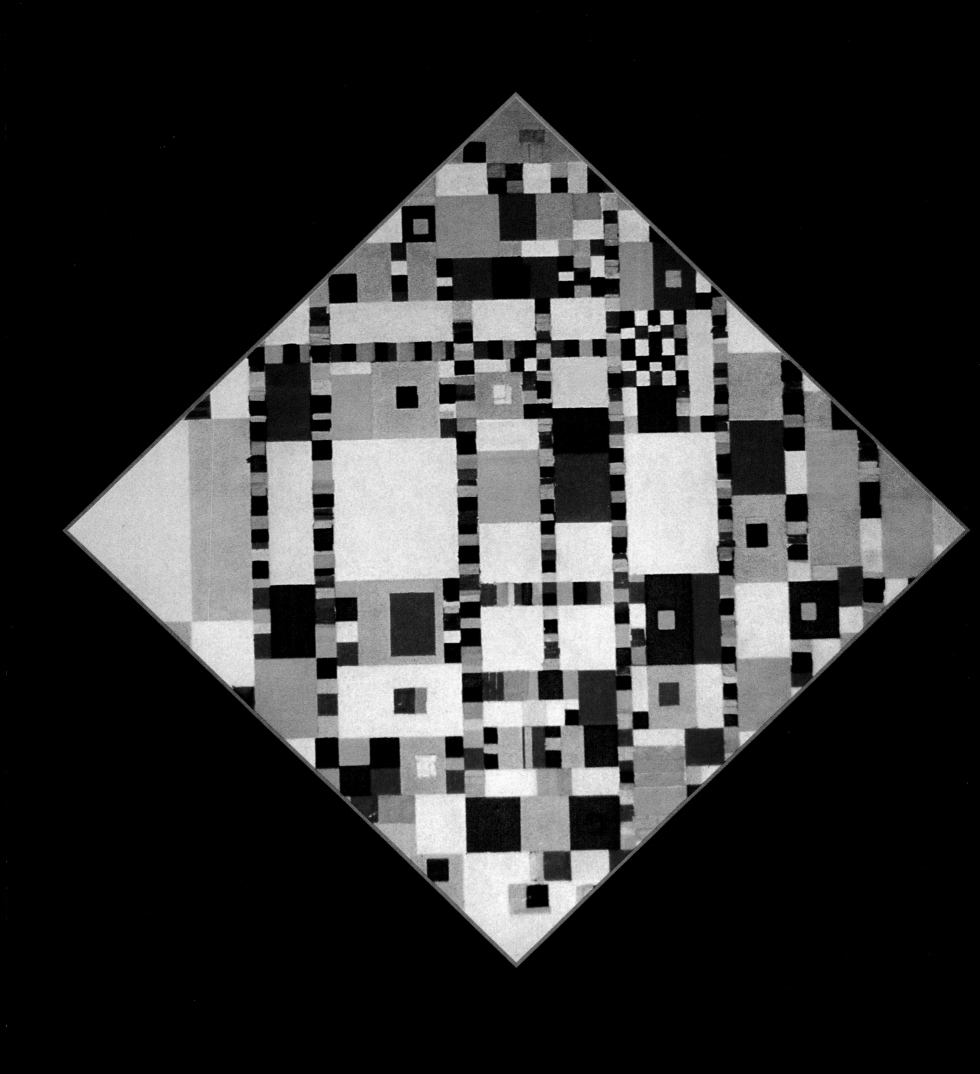

According to Holty, the artist never completed the *Victory*; others disagreed. When von Wiegand last saw the painting, she felt certain it was finished. Sweeney assumed that it was practically ready for exhibition when he saw it but reported that Mondrian then began "a drastic revision of his latest painting . . . to which he had already given more than nine months constant work." The Glarners were sure it was not complete, because the artist's whole process of working was evolutionary, they said.

The title had been almost inevitable. Not only was "Victory" a word that was heard frequently by now, but it had special poignancy for Mondrian. Every issue of *Knickerbocker Weekly* contained stories of hardships, and even atrocities, endured by his Dutch compatriots under the Nazis. These stories were interspersed with oft-repeated promises of a forthcoming allied victory. Even more pertinent was the exhibition entitled Artists for Victory (held earlier that year, at the Metropolitan Museum, from December 7, 1942, to February 22, 1943), in which the American Abstract Artists participated along with every major New York art organization. Mondrian had not sent any works, possibly because his own exhibition at Dudensing's was held near the same time. He must surely have heard the discussions and read the publicity, which would have given him the idea that his newest painting, begun shortly after the Dudensing exhibition, was a potent contribution to victory. Archipenko's message on the "Victory" endeavor (received as a letter by AAA in January 1943) would have been close to his own heart: "Artists for Victory is the greatest artists' organization in the world today. Our 10,000 members represent a powerful army on the cultural front of the United States of America. The noble mission of this army is to serve spiritual progress and the pure development of art."

Late in January, 1944, Mondrian accompanied Holty to a dinner party at von Wiegand's at which the guests carried on a lively argument over art. After the party broke up, very late, Holty took Mondrian home and went up to his studio, on invitation, to look at the *Victory*. When Holty left at about 4:00 am, the older artist said he was going to stay up and paint, because he saw "new things." He habitually worked at night and slept during the day. In fact, Mondrian often did not go to bed at all but painted feverishly until morning. The artist had begun to discourage visitors some time before, informing them with a postcard or a note pinned to the door that he would not be available until after a certain date. Consequently, when he did not appear on Monday, January 24, for a cocktail party at Hans Richter's apartment (in the same building), his friends were reluctant to call him away from work.

The next day, Holtzman met Glarner and Bolotowsky, who was home on leave from a military assignment in Alaska, at a gathering place off McDougal Street. They reflected worriedly that Mondrian had complained of a cold over the weekend. Becoming increasingly anxious by Wednesday, Holtzman and Glarner converged on his studio almost at the same time, followed shortly by von Wiegand. They found him in bed – already critically ill. A chronic predisposition to respiratory ailments (in the pre-penicillin era), joined with his neglected cold, fatigue, and unwillingness "to bother anyone," had brought on pneumonia. Holtzman and Glarner drove the artist to Murray Hill Hospital where, for the next five days, he gradually weakened. A few friends kept vigil at the hospital and were in the corridor outside his room when Mondrian died, at five o'clock in the morning on Tuesday, February 1, 1944.

Opposite page:
155 Mondrian, *Victory Boogie-Woogie*, as photographed
 from original when it was in the Tremaine Collection.

Later that day, the same close friends, plus Holty, Morris, Richter, and Dudensing, met in Sweeney's office at the Museum of Modern Art to hear the artist's will.[33] The lawyer read the simple legacy, endowing "my friend, Holtzman" with the full estate, whereupon Dudensing spoke up and said that the final, unfinished picture belonged to him. The artist, it seems, had promised the painting to Dudensing because he had not taken a commission on *Broadway Boogie-Woogie*. Holtzman later explained that he did not question the statement, on the grounds that Dudensing had given Mondrian his only one-man exhibition.

The discussion that ensued centered on what kind of funeral should be held for "an austere man of no religious affiliation." Finally, the group decided that the ceremony should be a formal one because, as Holty put it: "The master would have loved it so; he respected the conventions and the formality." The Dutch Consul, representing Mondrian's native country, and Alfred H. Barr, Jr, representing the art community, would each be asked to say a few words.

Holtzman arranged for the ceremony that was to be held in a funeral parlor. In his address, Barr said that it was with reluctance he had agreed to speak because words were inadequate at the funeral of an artist. His oration began: "When ordinary men die we try to speak well of them, remembering their virtues and their good deeds and forgetting for a solemn hour their faults . . . But when an artist dies, his art remains to make our words superfluous. This is peculiarly true of Mondrian who gave his life to his art more completely than any artist that I know of." Calling Mondrian "a devotee, an anchorite of art," Barr said that "he seemed able to live without the consolations of love or religion because painting itself was his love and his religion." He defended the artist's art against seeming "sterile or dead" and its lack of "variety, fantasy, sensuality, richness of human association," by speaking of its extraordinarily subtle and intense power that had a world-wide influence on design. More important, however, was the "continued vitality of his own painting, which even after his 70th birthday developed a new richness and complexity." Barr said he liked to think that "this recent flowering of his art" was due to the artist's coming to America:

> We cannot say that he had here, much more than abroad, the recognition which his art deserved, but he had devoted friends and disciples, and his last completed painting, on which he worked for many months, was based on his enthusiasm for our popular music – as if some great musician had taken material from folk dances for his final masterpiece of counterpoint.[34]

A small group, representing only a few more than the closest friends, accompanied the body to the Long Island cemetery, whose flat stones and blocks lined up close together in rows looked to Holty "very much like the Great Man's work."

One thing that Mondrian had molded according to his ideals was his studio-apartment, which was always his immediate paradigm of art moving into life. In order that other artists could see what Mondrian had done with his second New York studio, Holtzman kept it open for a while after the artist's death. He also tried to interest the museums in documenting the studio, but was unsuccessful; finally, he and Glarner took photographs themselves.

156 Plan of Mondrian's last studio-apartment in New York.

157-168 These are duplicates of the slides that were made by Harry Holtzman and Fritz Glarner of Mondrian's last New York studio shortly after he died (the original slides were lost in the archives of the Museum of Modern Art until 1971; Holtzman gave me a set of the duplicates at that time and said that I might use them in any way I wished).

In this sequence, we enter the apartment through the hallway and go immediately to the bedroom where we see a bookcase and desk made by his hand and, near the door, several of his early works. There is an arrangement of colored squares that are also to be seen in the living room that he used as a studio. In this room, we see a paint cabinet and phonograph near the door from the hall, another paint cabinet and tabouret near the fireplace, whose architectural details Mondrian concealed in order to display his colored squares which he frequently moved, judging by pin holes on the wall. Finally, we see the painting/collage *Victory Boogie-Woogie* as Mondrian left it, unfinished on the easel, when he died.

The apartment contained, in addition to its hallway, kitchen, and bath, a small back bedroom that Mondrian also used as an office, and a larger front room that he used as a studio.(156) Holtzman made slides that showed a sequential movement from the hallway, to the office-bedroom, to the front-room studio.(157-168)

A *New Yorker* reporter who paid a call to the artist's apartment during this time listed the bedroom furniture as "a cot, a small writing-table, a canvas-backed camp chair, and a set of bookshelves made of orange crates nailed together; in the studio another table, a few stools, racks for painting materials, and a stand for the artist's palette." For his bedroom, Mondrian had made a bookcase, a desk seat and desk out of crates; the latter's one-inch by two-inch legs were braced by slenderer strips nailed on in varied, asymmetric heights. For the entrance wall of his studio in the large front room, he had made a paint cabinet with a solid front. Another rack for paint tubes was set along the fireplace wall; its two crates set on end were connected across an interval between them by narrow strips of wood and colored cardboard rectangles. The artist had also fashioned a paint stand to use in this area from a crate set on end.

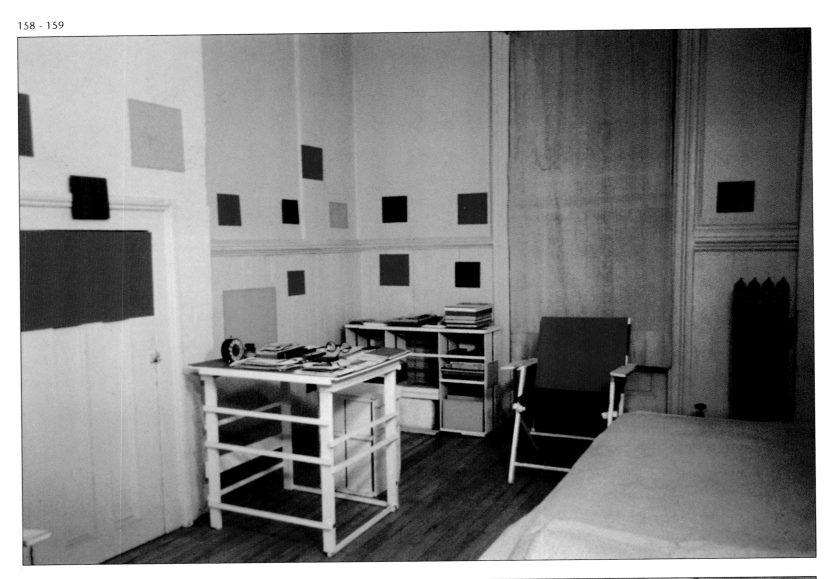

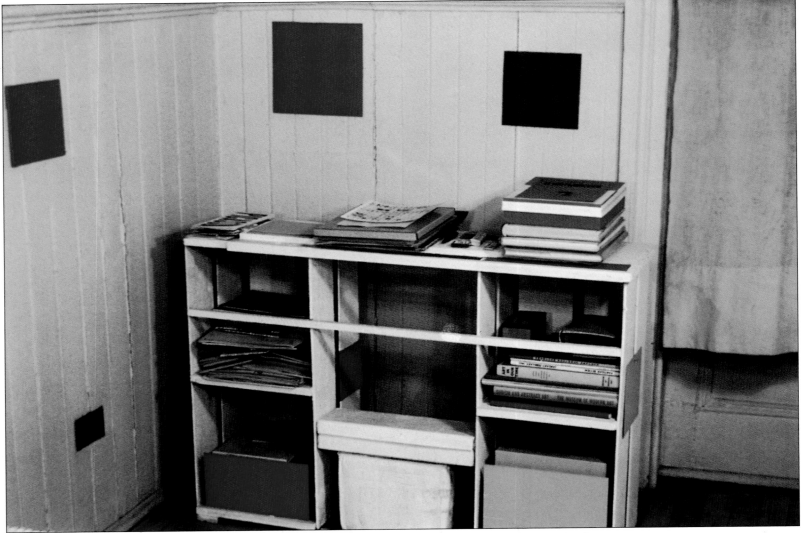

92

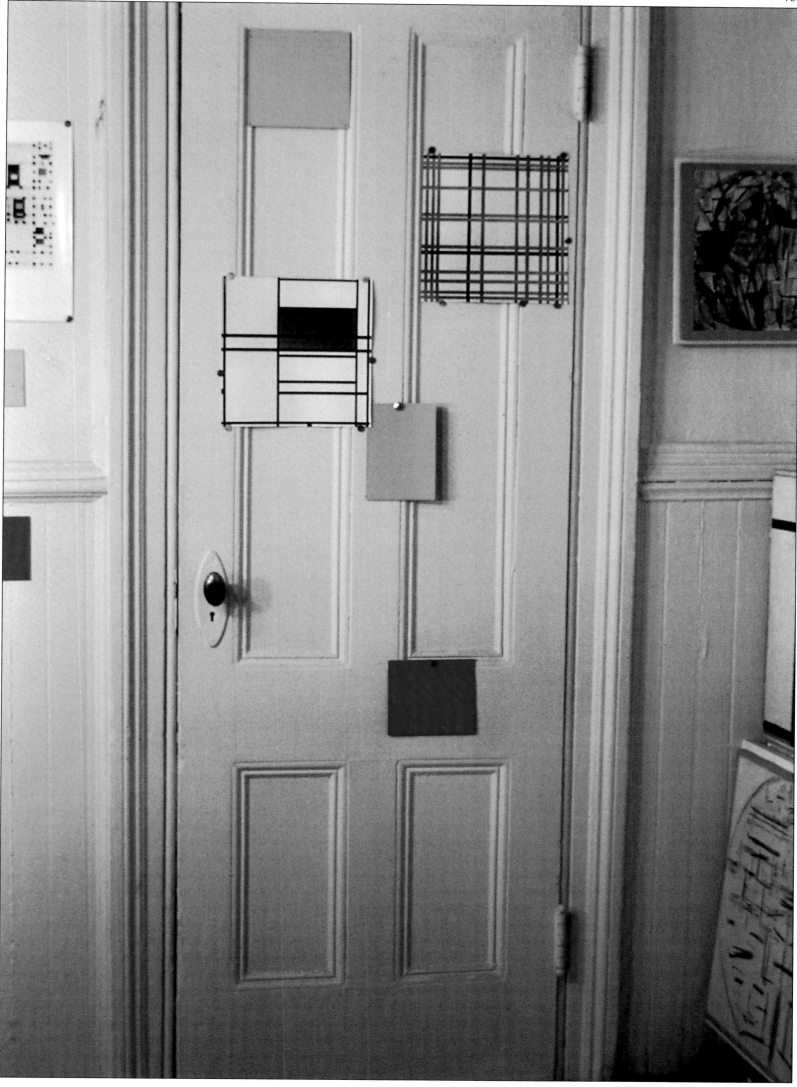

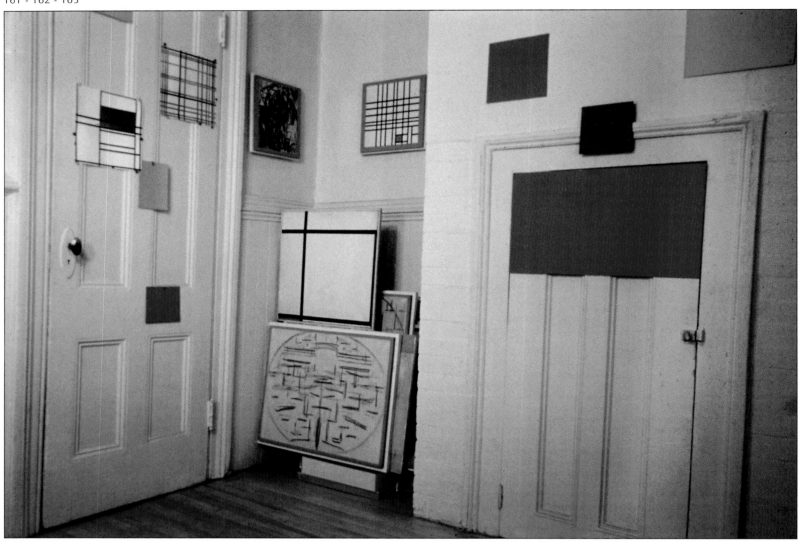

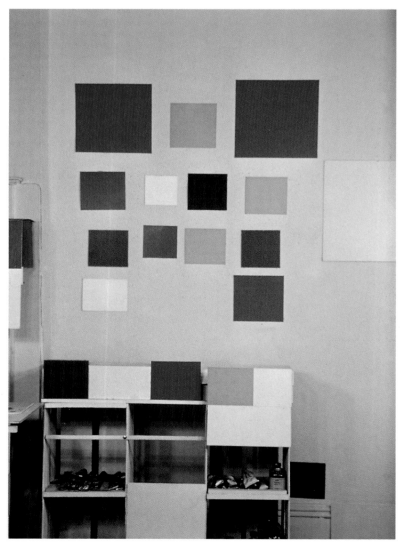

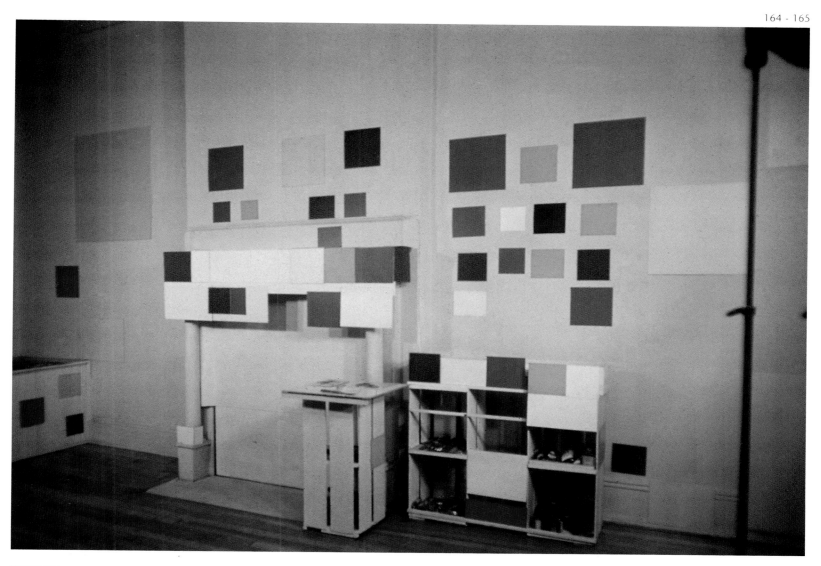

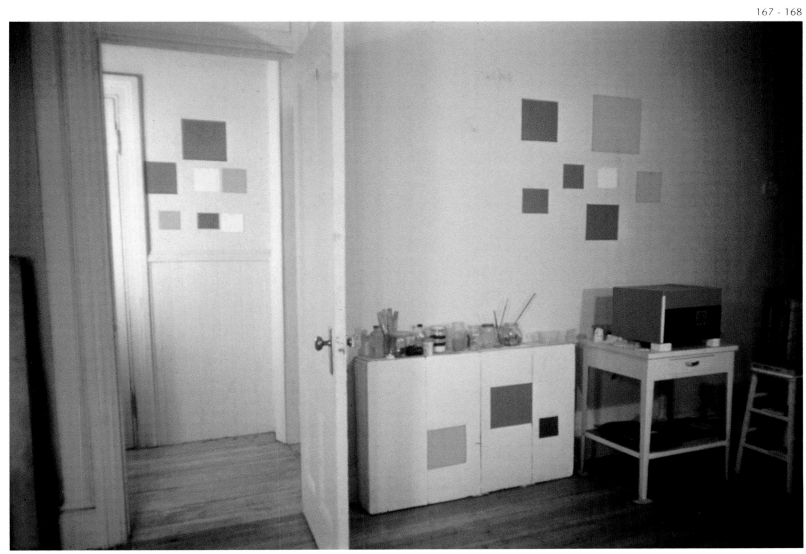

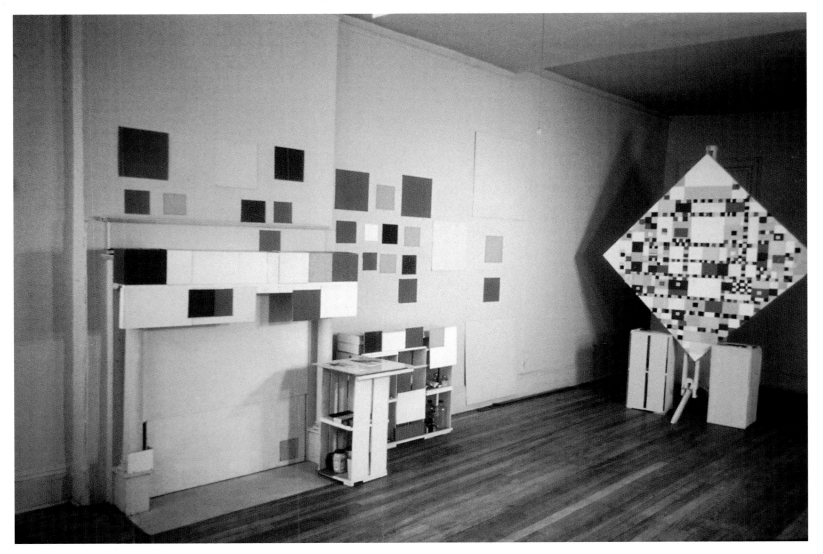

Just as in London, he had covered a curved mantel on the unused fire-place with an asymmetric arrangement of boards. Clusters of different-sized squares made of colored cardboard accented the mantel covering as well as the fireplace wall , liberally sprinkled with pinholes showing that the squares had been frequently moved. Aside from the phonograph table and stepladder chair against the entrance wall that was also decorated with squares , the room had nothing else to interrupt the expanse and bareness of its floor except the easel at the far end. Still on the easel, as Mondrian had left it, was his final, unfinished masterpiece, *Victory, Boogie-Woogie.*

In entries to his "Memoirs," on March 22 and 23, 1944, Carl Holty gave his personal reaction to visiting the artist's quarters during this time:

Harry said that he was going to show the studio a couple of afternoons to people who would be interested and to people from museums. Apparently this was the first of the afternoons – and a rainy one at that.

Piet must have been venerated, for practically all the invited guests showed up – weather or no weather – and it was quite shocking to go up the stairs into a room in which I had never seen more than one other person and to find it so crowded that one could hardly move around. I couldn't help thinking how few of those people would have gotten by the door had the Master been alive. . .

It was amusing to hear some of the people who knew Piet talk about how he asked advice on his pictures and how they helped him paint them. Factually it is true enough. If you were in his good graces at all, you had to know something about painting; and if you knew something about painting, you visited him. If he was working, he kept right on, and as sort of an excuse to continue with his work, he would ask you whether you thought it was all right. So you said it was or it wasn't, and since four eyes can see more than two, the visitor spotted things once in a while that Piet acknowledged. But he would have asked the man who reads the electric meter for the same advice. I mentioned this to Hans Hofmann, and he said he felt the meter reader would probably have done it better than some of the kibitzers had . .

Well, it's a novelty in these days to go see just one single painting by a man whom you might call a "living artist" – and an unfinished painting at that. But it is a good one, very good, and the beginning of a new creation which, unfortunately, wasn't achieved. It is a case where the picture will have meaning only to a few artists and they will have to carry on in the spirit – that is, if they get the spirit and not the letter of it. Piet had broken away from all those straight lines and had opened up the entire surface again and, for the first time in his whole career, revealed a possibility to those who believed in him to work on the basis of his purpose without landing in what to his former followers was a straitjacket . . .

I went right home and took a look at what I was doing, and found it not too bad and got a new impetus for "destruction" within the composition I was making. It is a very healthy business. Piet was so damned right about many things. . .

Of all the people in the world to give me freedom – Piet Mondrian! You never do know where the blessings will come from.[35]

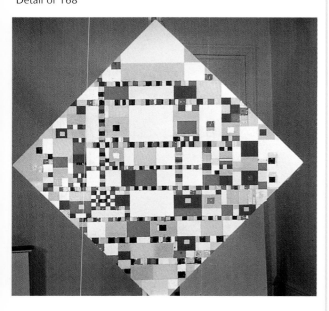

Detail of 168

CHAPTER THREE – REFERENCES

1 Jay Bradley, "Piet Mondrian, 1872–1944: 'Greatest Dutch Painter of our Time,'" *Knickerbocker Weekly*, Vol. 3, No. 51, February 14, 1944, p.17.

2 Harry Holtzman amplified Robert Welsh's account of Mondrian's reaction by explaining that Mondrian wanted to go back to New York because he felt the urgency to work again. All direct information from Holtzman here and elsewhere in the text came from interviews between 1967 and 1971, and in 1984 and 1985.

3 That group, which also included Seuphor, Vantongerloo, Hélion, Herbin, who followed Mondrian or were close to him in spirit, was founded for much the same purpose as AAA – to advance abstract structuralist concerns through writings and exhibitions in Paris, where reception of the abstract genre ranged from indifference to hostility. Like Cercle et Carré, which had performed a similar function a few years before, Abstraction-Création had broken up because, as Rose Fried said, "It was contrary to the French spirit."

4 George L. K. Morris's reminiscences, unless otherwise stated, are from an interview on December 16, 1967.

5 Actually, Charmion von Wiegand said that Mondrian would say to her, "You go, Charmion, and tell me what is happening." (Further von Wiegand reminiscences, unless otherwise stated, are from numerous interviews with the author between 1967 and 1973.)

6 *New York Times*, February 11, 1941.

7 *New York Sun*, February 16, 1941.

8 E. S., PM, February 16, 1941.

9 Von Wiegand, "Mondrian: A Memoir of His New York Period," *Arts Yearbook* 4, New York, 1961. (pp. 57-58)

10 These observations were made by Charmion von Wiegand and Lucy and Fritz Glarner; reminiscences from the latter, unless otherwise stated, are from several interviews conducted in 1967 and 1968.

11 The quoted phrasings of Mondrian's thoughts, here and later, are taken from musings by Robert Motherwell in an interview of March 20, 1967.

12 As Motherwell (who later edited Mondrian's essays in English for a posthumous publication) explained: "Mondrian was an internationalist, more exactly a universalist. He attempted to write in all the different languages he used, because he . . . thought he had found an art that belonged to no time and place."

13 Mondrian, "Toward the True Vision of Reality," Plastic Art and Pure Plastic Art . . . , p. 13.

14 Mondrian, "Liberation from Oppression in Art and Freedom in Art and Life," Plastic Art . . . , p. 39.

15 Sidney Janis, "School of Paris Comes to US: Piet Mondrian," *Decision*, November–December 1941, p.90.

16 In addition to the photograph that illustrated the article, one of the other photographs taken at this time (by the photographer Emery Muscetra, who accompanied Janis) was reproduced in a Janis catalogue of 1947, and another was used as the frontispiece for Ottavio Morisano's *L'Astrattismo di Piet Mondrian*, Venice, 1956.(I:2) These photographs are the only published documents of Mondrian's first New York studio. Two of the paintings shown in the photographs were begun in Europe and completed in New York. Under the right-hand easel can be seen what appears to be the left side of *Composition No. 7, 1937–1942*, and under the left-hand easel is *Composition II with Blue Square, 1936–1942*, both obviously begun in Paris although the second painting is sometimes associated with London.

17 Mondrian's only work known to bear the dates 40 above 42, *Composition London* is now in the collection of the Albright-Knox Art Gallery, Buffalo. Robert M. Murdock, the A-K curator, wrote in a letter of December 20, 1968, that the painting, "according to James Johnson Sweeney in a 1945 letter to Andrew Ritchie was 'begun during the blitz in London' – hence its title."

18 "Mondrian," *Art News*.

19 "Plastic Art . . .", p. 31.

20 Robert Motherwell, "Notes on Mondrian and Chirico," *VVV*, No. 1, June 1942, p.59.

21 Mondrian, "Abstract Art," *Art of This Century*, New York, 1942, p.33.

22 This was a posthumous tribute.

23 Quoted in *New York Times Magazine*, April 1967, p.62.

24 The first two quotations are from von Wiegand and Harriet Janis, "Notes on Piet Mondrian," *Arts and Architecture*, Vol. 62, No. 1 (January 1945), p.29; the latter was quoted by several of Mondrian's friends.

25 "Plastic Art . . .", pp.31, 20.

26 This line of reasoning was suggested by Carrol Janis, in an interview on March 22, 1967.

27 Close scrutiny of the surface of *Broadway Boogie-Woogie* bears out this theory, as the crackelure along the yellow lines reveals that other colors, notably red, were painted in earlier.

28 Sweeney, "Mondrian, the Dutch and De Stijl," *Art News*, Vol. 1, No. 4, June, July, August 1951. (p. 52)

29 Bolotowsky's phrase.

30 Clement Greenberg, "Art," *The Nation*, Vol. 157, No. 14, October 20, 1943, p.416.

31 According to Holtzman, Mondrian received $800 for *Broadway Boogie-Woogie*; von Wiegand remembered the amount as $2,500. Whichever it was, Mondrian was better off than he had ever been, in the last year or two of his life, for he had "about $2,000" in the bank when he died.

32 Von Wiegand, "The Meaning of Mondrian," *Journal of Aesthetics and Art Criticism*, Vol. 2, No. 8, 1943. (pp. 64,66)

33 The description of events that follows, unless otherwise stated, is a summary of reminiscences in Holty's unpublished "Memoirs" (reproduced by kind permission of Elizabeth Holty). Mondrian's bequest to Holtzman, which has been the subject of much speculation, is understandable in the light of his unprepossessing nature. Throughout his lifetime, Mondrian had made a habit of giving away his works to anyone whom he especially liked or who had rendered a service to him. His American friends

praised his generosity. He gave drawings to Glarner and Holty, to whom he explained: "Old artists die and they should help younger colleagues. Why should only speculators get rich?"

Harry Holtzman's deputation is still resented by some and misunderstood by almost everyone else. Some thought that Mondrian's bequest to Holtzman was not deserved – others that it was fully so. Holty and Bolotowsky were among the latter; Bolotowsky said: "Mondrian almost felt as if Holtzman were his own son." According to Holtzman:

We were close friends. He had been extraordinarily kind to me when I was very poor. Mondrian was finally reconciled that I didn't want pictures from him. I wanted nothing from him. I only wanted his productive happiness. After his death, I went through the peculiar position of being obliged to talk about Mondrian all the time. In the days of the Artists' Club [where the Abstract Expressionists met], I was always required to be Mondrian's advocate – at endless lectures, with people, in the calls I got all day long. I understood the weight of responsibility on me and feel that I have about paid my debt. Now Mondrian is a household name.

34 Quoted with Barr's verbal permission. Michel Seuphor gave some of the names of those who attended the artist's funeral (listed here as he told them to the *Knickerbocker Weekly*): Fernand Léger, Kurt Seligman, Marc Chagall, Jacques Lipchitz, Moholy-Nagy, Kisling, Ozenfant, Hans Richter, Fritz Glarner, Herbert Bayer, Matta, Max Ernst, Marcel Duchamp, Jean Xceron, Harry Holtzman, Stuart Davis, Calder, Holty, Diller, Saul Schary, Peter Blume, Walkowitz, Robert Motherwell, Ilya Bolotowsky, Charles Shaw, Leo Lionni, Alice Mason, Ibram Lassaw, Suzy Frelinghuysen, Charmion von Wiegand, Siegfried Giedion, Henry McBride, James Johnson Sweeney, Samuel Kootz, Dwight MacDonald, Clement Greenberg, Meyer Schapiro, Katherine Dreier, S. E. Gallatin, Mr and Mrs Bernard Reis, James Thrall Soby, Howard Putzel, Peggy Guggenheim, Hilla Rebay, Valentin Dudensing, Julien Levy, Pierre Matisse, Karl Nierendorf.

35 The paragraphs under Holty's entries for March 22 and March 23, 1944, have been rearranged for greater coherence.

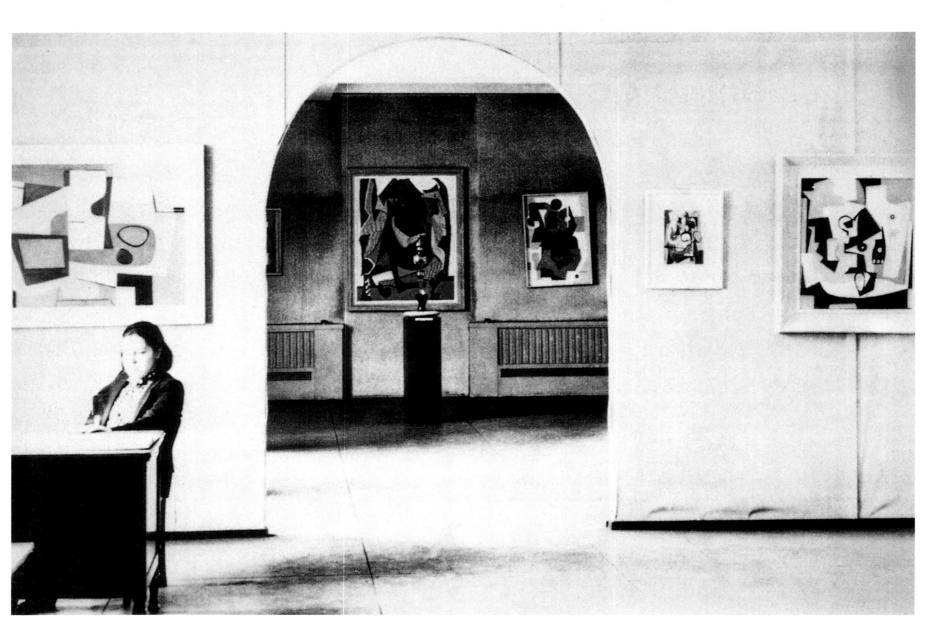

169 View in first American Abstract Artists
Exhibition, Squibb Galleries, 1937.

FOUR

MONDRIAN'S NEW WORKS: THEORY AND PRACTICE

Carl Holty wrote in an entry to his diary on March 14, 1944:

> Poor Piet, he really, from the bottom of his heart, wanted to fight all the things that oppress artists. He wanted to free them from the weight of their personality, free them from the suffering of their struggle with nature, free them from the superb game one plays only with the gods – the rhythmic mastery of space. So everybody feels oppressed by what Piet indicated they should do. For most of us are wedded to our oppression through an umbilical cord which is never cut – that is, until we are carried out feet first. Piet, the Puritan, who lived the life of a monk for the joy of life![1]

It was true that Mondrian's theorizing went beyond simply composing pictures. He obviously saw himself as a prophet who would free artists from their past oppressions. The best place to propagate his ideas was America, the land of freedom in art as well as life. Not that American artists understood him any better than Europeans, but at least they were untrammeled by tradition and had no inhibiting laurels to rest on.

In several conversations with James Johnson Sweeney, Mondrian had expressed his fear of not being able to communicate his ideas. Even during his final illness he indicated regret at leaving paintings behind – Sweeney thought to so little understanding. To explain the artist's position vis-à-vis other artists, Sweeney used the analogy of a bus that he took and stayed on as it moved forward. Some who aspired to the modern idiom but not Mondrian's version of it never mounted the bus and thus were left behind at the point where he began the journey. Those who got on the bus and benefited from contact with the artist got off in time to practice their newfound ideas, but the bus moved on. Mondrian was always beyond reach, even of his closest followers.

In truth, he was opposed to followers because De Stijl held that artists should serve the idea of art as the quintessential image of life, rather than follow a cult of personality. Yet Mondrian wanted to inform, especially in America, and if he failed to proselytize many American artists, at least he gained their confidence and laid down "the prerequisites for understanding," as Holty observed.

In a short article written for *Cahiers d'Art*, in 1926 – the year of Mondrian's first contact with an American collector and the first public showing of his work in America[2] – he stated very simply the essential nature of Neoplasticism:

> . . . it is a great error to envisage neo-plastic work as a total abstraction from life. Because, precisely by its relationships and its plastic means, it can express [life] in a most intense fashion. . . . Abstract art is expressed by a most concrete image, by the most reduced and elementary form.

The artist then summarized the steps by which this form of universal expression had been reached:

> the true unity of surface exists in a total equivalence of planes and ground, or, better, that the ancient ground of the surface must not exist at all. . . . only the equilibrium of planes in color and others in non-color [white, black and gray]. The plane becomes [the] sole plastic means and of the highest importance in the painting. . . . At the same time, just as visual third dimension in the new painting is lost, it is expressed by values and color in the plane.

To the above, Mondrian appended in a footnote that he had used the denomination *l'art abstrait-réel* before changing it to *le néo-plasticisme* in order to define his "personal fashion of envisaging this movement" (the first term actually conveyed his meaning more clearly than the second). Although he was to reiterate these themes more elaborately in later writings, the artist had unwittingly placed them in closer proximity here than ever again; they were the two foci around which his American influence would pivot. Destruction of the ancient object-ground relationship through use of variants on his means would be the prime concern of Mondrian's immediate followers in America, but re-interpretation of the very meaning of a work of art would be the long-term by-product of his influence here. The latter concept put in other words – that abstract art contained its own "reality" and therefore did not need to depend on any idea or image outside of its own parameters – would not reach full fruition in the work of other American artists or in American criticism until the 1950s and 1960s.

According to Mondrian's logic, not even the American Abstract Artists were as "abstract" as they believed.(169) He might have conceded that most of them no longer "'stylized' the natural apparition" nor even the "abstraction of this apparition" (his words for early stages of the process of abstracting).[3] In fact, they did not begin with nature at all but with "reduced" rectilinear or curvilinear shapes.(170) Even though these shapes were free from the associations of Synthetic Cubism or Surrealism, they were still too close to nature, being not only impure in color – "not yet primary," in Mondrian's words – but spatially unresolved. That is, when given diagonal edges, when placed diagonally, or when overlapped opaquely or transparently, they seemed to move within or hover over space, almost as their objective counterparts did in traditional works.(171) Even if separated from one another, the shapes' geometric clarity and completeness prevented their integration

105

172 Albert Swinden, *Introspection of Space,*
c. 1944–48.

with the areas between them.(172) Because their contours were never bro-
ken nor allowed to blend, the shapes seemed to remain as impalpable objects
floating above an impalpable ground.(173)

Actually, the Americans' method of abstraction was much closer to
Kasimir Malevich's than Mondrian's. What the Russian artist called the
"supreme" or "*gegenstandslose*" world was based on concept rather than per-
cept. As he wrote:

> When, in the year 1913, in my desperate attempt to free art
> from the ballast of objectivity, I took refuge in the square
> form and exhibited a picture which consisted of nothing
> more than a black square on a white field, the critics and,
> along with them, the public sighed, "Everything which we
> loved is lost. We are in a desert. . . . Before us is nothing
> but a black square on a white background!"[4](174)

173 Jean Hélion, *Composition*, 1934,
Guggenheim Museum.

Left:
174 Kasimir Malevich, *Painterly Realism.
Boy with Knapsack - Colour Masses in
the Fourth Dimension*. Oil on canvas,
28 x 17 1/2" (71.1 x 44.5 cm). The
Museum of Modern Art, New York.
Acquisition confirmed in 1999 by
agreement with the Estate of Kasimir
Malevich and made possible with
funds from the Mrs John Hay Whitney
Bequest (by exchange). Photographic
© 2001 The Museum of Modern Art,
New York.

Malevich was probing for the essential "spirit of non-objective sensation which pervades everything," of which the trappings were no more symbolic, he thought, than the bottle is symbolic of the milk. To express the true "feeling" to be found in masterpieces of the past required a new symbolism which the artist presented as follows:

> The black square on the white field was the first form in which non-objective feeling came to be expressed. The square = feeling, the white field = the void beyond this feeling.

Although he claimed as an "evident fact that feeling had here assumed external form," Malevich failed to explain how the square coordinated visually with the field. Nor did he distinguish the square from an object seen against a background as in traditional painting. In other words, the Russian artist had not solved the spatial ambivalence of Cubism.

175 Pablo Picasso, *The Kitchen*, Pairs, November 1948, Oil on canvas, 69"x 8'21/2" (175.3 x 250 cm). The Museum of Modern Art, New York. Acquired through the Nelson A. Rockefeller Bequest. Photograph © 2001 The Museum of Modern Art, New York.

According to an essay by Daniel-Henry Kahnweiler, there is evidence that Picasso understood this problem in early Cubism and sought to correct it later, although his method was somewhat quixotic. In works painted after November 1948, which belonged "to the beginning of the ultimate phase of Cubism," Kahnweiler said, the artist realized that while he and the other Cubists had clarified volumes, they had left the space around them ambiguous. He therefore began to avoid intersecting lines and to knot the ends of lines at their ends or where they crossed.(175) As Picasso explained to Kahnweiler:

> I don't want the eye of the spectator to plunge into the painting. Everything about it is true, you see. That is why there are no intersecting lines, for they would produce at once a three-dimensional effect! That is why I have tied the lines into knots. When they come up against something hard they stop.[5]

176 Joan Miró, *Swallow of Love*, 1934,
Nelson Rockefeller Collection.

Mondrian might have said that the Americans, too, had fallen into the illogical spatial trap of Cubism, which was inherited by Constructivism (as the general movement that started in Russia came to be known).[6] That is, although the Americans' shapes were abstract (or concrete, or "real," as the elder artist called them variously), the ground was not; it still gave the effect of space receding from the frame, as it does in the interior of a cup when the viewer looks away from the rim. Space, in such cases, bore exactly the same relationship to the frame as in paintings of the Renaissance, save that it was not bounded by walls nor specified by earth-sky-horizon demarcations. Since there was no allusion to natural objects, the painting space was only vaguely suggestive of natural space, but still it was less specific or "concrete" than the elemental shapes were presumed to be; the shapes and space were thus incoordinate. The Americans' chief deviation from the constructivist format was in adding biomorphic shapes from Surrealism, particularly shapes borrowed from Miró's paintings, which were frequently shown in the country in the early 1930s.(176, 177)

Following spread:
177 Arshile Gorky, *Garden in Sochi*,
1940 –41.

178 Detail of *Composition*, 1921.

179 Detail of *Composition*, 1921.

Sweeney understood the inconsistencies of Cubism; he wrote for the Gallery of Living Art catalog in 1933 that when artists gave up the "old absolute perspective" for one in which each area of the painting had a different viewpoint, there was no reason not to take the next step of no naturalistic intent at all and allow the artist to "express himself directly." He said that Mondrian had done this when he "decomposed [matter] into simple surfaces or simple lines . . . where the various planes are juxtaposed, and only enter into movement with one another in virtue of their contrasting colors." Sweeney clarified this point in his book *Plastic Re-directions in 20th-Century Painting*, of 1937, when he wrote (p.30) that the artist, "through a schematic suggestion of planes and a bold opposition of broad areas of pure color, strives to set up what he terms 'free rhythms' in contradistinction to the natural rhythms of limited forms." Nevertheless, Sweeney did not consider the spatial problems that would occur when Mondrian set out to work directly with artistic elements.

De Stijl artists alone discussed the exigent problems that they had to contend with in direct expression. Vantongerloo wrote, for example, that the straight line lent itself "less to the imitative than the curve" because there was only one straight line, and there were many different kinds of curves. He also dealt with the difficult problem of space, as in this passage:

> Art has no dimension and is, by its nature, as time and space. In order to determine space, I must take a point of comparison and, by rapport with its volume, posed in space, I must likewise determine its relation by rapport with another volume.[7]

The only layman to approach the question of space with specific reference to Mondrian was Herbert Read. In the English publication *Circle* (1937), he wrote that whereas Dali creates a "dream perspective,"

> an abstract artist like Mondrian attacks the same concept frontally. He presents us with a bare arrangement of lines and two or three pure colours which create and affirm the concept "space" in the most direct and unequivocal manner. The purer and more fundamental the elements which are used, the acuter and purer is our emotional awareness of "space" [making] our physical awareness of the concept more direct, more exact.[8]

Mondrian also wrote of "the direct creation of universal beauty" in his essay for the same issue of *Circle*, published the year before he moved from Paris to London.[9] Arguing that Surrealism's "descriptive character demands figuration . . . ," it was generally unrealized, he said (p.65), that "it is possible to express oneself profoundly and humanely by plastics alone, that is, by employing a neutral plastic means without the risk of falling into decoration or ornament." By "neutrality," he did not mean blandness but "a dynamic equation, or rhythmic interaction of plastic means, in which forms create relations and . . . relations create forms [and] neither takes precedence." It was "of the utmost importance," the artist insisted, that the solution to this problem should be solved pragmatically, in terms of art, and not theoretically. "The work of art must be 'produced,' 'constructed'," he said, but as to how this should be done in the studio, he was imprecise.

Probably motivated by the general lack of understanding he encountered in America, as well as by a genuine desire to elucidate his ideas, Mondrian made his most thorough attempt to explain the application of his theory in "A New Realism," written for his Nierendorf Gallery lecture of January, 1942. He again negated the idea that art should be simply the expression of space, since space does not represent life but only contains it. Without human scale, unlimited space can evoke feelings of awe and depression. In art, therefore, space must be controlled plastically by reduction of three-dimensional space to the conformations of a two-dimensional canvas. The artist's way of stating this idea was that "in abstract art, space determination, and not space expression, is the pure plastic way to express universal reality."

In practice, Mondrian meant that he had found it necessary to invoke not "space" but "a space," an area crossed in its length and breadth by lines that determined its dimensions. Of course, the word "line" is only a term of convenience; when anyone mentioned lines to the artist, he asked: "What lines? I don't see any lines." The blacks were planes in the same way as the white and colored rectangles. Although there appeared to be rectangles where the "lines" crossed one another, these were only by-products of the positioning of lines and were not to be taken as rectangles unless they were colored differently from the base plane. The artist interrupted the lines before they reached the canvas edges in some early works, to show that the black linear planes were independent of the colored rectangular planes that they bordered.(178-180) Rectangles represented in his system "forms" and "colors," both of which he had attenuated to their "purest" or least equivocal states.

180 Mondrian, *Composition*, 1921. Oil on canvas, 29 7/8 x 20 5/8 (76 x 52.4 cm). The Museum of Modern Art, New York. Gift of John L. Senior. Jr. Photograph © 2001 The Museum of Modern Art, New York.

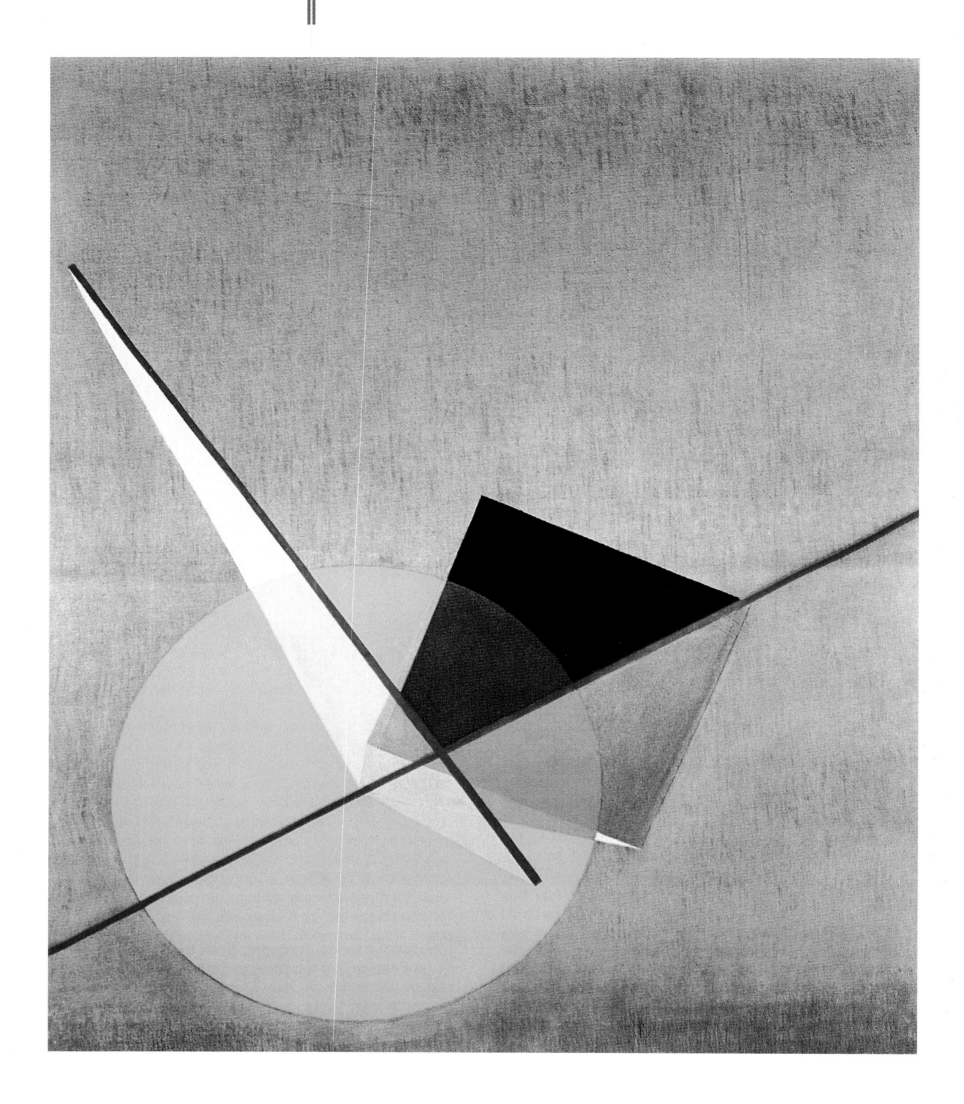

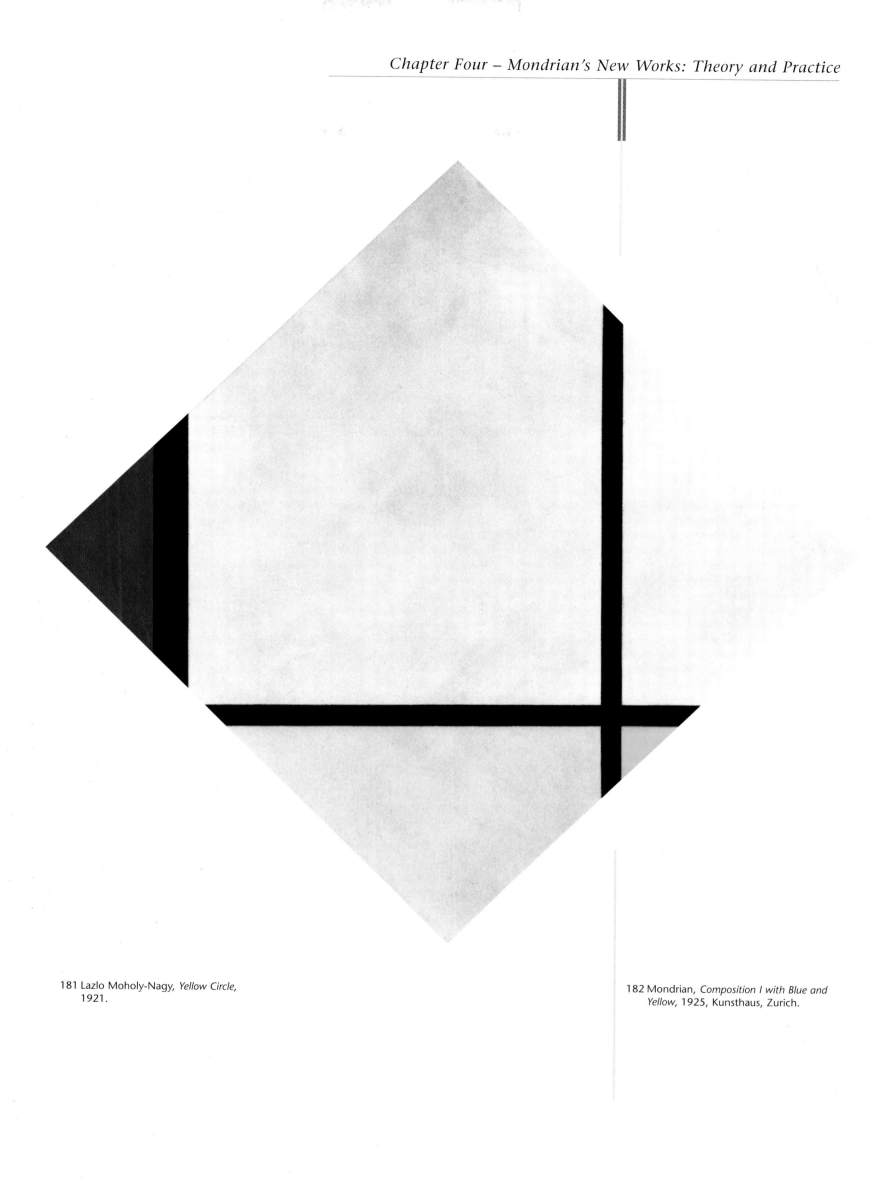

181 Lazlo Moholy-Nagy, *Yellow Circle*, 1921.

182 Mondrian, *Composition I with Blue and Yellow*, 1925, Kunsthaus, Zurich.

Nevertheless, Mondrian could not isolate them nor leave them unbounded by the lines, because the rectangles would then appear as entities. He did not deal specifically with this point in his Nierendorf essay but implied it by saying that to represent varied forms objectively would only express their particular aspects as "men, animals, plants, objects, etc." Should the artist transform them further through "subjective expression," he said, that would merely produce "other limiting forms." The only way to "establish a clear expression of pure reality" would be to bring these forms, as well as the space they occupied, into equivalent relationship.

Mondrian seemed to propose an intermediate category between "the objective expression of forms" – as in realistic art – and "the transformation of the limiting forms into a more or less neutral form" – as in abstract art. In this middle category was an art in which, "through subjective transformation, other limiting forms appear." The latter could be taken as a reference to the imperfect solution of Constructivism, whose artists reduced objective forms to "other limited forms" but did not destroy their particularity by bringing them into accord with ground, or "determined" space. Mondrian did not speak to the point of constructivist painting directly, however. While in England, he had even allowed himself to be called a "London Constructivist," probably at the insistence of Gabo, who reported this acquiescence with some satisfaction.[10]

Generally, the artist used "constructive" in its generic form and opposed it with the term "destructive," as in the following passage from his essay in *Circle*:

> It is of the greatest importance to note the destructive-constructive quality of dynamic equilibrium. Then we shall understand that the equilibrium of which we speak in non-figurative art is not without movement or action but is on the contrary a continual movement. We then understand also the significance of the name "constructive art."

When discarding various alternative terms for abstract art at the beginning of "A New Realism," however, he said: "'Constructivism' might also be misunderstood, since Abstract Art requires destruction of particular form." It would seem that Mondrian had given up the term "constructive," or "construction," by this time, regarding its opposite – "destructive," or "destruction" – as the positive corollary to abstract art.

In this same essay, he explained that "abstract forms or dislocated parts of forms have to become completely neutral in the composition." In other words, only by destroying the particularity of forms could the artist resolve them into reciprocal, universal relationships. It was impossible to neutralize curved forms, but even rectangles had to be integrated, or harmonized (other meanings behind the term "neutral") with the space, else they would appear to be discrete. Like curved forms they, too, would act as *repoussoir* agents that made the ground appear limitless rather than limited, that is, a quasi-natural "space."

If the rectangles were placed diagonally, as in Malevich's or Moholy-Nagy's paintings (174,181), they appeared to penetrate this space like "receding" orthogonals, even when not submitted to a system of convergence. By maintaining their vertical-horizontal placement and binding them

with the space-limiting lines, Mondrian brought rectangles into equivalence with non-color areas or "spaces," which had also been formed into rectangles by the crossings of the lines. All contiguous entities and areas were then in "rapport" (Vantongerloo's term) and thereby demonstrated "the unity of form and space."

The artist's further statement in "A New Realism" that "three-dimensional space had to be reduced to two-dimensional appearance . . . not only to conform to the canvas but to destroy the natural expression of form and space" should be emphasized, especially the words "to conform to the canvas," because they suggest that Mondrian conceived the painting as complete in itself, thus obviating any predilection for reading the lines as being extendable beyond the canvas.

Extendability is a problematic point in the artist's ideology and practice, especially in hindsight. A popular idea of the 1960s was that he adumbrated "field" painting, which was defined by Barbara Rose as a "new kind of all-over composition in which identical, usually geometric, motifs are repeated over the entire surface of the canvas — now conceived as a limitless field in an infinite space overflowing its edges."[11] For instance, David Rosand compared Mondrian's use of the frame with Degas's, as a device for isolating, in a "vast field" of space, "only a portion [of] an implied continuum." Allan Kaprow assumed that one of the artist's paintings was not finite but that "those rectangles formed by the canvas' edge and two or three lines can be completed anywhere outside the field." He paraphrased Meyer Schapiro's words, that: "The picture edge is not felt to be a real caesura. Thus the 'whole' painting is fragmentary, in spite of its first appearance of clear composure."

In a paper presented in the Mondrian Symposium held at the Guggenheim Museum in the fall of 1971, Max Bill expressed a theory that the lines of one of the artist's paintings, *Composition I with Blue and Yellow*, 1925, (182) "lead into the infinite and lose themselves beyond all conceptual frames of reference." He went so far as to say that Mondrian's greatest achievement and his work's most compelling quality lay in the fact that it was conceived as the nucleus of "an order capable of unlimited extension."[12] Bill considered the principle of extension to be most effective in the paintings that "are square and stand on one corner." (He said the artist referred to these as "lozenge," or "rhombic" paintings, but that he preferred the term "acute.")

E. A. Carmean, Jr, referring to them as "diamonds," in an essay for the catalogue of an exhibition of these paintings at the National Gallery of Art in Washington DC, also expressed the opinion that "the extension of certain shapes past the boundaries of the picture is implied." This "cropped effect," Carmean thought, was "central to the mature paintings [and would] continue until Mondrian's last diamond picture."

183 Mondrian, *Composition II* (Detail), 1929, Museum of Modern Art, New York.

Others countered this idea. Sweeney said that the artist intended only a limited extension of those rectangles that might appear to be truncated, especially along the edges of the angled paintings. Mondrian's closest followers disagreed entirely. Ilya Bolotowsky reflected that Mondrian "did not think of extending lines nor conceive his paintings in that way — if he had, they would have been only chopped-up larger paintings." "If the lines had been extended into space," said Bolotowsky, "the image would have rotated like a swastika."[13] Holty reported that the artist became furious when an

acquaintance said his work represented "the division of space." "Mondrian was emphatic in his reply, saying that his work showed 'the determination of space,'" Holty continued, "meaning that it is not infinity; those who speak of the infinite in his work are wrong." Of what he called the lozenge paintings, Holty said that the artist intended their internal forms to be resolved on the surface. The triangular segments along the borders, whose diagonal edges responded to the diagonal limits of the canvas, were to be considered as complete, even though he did intend a "feeling" of extension and an implied alliance of their verticals and horizontals with structural elements in nature and architecture.

That Mondrian wanted literally "to conform to the canvas" is borne out by his removing the canvas from all former associations of window or opening on the wall. In order to destroy the traditional importance of the frame as a device to separate the spectator from an illusionary area of depth, he removed the type of frame that was fitted flush with the canvas, mounted the canvas on a backing of white painted wood, and painted the elements beyond the canvas's surface onto the exposed canvas edges.(114; 86-88) Again, those who knew the artist threw light on his motivation. Holty said that he painted around the edges of the canvas to make it "solid" but did not do this consistently:

> Mondrian was not always sure he was right. He was a painter
> – an abstract painter. It was all right for others to work in
> three dimensions. He always came back to Leonardo.

Bolotowsky reinforced this point, in a different context, explaining that the artist did not just execute a plane: "He painted around corners because he was interested in architecture; also, it made the work final – not illusion." By this practice, Mondrian literally made the painting into an object that projected into, and imposed itself onto, the space of a room. It no longer alluded to an unlimited space beyond its boundaries or surface but became its own palpable, or "limited," space. Thus, the painting established an object-space, against a wall-space, within a room-space. It presented itself as an intrinsic form of individualized "reality," yet, according to Hegel's principle that a thing carried to its extreme becomes its opposite, it became a reflection of extrinsic, universal "reality."

After the artist's Nierendorf presentation as well as the demonstration that he provided by hanging his works in frequent exhibitions, a few more viewers began to understand them in terms beyond mere formal alignment of parts. George L. K. Morris showed this understanding in an article written for *Partisan Review*, in the following year – 1943 – when he discussed the fluctuating interchangeability of properties in painting and sculpture as revealed by the history of art. "Picturesquely remote illusions" and "sculptural hereness" were exchanged in both art forms without affecting the quality of either. Mondrian's paintings went furthest toward being sculptural objects, he said, because "the very frame (set behind the canvas-surface) pushes the area forward instead of letting the spectator into the wall." Whereas "previously the sculptural traditions had presented forms inside the painting realized in sculptural terms . . . Mondrian gives us a thing in itself – and here we have something entirely new, a fragment of the modern world, concise, compact, and complete."[14]

184 Mondrian, *Composition in White, Black, and Red*, 1936. Oil on canvas, 40 1/4 x 41" (102.2 x 104.1 cm). The Museum of Modern Art, New York, gift of the Advisory Committee. Photograph © 2001 The Museum of Modern Art, New York.

185 Detail of above.

The artist was certainly aware of this dichotomy between sculptural and optical space, because he argued with Gabo in London over what was, to him, the necessity of reducing a painting surface to two dimensions. Gabo referred to their disagreement on this point in a 1966 interview,[15] when he said of Mondrian that

> He was against space. Once he was showing me a painting. "My goodness!" I said, "Are you still painting that one?" I had seen it much earlier. He thought there was still too much space in the white, and he denied any variation of colour. His ideas were very clear. He thought a painting must be flat, and that colour should not show any indication of space. This was a main principle of neo-plasticism. My argument was, "You can go on for ever, but you will never succeed."

Obviously, the artist believed that only by careful execution could he make his surfaces appear to be flat. That is, only by repeated applications of paint — whether in color, or "non-color" — could he create surfaces that were both attractive and objective. However, their effectiveness would extend beyond mere exigency. "Such work can never be empty," he said, "because the opposition of its constructive elements and its execution arouse emotion."[16] In fact, Holty thought Mondrian's care in execution made the difference between his paintings and those of his followers. Even if he did not strive for an obvious painterliness, the artist achieved a very personal and traditional (perhaps European) patina, as can be seen in a close examination of his surfaces.(183) Again, according to Holty:

> Mondrian used light grey, expensive canvas, carrying the white in memory until he finished. If the color appeared too red or yellow, he'd change it. When he did get to the white, he'd pile it up in great mounds, then begin the infinitely tedious process of smoothing it out. That was an endless affair, brushing it now this way and now that to get as many of the strokes out as possible.

Before he found out about colored tape, Mondrian used stiff cardboard to keep the planes separate and the lines straight — a practice that was especially important with paint applied in different thicknesses. He not only left the whites thick but painted the whites again and again to give them a special intensity as well as to mitigate the strength of the blacks that otherwise would appear to come forward, like a grid. Despite the fact that in later years critics frequently referred to a "grid" when describing the artist's work, he never mentioned the term and would, in fact, have found it untenable. The blacks had to be kept lower, like "ditches" (130,131), but because they were "elements, or intervals used to hold the planes in tension, with kinetic space," according to Holty, they had to be viable with the whites. Mondrian repainted the blacks, too, until they held their own with the whites. That is why, in London, Read found him always painting the black lines in the same picture, and why, in New York, Sweeney found him varnishing the black lines.

When the artist had finally finished the painting process, his white spaces did not recede but seemed to lie on the surface, gleaming with light.

As the "tensions" pulled between planes of different sizes, intensities, and thicknesses, the surfaces also seemed to quiver, even though they resolved rhythmically into ultimate "equilibrium."

In New York, the artist continued to finish paintings as he had begun them in Europe (except for the addition of unbound color patches). He also continued to produce paintings with some black in them, but all of these were begun before the spring of 1942. Mondrian's elimination of black in 1942 was not a reaction to the new environment so much as a continuing imperative to neutralize, or harmonize the elements. Apparently, he tried to explain his rationale in a number of conversations with Sweeney. In an important letter to Sweeney dated May 24, 1943, the artist indicated that "Cubism *au fond* remained natural and was only an abstraction but not abstract." According to his conception of abstraction, the volume expressed (in early Cubism, at least) "just has to be destroyed" – Mondrian underlined here for emphasis and added (upside-down in the margin): "I think the destructive element is too much neglected in art."

The artist did not go into detail on how or in what works, but he listed several abbreviated steps to explain "why I left the cubist influence." We can surmise from the first step – that "I came to destroy volume using the plane" – that he had in mind works beginning in his late teens and early twenties. For example, in a painting such as *Composition with Colored Planes No. 3, 1917*, he had reduced volumes to rectangular planes placed frontally on a canvas. Because they were separate and freestanding, however, these planes seemed as spatial as in Cubism's "diagonal disposition of planes" (Holty's phrase).(74)

"Then the problem was to destroy the plane also," Mondrian explained further, and moved directly to the next destructive step: "This I did by means of lines cutting the planes." Actually, these words abridged a process that lasted from the early 1920s into the 1930s, during which the artist bound the planes contiguously with lines that continued beyond them (to and sometimes over the canvas edges) in many variations of size, position, and color weight.(186-188) By adding the lines, he had brought "means" (color and non-color planes), "structure" (black linear planes), and "space" (canvas space), into harmony[17] – but was this a true image of harmony when components were still discrete, in one case to the point of saturation?(189)

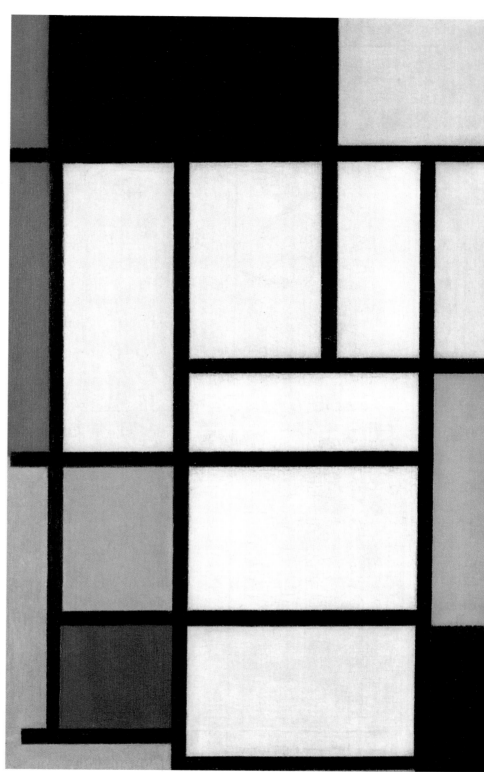

186 Mondrian, *Composition with Red, Yellow, and Blue*, 1921, Gemeentemuseum, The Hague.

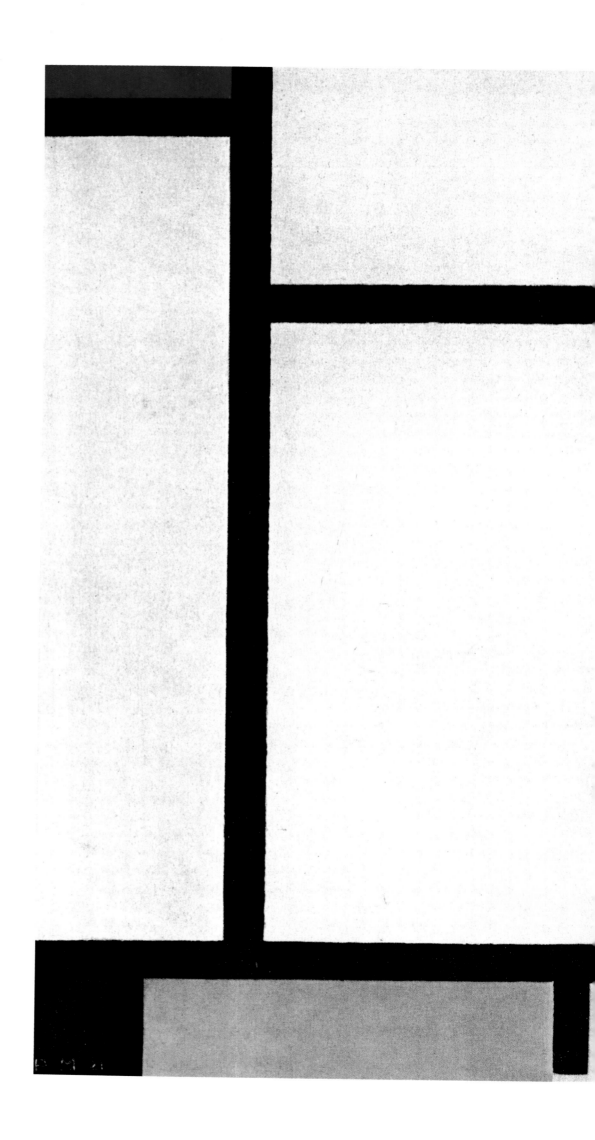

187 Mondrian, *Composition with Red, Yellow, and Blue,*
1921, Gemeentemuseum, The Hague.

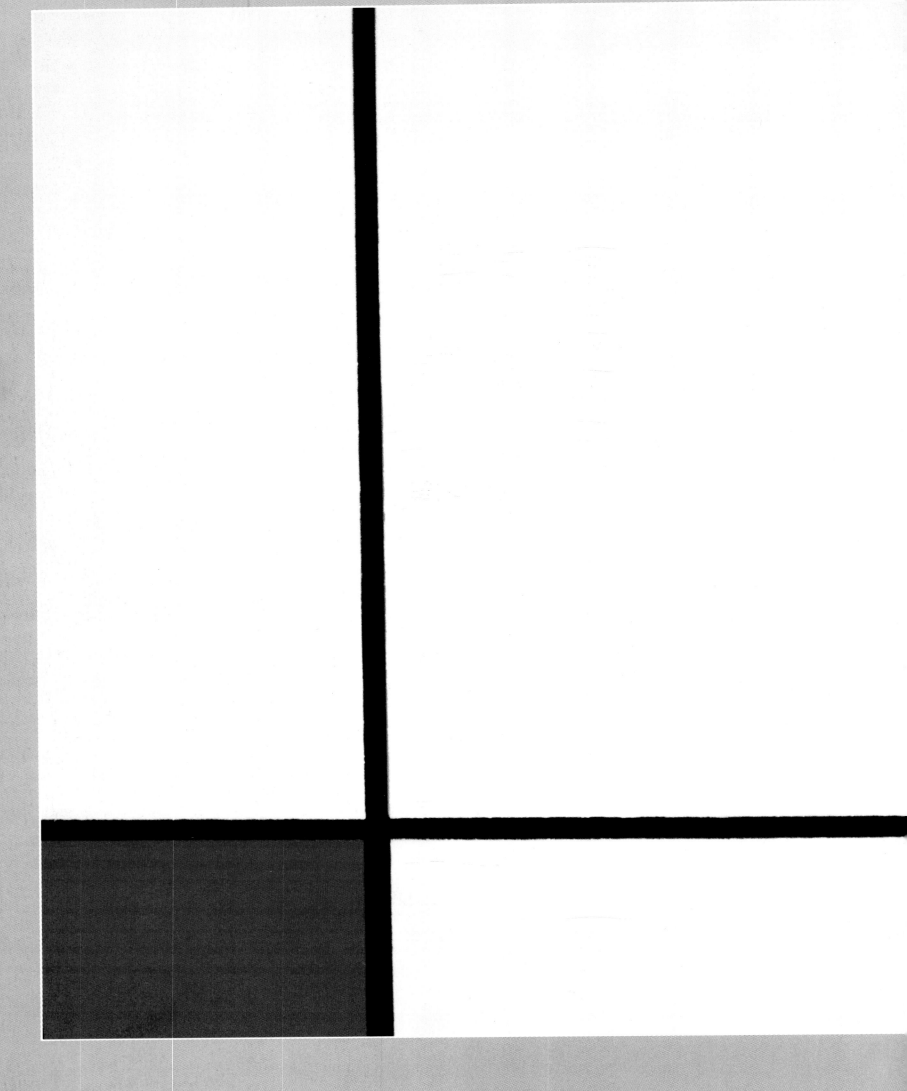

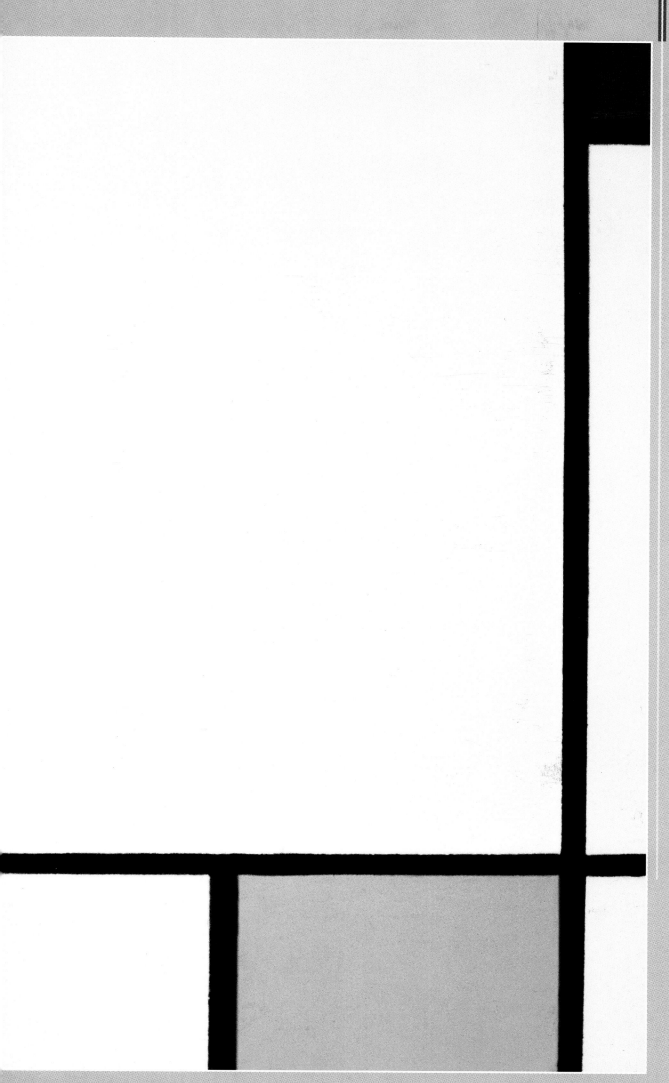

188 Mondrian, *Composition with Red, Yellow, and Blue*, Stedelijk Museum, Amsterdam.

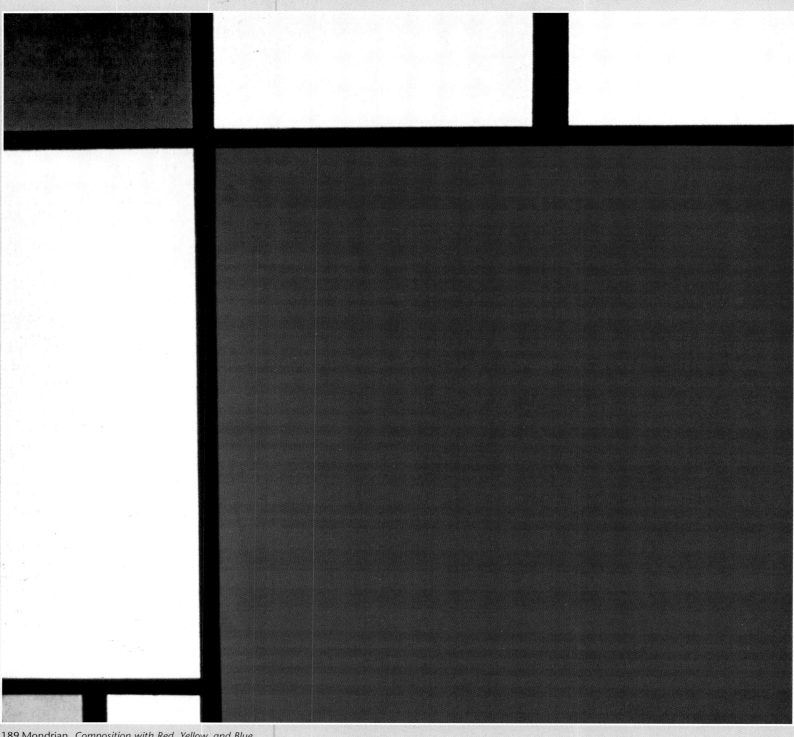

189 Mondrian, *Composition with Red, Yellow, and Blue*,
1930, Armand Bartos Collection.

Opposite page:
190 Mondrian, *Composition with Two Lines*, 1931,
Stedelijk Museum, Amsterdam.

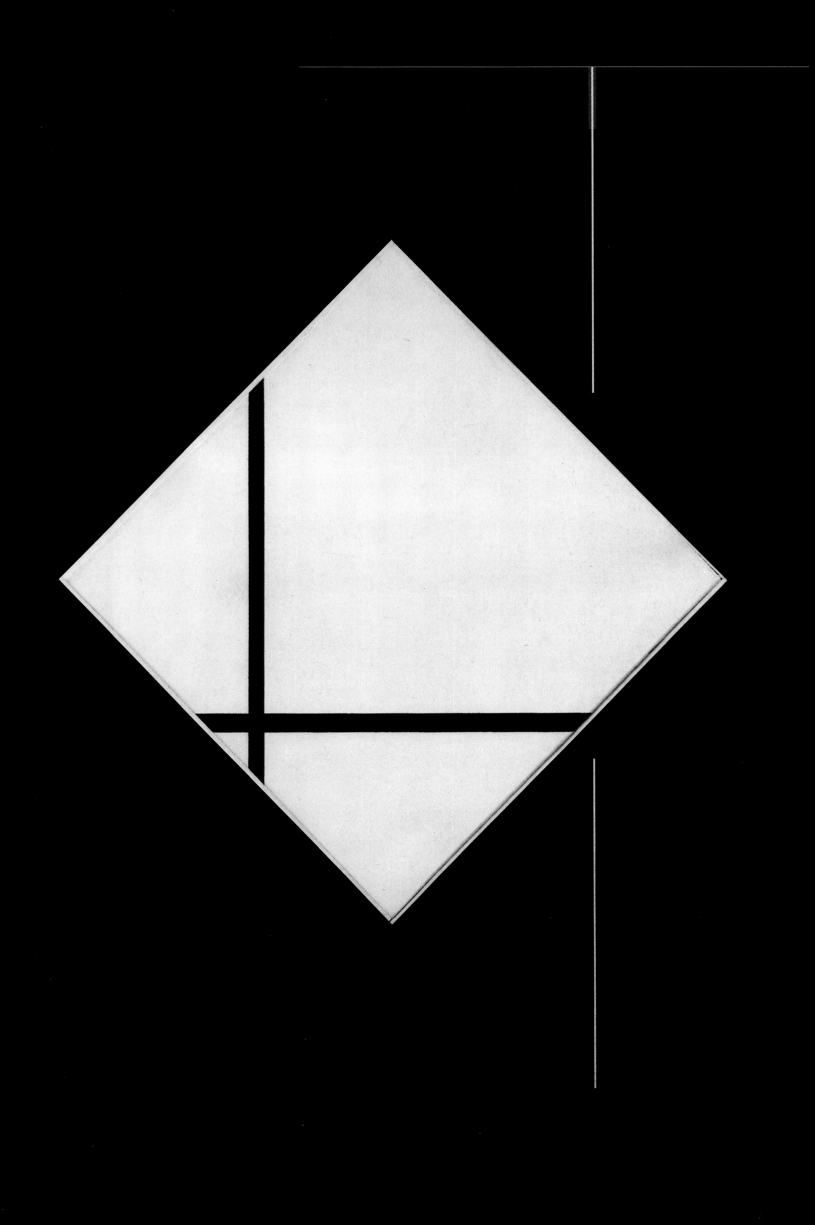

Radical simplification seemed to be the answer, so Mondrian reduced his elements in the 1930s to as few as one vertical and one horizontal (190) and often added only one colored plane, or none at all, to a composition.(191) Before leaving Paris, he had begun pairing thinner versions of his verticals or horizontals (192), but not until London did he further increase their number.(193) This was when the artist realized that his spareness had overemphasized structure and, ironically, had made the paintings appear "too monumental"; also, reducing the number of colored planes had made the remaining ones appear too prominent.[18](194)

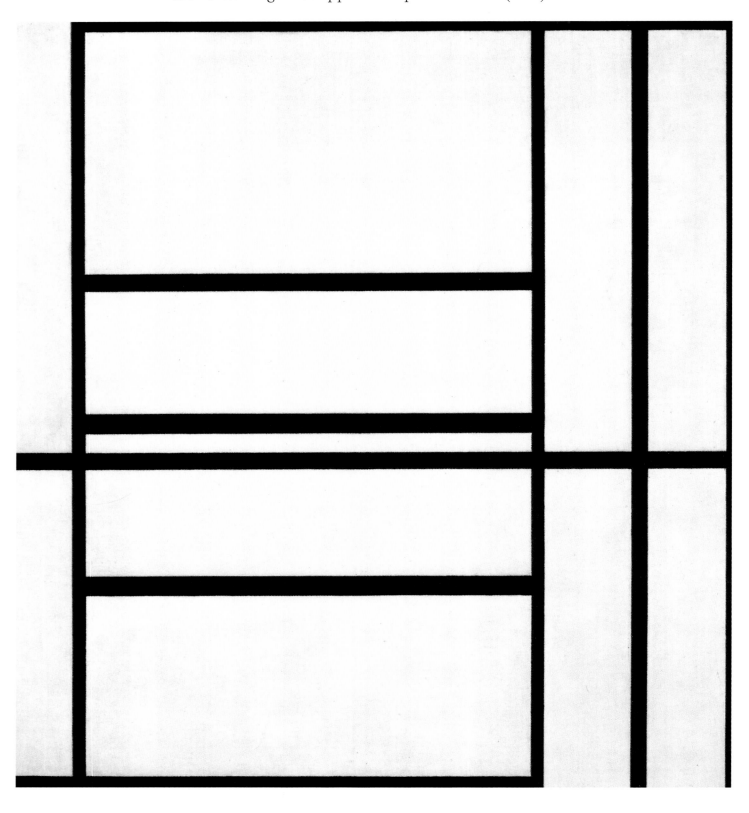

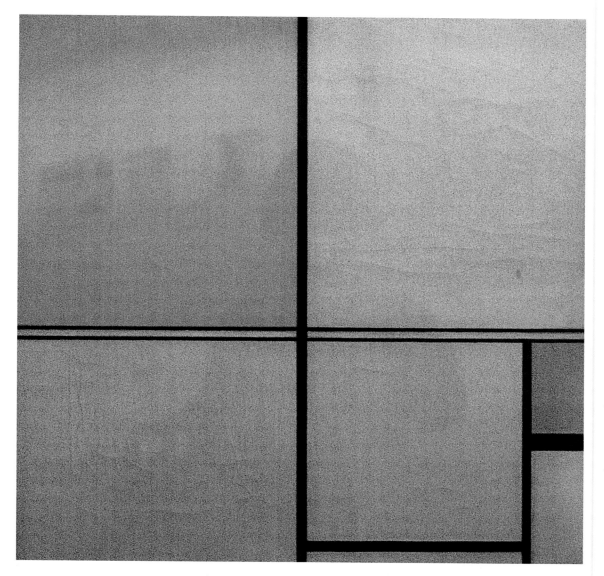

191 Mondrian, *Composition with Red*, 1939, Peggy Guggenheim Collection, Venice.

192 Mondrian, *Composition B with Gray and Yellow*, 1932, Muller-Widmann Collection, Basle (the artist's first use of double lines – this was photographed by the author, as were others that could be identified, in the Mondrian Centennial Exhibition, Guggenheim Museum, 1971).

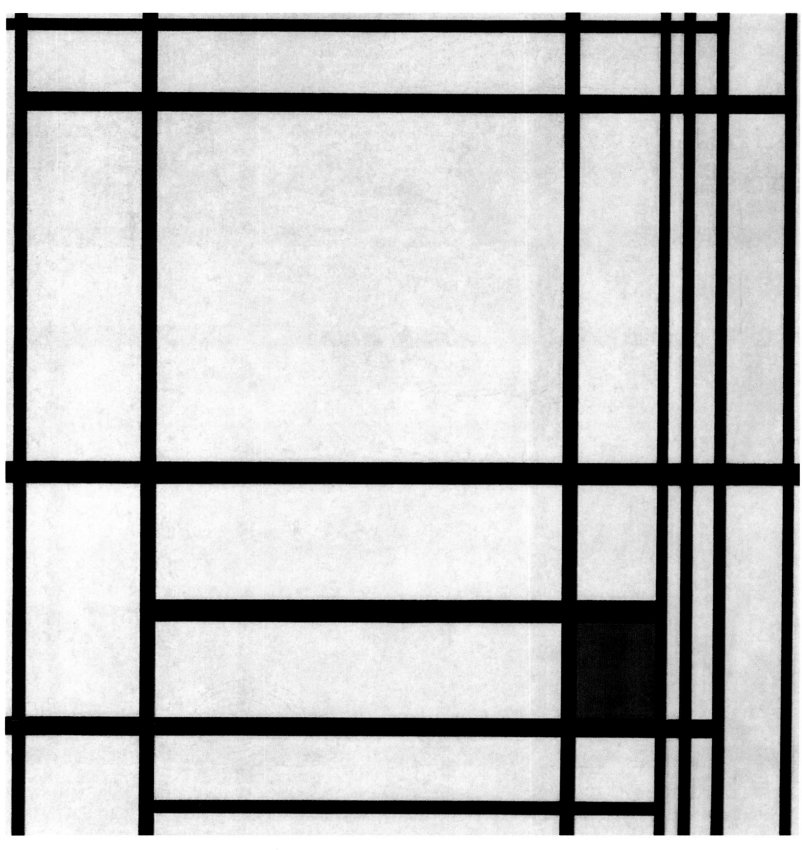

193 Mondrian, *Composition with Blue*, 1937,
Gemeentemuseum, The Hague.

194 Detail of above.

To take emphasis off of the planes, Mondrian then increased the number of horizontals and verticals according to his explanation in "A New Realism," that "in art, as in reality, the plurality of varied and similar forms annihilates the existence of forms as entities."(102) In some paintings he further suppressed the planes by cutting across their surfaces with lines.(114; 195) This is what the artist meant by saying in the Sweeney letter that he had destroyed the plane "by means of lines cutting the planes."

195 Mondrian, *Abstract Composition*, 1939, Taft Schreiber Collection, Beverly Hills (photographed at Guggenheim Museum, 1971).

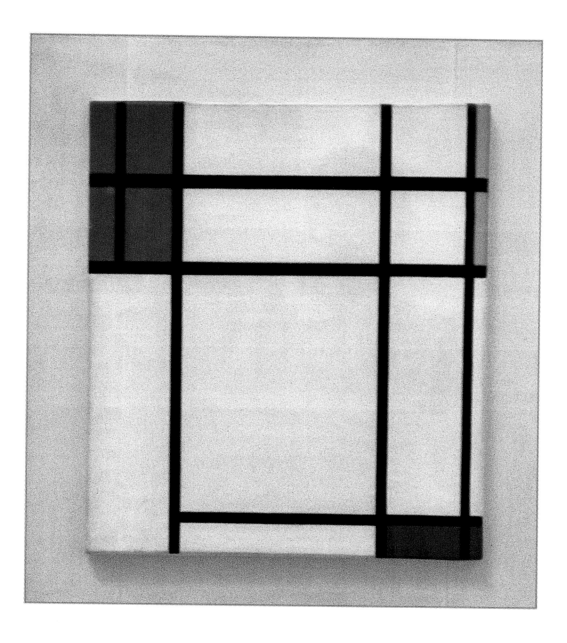

"But still the plane remained too much intact," he continued in Sweeney's letter, and declared: "So I came to make only lines and brought the color in these." Of course, there were intermediary stages in which Mondrian added small, unbounded color planes to the first "European" paintings completed in New York.(122,123; 196,197) He gradually added color lines to the paintings begun in New York – at first, in response to the greater color and vibrancy of that city as well as to the rhythmic color usage of American artists.(198,199) "Pouring color into their black veins" were words that Sweeney used to describe Mondrian's next attempt to avert his pictures' "monumentality."[19](130)

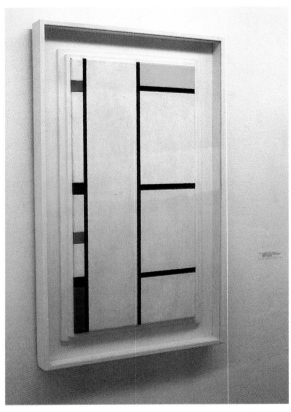

196 Mondrian, *Composition*, 1935–42, Tremaine Collection (photographed at the Guggenheim Museum, 1971 – may have changed hands since the deaths of Emily and Burton Tremaine).

197 Mondrian, *Composition with Red, Yellow, and Blue*, 1936–43, Moderna Museet, Stockholm (photographed at the Guggenheim Museum, 1971).

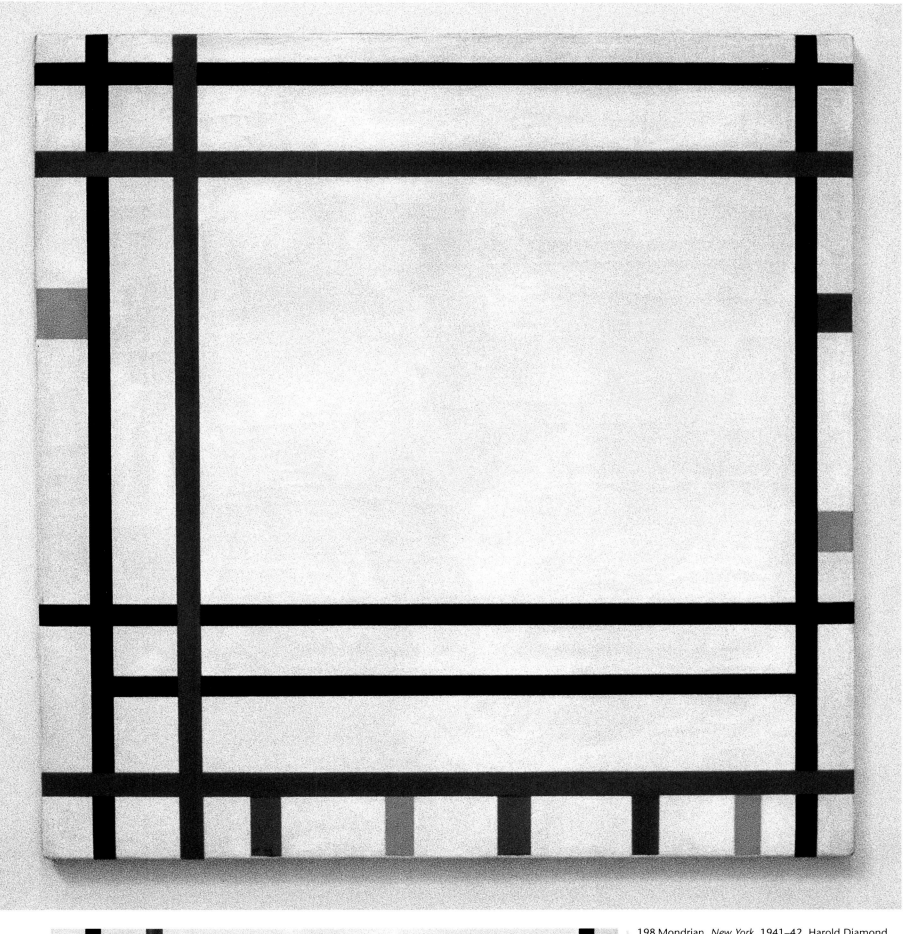

198 Mondrian, *New York*, 1941–42, Harold Diamond
 Collection (photographed at the Guggenheim
 Museum, 1971).

199 Detail of above.

Even though neutrality, for the sake of harmony or unity, was his chief aim at this time, the artist still maintained the separateness of his elements, as he had in earlier paintings. Close examination of *New York City, 1942*, for instance, shows that even when painting a yellow line crossing another yellow line, he made the strokes appear to follow the directions of the lines.(200) This was a theoretical reflex on Mondrian's part, as was also his decision to place a different color above the others at each corner of the canvas – an obvious impossibility since there were four corners but only three colors.(201; 126-129) Not until he began to think pragmatically, or visually, could the artist see that the planes in color did not simply join when they met, as black ones did, but appeared to move over and under one another.(202) He had again produced the appearance of space – that is, a disunity of ground and elements; there was no longer a fine equivalence of structure and means with space.

200 Detail of *New York City*, 1941 – 42.

Mondrian had written in "A New Realism" of two kinds of unity. "Proper unity" could occur with repetition of simple shapes and forms, but if they remained too particular, or distinct, then a static balance resulted. In order "to establish universal unity," he continued, the elements had to be brought into "continuous opposition." The artist referred this point to himself in the letter to Sweeney, saying that: "Many appreciate in my former work just what I did not want to express but established by incapacity to express what I wanted: dynamic movement in equilibrium." "The great struggle for artists," he said further in the letter, "is to annihilate static equilibrium in the way of continuous opposition of the means of expression." Soon after *New York City, 1942* was shown in Mondrian's first exhibition at Dudensing's (January, 1942), he began work on *Broadway Boogie-Woogie*. Arnold Newman, who visited frequently in his studio, recalled that the artist gave him two drawings (around April) on which he had worked out ideas for this painting.(203) The black and white drawings gave no indication of color but showed arrangements of verticals and horizontals similar to those in the three *New York City* paintings. Although the present appearance of *Broadway Boogie-Woogie* would indicate that its basic structure consisted only of yellow-colored lines, along which were painted colored squares, von Wiegand remembered that this painting had once been similar to the *New York City, 1942*, with primary-colored, "interwoven" lines. The only hint of a difference in the drawings between the earlier and later paintings was that some lines were connected by rectangles that cut across the white planes; there was no suggestion of the colored squares.(204)

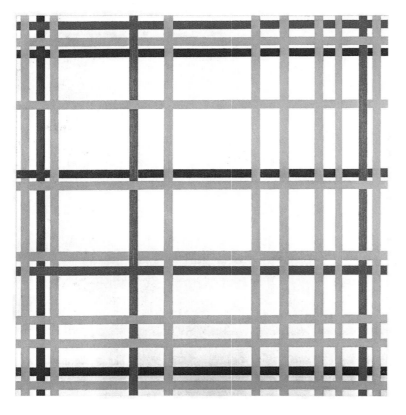

201 Mondrian, *New York City*, 1941 – 42.

STUDY FOR BROADWAY BOOGIE-WOOGIE (1942-43).

courtesy Sidney Janis Gallery, N.Y.

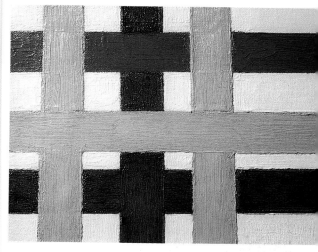

202 Detail of 201.

203 Mondrian, Studies for *Broadway Boogie-Woogie*, 1942, Arnold Newman Collection.
204 Detail of pen drawing on right above.

135

205 to 210 Mondrian, *Broadway Boogie-Woogie* (details), 1942–43, Museum of Modern Art, New York.

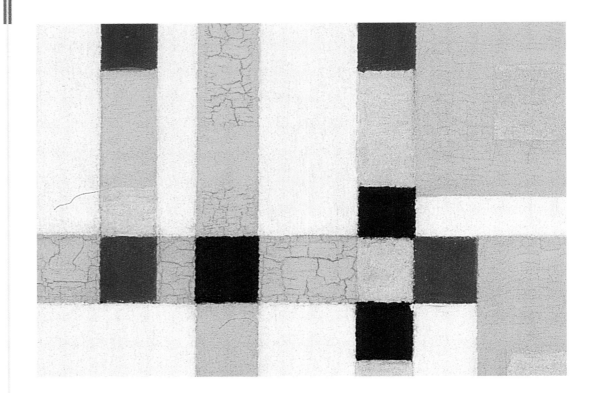

206.

These elements undoubtedly came from Mondrian's awareness of the spatial inconsistencies in the *New York City* paintings. His immediate solution was to pin the lines to the ground by painting squares of contrasting colors at their crossings.(205) If the squares were blue or red, he made them a darker-than-usual hue to compensate for the optical flicker noted in earlier paintings (in which lines at their crossings picked up an after-image of white that appeared to modify blacks into grays or, in these paintings, colors into their tinted counterparts). So that the crossing squares would not merely pin down lines but would still serve their primary function as means, the artist then painted other squares in alternating sequences of color along the segments of lines between the crossings.(206)

Mondrian explained his reasoning in the letter to Sweeney, which was written in the following spring: "Now the only problem is to destroy these lines also through a mutual opposition." Left as they were in *New York City, 1942*, the lines were too prominent; they therefore had to be cut with planes that countered their linear character. The small planes were also more integral with the spatial plane – especially when some of them, in alternation with blue and red squares, were painted a light gray.(207) In a painting that still had such linear dominance, however, the spatial plane appeared to be cut into many white rectangles. The artist had to mitigate them with smaller colored rectangles (208) to "annihilate" these whites as "entities" and neutralize their proportionate strength to the lines. When the smaller planes threatened to become too apparent, in turn, he laid planes of color across several of them, effectively cutting them into smaller units of equal size, and thus equivalence, with those that they cut apart.(209) Mondrian also inserted small squares onto larger squares or rectangles and inadvertently created another problem.(210) The superimposed squares were just that – they "floated" above colored ground. But when von Wiegand pointed out this inconsistency, he made clear that the act of painting took precedence over theory.

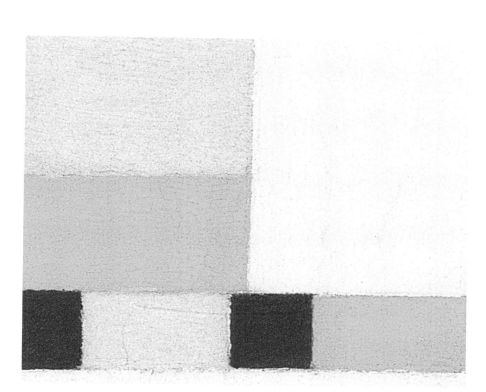
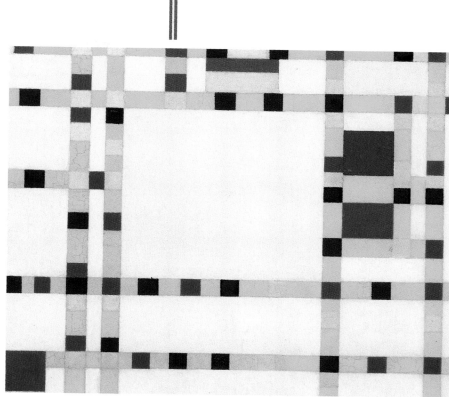

Holty said that the artist was still dissatisfied when *Broadway Boogie-Woogie* was finished. After he saw the painting hanging in the Museum of Modern Art, he felt that its effect was weakened by the preponderance of yellow. The colors had looked clearer and more distinct in the small space of Mondrian's studio than in the larger gallery at the Museum, where a desirable crisp effect was lost as the yellows appeared to bleed-off against the whites. This caused the surface to seem spotty and spatially unresolved.(211)

207 to 210.

211 Mondrian, *Broadway Boogie-Woogie*,
1942–43, Museum of Modern Art,
New York (it shows the painting hang-
ing in context).

He had to try again, this time bringing the ground into full orchestra-
tion with structure and means (now become one, as structure-means). As he
later wrote to Sweeney (in a postcard that came in the same mail as the
above-mentioned letter):

> Only now [1943] I become conscious that my work in black,
> white and little color planes has been merely "drawing" in
> oil color.
> In drawing, the lines are the principal means of expression;
> in painting, the color planes.
> In painting, however, the lines are absorbed by the color
> planes, but the limitation [contours] of the planes show
> themselves as lines and conserve their great value.

After this realization, Mondrian was at last ready to begin the new painting,
and he wrote in a note that came to Sweeney the following day:

> The true *Boogie-Woogie* I see as homogeneous with my intention:
> destruction of melody (natural appearances); construction,
> through continuous opposition of pure means. Dynamic
> rhythm.

In this painting structure, means, and space would not be separable but
work continuously together. Each would override, or "destroy," the domi-
nance of the other, even if no single element were sacrificed. Underlying
structure was viable in a basic framework of verticals and horizontals, but
these were no longer the attenuated linear planes of earlier paintings. Broken
into small colored planes that were strung together in structural directions,
they still preserved the "great value" of lines even as they also functioned as

means.(212,213) Similarly, when the larger planes were laid in contiguous sequences, they functioned as both means and lines.(214,215) Often indistinguishable in size from the white, spatial planes they cut apart, the colored planes also functioned as space.(216,217)

"I think the destructive is too much neglected in art," Mondrian had written to Sweeney. He was not thinking negatively. Destruction of "composing elements," through their complete integration, created a continuous visual interchange.(218,219) By bringing them into "universal unity" rather than "proper unity," the artist created "dynamic" rather than "static equilibrium" and, as a result, "dynamic" rather than "static rhythm." In the same letter, he had described van Doesburg's attempt to destroy the "static expression" in his Neoplastic paintings by placing his elements that represented structure and means diagonally. Mondrian objected to that solution because it destroyed the painting's psychic equilibrium and architectural relationships. The solution in *Victory Boogie-Woogie* – one he had often used before – was to turn the frame so that "only the limitation of the picture is in lines of 45°, not the picture." In doing so, the artist created a more active relationship between the painting's frame and its elements and, through the resulting tension that reinforced the interior tension, as well as "the advantage [of] the longer lines in this way produced," realized another of his goals – "a dynamic equilibrium," or a feeling of "extension."

212–219 Mondrian, *Victory Boogie-Woogie* (details), 1943–44, oc with colored tape and paper, Gemeentemuseum, The Hague, (photographed by Lucy Belloli, Assistant Curator, while the painting was still at the Guggenheim Museum after the Mondrian Centennial Exhibition was held there, in February 1972).

213

214

215

216

217

218

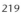

As we have seen, Mondrian's use of the word "extension" should not be taken to mean that he intended his paintings to extend beyond the frame, for that would have violated his essential classicism. Rather, to paraphrase Read's words about his "space," the artist's psychic feeling of extension affirmed "the concept ['time'] in the most direct and unequivocal manner." Mondrian did not specify that he meant extension in time rather than space, but we can infer this meaning from the end of his letter, that humans love "static balance," which is, of course, "necessary to existence in time." This type of balance is destroyed by the "vitality in the continual succession of time," he said: "Abstract art is a concrete expression of this vitality." The artist did not intend to destroy balance itself, which was imperative to life, but to extend the concept of balance to incorporate existence in time and, consequently, achieve the "dynamic equilibrium which the universe reveals." Thus, with his *Victory Boogie-Woogie* Mondrian extended the meaning of "a new realism."(220)

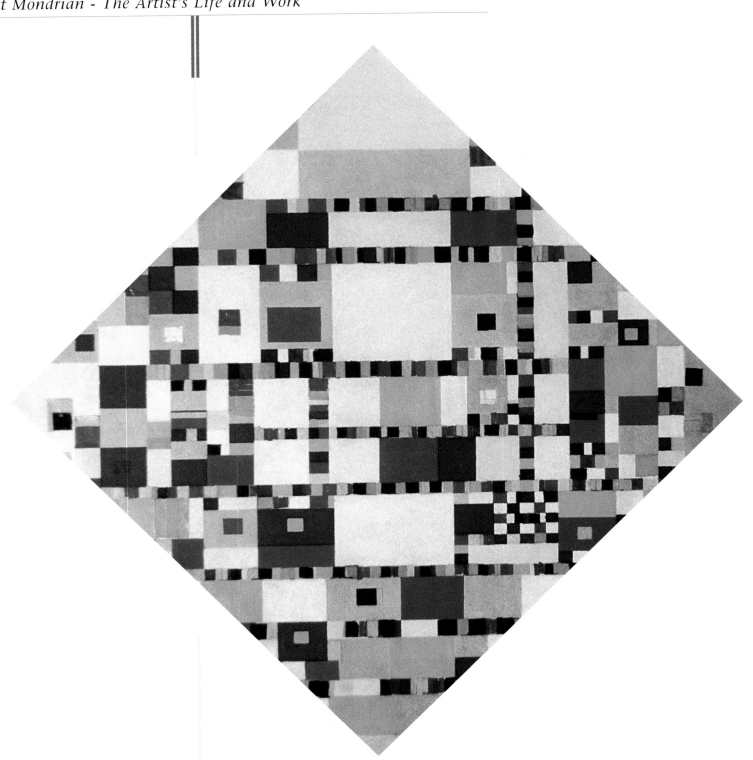

220 Mondrian, *Victory Boogie-Woogie* 1943–44, oc with colored tape and paper, Gemeentemuseum, The Hague.

Shortly before he died, Mondrian spoke of the "great struggle" to realize his aims that was "always going on." His late accomplishments did not violate his earlier precepts but expanded them to a new dimension. Carl Holty called such achievement, of a long-lived artist wise enough in his final years to achieve consummate mastery in method and means, "the old age of an artist." "In old age, an artist abjures crafts and skills," Holty said; "he abjures the truth, to come to greater truths." Mondrian did just that. Even if his fate was like that of other geniuses who died long before their work was fully understood, the artist's ideas, even in his last momentous quest, were to be acknowledged in the United States as nowhere else. It was fitting that he should be laid to rest in the country of his choice, because even if Mondrian did not finish his work there, he brought it to a resounding climax.

CHAPTER FOUR – REFERENCES

1 From Carl Holty's unpublished memoirs.

2 The collector was Katherine S. Dreier, and the exhibition that she mounted was entitled The International Exhibition of Modern Art Arranged by the Société Anonyme for the Brooklyn Museum, and was held at the Brooklyn Museum in the fall of 1926 and spring of 1927.

3 The artist had enumerated some of these stages in the article of *Cahiers d'Art* quoted above: *Cahiers d'Art*, 1, 1926 (translations throughout have been the author's).

4 Quoted from "Suprematism," the second of two essays in Malevich's *Die Gegenstandslose Welt* ("The Non-Objective World"), volume 11 of the Bauhaus books, published in 1927, trans. Howard Dearstyne, in *Modern Artists on Art*, ed. Robert L. Herbert, Englewood Cliffs, New Jersey, 1964, p. 94.

5 After explaining Picasso's use of the intersecting lines and knots, Kahnweiler explained further the artist's rationale: "It is doubtless clear by now that Picasso seeks to render on the plane surface, with absolutely no effect of illusion whatsoever, not only the shape and location of the objects, but also the space which contains them. It goes without saying that we are not concerned here with an unlimited space, which is only an abstract concept, but the particular limited space which happens to circumscribe these particular objects. . . . " Daniel-Henry Kahnweiler, "Notes about the Exhibition of Recent Works of Picasso at the Maison de la Pensée Française," *Transition Forty-Nine*, No. 5, Paris, 1949, pp.18–19.

6 I owe to Robert Welsh the idea that American abstraction before World War II combined Cubist and Constructivist elements. He believed the distinction between Neoplasticism and Constructivism (which has never been made entirely clear) to be a deep one, perhaps more responsible than a simplistic disagreement over diagonal lines for Mondrian's break with van Doesburg.

7 George Vantongerloo, "Preliminaire axiome," *Abstraction-Création*, I, Paris, 1932, p. 117.

8 Herbert Read, "The Faculty of Abstraction," *Circle, International Survey of Constructive Art*, ed. J. L. Martin, Ben Nicholson and N. Gabo, London, 1937.

9 Mondrian, "Plastic Art and Pure Plastic Art," published originally in *Circle*, as reprinted in *Modern Artists on Art*, p. 115 (from *Plastic Art and Pure Plastic Art, the Documents of Modern Art*, ed. Robert Motherwell, New York, 1945).

10 Gabo quoted Mondrian as admitting, finally, after their argument on this point: "All right, I am really a constructivist" (in "Naum Gabo Talks About His Work," *Studio International*, Vol. 171, No. 876, April 1966).

11 Barbara Rose, "The Primacy of Color," *Art International*, Vol. VIII, No. 4, May 1964, p.26.

12 Quoted from the paper as published in the catalogue of the Mondrian Centennial Exhibition (inaugurated at the same time) under the title "*Composition I with Blue and Yellow, 1926*, by Piet Mondrian," Piet Mondrian: Centennial Exhibition, the Solomon R. Guggenheim Foundation, New York, 1971, pp. 74-76.

13 This and further statements by Ilya Bolotowsky are from several interviews between 1967 and 1980.

14 Clement Greenberg admitted years later that Morris once took him to task for preferring "behind-the-frame" painting. The fact that Morris expressed so early the illusionist-sculptural dichotomy throws into a new light the credit which Greenberg is usually given for defining the aesthetic of the 1960s. Greenberg's term "post-cubist space" was cited by Rose in *The Primacy of Color*. His term "post-painterly abstraction" (from his catalog statement for the exhibition Post-Painterly Abstraction, Los Angeles County Museum, 1964) was cited "as having extensive influence" by Lawrence Alloway, among others, in his introduction to the exhibition catalogue *Systemic Painting*, Jewish Museum, New York, 1966.

15 "Reminiscences of Mondrian: Naum Gabo," *Studio International*, Vol. 172, No. 884, December 1966.

16 Mondrian, "Plastic Art . . . ," p.116.

17 Proof that the artist gave such designations to the various elements of his pictures is found not only in his words – even though he used them interchangeably, for example, designating the word "space" to mean both objective and canvas space – but in his explanation of the break with van Doesburg in 1925 (in the Sweeney letter cited above). He had believed that van Doesburg put too much emphasis on means at the expense of structure when he placed his planes and lines on an angle. As Mondrian saw it, structure was controlled by inevitable and irrefutable relationships in natural law that had to be expressed by the horizontal and the vertical.

18 The artist had placed only one small blue plane on the criss-crossed surface of *Composition II*, 1938-42, but it was successfully neutralized by its size and the surrounding activity. Still, as the only color space on the canvas, the blue plane stood out.

19 Sweeney was explaining the steps from *New York City, 1942* to the *Boogie-Woogie* paintings as Mondrian had abbreviated them in the above letter. This was in an article ("Mondrian, the Dutch and de Stijl," *Art News*, Vol. 50, No. 4, June, July, August 1951, p. 63.) in which Sweeney quoted the letter in its entirety, as well as a postcard that came in the same mail and a note that came the following day. All subsequent quotations from Mondrian, unless otherwise stated, are from these sources.

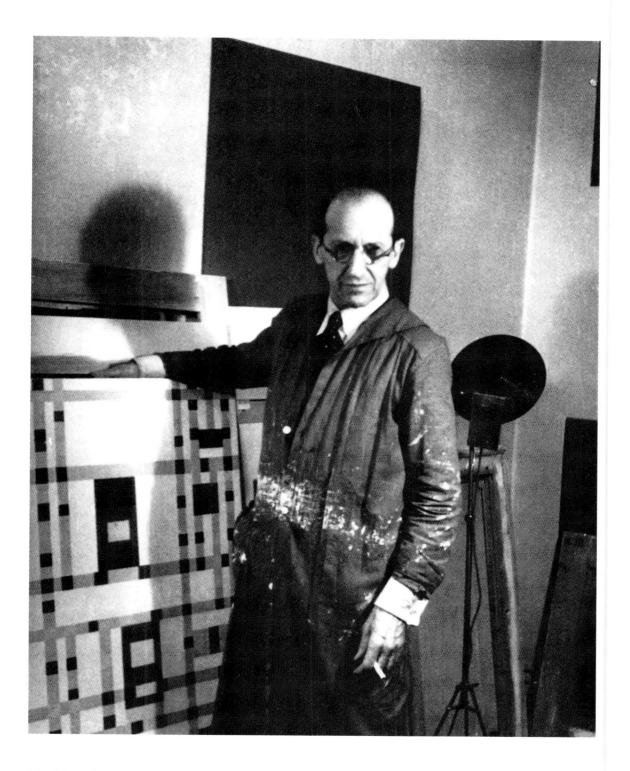

Mondrian with *Broadway Boogie-Woogie* in his New York studio, *c.*1942-43. Photograph Kunsthaus, Fritz Glarner Archive, Zurich.

Photograph of Mondrian,
Date unknown.

FIVE

THE IMMEDIATE FOLLOWERS

Mondrian's funeral was, according to George L. K. Morris, "perhaps the last turnout of the original AAA membership." The group had almost ceased to function during the War, but it was flourishing again by 1949. AAA produced two of its most successful exhibitions that year: its spring "annual" held at the Riverside Museum, and its show then traveling to universities and associations from the Mid-West to Canada. During the following year the group made plans to send its traveling exhibition to museums in Paris, Copenhagen, Rome, Munich, Amsterdam, London, and Dublin; in each city, the works received serious and complete press coverage.[1]

Some old members, such as Bolotowsky, Lassaw, Mason, and Morris, remained in AAA, but most were replaced by newcomers.[2] From then on, some of the future leading abstractionists would come and go in the organization. A book entitled *The World of Abstract Art*, AAA's fourth publication, came out in 1957. It presented abstract art as a world-wide phenomenon through articles on its genres in the United States, Britain, France, Germany, Italy, Japan, Latin America, and Russia.

Twenty years earlier, when AAA was born and began to fight from infancy for recognition of an international aesthetic in the midst of a nationalist ethos, its members were naturally impelled to look toward Europe. The group's international focus was justified when, by the late 1940s, most of the major European styles were represented in the United States by their European masters as well as their American followers. A more open climate both encouraged experimentation by artists and courted the approval of an art-conscious public. Abstractionism *per se* was no longer an issue.

With the rise of Abstract Expressionism, however, AAA artists were thought to be "too European." Whereas in the 1930s the hostility came from conservatives who considered them too avant-garde, it came now from progressives, who considered them too parochial. Most of the AAA artists chose the geometric mode out of preference, yet they were patronized for being "too limited in range" and for "turning out pallid copies of European models."[3] One of the complaints about these artists – that they concerned themselves only with "formal matters" took on a larger import in Holty's ruminations:

> As long as the creators of modern plastic art "abstract," [and]
> consider the means they employ as the only content, nothing
> will be clarified. For behind the means employed is the inspi-
> rational urge that makes these means imperative. In that urge
> is the content. Thus we had better analyze the urge to find the
> content.

Holty did just that in an imagined defense of Mondrian's work against
Hélion's charge that it was limited:

> Listen Jean, I don't have the ideas he had; the good ideas were
> limited; his work was limited – as everybody's is. But the idea
> of painting to reveal the living movement, the joy of an activ-
> ity of plastic color, not harmonious color – the creation of
> that would come as close to symphony as is possible in
> another medium. There is nothing narrow about that idea.
> You can work a hundred and fifty years at it without having
> exhausted it. Most of us [. . .] spent too much time trying to
> avoid falling into the trap of Mondrian, when a study of what
> he really wanted to do would have eliminated that danger
> completely.

A few American artists, all members of AAA at one time or another, had
the urge to take up the "idea" of Mondrian and devote their lives to finding
a personal mode within its confines. They were the first to admit being less-
er artists than he. Fritz Glarner never failed to take a deferential position to
the man he called his "master," and Charmion von Wiegand said about the
others in the group: "Minor painters are important; central painters would
be barren without their star clusters."[4] Yet, for their discipleship these artists
were subjected to pejorative comparisons. Their works were called "austere,"
"sterile," "purist," and "impersonal" when compared with Mondrian's,
despite the fact that similar labels had once been applied to his.

Like Mondrian, his followers believed that investigation of a single line
of reasoning was as vital in art as any other field of endeavor, and that it
should be judged within parameters set by the investigator. To denounce one
person's paintings as failing because they "derived directly from
Mondrian's" was to substitute a convention of originality for analysis of an
idea and its divergent possibilities of expression. To claim that another was
drawn to Neoplasticism because it "came with a built-in system that ade-
quately removed any obligations to tradition by fiat"[5] represented a misun-
derstanding of both the artist's intention and of De Stijl, in which denial of
subjectivity was a cardinal law.

In his introduction to the first issue of De Stijl's periodical, published in
1917, Theo van Doesburg had stated that the movement was "founded upon
a common embodiment of the new cognition of plastic arts." Artists would
not hold so anxiously to their "ambitions" and "limited" individualities
when they realized the necessity of communicating through a universal lan-
guage and serving a common principle of style, he said: "Only by conse-
quently following this principle can the new plastic beauty manifest itself in
all objects as style, arising from a new relationship between artist and soci-
ety." Mondrian wrote in 1925 that "art surpasses personal thought as the

[universal] unconscious surpasses the individual consciousness." Certainly, his followers were aware of another principle that the artist reiterated in 1942:[6]

> In painting and sculpture, one must . . . fear eclecticism . . . more obvious in genuine abstract art. But in every period of art, the expressive means are used in common and it is not the expressive means but the use of them that reveals personality.

Despite his belief in the commonality of the "expressive means," Mondrian's paintings were completely idiosyncratic and those of the followers were clearly distinguishable from his. It was both to his credit and theirs that they did not copy his usage but chose to work "within the logic of the style." In fact, Mondrian's principle of impersonality with its implication of freedom from discipleship was what originally attracted Harry Holtzman. In contrast to Hofmann, against whose powerful personality the young man had revolted in the early 1930s, he thought that Mondrian suppressed his individuality with followers in favor of (his term) "equivalent insight."

Holtzman was born in New York's Hell's Kitchen (West 39th Street), in 1912, to a family that had a general interest in theatre and music but none in the visual arts. The boy drew, on the sidewalk or any available space, from the time he was quite small. When his family moved to Bensonhurst, he began to study in the first high-school program of the New York system to offer art as a major. There, he came under the influence of an unusual teacher, Ann Seipp, "the first person to treat me like an artist," Holtzman said.

From her travels in Europe, Seipp had obtained a fine collection of art books that she shared with her student. She took him to the Société Anonyme's International Exhibition of Modern Art at the Brooklyn Museum and explained the strange new work, making it more comprehensible to Holtzman. She also encouraged him to make a "cubist" cover for a school publication. After graduation, when the young man's family refused to support his art studies away from home, he managed to obtain a scholarship at the Art Students League in New York City. He entered that school in 1928, at age 16.

Holtzman soon found himself in the midst of a controversy brought on by the League's self-governing system under which the students chose and hired their own teachers. When the names of recent immigrants George Groscz and Hans Hofmann were proposed, there was opposition from a conservative group led by one of the school's directors. Although Holtzman knew nothing of Hofmann's work and very little of Groscz's, he was incensed by the arbitrary views that he heard expressed and found himself speaking up against the director – so forcefully that the vote for both artists was positive.

Hofmann heard about Holtzman's intervening in his favor after he came to the League and asked the young man to assist in his classes. Holtzman did so at the League and, also later on, when Hofmann taught at the Thurn School in Gloucester. He also took over the school that Hofmann started in New York City when the older man had to leave for Europe in order to clear up his immigration status. There were personality conflicts, though, and the

two got on "roughly," because of what Holtzman called the German artist's "Wagnerian personality."

The major influence of the one on the other, according to Holtzman, was that the older man led him to "annihilate the image that Cézanne had achieved with rhythm and Matisse with color." Holtzman had been fascinated with the original works by Cézanne, as well as Seurat, Gauguin, and van Gogh, that were shown in the Museum of Modern Art's opening at the Hechscher Building galleries in 1929. Nevertheless, he was drawn more and more toward the "non-essentiality of nature" and began doing "structural" things as early as 1930.

This was when Holtzman became aware of what he called the "form problem" — that is, "of the rectangle as the artist's 'given' space, where perimeter and inner relationships have to be accounted for." In drawings of 1930 and 1931, his shapes became arbitrary, at first ovoid and irregular, then rectilinear, because of the importance of "parallelinity of linear boundaries." He retained a gouache painting which demonstrates an argument carried on with Diller over whether circular forms could be integrated into a grid arrangement without seeming to be discrete and arbitrary. By this time he had decided they could not.

The two had met at the Art Students League when Diller, who was an older student at the school, had come up to Holtzman — a new student — and thanked him for speaking up on behalf of Groscz and Hofmann. They became close, and after they had left the Art Students League, Holtzman and Diller lived on the same block and visited each other's studios almost daily. The story has been told earlier of Holtzman's having been directed by his friend to see Mondrian's paintings in the Gallatin Collection because, Diller said, "This man's ideas of structural concepts are like yours." The result was a turning-point in Holtzman's life that led him to seek out the elder artist in Europe and eventually to sponsor him in America.

There was also a transformation in the younger artist's thinking as he began to realize the full implications of Mondrian's presentation of "the form of space." This idea clarified to Holtzman the process of "perceptual metamorphosis," or the centuries'-long revelation that occurred between the "magical cave space" of prehistoric art and the "magical painting space" of present-day art.

When Holtzman first brought together the abstract artists who formed the AAA, he had hoped they would establish Mondrian's "essential trend," as he called it, but this ambition was thwarted somewhat. The other artists had less ambition to discuss the fine points of theory than to exhibit. As we have seen earlier, their works represented an ill-defined amalgam of European abstract styles — that is, until some of them absorbed Mondrian's example. Holtzman's understanding of that example and the elder artist's principles was reflected in his statements written for the publications of AAA (see Chapter 2) and in his paintings that were shown in the group's exhibitions.(221,222)

221 Photograph of Harry Holtzman in his studio at Lyme, Connecticut, 1985.
© Virginia Pitts Rembert

222 View of Holtzman's Connecticut studio. © Virginia Pitts Rembert

223 Holtzman, *Sculpture 1939–40*, as shown between two Mondrians in the Société Anonyme Collection at the Yale University Art Gallery.
© 2001, Holtzman Trust

Since Holtzman was the first AAA artist to follow Mondrian's theory, he was the one who was accused most severely of imitation. That fact, combined with jealousies that developed over what some believed to be his undue influence on the older man, caused Holtzman to be reluctant about showing his paintings. Privately he continued to work, but publicly he devoted himself to exhibiting his mentor's paintings or translating his writings.[7]

The work that Holtzman called *Sculpture 1939–1940* could be seen in the Yale University Gallery of Art as part of the Katherine Dreier/Société Anonyme bequest.(223) The paintings that led up to the "sculpture" were not on public view until the exhibition entitled Abstract Painting and Sculpture in America, 1927–1944, which originated at the Carnegie Institute, was also shown in 1983 at the Whitney Museum.(224)

224 Abstract Painting and Sculpture in
America 1927–1944 Exhibition at the
Whitney Museum, 1985.

225 Holtzman, *Square Volume with Green*,
1936 (photographed at the Whitney
Museum, 1985).
© 2001, Holtzman Trust

156

The younger artist had asserted his independence from Mondrian by adding a prominent green-color plane to the white and black planes of *Square Volume With Green* (he had recreated the 1982 version from the original, done in 1936).(225) His painting entitled *Horizontal Volume, 1938–1946* (226) was close to Diller's work of same period in that there was clear overlap in the way some of the structural planes seemed to cut across larger color planes.(227) The difference was in Holtzman's treatment of edges, which could also be seen in *Vertical Volume No. I, 1939–1940.*(228)

227 Detail of 226 above, Holtzman,
Horizontal Volume, 1938-46 (photographed at the Whitney Museum, 1985).
© 2001, Holtzman Trust

228 Holtzman, *Vertical Volume, No. I*, 1939–40 (photographed at the Whitney Museum, 1985).
© 2001, Holtzman Trust

The artist continued Mondrian's method of demonstrating the canvas' objectivity by using its edges, but he made of them autonomous compositions. He did this by carrying only selected planes around the edges in order to show that those surfaces were independent of the front face of the canvas. The next step was to move the painting away from the wall entirely. He took this step with his columnar paintings of 1939 and 1940, one later owned by the Yale University Art Gallery and the other by the Carnegie Institute.(229) This idea followed naturally from Mondrian who was, as Holtzman said, "certainly the first to take painting space as its own reality – abolishing the association of painting as a window or an extension of a room, or as a space of fantasy behind the frame; instead of the expression of form in space, a painting became the articulation of space itself."

Mondrian had made objects of his paintings by assigning them to spaces of canvas and by measuring out their surfaces with linear planes that did not stop at the frame but continued around the visible canvas edges. The younger artist went further, however. Realizing that Mondrian's paintings still maintained the convention of a single surface with edges determined by the depth of its stretchers, Holtzman painted around all four sides of a free-standing rectangular post that was independent of the wall. In his Yale *Sculpture* he subtly alternated yellow and blue planes with white planes separated by black intervals so that the elements appeared to move against and into one another as the spectator walked around the piece.(230)

230 Holtzman, *Sculpture*, 1939–40, Yale University Art Gallery.
© 2001, Holtzman Trust

Mondrian's reaction on first seeing this column was: "Harry, you've taken painting off the wall."(231) He thought the work was "too monumental," Holtzman said, the idea being that a painting had to be "the minimum size that would relate to human size, thus approaching environmental scale." Nevertheless, Mondrian saw the point of what the younger man was trying to do and remarked: "You are more consequent." In other words, "Mondrian had started with nineteenth-century religious, cultural, and academic thought," said Holtzman. "Obviously, I was influenced by him, but my terms were different from his."

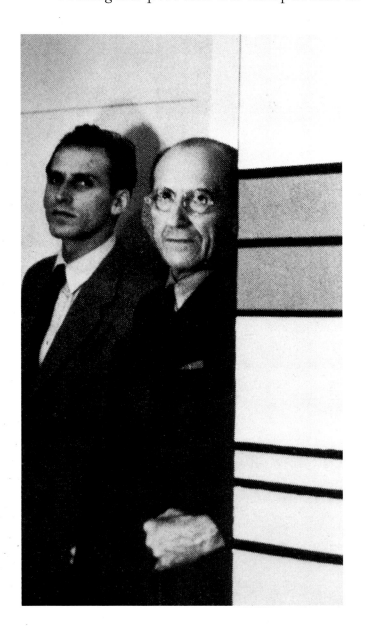

231 Photograph of Holtzman and Mondrian standing by Holtzman's *Sculpture I*, 1940 (c. 1940–41).

Opposite page:
229 Holtzman, *Sculpture I*, 1940 (photographed at the Whitney Museum, 1985 – currently owned by the Carnegie Institute Museum of Art).
© 2001, Holtzman Trust

Philosophically, Holtzman had always been very much allied with twentieth-century thought. By reading voraciously from a very young age, he "fell into" the social sciences, then into psychology and anthropology. His involvement with the field of semantics led the young man to meet Alfred Korzybski in 1947, and to teach with him for the last four years of the great semanticist's life. Eventually, Holtzman attempted to illustrate semanticism's theory of the interrelation of symbolization and perception in some of his works.

232 Harry Holtzman's studio, 1985.
© Virginia Pitts Rembert

These were free-standing structures made of gessoed mahogany, painted to stimulate visual interchange between the rectilinear solids and the voids (or intervals of space) as they were shaped by the solids.(232) Their interaction represented movement and space in viable experience while at the same time suppressing their divisions in artistic experience. The artist felt that these "open reliefs" – so called because they were both painting and relief – justified Mondrian's admission that Holtzman's work was "more consequent" than his, in its practice.

The free-standing painting problem was taken up a few years later by Ilya Bolotowsky, but he saw the effort as primarily architectural. Mondrian had predicted the interchangeability of painting with sculpture and architecture: "By means of the unity of the new aesthetic," he wrote in 1923, "architecture and painting will develop an art form and flourish together." Bolotowsky explained this fusion in his own work:

> Neoplasticism accepts the flatness of the paper and avoids three-dimensionality and images — so why three dimensions in my work? Mondrian was interested in architecture, made paintings as designed-panels, and thought of them as part of architecture. I made my own and didn't wait for architects.

The artist was speaking of the columnar paintings, not begun until around 1961, as being architectural in themselves. His mural paintings that were more directly a part of architecture, and indeed designed to complement the buildings they were in, dated from as early as 1937, when Bolotowsky painted a mural for the Williamsburg Housing Project.(233,234)

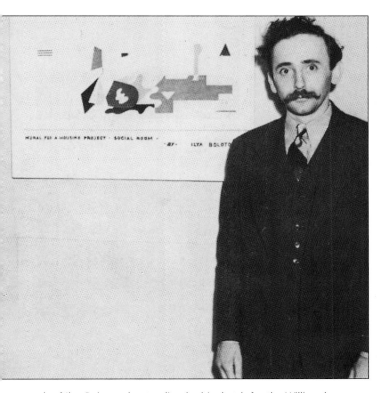

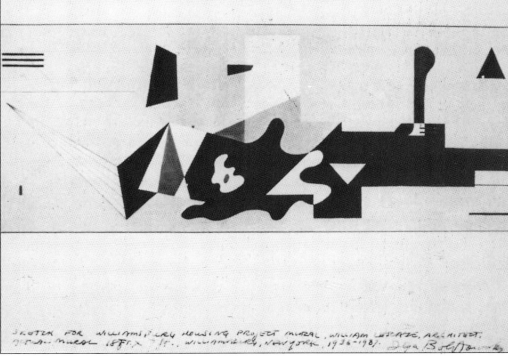

notograph of Ilya Bolotowsky standing by his sketch for the Williamsburg ousing Project, at the opening of a mural exhibition held at the Federal Art allery, 1938.

234 Bolotowsky, *Sketch for the Williamsburg Housing Proje* 1936, gouache and ink on paper. (234-236 are reproduced courtesy of the photographer, Otto E. Nelson).
© Estate of Ilya Bolotowsky/Licensed by VAGA, New York, NY

He did similar murals in 1938–1939 for the Hall of Medical Science at the New York World's Fair (235), and in 1939–1940 for the Hospital for Chronic Diseases at Welfare Island.(236) Among the earliest abstract murals in the United States, they combined biomorphic and rectilinear forms that revealed the artist's two earliest abstract influences, Miró and Mondrian.

Opposite page
235 Bolotowsky, *Mural for The Hall of Science*, New York World's Fair, 1939.
© Estate of Ilya Bolotowsky/Licensed by VAGA, New York, NY

236 Bolotowsky, model for mural for Men's Day Room, Hospital for Chronic Diseases, Welfare Island, New York, completed 1941.
© Estate of Ilya Bolotowsky/Licensed by VAGA, New York, NY

Bolotowsky was born in Petrograd, Russia, in 1907. His father was a lawyer and his mother a university graduate who started an art club for the children of her professional friends when the family moved to Baku. He studied for two years at St. Joseph College in Constantinople, where the family waited before immigrating to America, in 1923. After settling in New York City, Bolotowsky began to study at the National Academy of Art where he distinguished himself by painting two works during one year that were accepted in the academy salons.

On frequent visits to the Société Anonyme, the Museum of Modern Art, and the 57th Street galleries that were just becoming "wide awake," he had successive revelations on seeing his first works by Soutine, Kokoschka, Braque, and Gris. A large showing of Russian art covering the extremes of Realism and Constructivism also had a "tremendous" impact on the artist.

237 Bolotowsky, *Gray and Ochre*, 1941 (unless otherwise stated, Bolotowsky's works were photographed by the author in his mother's Thiemann Place apartment and his exhibition at the Grace Borgenicht Gallery, in 1967 and 1968, and in his Spring Street studio-homesite in 1980; his paintings are all oc and his constructions of wood and acrylic).
© Estate of Ilya Bolotowsky/Licensed by VAGA, New York, NY

Around 1933, Bolotowsky came under the influence of Miró, whose paintings were shown at Pierre Matisse's Gallery. Both Miró's and Jean Arp's free forms intrigued him and accounted for similar ones that he introduced into works shown in the early AAA exhibitions. In his *Gray and Ochre*, 1941,(237) bands of ochre at both top and bottom of the gray rectangles implied vestigial landscape elements, while black shapes seemed to "float" above planes that – painted lighter where they "overlapped" – appeared to be transparent. Although restrained, certain tonal areas hinted at the artist's predilection for color, which was to blossom in later works.

Bolotowsky was immediately attracted to Mondrian's paintings on first seeing them at the Gallatin Museum. His *Arctic Diamond*, 1948 (238) showed the early nature of that influence, although he used diagonals and a greater number and variety of planes and colors in the lozenge form than the older artist did, at least prior to *Victory Boogie-Woogie*. Bolotowsky's increased use of color came from a need within himself "to do something more fresh and personal." His color in *Arctic Diamond* included tinted and toned variations of secondaries, tertiaries, and complementary mixtures along with the "non-colors," black, white, and gray. The artist said he was reaching for a quality of light like that in Nome, Alaska, where he had been stationed during World War II.

238 Bolotowsky, *Arctic Diamond*, 1948.

239 Bolotowsky, *Ascending White*, 1952.
© Estate of Ilya Bolotowsky/Licensed
by VAGA, New York, NY

Although Bolotowsky's colors came closer to the primaries in the 1950s, they were still variants of the pure hues. In his lozenge-shaped *Configurations*, 1951 (240) and his vertical *Ascending White*, 1952, (239) he placed somewhat diminished primary-colored planes alongside warm and cool grays. The artist also eliminated black, allowing dark blue to serve the purpose of accent. In both of these paintings he composed colored planes of various lengths and widths around or alongside large white rectangles that alternated as space and plane, creating — as the eye saw them first one way and then the other — an effect of continuous rhythmic vibration.

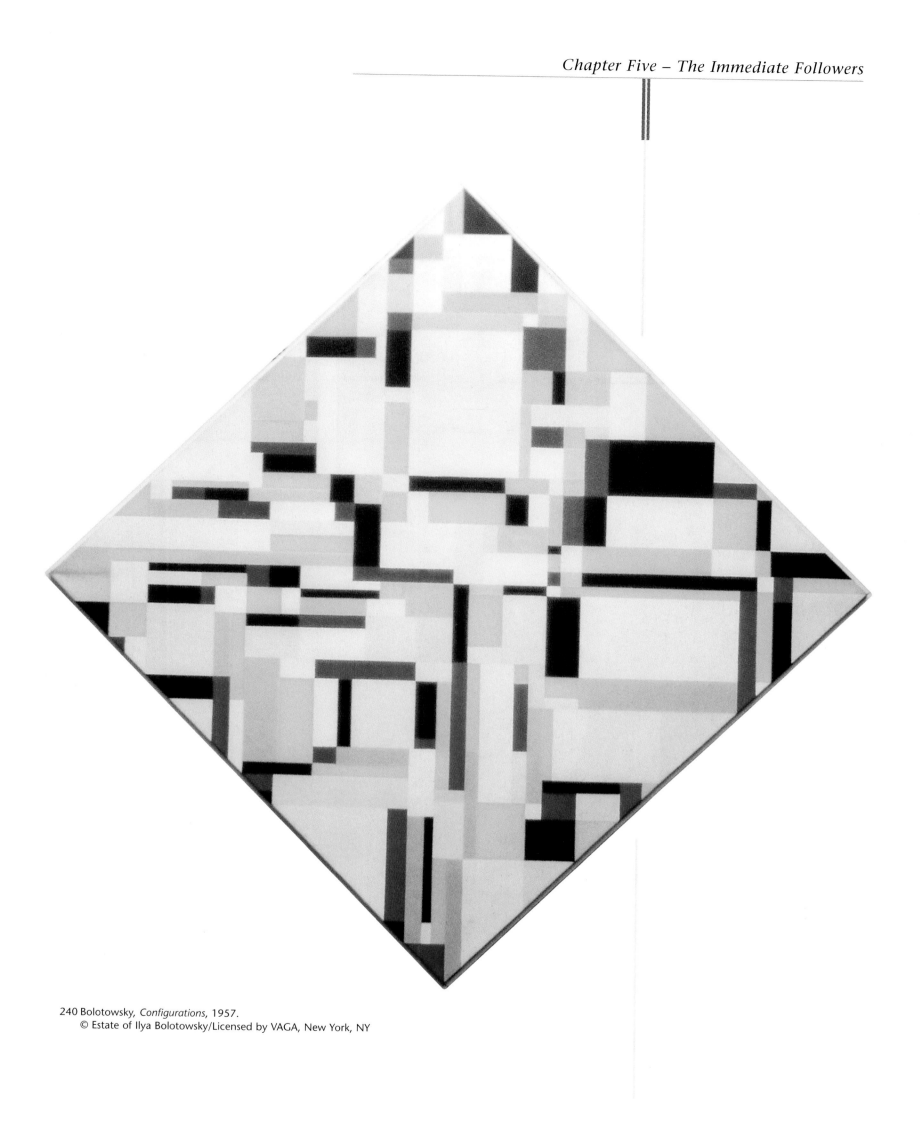

240 Bolotowsky, *Configurations*, 1957.
© Estate of Ilya Bolotowsky/Licensed by VAGA, New York, NY

241 Bolotowsky, *Vertical Oval*, 1964–65.
© Estate of Ilya Bolotowsky/Licensed by VAGA, New York, NY

In paintings of the 1960s, Bolotowsky illustrated his more personal version of Neoplasticism by aligning colored shapes that appeared to alter their sizes and color relationships. When he placed a thalo blue plane next to a white one in *Vertical Oval*, 1964–1965,(241) the thalo was "blacker than black," except that it appeared to turn green next to lavender or cobalt blue planes. Rectangles barely tinted with cobalt were hardly distinguishable from the whites with which they cut a light swath through the center of *Vertical Yellow Ellipse*, 1962.(242) When the artist placed the same cobalt against darker blue rectangles in the center of *Turquoise Diamond*, 1968,(243) they seemed to be no longer blue but cream.

242 Bolotowsky, *Vertical Yellow Ellipse*,
1962.
© Estate of Ilya Bolotowsky/Licensed
by VAGA, New York, NY

243 Bolotowsky, *Turquoise Diamond*, 1968.
© Estate of Ilya Bolotowsky/Licensed
by VAGA, New York, NY

244 Bolotowsky, *Blue Tondo*, 1966.
© Estate of Ilya Bolotowsky/Licensed
by VAGA, New York, NY

Later works depended less on proliferation of planes and intervals than lucidly balanced shapes and colors. The surface of *Blue Tondo,* 1966 (244) is made up of only three large blue planes, two of thalo and one of cobalt; these appear to change hue and intensity where they are interrupted by the downward thrust of white and red linear planes. *Red Tondo,* 1967–1968 (245) takes its name from a dominant red plane that supports only four asymmetrically-placed white linear planes and a thin red one of a different hue from the base plane's.

245 Bolotowsky, *Red Tondo,* 1967–68.

246 Bolotowsky, *Dark Diamond*, acrylic,
1971.
© Estate of Ilya Bolotowsky/
Licensed by VAGA, New York, NY

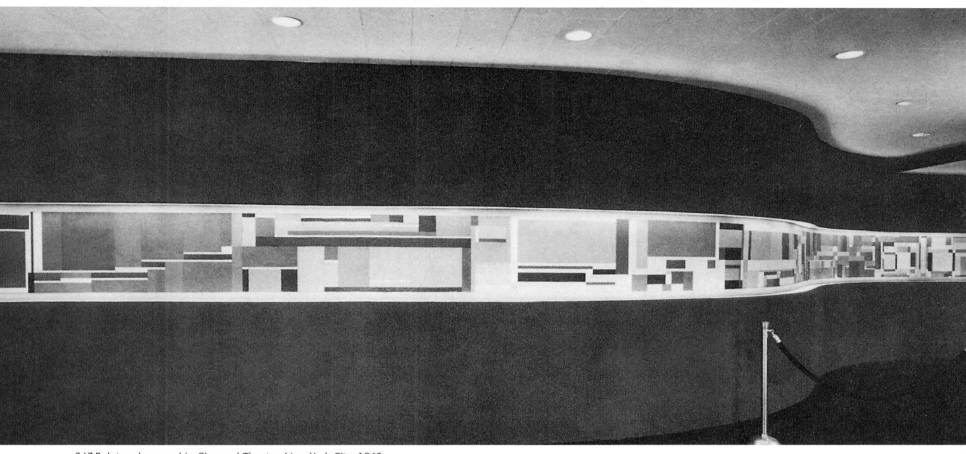

247 Bolotowsky, mural in Cinema-I Theater, New York City, 1963.
 Reproduced With kind courtesy of Andrew Bolotowsky
 © Estate of Ilya Bolotowsky/Licensed by VAGA, New York, NY

Despite his more economical use of internal elements in the latter paintings, Bolotowsky still experimented with varied formats, such as squares, tondos, ellipses, narrow rectangles, and diamonds. He said that diamonds had more feeling of space than squares because the vertical and horizontal dimensions were greater, especially when elongated in one direction as they are, vertically, in *Dark Diamond*, 1971.(246)

The artist consciously sought the bending sensations in the tondos and ellipses that their curved surfaces lent, apparently, to the straight lines within them. He also sought the effect of curving movement that straight lines sometimes seemed to affect in a rectangular format, as with a mural painted in 1963 for the Cinema-I movie theater in New York City.(247) The wall panel that architect Abraham Geller designed for the mural was curved in an S-shape, but the mural itself was a 45-foot long by 2-foot high rectangle. Bolotowsky explained that "without using any curved lines or edges, I composed a curved movement in the mural to work contrapuntally with the curvature of the wall panel."

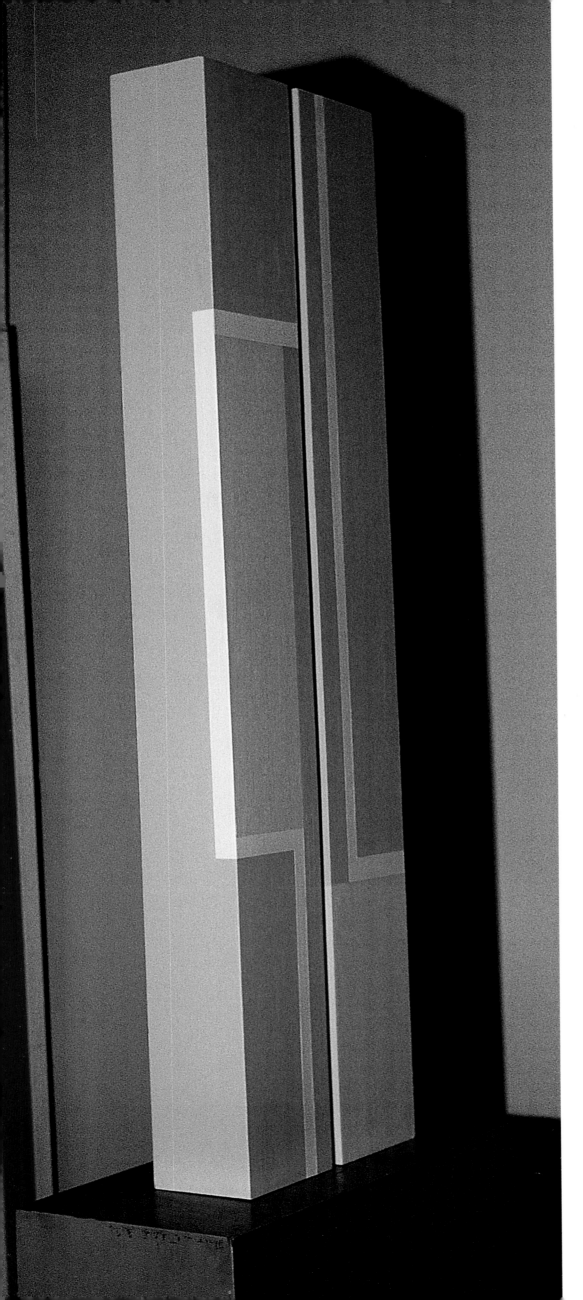

Even though he deliberately courted a "bowstring effect" derived from changing color relationships, the artist still thought of his paintings as being flat and non-illusionistic. It was their implication of a new reality distinctly different from nature that led him to the columnar paintings. The idea had evolved as he continued the surface planes around the edges of the easel paintings and consequently took the surfaces around four sides of a flat column. Bolotowsky treated each side as a self-contained unit but soon saw the possibility of composing so that any two sides seen together could take on a dual relationship. The tops of the columns could also be observed as independent of or as melding into compositional relationships with the sides. He felt that rotating a column on a stand or having the viewer walk around it created a "sequence of design in motion" that could be read "something like an Oriental scroll, a sort of a modern Kakemono, or like an abstract motion picture."

Bolotowsky characterized the columns according to their numbers of sides, including the top and the bottom. Thus there were six-sided "parallelopipeds" such as *Red and Yellow Column, 1968,*(248) or five-sided "trilons" such as *Trilon, 1967.*(249) By abutting two L-shaped planes at their joints, the artist formed "open" columns painted so that paired planes appeared to be composed in color and format as a single unit until the spectator moved. Then their different colored planes slipped over and under before the viewer's eyes in compositions that were seemingly endless. Examples were *Open Column, 1967,*(250,251) and *Black, Red, White, and Blue Column, 1967.*(252) A variation on the rectangular column could be seen in *Three Cubes, Yellow, Black, and White, 1964,*(253) in which planes of three equal-sized cubes sat atop one another but were painted in only partial alignment. Bolotowsky reinforced the animated effect that resulted by splitting and progressively separating the color planes painted vertically on the cubes so that they met, continued, or countered one another.

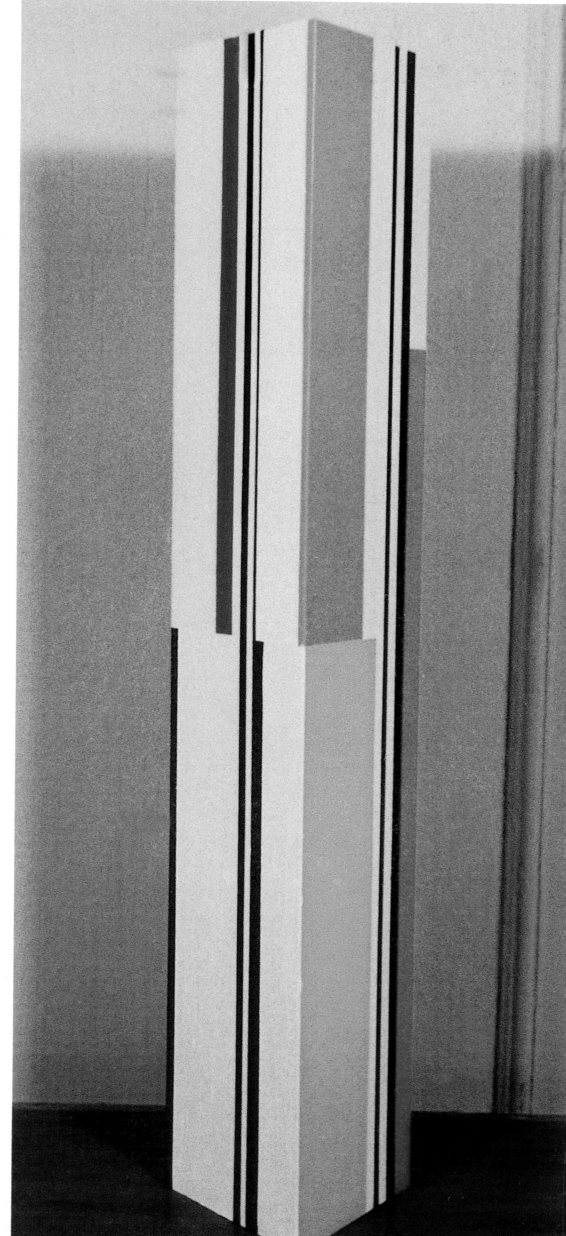

249 Bolotowsky, *Trilon*, 1967–69.
© Estate of Ilya Bolotowsky/
Licensed by VAGA, New York, NY

250 Bolotowsky, *Open Column*, 1968.
© Estate of Ilya Bolotowsky/
Licensed by VAGA, New York, NY

251 Another view of *Open Column*.
© Estate of Ilya Bolotowsky/
Licensed by VAGA, New York, NY

252 Bolotowsky, *Black, Red, White, and Blue Column*, 1966.
© Estate of Ilya Bolotowsky/
Licensed by VAGA, New York, NY

The artist's personal variation on Neoplasticism was in color and canvas shape. He kept the vertical-horizontal interior elements while departing from the primaries and the rectangular canvas. By avoiding exclusive use of the primary triad and by deliberately attempting to make hues appear of different intensity or value, he claimed to deviate from Mondrian, who varied his hues only to make them appear absolute and distinct when others were juxtaposed to them. The artist also reversed Mondrian's color distribution, explaining that in the older man's paintings chromatic colors tended to occupy the small areas and achromatic colors to occupy the large areas.

253 Bolotowsky, *Three Cubes: Yellow, Black, and White*, 1964.
© Estate of Ilya Bolotowsky/Licensed by VAGA, New York, NY

However, Bolotowsky's own paintings were dominated by the chromatic colors. Sometimes, he used the "negative," achromatic colors, whites, grays, and blacks, to cut through the chromatics. Because the latter were inclined to pull together visually, even across a negative area, the artist created a tension through "the feeling that the whole structure was rebuilding itself against obstacles."

Although Bolotowsky insistently employed right-angled internal relationships, he used tondos and oval-shaped canvases because of the variety of visual effects that were possible on differently-shaped canvases. He con-

sciously sought curved effects in lines or edges of planes and attempted to achieve the effects of depth that came from a "tense" illusory shifting of his planes. Thus the artist's paintings actually defined Neoplasticism by their deviation from it, and he created a style as distinctive as that of any other Mondrian disciple.

For years, he suffered as a result of critical myopia about his work. Nevertheless, Bolotowsky remained hopeful about the future, even during the period dominated by Abstract Expressionism. In the 1960s he wrote:

> Action painting had the whole field to itself – anything else was treason – but it is dated now. Neo-Plasticism is not dated – it has not had its day.

By 1972, he was said to have contributed significantly to the Constructivist Style, which was "always a self-confident and in certain quarters well-received elaboration of traditional values derived from classical humanism – moderation, impersonality, balance, linear clarity, and so on."[8]

The artist's place in American art was settled when he was given a major showing at the Guggenheim Museum in the fall of 1973. Almost 100 works borrowed from 44 collections hung in an exhibition that was accompanied by a significant catalogue.

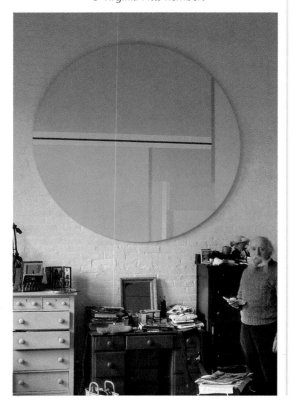

254 Bolotowsky's Spring Street studio-homesite, 1980.
© Virginia Pitts Rembert

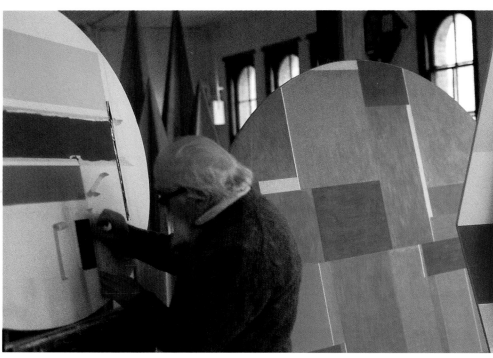

255 Bolotowsky at work on one of his tondos in his Spring Street studio, 1980.
© Virginia Pitts Rembert

Before his death in 1981, Bolotowsky entered a new phase of artistic maturity. His paintings (and silk-screened prints made of the images, 254) reached an authoritative peak and his columns, especially in multiple arrangements, offered infinite observable possibilities.(255-258) These richly varied works seemed to embody the artist's expressed ideal, to "create visual poems of a lyrical, structural nature – each with that particular aliveness that distinguishes art from decoration."[9]

256 Bolotowsky, *Yellow Square*, silk-screen print, date unknown (photographed by director William Dooley from collection of the University of Alabama Moody Gallery of Art).
© Estate of Ilya Bolotowsky/Licensed by VAGA, New York, NY

257 View of works-in-progress in Bolotowsky's Spring Street studio, 1980.
© Virginia Pitts Rembert

258 View of works-in-progress in Bolotowsky's Spring Street studio, 1980 © Virginia Pitts Rembert

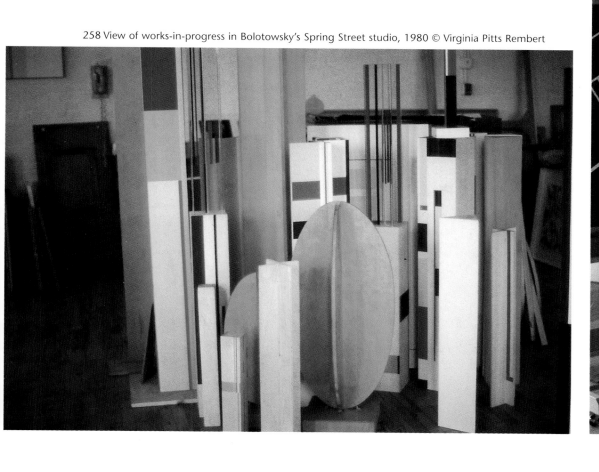

259 Burgoyne Diller, *Untitled*, oc, 1933.
© Estate of Burgoyne Diller/
Licensed by VAGA, New York, NY

Burgoyne Diller came to think of himself, during his last years, more as van Doesburg's artistic descendent than Mondrian's. He was adamant when the reporter for a newspaper in his home town of Red Bank, New Jersey, referred to him as a follower of Mondrian and even threatened to sue an American collector for making this same claim.[10]

Holty called Diller's mode "pure De Stijl" because, he said, "I always thought he was closer to the general nature of De Stijl, having a more relaxed quality and more of a sense of color than Mondrian, who was not naturally a colorist." It is indisputable, however, that Diller was introduced to De Stijl by seeing Mondrian's work and that he always retained certain aspects of that artist's influence.

In a sense, Diller was coming home when he enrolled in the Art Students League in 1926. He was born in New York City in 1906 but moved with his family to Michigan, where he attended Michigan State College on an athletic scholarship. His interest in art was sparked when Diller visited the Art Institute on weekend trips to Chicago. There, he began to jot down random notes on paintings, a practice that was to become lifelong. He especially admired the Post-Impressionists and German Expressionists from whom he first learned that it was possible to express volume through emphasizing flat areas of color.

Diller left college in 1927, and after jumping from job to job, at first at home and then in New York City, he decided to attend the Art Students League on a scholarship that he soon realized would not support him. He thereupon went "from silk-screening to window-cleaning," in an effort to supplement his income, and finally obtained a part-time job selling paints in the League's supply store.

Despite the fact that his friends were poor too, and they had to pool their resources, Diller felt very fortunate to be at the Art Students League. "There was a wonderful sense of belonging to something, even if it was an underprivileged and downhearted time," he said.

When he enrolled in the League, Diller was experimenting with Cubism synthesized with elements of Expressionism and Surrealism (mostly influenced by Kandinsky and Arp). His untitled painting of 1933 contained a mottled, biomorphic "figure" in a geometricized "room" whose ceiling, wall, and floor were all in ambiguous perspective.(259) The artist's work showed an abrupt change to Neoplasticism in 1934, suggesting that he saw Mondrian's art at about that time. *Geometric Composition*, 1934,(260) with its reduced color planes delineated with cruciformed and doubled blacks, was a watered-down version of what the older artist was doing earlier in the 1930s.[11]

For about ten years, from 1935 to 1945, Diller's work was interrupted by his service as Assistant Technical Director and head of the Mural Division of New York City's Federal Art Project. The "Project" was part of the Roosevelt era's Works Progress Administration. When the artist was commissioned as a naval lieutenant in World War II, he served in the Training Aid Development Center and as Director of the Service Art Section for the WPA in New York City.

260 Diller, *Construction, 1938.*
© Estate of Burgoyne Diller/
Licensed by VAGA, New York, NY

His contributions to the Federal Art Project were considered of enormous benefit to Diller's colleagues, perhaps even to the course of American Art, because of his "ability not only to understand the artist's point of view, but to accomodate it to the needs of the political and governmental figures of the era." For the first time in history, thousands of artists were employed full-time in their own fields. It was possible to survive doing what they did best and, even though the wage was minimal, the artists took full advantage of the opportunity. "The main trouble was not how to get them started, but how to stop them," Diller said, "because they'd work seven days a week, and they loved it."

He thought that abstract artists should have a part in the Project, even though its officials feared that there could never be enough public sympathy or understanding of their work. When Diller was able to secure a few com-

261 Diller, *Painting-Construction*, oil on wood, 1938, Lillian H. Florsheim Collection, New York.
© Estate of Burgoyne Diller/ Licensed by VAGA, New York, NY

missions for these artists, the abstract genre became more meaningful to his own life. "After all," he said, "you can't disassociate your art as something separate from life and living, and responsibility."

The American Abstract Artists had solicited Diller's membership close to its inception, and he participated in the group's early exhibitions. There was always a steady development in his own work, even when he could only "sweat out a few hours" for it. In the late 1930s and early 1940s, the artist made wood relief and freestanding constructions in a version of the Neoplastic style. *Painting-Construction*, a relief of 1938 (261), was similar to paintings he had seen by Mondrian in that its surface was projected about an inch beyond the frame. Cruciform black lines enframing a colored rectangle

on the upper left came directly from the older artist. The depressed circular shape on the right, however, deviated toward a type of relief often used by Ben Nicholson in the 1930s but never by Mondrian. By inserting a painted circle and an unattached bar on the lower right, Diller also created a spatial effect never found in the latter artist's work.

262 Diller, *Wood Construction*, 1938 (unless otherwise indicated, the following constructions, of stained or painted wood, and paintings, oc, were photographed by the author after Diller's death, in the Diller home in Atlantic Highlands, New Jersey).
© Estate of Burgoyne Diller/ Licensed by VAGA, New York, NY

Diller began to make reliefs in the 1930s, some that hung frontally like paintings and others that were free-standing. *Wood Construction*, 1938 (262) had no surface other than the wall to support its metal "lines" and wooden rectangles that were attached to an open frame. In this panel, the artist made one of his few departures from the primary colors by allowing its materials to remain natural. *First Construction*, 1940, (263) was more typical of a later direction in his work, also seen in *Construction*, 1961, *Project for Stainless Steel*. (264) The earlier composition was enframed by two white boards, attached at a right-angle, onto which Diller had either mounted or painted the colored and black linear planes. The later construction was composed of rectangular red, yellow, black, and white wood pieces which supported one another without an enframement. This piece, free-standing rather than in relief, presaged sculptures that the artist would execute shortly before he died.

264 Diller, *Construction: Project for Stainless Steel*, 1961.
© Estate of Burgoyne Diller/
Licensed by VAGA, New York, NY

Opposite page:
263 Diller, *Construction*, 1940.
© Estate of Burgoyne Diller/
Licensed by VAGA, New York, NY

185

For most of his life, Diller worked at painting and drawing along the line of three "themes" that were established as early as 1933. He did not necessarily follow the themes in numerical sequence but moved "tangentially" from one to another. Simply put, the artist's first-theme works demonstrated the independence of base plane and compositional planes, second-theme works began to unite the two while still keeping them clearly separate, and third-theme works integrated the parts with constant interchange (much as in Mondrian's late paintings).

Similarities of paintings separated by 20 years demonstrate Diller's constancy in following his themes. Still strikingly close in use of white ground with superimposed primary-colored rectangles, or "elements" as he called them, to *First Theme*, 1942 (265) and *First Theme*, 1942–1943 (266) was *First Theme*, 1961.(267) He placed at least one element alongside a canvas edge in each, as if to establish the base plane that seemed to disappear behind other "floating" elements. With the exception of a yellow square suspended by its corner from a blue rectangle in *First Theme*, 1961, the other elements rode free in all three paintings; each was accented by a small black rectangle placed horizontally to oppose the dominant vertical element. The artist used other variations of this scheme when he reversed the ground color to black in *First Theme*, 1933–1934,(268) and joined some of the elements in *First Theme*, 1943.(269) In one case he worked out the first theme in wood relief, attaching white and primary yellow and blue rectangles to a lighter blue surface.(270)

265 Diller, *First Theme*, 1942. Oil on canvas, 42 x 42" (106.6 x 106.6 cm). The Museum of Modern Art, New York, gift of Miss Silvia Pizitz. Photograph © 2001 The Museum of Modern Art, New York.
© Estate of Burgoyne Diller/ Licensed by VAGA, New York, NY

268 Diller, *First Theme*, 1933–34.
© Estate of Burgoyne Diller/
Licensed by VAGA, New York, NY

269 Diller, *First Theme*, 1943.
© Estate of Burgoyne Diller/
Licensed by VAGA, New York, NY

270 Diller, *First Theme: Relief*, date unknown.
© Estate of Burgoyne Diller/ Licensed by VAGA, New York, NY

189

In his second-theme paintings Diller clearly revealed his debts to van Doesburg and Vantongerloo when he attempted to determine the base plane (somewhat ambiguous in first-theme paintings) by attaching the elements to it or to one another as they lay across it. He painted planes and/or lines across the base plane's surface, usually stretching them from edge to edge, but sometimes only until they met other planes or lines. While the artist's main intention here was to make an "impact of base plane" with "separation of planes minimal," as he put it in a notebook notation on the second theme, he also wished to "generate" the element by "continuous lines." Any eye movement in a first-theme painting would take place only as the spectator looked along a rectangle's chief axis, but in the second theme it would follow the line that connected the rectangle to an edge of the painting. Since the connected elements would be perpendicular to one another, their tense relationship would add an active ingredient to the paintings.

271 Diller, *Second Theme*, 1944.
© Estate of Burgoyne Diller/
Licensed by VAGA, New York, NY

Diller demonstrated the variety (as well as sparsity) that was possible within this theme in *Second Theme*, 1944.(271) The painting's base was divided into four white vertical planes; these were separated only by pencilled lines that "determined" the base by making apparent its height and width. The only element, a red rectangular bar that cut across the right-hand white plane was so narrow that it barely intruded upon the base plane – thus did not mitigate its strength. Both van Doesburg and Vantongerloo had done something similar at a much earlier time. Van Doesburg's *Rhythm of a Russian Dance*, 1918, (272) however, had lines that did not run in opposition to his elements but connected those that moved in opposite directions; Vantongerloo's $x^2 + 3x + 10 = y^2$, 1934,(273) had some rectangles that were connected by an edge to opposing lines but others that were attenuated to act as both elements and lines.

272 Van Doesburg (C.E.M. Küpper), *Rhythm of a Russian Dance*, 1918. Oil on canvas, 53 1/2 x 24 1/4″ (135.9 x 61.6 cm). The Museum of Modern Art, New York, acquired through the Lillie P.Bliss Bequest. Photograph © 2001 The Museum of Modern Art, New York.

273 George Vantongerloo, $x^2 + 3x + 10 = y^2$, acrylic (hereafter ac), Lillian H. Florsheim Collection, New York.

274 Diller, *Second Theme*, 1961.
© Estate of Burgoyne Diller/
Licensed by VAGA, New York, NY

275 Diller, *Painting: Second Theme*, 1942, 1944, 1945 (painted over edges).
© Estate of Burgoyne Diller/ Licensed by VAGA, New York, NY

In an untitled painting of 1961, Diller varied the extreme lengths to which he would take the second theme.(274) This painting's vertical, primary-colored rectangles were connected to the canvas sides by three thin black lines that crossed the dark gray base plane. *Second Theme, 1943, 1944, and 1945* (275) was a more animated painting of this type because the lines that connected the elements to the sides of the canvas were longer and were cut vertically by lines that ran from top to bottom of the canvas on both sides.

Paintings with which the artist demonstrated the third theme sparkled with activity, as seen in the constant interchange of direction and color of *Third Theme, 1948–1949* (276) and *Third Theme, 1950–1955*.(277) In the latter painting, Diller transformed lines into planes and planes strung in parallel columns into lines until "linear planes" were hardly distinguishable from "planar lines," as in Mondrian's *Victory Boogie-Woogie*. Their in-and-out movements, augmented by continuous color alternations, created rhythmic vitality that became almost too rich over a period of time, prompting the artist's return to the simpler, more elemental statement of his first theme, wherein he would begin the cycle again.

276 Diller, *Third Theme*, 1948–49.
© Estate of Burgoyne Diller/
Licensed by VAGA, New York, NY

277 Diller, *Third Theme*, 1950–55.
© Estate of Burgoyne Diller/
Licensed by VAGA, New York, NY

278.

Diller also treated the three themes in drawings. They were never shown separately and were not noted by critics before his death, but the drawings probably meant as much to the artist as his paintings. Two of the drawings dated in the 1940s showed his respective influence from Mondrian's diamond paintings of the 1930s and of *New York City*, 1942, although the elements in *Pencil Drawing, 1944* (278) were left free within the space, and in *Drawing, Colored Crayon, 1948* (279) they crossed a gray background instead of a white one.

279.

278-284 Diller's pencil and crayon drawings, dating from 1944 to 1964, were photographed in 1968 by the author at the Noah Goldowsky Gallery soon after they were removed from Diller's home.
© Estate of Burgoyne Diller/
Licensed by VAGA, New York, NY

280

While most of the drawings followed the same thematic lines as the paintings did,(280-282) some of the later ones deviated in color, content, and treatment. Diller changed primary colors to pale pink and yellow in *Drawing No. 14, 1962,*(283) and he turned to symmetry in *Drawing No. 2, 1963,*(284) probably because Ad Reinhardt chided him about staying too close to Mondrian's asymmetry.[12] The artist's use of symmetry resulted in a "certain amount of space," according to Bolotowsky, but the tensely held symmetry of black planes pushed apart by white yet held together by overlapping linear planes gave an overpowering effect to a late painting, *First Theme, 1964.*(285)

281

282

283

284.

285 Diller, *First Theme*, 1964.
© Estate of Burgoyne Diller/
Licensed by VAGA, New York, NY

286 Diller, *Project for Granite, #6,"* formica on wood, 1963, New Jersey State Museum of Art (photographed in 1969 by author in NJSM, where work was kept on temporary loan).
© Estate of Burgoyne Diller/ Licensed by VAGA, New York, NY

287 Diller, *Project for Granite, #5,* formica on wood, 1963, New Jersey State Museum of Art.
© Estate of Burgoyne Diller/ Licensed by VAGA, New York, NY

The artist's final "color structures" were conceived as models for monumental sculptures that were never realized. He had constructed them from wood and formica but intended that the finished structures be executed in granite. Because of their frontality and symmetry they had an affinity with the late drawings and paintings that was made clearer by their "having been mocked up for obvious reasons in colored formica," as Robert Pincus-Witten pointed out. This made them seem more "painterly" than monumental.[13]

Examples of these constructions were *Project for Granite No. 5* and *Project for Granite No. 6*, both of 1963 (286,287), that were shown in the posthumous section of the International Exhibition at the Guggenheim Museum in 1967. Each was formed of a large rectangular block that had a smaller block thrust at right-angles through a rectangular slit in its center. Diller achieved variety in these sculptures by color or size; those of a single color were larger than those that included another color which was usually, if not always, confined to the smaller central element. These sculptures carried out the concrete implications of Neoplasticism, coordinating and interchanging form and space both conceptually and perceptually.

288 Detail of Diller, *First Theme*, 1942,
Museum of Modern Art, New York.
© Estate of Burgoyne Diller/
Licensed by VAGA, New York, NY

Despite his protestations, the artist was in some respects closer to Mondrian than were the other Neoplasticists. Like Mondrian, he used primary colors and non-colors exclusively; the younger artist also experimented to get the right mixtures. This meant that while he wanted his elements to be distinctive he did not want them to advance independently of one another nor of the base plane. By maintaining the clarity of color, he would achieve the highest impact together with the least separation of parts.

Like Mondrian, Diller occasionally painted over the edges of his canvases, as in *Second Theme*, 1943, 1944, and 1945. (275) Also, he used only vertical and horizontal relationships but implied other movements that were extrinsic to the surface, thereby exploiting the tendency of eyes to follow color planes in directions established by the artist.[14]

Unlike Mondrian, the artist brushed all vestigial painterliness out of his surfaces (288). Holty, who was well acquainted with Diller as an artist, defended him by saying: "Good painters use thin paint as good ones use thick paint." Also unlike Mondrian (but like Holtzman and Glarner), Diller carried the incipient sculptural nature of his paintings into fully-developed, three-dimensional structures. Indeed, critics equivocated with respect to Mondrian's influence on the artist, and since the artist was usually treated pejoratively in relation to Mondrian and even De Stijl, he himself understandably rejected a too-close association with Mondrian.

In 1972 and 1973, years after his death, the artist's place in contemporary history was approached more objectively by two perceptive critics. Art historian Robert Pincus-Witten concluded: "Through a tenacious belief in the symbolic power of a spare, formalist vernacular, Diller, while producing works alien to the conventional styles of the early 1960s, is able to succeed today in convincing the spectator of the value of his enterprise." In a review discussing the artists in an exhibition of Mondrian's American Circle held in Chicago, Jack Burnham said of Diller's work that he "quite possibly had the best grasp of Mondrian's evolutionary intentions." Burnham thought that the bilateral symmetry of the artist's late work was undoubtedly a "concession to the mood of the early 1960s," but he also recognized "that Mondrian's theory of 'Dynamic Equilibrium' had reached a point of stasis." The critic said that the sculptures represented a transition between the "parts-to-whole relationships of formalist art and the overt axial symmetry of most Minimalism."

Diller was almost incapacitated by alcoholism and a heart condition during the early 1960s, but he seemed to prepare more canvases and to work feverishly as if with a presentiment of his death in 1965. The following words from his notebook jottings indicate that Diller might finally have made his artistic peace:[15]

> How does one express the creative moment? . . . or the creative life? . . . the times of trial and error . . . of hope and despair of sweating work and quiet seeking? Times when you play tricks on yourself to get working . . . you tidy up the studio . . . wash your brushes, clean the palette . . . make little drawings . . . find yourself getting interested, then . . . [off you go] . . . to work. How much time there is . . . how little time there is . . . how much has been done . . . how much there is to do. Now there is no time . . . now minutes seem like the slow dripping of cold honey. There is no past . . . there is no future . . . there is only now. Time is the past, present, and future . . . now . . . and time is understood. Space is realized . . . the image is clear.

It would be natural to expect Fritz Glarner, whose training and artistic development were entirely in Europe, to seem the most European of Mondrian's American followers. This stance was seen in his willing subservience in the role of disciple to master, his ready submission to the tenets of a style, and his reverence for craft.

Because his father was a flour-mill engineer, the family moved frequently – from Zurich, where Glarner was born in 1899 of an Italian mother and a father who was half-Italian and half-Swiss, to Salerno and then to Chartres, which was centrally located in the French grain-growing region. Glarner always believed that the stained glass of Chartres Cathedral inspired his later art, because he began to paint water colors based upon the windows at about the age of ten. His family left Chartres during World War I and settled in Naples, where he entered the Royal Academy of Fine Arts. There, Glarner became a "seasoned technician,"[16] although he remained innocent of modern painting culture.

This was except for Impressionism, which he had seen in the paintings of Monet when taken by his father to a museum. The Impressionist influence, in particular, was to have a decisive influence on the young man's art. One of his early paintings, *Buttercups*, 1919, (289) had a fluctuating textural quality, brought out by alterations in strokes and values, that not only revealed Glarner's sensitivity to the painterliness of Impressionism but looked forward to his particular brand of Neoplasticism.

His interests as a student were somewhat diverted from Impressionism when Glarner moved with his family to Paris. He worked in the Colarossi Studio, where there were many incipient artists, including Giacometti and a man named Licini, a friend of Modigliani who had died the year before. Glarner's interest in Modigliani was strengthened when he met his future wife, Lucy, and found that her aunt Hélène Povalotsky owned a portrait of herself painted by Modigliani (now in the Phillips Memorial Gallery, Washington DC).

Glarner explained best his own development in a lecture he gave at a New York school:

> I came to Paris in 1923. A revolution or turning point or break had already occurred in the plastic arts. . . . I began to represent objects in flat tones and I felt need to dematerialize them – eliminating shadows – outlining them to give them a more definite size and proportion – not copying the relationship that they occupied in nature, but relating them to the size and limits of the canvas. By that way of working I noticed that, for example, if I first painted a cup and saucer, and then added a spoon, the outline of the cup and saucer had to be changed in size, place, and tone in order to maintain that tension that I felt was the more active movement of the composition. The fact that the cup and saucer had to be displaced suggested to me more and more that what was really active in the painting was a kind of two-dimensional relationship giving a greater sense of space. Little by little, I reduced the apparent shapes of the cups or whatever objects happened to be, to more geometric forms.
>
> All my attention was focused in the area between these form-symbols. The relationship between the background and the form-symbols seemed to change, the background became somewhat more active than the form-symbol itself. To bring about a purer and a closer interrelationship between form and space has been my problem since that time.

290 Glarner, *L'Equarre*, 1928 (unless otherwise indicated, paintings are oc and were photographed by the author in the artist's collection). © 2001 by the Estate of Fritz Glarner, Kunsthaus Zurich. All rights reserved

291 Glarner, *Painting*, 1930 (reproduced from photograph courtesy of the artist).
© 2001 by the Estate of Fritz Glarner, Kunsthaus Zurich. All rights reserved

The still life *L'Equarre*, 1928 (290) illustrates an early stage of the artist's changing attitude toward flattening objects and relating them to their positions on the canvas rather than to their functions. He frontalized the tabletop in order to establish its actual size and shape; then he tilted the floor upward into a plane parallel with the table and placed the triangle so as to make its top side and shadow accord with the edges of the floor.

In an untitled work of 1930, painted when Glarner first came to New York (291), he reduced and displaced the corner walls and floor of a room to bring them into a "two-dimensional relationship giving greater sense of space." The artist had penetrated the surface by giving the right-hand segment of baseboard a correct perspective, but he pushed it out again by reversing the perspective of the left-hand segment. That segment, which was parallel with the base of the tilting stick, held it in place while at the same time the stick's imbalance created a tension that actively unified the painting.

292 Glarner, *Painting*, 1937, Kunsthaus, Zurich.

By 1937 Glarner had reduced objects to "form-symbols" that were no longer completely recognizable, but he had so concentrated attention "in the area between these form-symbols" that "the background became somewhat more active than the form-symbol itself." The artist's intention could be seen in *Painting*, 1937,(292) especially the area around the table wherein quadrilateral shapes (presumably fragments of the wall) claimed as much attention as the objects, or form-symbols on the table. In *Painting*, 1940,(293) he allowed edges of space segments to move toward form-symbols that no longer had any connection with their former associations. By not quite connecting the curves behind them Glarner activated the forms, but there was implied space in their apparent overlap. Before knowing Mondrian, however, he had reached a stage of problem-solving that put him on the verge of the Neoplastic solution.

294 Glarner, *Composition*, 1942.

The artists met in around 1927, in Paris, when they belonged to a group that frequented the Closerie des Lilas Café. At that time, Glarner was impressed neither with the elder artist nor with his work. He and his wife had lived in New York for a while in the early 1930s. Then they returned to Paris and met Mondrian in the Abstraction-Création group. In the mid-1930s they lost contact again when the Glarners settled permanently in New York. Although the younger artist had found the atmosphere of New York to be "stagnant and depressing" during his first stay there, he now felt more at home. This was because the American Abstract Artists group, which he joined in 1938, included a number of artists whom he had met in Europe. Some of them spoke French, his preferred language.

Fritz and Lucy Glarner were not well-acquainted with Mondrian when the elder artist first came to New York but were close to him for about a year before he died. At first unsympathetic to Mondrian's late change of style, Glarner was affected by his continual search during the "Boogie-Woogie" period for a way to integrate form and color completely with the plane.

Composition, 1942 (294) illustrated the artist's realization that in order to establish the painting's dimensions objectively, he had to anchor its composition securely to the edges of the canvas, "as the rectangle was the only fixed factor to which all the parts of the painting were constantly related." With its

white ground, black lines of varying thicknesses, and use of primary red and yellow, this painting already showed Mondrian's influence. Still, the brown color of the shape on the lower left was too reminiscent of a "natural" table, and its overlapping square was too outstanding, as the younger artist explained. He was eventually to understand that circles, triangles, and squares could be taken for something too particular (as in late paintings by Kandinsky).

The artist realized that he had to neutralize his "particular" forms and also, that the diagonal he had placed across the square was arbitrary. "I always had a diagonal where it didn't belong," Glarner said; "it came out occasionally, by accident, but I wanted consistency."

This stage led into a series that occupied him for about three years (1941–1944), during which he developed his "point-center" paintings. As the artist explained in his lecture:

> I found that a line stopped abruptly created dynamic move-
> ment. If we assume that a line is a succession of points, the
> last one has a different activity from the others because it is
> not succeeded by another point. Somewhat as a pebble whose
> momentum, stopped by the surface of the water, creates con-
> centric motion, so that last point acts as a point-center. The
> relationship between these point-centers increases the activi-
> ty of the space area.

Two paintings of different shapes illustrate this factor. In *Relational Painting, No. 50*, 1943 (295) and *Relational Painting, Tondo No. 1*, 1944,(296) Glarner allowed lines to enter the "space areas," but he broke them off to focus attention upon their point-centers; this also increased the spectator's awareness of the areas concentric to them.

295 Glarner, *Relational Painting, No. 50*, 1943.

No longer was there any reference to objects; all of the elements were now quadrilaterals. Lines of varying thicknesses in the latter painting either stopped or abutted one another. The artist did not cross them, which would have created three dimensions. But he still felt dissatisfied with this solution and used a rationale for his method that was close to Mondrian's. "Although my paintings of that period were always conceived and worked out in a two-dimensional intention," he said in the lecture, "the space between the form-symbols and the point-centers produced an indefinite sense of space, such as we experience looking at the sky or the sea. The vague sense of space was an oppressive factor and I felt the need to free the painting of it."

Dore Ashton thought that Glarner's dilemma over the unintentional spatial quality in his work was heightened by frequent conversations with Mondrian who, during these final years of his life, was reexamining his own theories. Apparently, the older man questioned both artists' use of line at the time he was working on the *Broadway Boogie-Woogie*, because he said to Glarner: "You stopped the line. I'm going to break it." Ashton assumed that this was what Mondrian meant when he wrote to James Johnson Sweeney: "Only now I become conscious that my work in black, white and little color planes has been merely 'drawing' in oil color." She thought, too, that the older man's final quest "to annihilate static equilibrium" was carried on by the younger one and became his personal contribution to Neoplastic painting.

Glarner arrived at his personal resolution after Mondrian died, partly as a result of watching that artist's final involvement with the plane. "Mondrian's plasticism was expressed through the vertical and horizontal line, but mine through the plane," he stressed. Once reached, the younger artist's personal statement was highly formalized and sufficed without change from that time on. And having achieved an intuitive solution, Glarner could explain his thinking rationally:

> In the course of my development, there were moments in which something had to be eliminated so that something else could come to life. I wish to make it clear that those moments were not iconoclastic in character but relational. I used the title *Composition Relative* or *Peinture Relative* to designate the paintings in which that condition was visible.
>
> The slant or oblique that I introduced in my painting created a stronger diagonal movement although maintaining the emphasis of the horizontal and of the vertical. The slant divided the rectangle by forming two similar quadrilaterals with the rectangle. This annihilated the form-symbol, for the form-symbol lost its particularity and became the same as space. When the form area and the space area are of the same structure, the differentiation has to be established by opposition, proportion, color, etc. The slant establishes the structure that determines space and liberates form.

Opposite page:
296 Glarner, *Relational Painting, Tondo No. 1*, oil on masonite,
 1944, Kunsthaus, Zurich.

Translated in terms of particular paintings, this meant that the artist no longer used a white ground as a base for black lines and isolated colored elements, as in *Relational Painting, 1945, 1948.*(297) Here, he divided the entire surface with rectangles and then bisected each of them obliquely. Lines around the planes had been abolished, but this did not mean that lines did not exist symbolically; the thinner of the two quadrilaterals within a rectangle functioned both as line if painted black, or as color if painted one of the primaries. The smaller area also assumed the role of structure, or "form," with the remaining gray quadrilateral acting as "space."

At this point, Glarner's work had reached a stage similar to the *New York City* paintings, in which Mondrian had added color to lines. The younger man's gesture had amalgamated colored elements and lines, or form and structure, but he still had the problem of a non-integrated space. Thus, out of a desire to reduce everything to the same structural form, he had eliminated lines and retained only planes. There were still rectangles, but Glarner claimed to have eliminated them, as well, because he had sliced each rectangle diagonally down its center to make two planes that were designated as a form plane and a space plane. Form and space then became similar structures that differed only in amount of color or value. The form was usually primary-colored, although the artist might make it a strong gray or black. The space area was usually a gray that was lessened in value from the gray of the accompanying form plane.

Pairing a strong form plane with a less strong space plane posed an inconsistency also to be found in dominant-subordinant relationships of color to non-color, dark to light, and warm to cool. Glarner was always anxious to resolve such dichotomies, so he insisted that there was no dominating element: giving both quadrilaterals the same five-degree/fifteen-degree angles made for absolute equation. He saw no contradiction in reaching for unity while at the same time stressing the "duality" to be obtained through "color, proportion, contrast, etc."

297 Glarner, *Relational Painting*, 1945, 1948.

Neither did he mind the movement that resulted when "the slant or oblique created a stronger dynamic movement," because, he explained, "it established the structure that determined space and liberated form."[17]

The artist maintained the same approach to another canvas shape, the tondo, that he employed out of respect for the Italian Renaissance tradition. He did not choose a round format for variety's sake but to demonstrate further his theory of Neoplasticism. As he explained:

> The circle is the strongest form-symbol of oneness. Its complete space detemination can be achieved by plastic means. A multiplicity of similar quadrilaterals of which one side is a segment of the circumference establishes the structure that determines space and liberates form.

Glarner thought, in other words, that he could determine the space of a circular canvas even more exactly than a rectangular one because the component rectangles could neither be extended implicitly beyond its surface as with a rectangular canvas, nor be so easily interchanged. He believed they were therefore more fixed and absolute in their relationships while being at the same time more organic a part of the area to which they belonged.

When he began a circular painting, the artist crossed its vertical and horizontal axes with imaginary lines. That is, he detemined its diameters and at the same time divided its surface into four equal segments. Then he drew a small "microcosmic" circle around its center, where the axes crossed; this small circle incorporated the angles of the larger circle's quadrants. By "removing" these angles from the canvas' center to its circumference, Glarner implied that its size was predetermined and could not be infinitely extended. Its remaining body then could be apportioned into quadrilaterals, each of which not only was sliced by a diagonal but was shaped on one curved side by the circle's circumference.

The artist composed many subtle variations on this format, as with *Relational Painting, Tondo No. 3*, 1945, (298) in which the rectangles are approximately the same width but the formal elements are slenderer than the spatial ones. In *Relational Painting, Tondo No. 20*, 1951–1954, (299) on the other hand, the rectangles vary considerably in width and length, as do the "forms" in relationship to the "spaces." By making the forms larger than spaces in *Relational Painting, Tondo No. 37*, 1955, (300) he endowed this small painting (19 inches in diameter) with monumental size. Adding an extra form element at the alternating curved and straight edges of his quadrilaterals, he enriched the painting with further rhythmicality. The curved elements are especially effective, as they appear to weave in and out around the circumference of the canvas.

298 Glarner, *Relational Painting, Tondo No. 3*, oil on masonite, 1945.

His careful and clever manipulation of grays did not preclude an intense interest in color that the artist felt had its own true identity. Thus in his murals he exploited the nature of color to act in concert with surrounding hues. Glarner conceived of the large mural that he painted for the Time and Life Building in New York City as a triptych.(301) He devoted each of its sections to a different secondary effect produced by a dominance of two of the primaries: the first section, "with emphasis on red and blue, has a purplish effect"; the second, "with emphasis on yellow and blue, has a green effect"; the third, "with emphasis on yellow and red has an orange effect." By the receding and advancing properties of the various colors "a new kind of depth can be established," the artist said. This aim was the opposite of Mondrian's, which was always to keep the hues pure.

299 Glarner, *Relational Painting, Tondo No. 20,* oil on masonite, 1951–54.
© 2001 by the Estate of Fritz Glarner, Kunsthaus Zurich. All rights reserved

300 Glarner, *Relational Painting, Tondo No. 37,* 1955. Oil on composition board, 19" (48 cm) diameter. The Museum of Modern Art, New York, gift of Mr and Mrs Armand P. Bartos. Photograph © 2001 The Museum of Modern Art, New York. © 2001 by the Estate of Fritz Glarner, Kunsthaus Zurich. All rights reserved

301 Glarner, mural for the Time-Life Building in New York City (photographed by the author).
© 2001 by the Estate of Fritz Glarner, Kunsthaus Zurich. All rights reserved

Among other murals that were coordinated with their surroundings was one designed for the Mall of the Justice Department in Albany, New York.(302) This project was undertaken under the auspices of Governor Nelson Rockefeller, who also commissioned Glarner to work in his home. Another mural was commissioned by his friend Dag Hammerskjöld for the entrance to the library named for that statesman at the United Nations Plaza, New York City.(303)

The color-orchestration in these works, as well as in his easel paintings, produced a diffuse quality of surface, "a palpitation," Glarner said. This vibration was also enhanced by the underlying pulsation of his strokes, as can be seen in a detail of *Relational Painting, Tondo 37* (304) Finding that "any tool or technique used to apply paint produces texture" and that "the intentional differentiation of texture disturbs the unity of a painting of pure relationships," he concluded in his lecture that "the painter should produce the same texture throughout the entire work." While he played down texture, however, he did not totally suppress it but shared with Mondrian a penchant for painterly technique that probably came from the two artists' European backgrounds. Both produced on their canvases a fabric of sensitively-brushed strokes. This practice distinguished Glarner's paintings from those of the other Neoplastic followers and recalled his early interest in Impressionism.

304 Detail of Glarner's *Relational Painting, Tondo No. 37*, 1955, Museum of Modern Art, New York. © 2001 by the Estate of Fritz Glarner, Kunsthaus Zurich.

305 Glarner, *Drawing for a Tondo*, pencil on paper, 1959.

306 Glarner, sketch for the Dag Hammerskjöld Library mural, charcoal and crayon on cardboard

Glarner's sensitivity to surface can also be seen in study-drawings that he sometimes displayed as finished works – such as his sketches for a tondo, in 1959, and for the Hammerskjöld mural.(305,306) Perhaps it was his being part of an older tradition that made drawing and its corollary, lithography, so meaningful to him. He began to employ the print medium for its expressive as well as doctrinaire possibilities when he and his wife moved to Huntingdon, Long Island, to inhabit the converted-barn studio that had once belonged to sculptress Mary Callary (according to Lucy Glarner, the reconversion had been done from a sketch made by Mies van der Rohe).(307)

From the summer of 1964 until the fall of 1965, the artist was involved in a project at the lithography workshop of Tatyana Grossman in West Islip, New York, where almost daily he drew directly on the stones. By the end of 1965, when Glarner and his wife left for their annual winter's stay in Locarno, Switzerland, he had covered almost 50 stones with drawings designed to show his development from the early 1940s when the work became completely abstract until its fully-realized "relational" style.

307 Glarner's studio-homesite, Huntingdon, Long Island (photographed by the author in 1967).

During a storm on his return trip, in the spring of 1966, the artist was thrown against a bulkhead on the Italian liner *Michelangelo* and suffered a head injury so severe that he was an invalid for the remainder of his life. After a brain operation and a year's convalescence at the Institute of Rehabilitation in the New York University Medical Center, he resumed his work on a limited basis.(308-310)

Eventually, Glarner finished his lithographic project with the help of Riva Castleman, who published the book that had taken him over four years of work. The book's most ambitious page, a sketch for the Time and Life Building mural,(311) accompanied by handwritten notes, made clear the mural's complex color relationships. Castleman said that the book was "the accomplishment of not only a color and space theoretician but a sensitive draftsman."

311 Glarner, sketch for Time and Life Building mural (reproduced from photograph courtesy of the artist).

308 Photograph of Glarner in his Long Island studio, fall 1967. © Virginia Pitts Rembert

309 Photograph of Glarner in his Long Island studio, fall 1967. © Virginia Pitts Rembert

310 Glarner's Long Island studio, fall 1967.
© Virginia Pitts Rembert

Even though he had not lived in Switzerland since childhood, except for a short stay in Zurich from 1935 to 1936, Glarner was chosen as one of two artists to represent his native country at the 34th Venice Biennale in 1968. The exhibition was undoubtedly a triumph and perhaps influenced his decision to move back to Switzerland in 1971, by which time the artist was receiving serious coverage in the international press. The stature that Glarner had attained at the time of his death in 1972 was demonstrated by articles that appeared in German, French, Dutch, Swiss, and American publications.

Like Mondrian, Glarner had looked forward to a time when "all will be one — a long time away," but also like his "master," Glarner saw his form of Neoplastic Relational Painting as part of "a step-by-step development toward the essential integration of all plastic art."

Charmion von Wiegand was born in Chicago around 1900 and grew up mainly in Arizona and California; most of her adult life was spent in New York City.[18] Her schooling was irregular. She sampled archeology, Greek, philosophy, drama, and art history while attending public and private schools in San Francisco and Europe, the Berlin University, and the Columbia University School of Journalism. But she had no training in art — she was brought up by her father to be a writer and did not begin painting until 1926 while undergoing psychoanalysis. The therapy brought out experiences that were impressed visually on her mind in childhood, such as the red dragons and fire-crackers that she had seen in San Francisco's Chinatown. During her first marriage she lived in New York and took a studio in Greenwich Village, where she met the artists Joseph Stella, Jules Pascin, and John Graham and the writers Theodore Dreiser, Frank Harris, Max Eastman, and Hart Crane. They were to remain her friends for life.

The young woman followed the example of her famous father when she was sent by the Hearst papers to be the only woman correspondent in Russia, from 1929 to 1932. While there, she was inspired to do paintings such as *Orthodox Church in Moscow*,(312) and *Moscow Room* (313) after seeing European works in the Schukine and Borosof collections. A self-acclaimed "radical," the artist did not follow "revolutionary" themes until her return from Russia in 1932, when she painted several industrial landscapes. After her marriage to Joseph Freeman she continued to paint these landscapes at their home in Woodstock, New York; an example is *Railroad Siding, Croton-on-the-Hudson*.(314)

When she and her husband moved to New York City, von Wiegand did not find the city environment to be conducive to realistic treatment in her art. She had difficulty with spatial relations, without realizing that she was stressing the surface plane; this would become a conscious interest in her later work. Out of frustration, the artist stopped painting for a while. Her artistic idol at the time was Picasso; she knew little of Mondrian until reading a pamphlet published in England on five abstract artists, but even then she dismissed Mondrian as a mathematical painter.

312 Charmion von Wiegand, *Orthodox Church in
 Moscow*, oc, 1932–33.
 © Estate of Charmion von Wiegand, courtesy
 of Michael Rosenfeld Gallery, New York, NY

315 Photograph of von Wiegand in her 33rd Street
studio-apartment, 1968
© Virginia Pitts Rembert

Everything changed when von Wiegand first met Mondrian. Commissioned by *The Journal of Aesthetics and Art Criticism* for an article on the elder artist, she wrote the first critical study of his work in the United States.[19] The notes recorded in her journal during this first visit became widely known when Michel Seuphor drew on them in his monograph (published in French, English, and German in 1956 and 1957; von Wiegand's reminiscences were not published until 1961[20]). As a result of her visit to Mondrian's studio, the young artist became fascinated with Neoplasticism and began to study it on her own; later, she helped Mondrian with his writing and frequently watched him paint. He encouraged von Wiegand to join the American Abstract Artists; she did this at first on an associate basis because she did not paint abstractly at that time.[21]

The artist was led into abstraction after Mondrian's death by another artist-in-exile, Hans Richter, who first encouraged her to experiment with collages. Richter also urged her to do automatic drawings, 50 or more at a time. "Draw, don't think," he'd say. "If you stop, the line breaks." Von Wiegand translated some of these exercises into paintings, such as *Non-Figurative Composition*, 1945.(316) She also gave credit to Stella, Pascin, and Graham for the infomal instruction they gave her but claimed that Mondrian was her most important teacher. He "never took a pupil," she said, but he "transformed my life in art and gave me discipline and the goal which leads to freedom."(315)

316 Von Wiegand, *Non-Figurative
Composition*, 1945.
© Estate of Charmion von Wiegand,
courtesy of Michael Rosenfeld
Gallery, New York, NY

Von Wiegand's devotion to Mondrian was so intense that she "wept at his funeral and for months could not bear to go past and look up at his unlighted studio," yet she did not work under his influence until over a year after he died. Indeed, the younger artist probably would not have painted in Mondrian's style at all had they not shared an interest in Theosophy. Actually, the content of her painting was more strongly influenced by Theosophy than his. Von Wiegand first learned of the movement through her parents, who had joined when they lived in California, but she had become such a dialectical materialist that for some time after meeting the elder artist she could not communicate with him about the movement. Her ideas soon began to change, and a revived interest in Theosophy led von Wiegand, eventually, to use a geometric format that had not seemed natural when she was most directly under her mentor's influence. She found herself fascinated by the color notes and oriental canons – Egyptian, Chinese, Indian, and Tibetan – from which Mme Blavatsky had derived Theosophy.

317 Von Wiegand, *The Ka Door*, 1950 (unless otherwise indicated, this and the following paintings are oc and were photographed by the author in the artist's studio in 1968 and 1980).
© Estate of Charmion von Wiegand, courtesy of Michael Rosenfeld Gallery, New York, NY

From the nearest direct source, New York's Metropolitan Museum of Art, the artist studied Egyptian motifs; she borrowed the idea of the false door for the Ka indicated in *Ka Door*, 1950 (317) from an Egyptian casket in that collection. At this time, primary colors dominated von Wiegand's palette, but she took the reds and blues, as well as the small squares in the painting, from Egyptian, not Neoplastic, sources. Nevertheless, the vertical-horizontal framework containing linear planes broken by small squares strung along their lengths was strongly reminiscent of Mondrian's *Victory Boogie-Woogie*.

318 Von Wiegand, *The Wheel of the Seasons*, 1957.
© Estate of Charmion von Wiegand, courtesy of Michael Rosenfeld Gallery, New York, NY

319 Von Wiegand, *The Magic Cross*, 1961
© Estate of Charmion von Wiegand, courtesy of Michael Rosenfeld Gallery, New York, NY.

The artist also used the small squares in *Wheel of the Seasons*, 1957,(318) although here they were part of a more unusual format, the logarithmic spiral. The spiral was Pythagorean in origin, but with it she used Blavatsky's "prismatic" colors, calling them the minor chords, or harmonies, as opposed to Mondrian's major ones, or primaries. Putting the Egyptian squares at the service of Christianity in *The Magic Cross*, 1961,(319) von Wiegand integrated the cross with the ground by making effective use of white among the color squares.

She returned to a more specifically Egyptian idea in *Desert Sanctuary,* 1959–1960,(320) which charted the plan of an Egyptian rock-cut tomb. The painting's linear scheme of rectangles referred conceptually to the New Kingdom tomb-shaft, entry-court, and offering chambers, but its structure came directly from Mondrian. He had provided the means, she said, through which to express her continuing interest in the sanctuary, an idea that was carried out with a Buddhist temple plan in *Sanctuary of the Four Directions,* 1959. (321,322) The younger artist found this painting's Mondrianesque format "impossible to eliminate," she said. "I tried to take out the red in the upper left – took it out, then put it back." Even so, the layout seemed perfectly suited to a plan of the climactic stupa and its adjacent shrines in a Buddhist nave.

320 Von Wiegand, *Desert Sanctuary,* 1959–60.
© Estate of Charmion von Wiegand, courtesy of Michael Rosenfeld Gallery, New York, NY

321 Von Wiegand, *Sanctuary of the Four Directions,* 1959.
© Estate of Charmion von Wiegand, courtesy of Michael Rosenfeld Gallery, New York, NY

322 View into von Wiegand's living room.
© Virginia Pitts Rembert

324 Von Wiegand, *The Joyous Lake*,
1955–56.
© Estate of Charmion von Wiegand,
courtesy of Michael Rosenfeld Gallery,
New York, NY

Gradually, von Wiegand's interests turned more and more to the East. At first, the "logarithmic" paintings, such as *Heaven Within the Mountain* (323), *The Joyous Lake* (324), and *Image of Abundance* (326), were distinguishable from earlier ones only by titles that suggested paradisiacal Taoist themes. *Heaven Within the Mountain*, however, retained the primary colors, while the other two paintings began to deviate toward the prismatic. Titles for such works as *The Golden Flower* (325), the name of the third eye in the forehead of the Buddha, were taken from a Chinese philosophy book given to the artist by Ibram Lassaw. This painting, which contained circles and hexagonal star and lotus symbols formed with diagonal lines, showed the first signs of her departure from basic right-angled relationships. She used darker values to superimpose diagonals upon the original right-angled shapes.

Von Wiegand's interest in Buddhism increased when she met American descendants of the Russian group that had first inspired Mme Blavatsky. They honored her with the rarest privilege for a non-initiate: an invitation to visit their temple in New Jersey. She said of the experience:

> I was spell-bound – knocked out by the color. That is why my pictures changed. You can't change your color and not your form, so that is why my form changed.

The artist's content changed as well, because she met refugees in the group who showed her the texts and paintings they had brought with them from Tibet.

323 Von Wiegand, *Heaven Within the Mountain*, c. 1955–56.
© Estate of Charmion von Wiegand,
courtesy of Michael Rosenfeld Gallery,
New York, NY

325 Von Wiegand, *The Golden Flower*, 1952–53.
© Estate of Charmion von Wiegand,
courtesy of Michael Rosenfeld Gallery,
New York, NY

326 Von Wiegand, *The Image of Abundance*, 1956.
© Estate of Charmion von Wiegand,
courtesy of Michael Rosenfeld Gallery,
New York, NY

From the time von Wiegand met the Tibetans, she began to draw her imagery almost exclusively from Tantric imagery, mostly Buddhist, although there was some Hindu symbolism as well.(327) She did not try to be illustrational, but found that her oriental friends could "read" the paintings. This was not only because she used some of the canonical colors and imagery but because pure Tantric art is already geometric.(328) Thus it seemed perfectly natural to the artist to move via Mondrian's principles to paintings that were inspired by oriental principles. The desire to create "luminous sound" in shapes of "absolute 'geometrical purity,'" the only form allowable to the "formless," is the motivation behind many Tantric images. It is also the motivation behind several of von Wiegand's paintings, such as *Invocation to the Winter Goddess*, 1965–1966 (329), *The Diamond Scepter*, 1966–1967 (330) and *Adi-Buddha*, 1967–1968.(331)

327 View into von Wiegand's living room showing her Buddhist shrine.
© Virginia Pitts Rembert

328 Abstract Tantric painting: *Sri Yantra*, Rajasthan, late 18th century, private collection.
© Estate of Charmion von Wiegand, courtesy of Michael Rosenfeld Gallery, New York, NY

330 Von Wiegand, *The Diamond Scepter*, 1966–67.
© Estate of Charmion von Wiegand, courtesy of Michael Rosenfeld Gallery, New York, NY

329 Von Wiegand, *Invocation to the Winter Goddess*, 1965–66.
© Estate of Charmion von Wiegand, courtesy of Michael Rosenfeld Gallery, New York, NY

225

331 Von Wiegand,
Adi-Buddha, 1967–68,
Michener Collection
(photographed by the
author in von Wiegand's
apartment, 1968).
© Estate of Charmion
von Wiegand, courtesy of
Michael Rosenfeld
Gallery, New York, NY

The artist also became interested in Hindu Tantric artists and, like them, used the equilateral triangle to symbolize the basic mandala or mystogram, a yoga device used to aid artists in achieving identification with their creative sources. For instance, in *Chakras*, 1958 (332) Von Wiegand stacked squares and interlocking triangles vertically within a geometric format to imply the ascending annihilation of consciousness from the body's lower, physical centers (encased in red) to its upper, spiritual centers (progressively lighter in color). The mental climax occurs in the area where multiple squares of whitened color ("millions of lightning flashes") reveal the ultimate union with Siva.

333 View into the von Wiegand exhibition at the Birmingham Museum of Art, 1968.
© Virginia Pitts Rembert

The artist's later paintings were increasingly rich and subtle variations on these themes (333-336) and as such, diverged far from Mondrian's course. Even though she did not admit having deviated from his basic denominators, von Wiegand cannot be classified as a Neoplasticist. She followed the older artist in her geometric organization of a relatively flat plane but did not attempt to "determine" its dimensions nor maintain, exclusively, either the primaries or right-angles in her components. Rather, she introduced diagonals and curves and altered colors to include a variety of tints and mixtures. And when von Wiegand added explicit content, equating colors and geometric shapes with the arcana of certain oriental systems, her work became, in fact, antithetical to her mentor's. Nevertheless, she was linked to the man she called her master, as to the unknown Tantric artists, by her belief that art was not "a profession, but a path toward truth and self-realization both for maker and spectator."

332 (Top and bottom right)
Von Wiegand, *The Chakras*, 1958.
© Estate of Charmion von Wiegand, courtesy of Michael Rosenfeld Gallery, New York, NY

335 Von Wiegand, *Offering of the Universe*, 1963, at the Birmingham Museum of Art exhibition.
© Estate of Charmion von Wiegand, courtesy of Michael Rosenfeld Gallery, New York, NY

Opposite page:
334 Von Wiegand, *Kundalini Chakra*, 1968–69, at the Birmingham Museum of Art exhibition.
© Estate of Charmion von Wiegand, courtesy of Michael Rosenfeld Gallery, New York, NY

CHAPTER FIVE – REFERENCES

336 Von Wiegand, *The Paradise Gambit*, 1964-65.
© Estate of Charmion von Wiegand, courtesy of Michael Rosenfeld Gallery, New York, NY

1 This and all information and quotations that concern the American Abstract Artists, unless stated otherwise, were extracted from "Papers relating to the organization American Abstract Artists, lent by A. T. Mason, George L. K. Morris, and M. B. Coudrey" to the Archives of American Art, Detroit; recorded on microfilm by the Archives of American Art, New York City (quoted by written permission of Alice Trumbull Mason).

2 Among them were Nell Blaine, Perle Fine, Fannie Hillsmith, Karl Knaths, Charmion von Wiegand, Jean Xceron (listed in 1947), and Lewin Alcopley, Herbert Ferber, Richard Lippold, Seymore Lipton, Michael Loew, Louise Nevelson, and Hyde Solomon (listed in 1949).

3 Irving Sandler, *The Triumph of American Painting*, New York, 1970, p.1.

4 Statements by Fritz (and Lucy) Glarner were made in interviews from 1967 through 1968, and by Charmion von Wiegand in interviews from 1967 through 1980.

5 Sidney Tillim, "Month in Review," *Arts*, Vol. 35, No. 8–9, May-June 1961, p. 78.

6 Mondrian, "Toward the True Vision of Reality," *Plastic Art and Pure Plastic Art*, the Documents of Modern Art, ed. Robert Motherwell, New York, 1945, p. 14.

7 Undoubtedly, one of Holtzman's chief contributions lay in his continuing contribution to an awareness of Mondrian in the United States. This consisted of exhibiting the Mondrian works in his estate, of lecturing and distributing the film and slides he made of Mondrian's studio, and of preparing a translation with his former colleague at Brooklyn College, Martin James, of the entire body of Mondrian's writings.

8 Carter Ratliff, "New York Letter," *Art International*, Vol. XVI, No. 4, April 20, 1972, p. 31.

9 As quoted in Lawrence Campbell, "Squaring the Circle and Vice Versa," *Art News*, Vol. 68, No. 10., February 1970, p. 41.

10 According to Mrs Burgoyne Diller and her son William la Crone.

11 See catalogue of Mondrian's paintings in Michel Seuphor, *Piet Mondrian: Life and Work*, New York, 1956 (previously and hereafter referred to as Scc, followed by number of entry); an example of a Mondrian painting with a doublet of thin blacks is his *Composition with Yellow and Blue*, 1933 (Scc 369).

12 According to Reinhardt, who was a friend of Diller's for many years, both from the early years of American Abstract Artists and from the Brooklyn College Department of Art, where they were colleagues.

13 Pincus-Witten thought the material kept them from being just another brand of minimal sculpture "in the manner of Ronald Bladen, Tony Smith, or Donald Judd." He went on to say that these works "occupy a bracketing position between David Smith and the architectural/sculptural ambitions of the mid-1960s, but one which is fed by a much older, non-Cubist position in the 20th century." He did not explain that position, nor why they should be considered "non-Cubist" sculptures.

14 Both Holty and Bolotowsky spoke of the diagonal and curving implications in Mondrian's work. Holty said: "Mondrian didn't add curves, but they are there, in the way a plane will move before your eyes, describing arcs on the space of the canvas, if you know how to see them." Bolotowsky said: "Mondrian allowed himself freedom, color vibrations, and curved movements in his last paintings."

15 Edited from Diller's personal papers by Kenneth W. Prescott for preface to the catalogue, *Burgoyne Diller.*

16 Ashton, "Fritz Glarner," *Art International*, Vol. 7, No. 7, January 1973, p. 50. Unless otherwise indicated, additional information in this section is from interviews with Fritz and Lucy Glarner.

17 Quoted from *Recollection 1940–65* album with fourteen lithographs and texts by Glarner, ed. Tania Grossman, West Islip, Long Island, New York, 1968, np.

18 Information in this section is from biographical notes von Wiegand made for the Seattle Museum of Art, and from interviews with the author.

19 Wiegand, "The Meaning of Mondrian," *Journal of Aesthetics and Art Criticism*, Vol. 2, No. 8, Fall 1943. Von Wiegand first interviewed Mondrian in the fall of 1941.

20 The French edition of Michel Seuphor's *Piet Mondrian: Life and Works* was published by Flammarian, Paris, 1956; the English edition by Abrams, New York, 1956; and the German edition by Dumont Schamberg, Cologne, 1957. Von Wiegand's reminiscenses were published in her article entitled, "A Memoir of His New York Period," in *Arts Yearbook 4*, New York, 1961.

21 Because von Wiegand did not paint abstractly at the time she knew Mondrian, she first joined AAA in 1941 as an Associate Member. She then left the group when Mondrian died and did not return until 1947, when she came in as a full member. She was president 1951–1953.

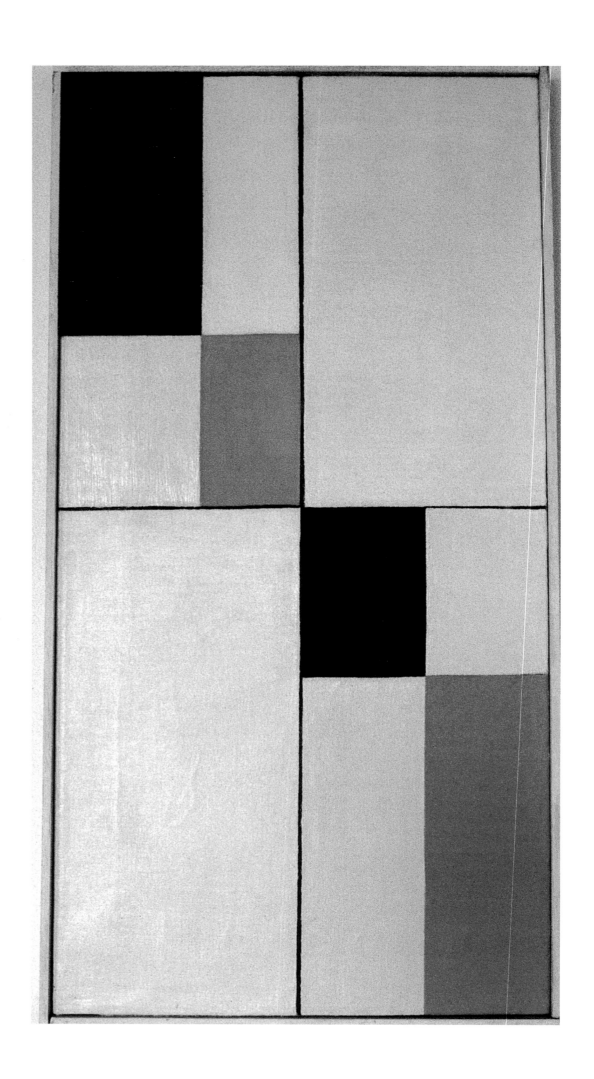

337 Leon Polk Smith, title unknown (it is
assumed that this painting is oil on
canvas as were most of Smith's paint-
ings through the mid-1960s; in about
1967 he began to use acrylic paint,
exclusively).
© Estate of Leon Polk Smith/ Licensed
by VAGA, New York, NY

SIX
REACTION: 1940's–1950's

As we saw in Chapter 4, the two principles around which Mondrian's American influence was to pivot were: the destruction of the ancient object-ground relationship through use of variants on his means, and the reinterpretation of the very meaning of a work of art.[1] His closest followers were more influenced by the first; later artists, especially of the 1960s, by the second — but there were others in between who changed their work in some lasting way after contact with Mondrian or his ideas. Many more than would recognize it in themselves were affected by the artist's analysis of painting space, his asymmetric plan for its structure, and his justification of its autonomy.

Because Mondrian's influence cannot be separated from other sources in the works of artists who acknowledge it, and nor can his indirect sway be verified on those who do not, this book deals only with direct evidence. In an attempt to be both selective and representative, therefore, this chapter focuses on artists who follow directions that can be summarized as follows:

(1) Close followers, almost familial, who deviated more obviously from the Neoplastic principles than those in the "star-cluster"; these may be represented by Leon Polk Smith.

(2) Cubist-Constructivist artists, who either belonged to the American Abstract Artists group or worked in a similar direction but changed their work appreciably after contact with Mondrian; an example is Alice Trumbull Mason.

(3) Abstractionists who reacted in logical fashion against Mondrian or the tradition he represented, as did Charles Biederman.

(4) Abstractionists who reacted in non-logical fashion against the same tradition, as did the Abstract Expressionists. Among the latter were two separate persuasions. One set of artists used Cubism's vestigial shapes but "softened" them until they were almost organic; the other adopted Surrealism's spontaneous

methodology. Both groups employed an underlying rectilinear structure similar to Mondrian's (or from the same tradition of which he was the most avowed exemplar). While these groups included artists who rejected everything the elder artist stood for, ironically they made him (or his abstraction) their major point of departure. Because these artists are not easily categorized, they are mentioned only where their statements or examples clarify their relationships to Mondrian. The few who are singled out, such as Barnett Newman and Ad Reinhardt, are discussed only insofar as each one clearly identified his relationship to the artist.

(5) Abstractionists, chiefly of the 1960s, who continued Mondrian's ideas of flatness, figure-ground equivalence, determined space, and objecthood. These are rarely singled out in this chapter but dealt with according to their characteristics as a whole.

338 Leon Polk Smith, *Homage to 'Victory Boogie-Woogie,' No.1,* 1946–47 (against the wall, center, in this view into Smith's New York City studio – unless otherwise indicated, photographs are by the author).
© Estate of Leon Polk Smith/ Licensed by VAGA, New York, NY

Artists of the first two groups, who had met Mondrian and were impressed personally with him, were affected so strongly by his visual logic as to change their own. Usually, they were already working abstractly with an amalgam of shapes derived from Cubist, Constructivist, and even Surrealist sources. Mondrian never intended to instruct them and did not do so directly, but after absorbing his influence these artists regularized and redirected the geometric tendencies they had inherited from Europe. Thereafter, they rarely placed distinctive elements against an indeterminate "spatial" ground. Without avoiding specific shapes or restricting them entirely to straight edges and right-angles, they submerged the shapes into a framework that deemphasized particularities by stressing similarities of color, size, or shape.

Mondrian's effect was close enough on one such artist that his early work was categorized as "Mondrianesque." This was Leon Polk Smith, whose reinterpretation of his mentor's early style in years to come made him an important transitional figure between the elder artist and the hard-edged abstractionists of the 1960s. Like von Wiegand's late work, his had an extra dimension – in his case, colors and rhythms belonging to his Amerindian background.

Smith undertook a master's degree in art at Teachers College, Columbia University, from 1936 to 1938. An instructor's eagerness to have him see what she called "the greatest paintings in the world" sent him to the Gallatin Collection which was then hanging at New York University. There he encountered his first Mondrians. Smith spent six months in Europe in 1939, steeping himself in art, and in 1943 he won a Guggenheim grant that allowed him to work in California and New Mexico. From time to time he visited New York City and on one of these visits met Mondrian at the opening of an exhibition.

339 Smith, *White-White, No.2,* oc, 1950.
© Estate of Leon Polk Smith/ Licensed by VAGA, New York, NY

Very impressed, Smith soon began to express in his own work the admiration he felt for the older artist. Several of his paintings, such as *Homage to 'Victory Boogie Woogie'* No.1, 1946–1947 (338) and an untitled painting of about the same time (340), were direct quotations from Mondrian. Planes that related to one another and the base plane by barely distinguishable lines became the only surface articulators in a series of white-on-white (339) and black-white-and-gold (337) paintings of 1948–1950. In a series beginning in 1946–1947, however, the artist eliminated lines in favor of planes that were extracted from squares, broken apart, and bracketed by off-set juxtapositions.(341)

340 Smith, Mondrianesque painting.
© Estate of Leon Polk Smith/ Licensed by VAGA, New York, NY

341 Smith, title unknown.
© Estate of Leon Polk Smith/ Licensed by VAGA, New York, NY

342 Smith, *No. 7807 Hillhouse*, acrylic,
1978.
© Estate of Leon Polk Smith/ Licensed
by VAGA, New York, NY

Smith said that he followed his mentor's work closely only to get a bet-ter understanding of his method. He also abstracted from natural objects as van Doesburg had done with cattle, and drew on that artist's diagonals, not directly so much as implying their movements with an adroit placement of angles. Smith's interest in diagonals, which first emerged in a series from 1947–1948, was still seen in paintings of the late 1970s. One, entitled *No. 7807 Hillhouse*, 1978,(342) is made up of implied portions of squares, sepa-rated and placed diagonally to create a diamond format. The artist brought the same interplay of implicit and explicit vertical, horizontal, and diagonal directions into circular formats of *No. 7611*, 1976,(343) and *No. 7621*, 1976.(344) An incipient form-space inversion of the type that occupied him from the 1950s to 1970s was to be his abiding legacy from Mondrian. Subsequently, he carried out the device in mortise and dentil, angular, and rectangular forms that were still set within a vertical, horizontal, and diago-nal configuration, as in *Black-White Repeat* (345) of 1953.

343 Smith, *No. 7611*, acrylic, 1976.
© Estate of Leon Polk Smith/ Licensed
by VAGA, New York, NY

344 Smith, *No. 7621*, acrylic, 1976.
© Estate of Leon Polk Smith/ Licensed
by VAGA, New York, NY

345 Smith, *Black-White Repeat*, oc, 1953.
© Estate of Leon Polk Smith/ Licensed
by VAGA, New York, NY

In 1954, the artist took a surprising new turn in his work when he discovered, almost by accident, some drawings of athletic balls whose covers were stitched in continuously interlocking curves.(346) From the form-space interaction of the curving shapes he began to make multiple variations on the juxtaposition of two or more differently curving colored shapes that covered a base canvas. As in *Expanse, 1959,*(347) the overall format might be a rectangle over which white and black shapes intrude upon one another. Or the canvas itself might be curved, as in *Black Rock, 1955,*(348) in which a circular canvas is sliced by the juxtaposition of black and gray curved shapes.

346 Photograph of Smith sketching the interlocking curves with which the covers of baseballs are sewn. © Virginia Pitts Rembert

347 Smith, *Expanse*, oc, 1959, as seen hanging in Smith's New York studio (the similar settings of Smith's paintings may be assumed to be in the same studio).
© Estate of Leon Polk Smith/ Licensed by VAGA, New York, NY

348 Smith, *Black Rock*, oc, 1955.
© Estate of Leon Polk Smith/ Licensed by VAGA, New York, NY

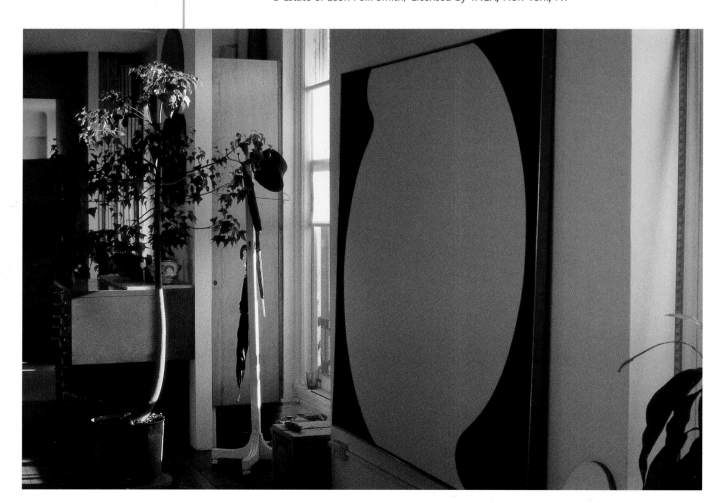

The occlusion of forms with space became less fluid – and at the same time more dynamic – in the later 1960s, as Smith morticed the curving interrelationships (349), made them play over more varied formats (350), or applied arrow or tower shapes to their surfaces.(351) Some of these canvases were painted in strident colors that seemed to suggest motifs of Southwestern or Plains Indians.(352)

350 View of painting with "mortised" shapes hanging behind Smith. © Virginia Pitts Rembert

351 Smith, *Correspondence Blue-Black*, acrylic, 1967. © Estate of Leon Polk Smith/ Licensed by VAGA, New York, NY

349 Smith, title unknown (note sketches of variations on the interlocking shapes below the larger painting). © Estate of Leon Polk Smith/ Licensed by VAGA, New York, NY

352 View of paintings with variable interlocking formats and colors in Smith's studio. © Virginia Pitts Rembert

353 Smith, *George Washington Bridge*, date unknown (probably in the 1970s).
© Estate of Leon Polk Smith/ Licensed by VAGA, New York, NY

354 Variation on Smith's *Constellations*. © Estate of Leon Polk Smith/ Licensed by VAGA, New York, NY

Mondrian's idea of a painting as an autonomous object (already carried out in three-dimensional canvases by Holtzman and Bolotowsky) was germinal in the artist's shaped paintings, but he emphasized their autonomy in his *Constellations* of the late 1960s and 1970s. These were made of two or more canvases bolted together but related by colored shapes that were shared by all. A theme that ran through several of these was the George Washington Bridge, essentialized into a shape of concave and convex curves painted across the center of three adjoining canvases.(353) As with most of the *Constellations*, traditional hanging did not matter. Smith explained that since there were no verticals, horizontals, or diagonals in outer space, there was neither any up nor down, as the astronauts proved when they had to look up to see the Earth; thus he created most of his Constellations so that they could be hung in any direction or on any part of a wall. Liberated so, they became ever richer and more daring in their shapes, arrangements, and colors.(354-357)

Smith broke through the form-space dichotomy in ways that he explained:

> There is no longer form and space in my *Constellations*, but only space. Space has absorbed the form, so there is no longer any need for space to balance form. Once you look at these as all space, it is no longer shocking to hang them high on the wall. That is something that did not occur with Mondrian's paintings.

Just as the older artist had broken his own rules, Smith broke them too, by using acrylic paint and by employing diagonals, curves, multiple canvases, and disoriented space in his paintings. He referred to himself as a Constructivist but said that artists fascinated by Constructivism have rarely brought anything new to it. He claimed to have lifted the horizons of

355 Variation on Smith's *Constellations*. © Estate of Leon Polk Smith/ Licensed by VAGA, New York, NY

357 Variations on Smith' *Constellations*.
© Estate of Leon Polk Smith/ Licensed by VAGA,
New York, NY

356 Variation on Smith's *Constellations*. © Estate of Leon Polk Smith/ Licensed by VAGA, New York, NY

Constructivism, a movement that he identified with Mondrian, by adding significantly to that artist's concept of space. Smith's use of space in his later *Constellations* contrasted with his predecessor's by being more energized and open.

Smith was frequently asked to include his works in exhibitions designed around Mondrian, but his chief exposure was in one-person exhibitions in New York City and in California such as the Ace Gallery in Venice, 1979. Los Angeles critic Suzanne Muchnic noted that he was 72 years old when his works were shown in the latter exhibition, but that "the pioneer abstractionist who invested Mondrian's hard-edged purity with vast scale, curving contours, bouyant form and ambiguous space . . . has been widely emulated by younger painters but his canvases still look fresh."[2]

Alice Mason had painted abstractly for several years before joining the American Abstract Artists, but she said that her meeting with Mondrian was an important moment in her life.[3] She was born, in 1906, to a wealthy and venerable New England family that could trace its roots to Revolutionary personages such as the notable painter John Trumbull; she used the name of Alice Trumbull Mason after her marriage to Warwood Mason, who was a ship's captain by profession.

The artist had studied in Italy when she was very young and was strongly influenced by Florentine art. One of her adult, abstract paintings, *Out of the Valley*, 1956, (358) was based on a drawing in the Uffizi Gallery attributed to Cimabue. Its central motif was a cross wedged into the ground like an arrow but that seemed to open at the top, "as if implying Resurrection," she said.[4] After returning from Italy in the 1920s, Mason studied at the National Academy and followed academic realism until she saw her first Parisian paintings in America. She soon started painting abstractions and taking them around to dealers who told her they had nothing against which to judge her paintings since there were so few like them in the country. As a final resort, she showed them in an annual outdoor exhibition on Washington Square, which anyone could enter. Abram Lassaw, Byron Browne, and Balcomb and Gertrude Greene saw this exhibition and persuaded her to join the fledgling group that was then forming into the American Abstract Artists. She was in the group during its beginnings, much involved with the annual struggle to find a place to show.

She told of the effect that Europeans, particularly Mondrian, had on her:

> When I met Mondrian, I was enormously impressed with his naturalness and elegance. His chief influence on my work was in leading me to straight-edged forms. My use of straight lines took emphasis from the forms and put it on color. I did not follow the primaries, nor maintain a vertical-horizontal, right-angled relationship, because I felt that would be too rigid a formula for me. I did stick with straight-edged forms, although now and then I came back to curved ones.

Beside the Way, 1930,(359) one of Mason's earliest abstract paintings, showed the emphasis on forms in the paintings that she made prior to meeting the elder artist. In a post-Mondrian painting of 1959, which could be turned either horizontally, as *Surface Winds*, or vertically, as *Suspension Points*,(360) she neutralized the forms by making them correspond in size and shape to one another and to the spaces between them. Her emphasis on color gave the work its variety and interest.

By converting the city-scape images of *86th Street High #1*, 1967 (361) into a scheme of over-all rectangles, the artist once again underplayed the forms with relation to their colors. Nevertheless, she brought forms and colors into equivalence in most of her later work. Diverging far from any obvious relationship to Mondrian's influence, paintings such as *Catalyst*, 1967,(362) *Formal Echoes*, 1967,(363) and *Yellow Spring*, 1967,(364) revealed a distinctive, personal direction.

359 Mason, *Beside the Way*, oc, 1930.
 © Estate of Alice Trumbull Mason/ Licensed by
 VAGA, New York, NY

360 Mason, *Surface Winds* (horizontally) or *Suspension Points* (vertically), oc, 1959.
 © Estate of Alice Trumbull Mason/
 Licensed by VAGA, New York, NY

361 Mason, *86th Street High #1*, oc, 1967.
 © Estate of Alice Trumbull Mason/
 Licensed by VAGA, New York, NY

Even though Mason's works were shown in several solo exhibitions from 1942 to 1974, they received little individual attention and were usually mentioned only in connection with exhibitions of AAA. She served as secretary of the group in the early 1940s (during the time that Mondrian belonged), as president in the 1960s, and as a member until her death in 1971. She strongly identified herself with AAA and saw her position as being enhanced by its success.

Mason was included in the group exhibition entitled Women Artists 1550–1950 that was shown during 1976 and 1977 at the Los Angeles County Museum of Art, the University of Texas at Austin, Carnegie Institute, and the Brooklyn Museum. Her painting L'Hasard, 1948 (365) was reproduced in color both in the catalogue and in a review of the exhibition in *Time* magazine.

364 Mason, *Yellow Spring*, acrylic, 1967.
© Estate of Alice Trumbull Mason/ Licensed by VAGA, New York, NY

365 Mason, *L'Hasard*, oil on masonite, 1948–49.
© Estate of Alice Trumbull Mason/ Licensed by VAGA, New York, NY

Opposite page:
Top
362 Mason, *Catalyst*, medium unknown, 1967.
© Estate of Alice Trumbull Mason/ Licensed by VAGA, New York, NY
Bottom
363 Mason, *Formal Echoes*, acrylic, 1967.
© Estate of Alice Trumbull Mason/ Licensed by VAGA, New York, NY

Among the myriad artists influenced by Mondrian must be placed the ones who rejected him or his ideas; they were formed as truly by his impact as those who deviated from him only by degree. Some dissenters opposed his "laws" because they believed them to be fallible; others who took a more positive stance believed that his mode required no further exegesis. Thus it was with two main groups of artists who moved apart from Mondrian, the Abstract Constructionists (or Structurists) and the Abstract Expressionists.

The Abstract Constructionists can be represented by their founder, Charles Biederman, whose strong if controversial ideas earned him a respectable reputation and following abroad, while he was more or less neglected in the United States. Understandably embittered by such neglect, the artist apparently secluded himself in the Mid-West, where he established a private publishing firm devoted to his and other Structurist works. Biederman's views (when known at all in his home country) so overshadowed his works that they were shown infrequently. This circumstance caused New York critic Sidney Tillim to characterize the artist as "emerging from cranky obscurity," when one of his constructions appeared in Marlborough-Gerson's De Stijl exhibition of 1964.

Biederman, who was born in Cleveland of Czech parents, in 1906, studied at the Art Institute of Chicago and was much influenced by the Post-Impressionist paintings in the Institute's collection. The young artist particularly admired Cézanne, who had a direct influence on his early paintings and an indirect influence on his subsequent theories.[5] Also an admirer of Cubist works, Biederman based *Figure, Chicago*, 1934 (366) on ideas gleaned from reproductions of Picasso's paintings.

After moving to New York in the fall of 1934, he saw his first original works by Cubists, including Mondrian, and did his first entirely abstract painting. In 1935, he made his first relief panel, a medium he would adopt exclusively in the future. A one-artist exhibition, held at the Pierre Matisse Gallery in March, 1936, brought the first recognition Biederman had in the East. That same year, his work was included in group exhibitions at the Albright-knox Art Gallery, in Buffalo, and at the Paul Reinhardt Galleries in New York.

Discouraged over what he felt was abiding American regionalism, Biederman left New York in the fall of 1936 for Paris. There, he met many of the well-known contemporary artists, including Delaunay, Miro, Picasso, Vantongerloo, Brancusi, Léger, Arp, Mondrian, Domela, and Pevsner. Mondrian and Pevsner were to have the greatest influence on his work. Biederman's *Paris, January 14, 1937* (367) already showed an interest in attenuated

366 Charles Biederman, *Figure, Chicago*, oc, 1934 (366-373 are reproduced by kind permission of the artist).

367 Biederman, *Paris, January 14*, oc, 1937.

368 Biederman, *No.4, Paris*, painted wood, 1937.

forms, not yet reduced geometrically nor primary-colored as they would soon be in his "De Stijl" works. Convinced of having come "too late" to Paris, however, the artist returned to America in 1937. Here, he was further discouraged by finding no interest in his new work, not even from New Yorkers who had been previously attracted to them. Subsequently, Biederman went back to Chicago in 1941, but he moved during World War II to work on an army medical project in Red Wing, Minnesota, and remained in Minnesota from that time on.

After hearing lectures by Alfred Korzybski, in 1938, the artist developed a profound interest in semantics and science, which affected his views on art as well as his later writings. The latter included Biederman's books *Letters on the New Art*, 1951, *The New Cézanne: From Monet to Mondrian*, 1958, and numerous articles in *Structure*, *The General Semantics Bulletin*, *Artforum*, and various British, Swedish, and Canadian periodicals.[6]

The most important presentation of Biederman's views is to be found in the 696 pages of his first book, *Art as the Evolution of Visual Knowledge*, published in 1948 after ten years of work.[7] His thesis was that art history is a "scientific development" that culminates with an insight into natural law. With Cubism came the important change "from the *recorded* forms of nature to the now largely *created* shapes of man." Most artists regressed after that style's early invention, however, because they were hypnotized by "the Pied Pipers from Spain," Picasso, Dali and Miro, whereas they should have realized the stature of the Dutch and the Russians. Above all, Biederman respected Mondrian and van Doesburg. They stood alone, he thought, among artists whose works and theories would continue to remain respected even if, in the final analysis, their works were inadequate. He went on to develop that theme, notably with regard to Mondrian.

369 Biederman, *Work #79, Red Wing*, painted aluminum, 1952–53.

The author assumed, wrongly, that Mondrian had intended, by setting the frame behind the canvas, to push the lines forward in order to "further the effect of the lines in space." He did reveal a complete understanding of Mondrian's objectification of the canvas, though, by writing that in some of his paintings, the use of thick paints in order to raise certain surfaces showed that "he wished to make the space and lines real and not mere linear illusions." Biederman's disagreement with the older artist was that his departure

from "the old content" and even his change to two-dimensionality were only a partial solution, since he could not free himself from "the old primitive medium that went with it."

Mondrian's late works were retrogressive, according to the author, because he not only gave them titles that represented "macro-reality" (Biederman referred here to the *Boogie-Woogies*) but "closed their forms illusionistically." His last paintings were similar to earlier ones because in those paintings, too, Mondrian stretched the illusionistic painting medium as far as it would go and began to treat the canvas as a sculptured object. Since he did not go on to create sculpture after doing such paintings, however, the older artist's Neoplastic works were invalid.

370 Biederman, *#24, Red Wing*, painted aluminum, 1958–62, private collection.

371 Biederman, *#39, Red Wing*, painted aluminum, 1961–71.

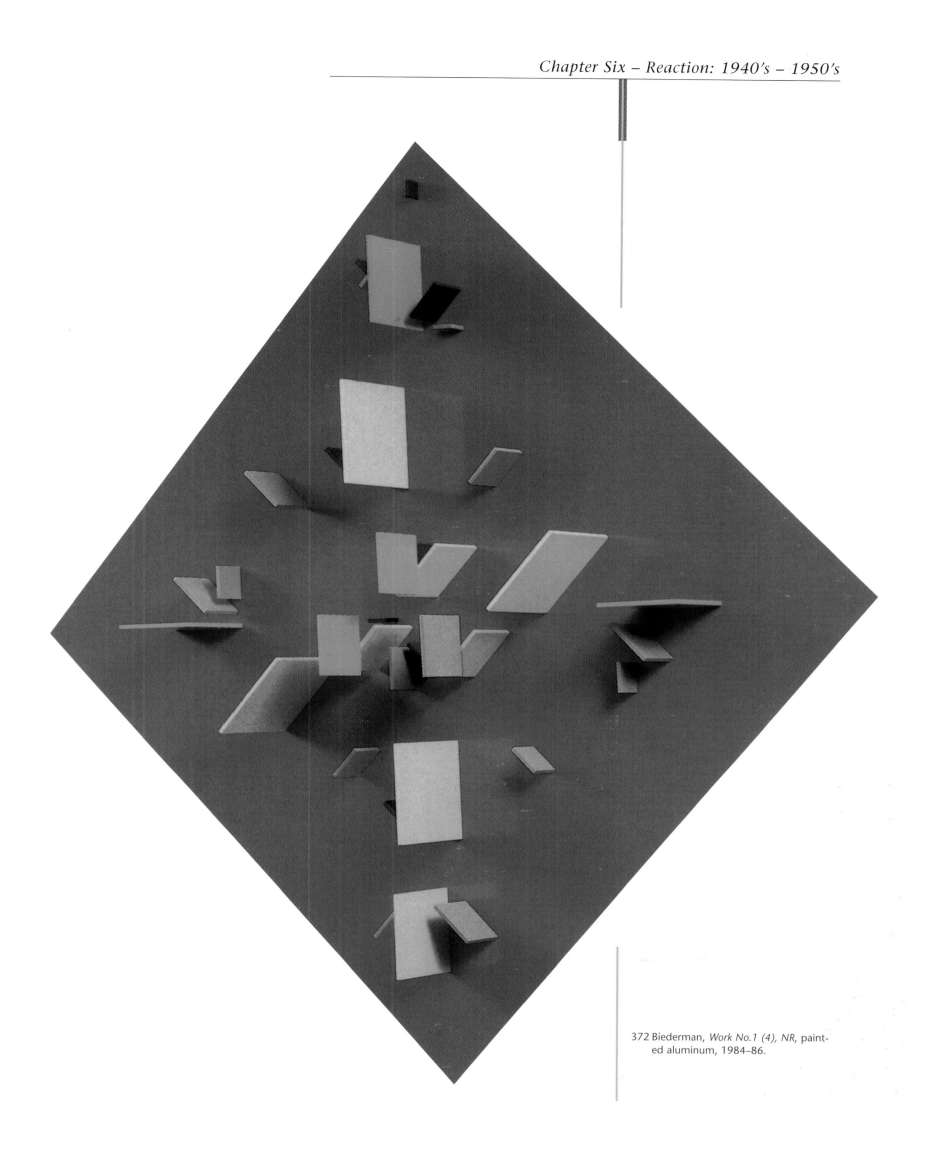

372 Biederman, *Work No.1 (4), NR*, painted aluminum, 1984–86.

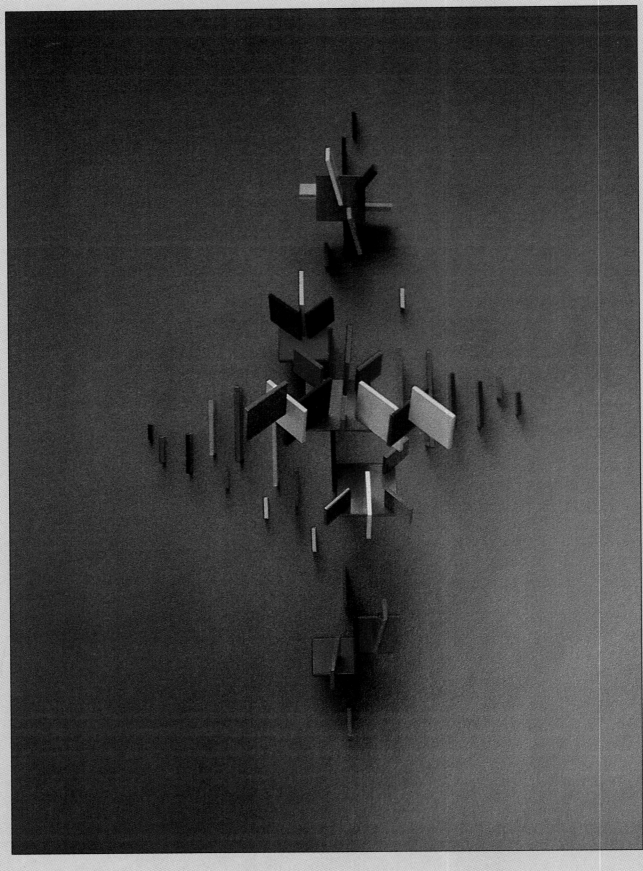

373 Biederman, *#9, MKM,* painted
aluminum, 1980–82.

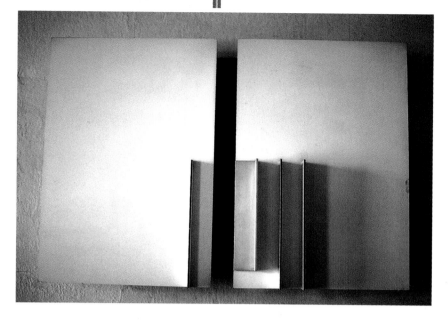

The younger man admitted to having been influenced by Mondrian, although he said that influence had "all but run its course" by the time he was able to read the elder artist's essays when the Documents of Modern Art Series book was published in 1945. But despite his dismissal of the older artist and emphasis in subsequent statements on the "revolutionary" character of his own mature work, Biederman conceded that he and his followers had continued the work of Mondrian by making constructions and "employing the Structural Process of nature." These constructions were invented, or created, objects made of both natural and manufactured materials, and thus did not substitute for nature in the same way as objects that were imitated in paintings — nor were they constructed of traditional illusionistic and two-dimensional materials, such as paint and canvas. Instead, they existed in space and took their place in nature, like natural objects. Biederman saw the process as being related to Russian Constructivism, which he called "Constructionism," a name he also used to refer to his own relief style. Later, to avoid confusion with the Russian term, he changed the name of his style to Structurism.

Although the artist claimed that by moving into three dimensions, he had gone further than Mondrian, his early reliefs, at least, depended on the use of primary colors and horizontal-vertical relationships within an asymmetrical organization. The early reliefs were also organized in a planar manner, oriented frontally and to the floor, and they were fashioned from painted materials. These conditions did not entirely prevail in later works, however. Some of the later reliefs became more spatial while still maintaining their wall orientation, and their colors deviated from the primaries. *No.4, Paris, 1937* (368) belongs among the artist's early works that were clearly associated with Mondrian's colors and configurations. The wide vertical strips of painted wood that create the surface are balanced by thinner strips placed horizontally.

In later works, Biederman departed from his earlier colors and materials. He fastened small, varicolored rectangles, on edge, atop the aluminum strips that formed the surface of *Work #79, Red Wing, 1952–1953.*(369) Then he began to arrange the small rectangles into groups above the surfaces of his subsequent reliefs.

374-376 Anthony Hill's London studio, 1978 (photographed by the author).
© Virginia Pitts Rembert

Obviously, the artist was also beginning to exploit the color and spatial effects (including evocative atmospheric ones) caused when the forms and their secondary colors were reflected in the colored metal base, as in #24, *Red Wing*, 1958–1962.(370) Biederman entered a Baroque phase of his own work, as a critic observed, when he began to attach some of the small colored rectangles diagonally to the aluminum base. At first, merely rotating vertical planes that were set on horizontal planes to an angular position, Biederman next turned the horizontal planes and finally moved the verticals and horizontals above them, "up, down and sideways," as in works ranging from #39, *Red Wing*, 1961–1971 (371) to #9, *MKM*, 1980–1982[8] (373) and *Work No.1* (4), *NR*, 1984–1986.(372)

In an essay on his works shown at the Borgenicht Gallery in 1985, historian Donald Kuspit said that the artist had given Mondrian's "dynamic equilibrium" a new twist by setting the color planes "in such tense motion that they seem to be mutating." This sensation, of "form in the process of evolution," the critic wrote, was similar to that captured by Cézanne. Actually, the artist had repledged himself to Cézanne in his break with Mondrian. In a statement for the catalog of his retrospective exhibition at the Minneapolis Institute of Arts in 1976–977, Biederman said: "I restored the 'plane' of Cézanne, which Mondrian was so fanatically bent on 'destroying' and thus pursued the 'new vision' called for by Cézanne."

The author misinterpreted Mondrian's concept of "destruction," which was the destruction of the allusory and illusory in order to create a new form of nature. His own claims to work more directly from nature in recreating its structural processes remained simply a claim. This was because Biederman's relief art was another variation on the geometric theme that, if not strictly Neoplastic, was certainly Constructivist. The younger artist could be credited with an abstract version of the relief (although whether he invented it was debatable). Also, his late reliefs presented "an intricate system of formal and coloristic relationships" that were closer to nature than Neoplasticism.

Biederman's resolute contention that the logic of abstract art should lead beyond the two-dimensional surface found some response in other countries, mainly from Eli Bornstein in Canada, Joost Baljeu in Holland, and several artists in England. Victor Pasmore was the source through which Biederman's ideas passed to Anthony Hill, Kenneth and Mary Martin, Gillian Wise, Stephen Gilbert, and John Ernst.[9] As an example, Hill's relief work is of particular purity and elegance.(374-376) The relief idea was virtually ignored in the United States. Several of Mondrian's American followers made three-dimensional works that extended Neoplasticism into space, but these evolved primarily out of painting. Indeed, most painters continued to paint, but quite often they carried on some vestigial theory of Mondrian's (even if unaware) while rejecting his aesthetic system.

377 Carl Holty, an "all-over" painting photographed by the author in his New York studio, 1967.

Opposite page:
378 Jackson Pollock, *Male and Female*, oc, 1942, Philadelphia Museum of Art.

379-380 Pollock, *Cathedral*, 1947, and
detail (photographed by the author in
the Museum of Modern Art, New
York).

Carl Holty, in an intriguing article that paid homage once again to his friend and mentor, attempted to assess Mondrian's relationship to the type of painting that was current in 1960. The younger man was quick to point out that Mondrian was never in the dominant positions occupied by Picasso and Matisse. "It was his fate to stand alone," he said, and yet "while his influence and spirit on contemporary painting can only be seen as indirect, I believe it was nevertheless profound." Contrary to all generally held opinion, Holty maintained that this influence was most deep in the "enemy or alien camp" of Abstract Expressionism.

This was true of some, not all, of the Abstract Expressionists. Those artists who were born before World War I and had turned in the direction of Abstract Expressionism from Cubism were still strongly disposed to an artistic heritage from Europe. They had been reared in the tradition of Modern Art and they were loath to discard the spatial and formal conceptions of their great forebears in that tradition which was considered by the Surrealists to be burdensome. Nevertheless, the "visionary spirit" and "poetic content" of the Surrealists had inspired the Americans, according to William Rubin. Those qualities in the definitive works of Abstract Expressionists such as Pollock, Rothko, Newman, Still, Motherwell, Gottlieb (and some sculptors), he believed, served to distinguish them from Picasso, Matisse, and Mondrian more than technique or structure did.[10]

381 Pollock, *Number 8*, oil and aluminum on canvas, 1949, Collection of Mr and Mrs R. Neuberger, New York.

Actually, it was not the poetic content so much as the formal and spatial content that either allied or separated the Americans from European artists, those three in particular. Granting Rubin's additional opinion that the Americans' abstraction was quite different from that which Cubism and Fauvism alone might have spawned, Cubism was obviously the greatest influence on them. Most of the action painters embarked from the open structural forms and loose, painterly surfaces of Analytic Cubist paintings. The imagists were more attuned to the closed forms and integrated surfaces of Synthetic Cubist paintings. Mondrian passed through several phases of Cubism and, at different times, his work affected Americans who belonged to both styles of Abstract Expressionism.

While the structural accents, or rhythms, in the more painterly expressionists' works were often mentioned by critics as coming from Mondrian's Analytic, as well as later, Cubist phases,[11] his less obvious influences on these artists were overlooked. Carl Holty was the first to claim that he was behind the "integrity" of their canvases.

The complete coalescence of movement, form and space that Holty sought in his own work (5; 377) and claimed to be an aspiration of the Abstract Expressionists can be seen in Jackson Pollock's mature style. In the early, figural work done just before his breakthrough to a completely abstract style, that artist faced the dilemma that his biographer Elizabeth Frank described, as having "to work his way through Cubism, and not just late Cubism but the underlying principles of Analytic Cubism."[12] That is, the rectangular bodies of *Male and Female*, 1942,(378) no longer illusionistic or organic by being freely colored and distributed, were still fitted within a compositional scheme derived from the perimeters of the canvas.

Even when, in a more personal vein, the artist developed his autographic pouring technique that succeeded in integrating the figures with the ground and finally in subsuming them within "the large sustained rhythms of the 'all over' style,"[13] he was aware of the limitations of the canvas space and achieved accents that acknowledged its dominant structure.(379-380)

Pollock's works were considered "savage and explosive" during the period in which Abstract Expressionism was most viable. With a decade gone by in the late 1960s, however, critics began to look differently at his and the other Abstract Expressionists' paintings. After the notion of surface as a continuum beyond the canvas was popularized by "color field" painters of the 1960s, the term "all over" was applied in hindsight to Pollock. In 1967, for example, Barbara Rose interpreted the artist's poured paintings as offering the first real spatial change on the canvas since Cubism. She called the change "a new kind of 'optical' pictorial space as well as a new kind of 'all-over' pictorial organization."[14]

In an article of the same year, William Rubin related this type of organization to Mondrian who was, he felt, vital for the pictorial development of Pollock's compositions, that were "lighter and dissolve toward the edges."(381) Rubin also reported a conversation at a Mondrian retrospective in the Janis Gallery during which Pollock specifically affirmed the connection of "all over painting" with the development of Mondrian's 1913–1914 paintings.[15](382,383) The all-over style of artists like Pollock – that is, with no salient or specific elements to "fall out" of the picture in their works and others such as Holty's – had definite connections with Mondrian.

Opposite page:
382 View of Mondrian Exhibition at Sidney Janis Gallery, New York, 1949.

383 View of Mondrian Exhibition at Sidney Janis Gallery, New York, 1953.

382-383 are reproduced courtesy of Sidney Janis Gallery

Actually, abstractness was the common denominator that related expressionist artists, particularly the imagists, to Mondrian, even though they did not seem to be aware of its provenance. Dore Ashton recognized the important connection, writing prophetically in 1968: "When the time comes for a cool assessment of the entire movement, probably to be put off for some time, it will be recognized that it is not the expressionism in Abstract Expressionism that made it singular but the abstraction, the profound and effective sublimation of subject beneath the skin of the abstract painting."[16]

The Americans shared with Mondrian a Protestant tradition that, as Robert Motherwell suggested, not only eschewed images but represented "a puritan, puritanical, sublimated . . . getting-rid of images, even as do the white-painted churches of the Northeast and South." Motherwell related this American iconoclasm to Mondrian's similar heritage but also added the extra, often neglected dimension that both he and the Americans shared:[17]

> Only a Northern country could have produced Mondrian. Rembrandt has qualities which others of his time didn't have, because he was Protestant. Mondrian's pictures quiver with life; they are heir to van Gogh's pictures, which quiver with life. Rothko is a passionate painter, Rembrandt is, van Gogh is. Albers — most of the Constructivists — are not. Mondrian's paintings have life, with a capital L.

Yet if the "imagist" painters of Abstract Expressionism acknowledged Mondrian's authority it was only by rejecting it. When they cast off geometry and, concomitantly, composition, they illustrated Holty's thesis that it was not so much what the older artist did as what he proved need not be done that was his legacy to their generation. They voiced both publicly and privately their dualistic attitudes toward Mondrian, usually in respectful terms, but when they attacked him, it was through geometry, his most obvious characteristic.

He was not mentioned in an article on Clyfford Still's stylistic philosophy, but the implication was there when the author[18] asserted that Still had to break out of the authoritarian "Euclidean prison" that was represented by the enframed canvas.(384) Barnett Newman arraigned Mondrian directly in his own disavowal of geometry. Newman's paintings also underwent a critical shift similar to Pollock's that, in fact, was evident over a period of twenty years. His one-artist exhibitions in 1950 and 1951 produced responses ranging from public hostility to critical indifference. Artists themselves had to be acclimated by the Rothkos, Stills, Reinhardts, Yves Kleins, Frankenthalers, Nolands, Louises, and Olitskis that followed before anyone could see Newman's paintings for what they were or take seriously their aggressive simplicity. In 1963, Allan Kaprow summarized the impact of Newman's paintings which had continued to remain controversial for at least a decade. He said that it had been customary to dismiss Newman because his "stripes did not do what Mondrian's stripes do," but now that his paintings had shown themselves to have "borne many children," they continued to evoke a mystery to the intuitive observer.[19] (Newman "stripes" were what he himself called "zips" because each was "not a stripe nor . . . a line". He recounted how when he did the first "zip" in around 1949, it had such an effect on him that he painted nothing for nine months afterward)(385).

384 Mondrian, *Composition*, 1917. Oil on canvas, Rijksmuseum Kröller Müller, Otterlo.(This painting was shown at the Sidney Janis Gallery exhibition. See ill. 382).

385 Barnett Newman, *Day One*, oc, 1951, and *Ulysses*, oc, 1952 (left and right, respectively – photographed
by the author when they were hanging at the Museum of Modern Art, New York).

Most of Newman's public statements, however, concerned the issues of space and composition. These he related obversely to Mondrian in an interview in 1968:

> Mondrian confronted Picasso. He didn't say, "I'm going to confront that man." That's ridiculous. But confronted with Cubism, Mondrian said, "I'm going to change" [plus-minus to grid]. He moved to flatness, relating things – red and blue, horizontal and vertical, square and flat, in a series of compositional relations. . . .
>
> What I ask of a painting is, "What the hell does it mean to me?" It must have an effect on me more than anyone else. Now, I was free in painting from the restrictions of Mondrian. People accused me of being involved in the "stripe-field," but I don't know what stripe and which field. I was having a dialogue with Mondrian, although I never met him. . . .

It's a difference in picture-making. The formal difference is – Mondrian's are – in the nature of picture-making. He was involved in making a whole out of a series of parts. Mine is a wholeness rather than how the parts move toward one another. I am involved in the single impact; I am involved in painting white in the middle and white on the ends. Mondrian was different, but I would be the last to deny his majesty. He understood – more than anyone – but he couldn't get that cube out of the composition. Mine is a spreading out beyond the frame. Rather than mean only the picture, it can take in everything.

Even though Newman discarded geometry and the doctrinaire aesthetics associated with that discipline, he retained the idealism of first-generation Abstract Expressionists. The artist also insisted that the social meaning of his work was in the type of freedom that repudiated all dogma. An example of his repudiation of Mondrian while at the same time embracing the elder artist's color and vertical-horizontal theory is seen in one of his three versions of *Who's Afraid of Red, Yellow, and Blue?* (386)

386 Newman, *Who's Afraid of Red, Yellow, and Blue? I*, oc, 1966, S. I. Newhouse, Jr Collection, New York (reproduced from commercial slide).

Mondrian's absolutism also affected Mark Rothko, but more like Newman than the older artist, he, too, daringly simplified his rectilinear presentation for a total, immediate, and unmitigated impact. Rothko admitted a strong affinity for Mondrian, while claiming at the same time to be a great admirer of Picasso and Matisse. Nevertheless, the artist resisted all critical efforts to read Mondrian's influence in his work. Such efforts were usually due to glib association, he felt. He did not like to link himself with the older artist yet allowed for the possibility by admitting that he would not stop anyone else from "ruminating."[20]

His biographer Diane Waldman did just that for the catalogue of the Guggenheim Museum's retrospective exhibition of Rothko's work in 1978 (following the litigation that went on long after his death in 1970). She wrote that the artist's "attention to order, stability, rectilinear structure and balanced asymmetry, his developing sense of the need to express a Platonic ideal, a higher spiritual or metaphysical truth through abstract form," were the same goals as Mondrian's. By noting that "despite Mondrian's personal asceticism and aesthetic purity, he [Mondrian] expresses in his painting a rich, if highly controlled vein of emotion," Waldman implied that Rothko did the same in his mature paintings.[21](387)

Rothko himself observed that Mondrian's method of organization was true of a great many artists. "Everyone wants to compose with that absolutism," he said, and agreed that the rectilinear mode of his own paintings might be from Mondrian, although he thought that it could be as well from Rembrandt. "Every great artist has had an effect on all subsequent artists," he said.

Rothko met the older artist at one time and admitted to being "tremendously impressed." "Mondrian's way," he explained, "was a miraculous division of the canvas – the equivalence of lines and planes, but he put objects on a ground that rode before and then behind; his paintings palpitate."

387 Mark Rothko, Numero 16, 1960, oil on canvas, 102 X 119 1/2".
 Metropolitan Museum of Art, New York. (photographed by the
 author in the Whitney Museum).

It was in respect of Rothko — and Still, Newman, Gottlieb, and Baziotes — that Sam Hunter wrote later: "Again and again, one encounters in the statements of these artists the repudiation of purist abstraction, and the identification of an abstract means with emotion, fantasy, and the inner drama of the self."[22] Within what Dore Ashton called the "romantic preoccupation" of the Abstract Expressionists, there was also an interest in myths, from Greek to the American Indian, and in the philosophical and literary positions of Nietzsche, Heidegger and Sartre.[23]

Such posturings not only separated these artists from Mondrian but also from another Abstract Expressionist, Ad Reinhardt, who took Mondrian as his paradigm for an entirely Apollonian direction — that of moralist.

Actually, Reinhardt had two constantly reiterated aims, which were closely associated in his art — "to demythologize the art world"[24] and to purify art by reducing it to an extreme form of classicism. In an effort to achieve the first aim, he wrote dogmatic articles on the proper mental state, studio, and materials an artist should maintain. His advice was couched in the form of admonitions given by oriental artist-teachers to their followers, which put him in an academic position that was almost universally misunderstood. Reinhardt said that like most moralists he had "only a few things to say, and said them often."[25]

Also, he made frequent retorts to abstruse language used by the other artists, particularly the Abstract Expressionists. Reinhardt's original aim to "purify" art probably came from Carl Holty, who was one of his teachers at the American Artists School and one of his chief early influences in the late 1930s. Holty encouraged the young man to join the AAA, which Reinhardt said "was one of the greatest things that happened to me." After joining AAA, Reinhardt went through various abstract phases, often parodied in the critical jargon he was so familiar with through his own work in the media. He explained that in the course of development to his final style, he had "got into all-over calligraphic things, like Tobey," then into "abstract pointillist paintings" and paintings which he called "snow storms." "In a way I was an Abstract Expressionist," the artist said: "Stylistically, the Abstract Expressionists were my friends, but I guess I was doing a kind of Impressionist painting; they called Rothko 'the fuzzy Mondrian' — me, too." He admitted the elder artist's influence on his work, qualified as "post-plus-and-minus-Mondrian, with consistency of deliberate and random repetition of identical elements but without scotch-taping-shifting-balancing-spacing-Cézanneism." (388)

388 Ad Reinhardt, *#88*, 1950.

Concerning his final, characteristic mode, parodied as "classical black-square uniform five-foot timeless trisected evanescences of the sixties,"[26] Reinhardt said: "When I went back to geometry, I went to monochrome. My late work belongs to another kind of abstract painting. I was the first to remove composition absolutely. I trisected the canvas, in red and blue monochrome paintings, with very little contrast.(389) [In the black paintings] I made art mechanical, monochrome, symmetrical. Systemic, Minimal – I did all that. Differences, samenesses, regularity, mechanicalness are in them – even though handmade." By naming many of his black paintings "Ultimate" (wittily adding a series number after the title), the artist insisted that he had carried Mondrian's art to its logical conclusion. In other words, he negated and affirmed art at the same time, by freeing it of all contingencies: composition, color, and light. Nevertheless, Reinhardt did not push painting beyond its medium. As he said to me:

389 Reinhardt, *Black Painting*, 1960–66, Mrs Reinhardt's collection (two views, showing, in one, the tripartite divisions and, in the other, the all-over blackness).

Whistler took the painting behind the frame – Mondrian brought it out; I have pushed it behind the frame again. I didn't mean it to come into the room – that was Mondrian's idea. He never made sculpture; his idea was "art moving into life," but it only made a one-half-inch step.

Like the other Abstract Expressionists, Reinhardt reflected Mondrian's abstract and non-spatial intentions as well as his absolutism, even while he appeared to oppose everything the older artist stood for. Nevertheless, he also abjured qualities in Mondrian's work that were fully as seminal as those features he appropriated.

Ad Reinhardt rejected the older artist's light, color, and asymmetry, but his style – while appearing to be the reverse of Mondrian's – actually stood between that artist's theory and Newman's practice. Reinhardt's surfaces were more integrative than Newman's, whose "zip" acted as a *repoussoir* to the background. A difference in their use of symmetry served to make Newman's "conspicuously indexical and bilateral" and Reinhardt's, "after the adoption of the tripartition, exclusively, biaxial."[27] By apportioning the surfaces equally, Reinhardt made them more measurable than Newman's; thus, he brought his works closer to Mondrian's. Yet, by suppressing contrast so that his elements were barely distinguishable and by surrounding the surface with a conventional frame, the artist was able to retain in his paintings a mysterious, illusory appearance.

The combination of both quiescent and metamorphic qualities in his paintings placed Reinhardt in a mediating position for the younger artists of the 1960s – they acknowledged his legacy, but not Mondrian's.

CHAPTER SIX - REFERENCES

1 These foci are paraphrased from statements that Mondrian made in his article "L'Expression Plastique Nouvelle dans la Peinture," *Cahiers d'Art*, 1, 1926, pp.181–182. See Chapter 4.

2 S. M. (Suzanne Muchnic), "The Galleries: Venice," *Los Angeles Times*, November 16, 1979.

3 Statements and information from Alice Mason are from an interview with the author in December 1967.

4 Several of Mason's subsequent paintings containing the same wedge-shaped form harking back to the Cimabue were done as a result of the emotional turmoil Mason suffered following the death of her only son. He had followed his father's lead as a seaman but suffered a mysterious accident in which he disappeared from the ship; his body was washed ashore, months afterwards.

5 Material in this and succeeding paragraphs is based on the biography in the catalog of Biederman's exhibition held at the Minneapolis Institute of Arts from October 1976 to January 1977, and on the essay by Orrel Thompson in the catalogue of Biederman's exhibition held in Rochester, Minnesota, April-May 1967.

6 For several years, one of Biederman's most sectarian followers, Eli Bornstein of the University of Saskatchewan, Canada, published the artist's articles in a periodical called *The Structurist*, which was built around his ideas. Another follower, Leif Sjoberg who was Professor of Literature and Scandinavian Studies at the State University of New York in Stony Brook, translated some of his articles into Swedish.

7 Red Wing, Minnesota, 1948. Quotations from this book are printed with the author's written permission.

8 The initials MKM refer to Biederman's late wife, Mary Katherine Moore Biederman (d. 1975), to whom he acknowledged a debt in contributing to his work "beyond any sense of measure."

9 According to Victor Pasmore, after Biederman published the *Evolution* book on his own press in Minnesota, he distributed it rather informally, often sending a copy to someone he had met or who had written or composed something he enjoyed. When he sent a copy to an English music-book author, it passed through several hands to Pasmore who found the book extremely interesting, "as the first attempt at constructive criticism of modern art." Pasmore handed on the book to some of his friends and students who were more or less floundering in the breakdown of the modern movement in England following WWII. After absorbing the Biederman book they "formed some sort of a group, put on exhibits, and started the post-war abstract movement," he said. When what Pasmore called the "American thing," or Abstract Expressionism, came to England in the form of exhibitions in the late 1950s, the younger English artists "followed America," and

Pasmore moved on to his definitive style, that he called "a form of abstract organicism" (from an interview with Victor Pasmore in June 1978).

The others who had been stimulated in this way to make reliefs included Anthony Hill who was led by his interest to exploration of the relief form in his art and to supposition about Mondrian's connection with science and mathematics in his writings, such as "Art and Mathesis: Mondrian's Structures," article in *Leonardo*, Vol. 1, No. 3, July 1968, and "Mondrian metrisch-statistisch" and "Mondrian structurell-topologisch," articles written with Frieder Nake in *Aesthetik als Informations*, Vienna-New York, 1977.

10 William S. Rubin, "Surrealism in Exile and After," *Dada, Surrealism and Their Heritage*, New York, 1968.

11 Sam Hunter traced the vertical and horizontal accents of Philip Guston's abstract paintings to the "plus-and-minus" drawings, which belonged to an analytic cubist phase of Mondrian's work. He also related the "syncopated rhythms" of Bradley Walker Tomlin's *Number 20, 1949* to that artist's work, generally: *The United States' Art Since 1945*, New York, 1962. William Rubin used the terms "axiality" and "grids" to characterize analytic cubist and Mondrianesque "patterns" in Guston's abstract paintings and, by association, in those of Pollock, "Jackson Pollock and the Modern Tradition," *Artforum*, Vol. V, No. 8, April 1967.

12 Elizabeth Frank, *Pollock*, New York, 1983, pp. 36-37.

13 These paintings, according to Frank, represented an "unprecedented synthesis that now took place between Impressionism, Cubism, and Surrealist automatism."

14 Barbara Rose, *American Art Since 1900*, New York, 1967, pp. 47-63. p. 179.

15 The artist had seen these paintings in the permanent collection of the Museum of Modern Art, in Peggy Guggenheim's collection (where Pollock had his first exhibitions), in the Museum of Non-Objective Art (where he had worked in the early 1940s as a part-time carpenter), and in the frequent Mondrian exhibitions held in the Sidney Janis Gallery.

16 Dore Ashton, "New York Commentary," *Studio International*, Vol. 175, No. 899, June 1968.

17 Motherwell's association of the artist with the passionate qualities of Rembrandt and van Gogh is an interesting reversal of the usual assumption that his Dutchness lay only in his "purity," "cleanness," and rectilinear organization.

18 Ti-Grace Sharpless, "Freedom . . . absolute and infinitely exhilarating," *Art News*, Vol. 62, No. 7, November 1963, p. 53.

19 Allan Kaprow, "Impurity," *Art News*, Vol. 61, No. 9, January 1963.

20 This and further statements by Rothko were from an interview with the author in March 1967.

21 Diane Waldman, "The Farther Shore of Art," from *Mark Rothko, 1903–1970*, catalog for the exhibition held at the Guggenheim Museum, New York, 1978.

22 Hunter (*op.cit.* Note 11 above), pp. 305–306.

23 Dore Ashton discussed these interests at length in the chapter entitled "Existentialism," in *The New York School*, New York, 1973, pp. 174-192.

24 Quoted by Lucy Lippard, in her essay in *Ad Reinhardt*, catalog for his exhibition at the Jewish Museum (November 1966-January 1967), ed. Lucy R. Lippard, New York, 1967, pp. 15,19.

25 Interview with the author in December 1967.

26 *Art-as-Art: The Selected Writings of Ad Reinhardt*, ed. Barbara Rose, New York, 1975, p. 9.

27 Yves Alain-Bois, "The Limit of Almost," *Ad Reinhardt*, catalog published to accompany exhibition at the Museum of Modern Art, October 1991-January 1992, New York, 1991.

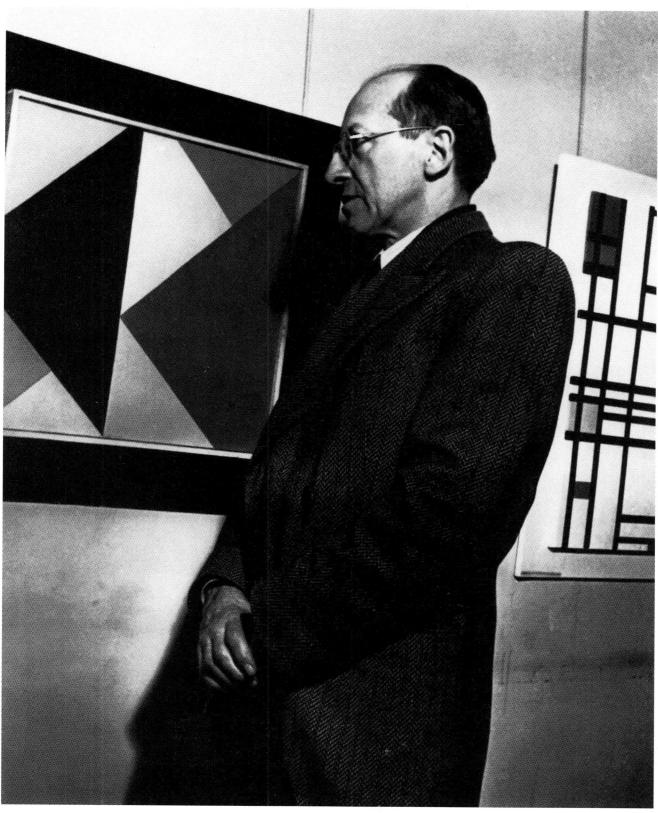

Mondrian standing near Theo van Doesburg's painting, 1928. Kunsthaus, Fritz Glarner Archive , Zurich.

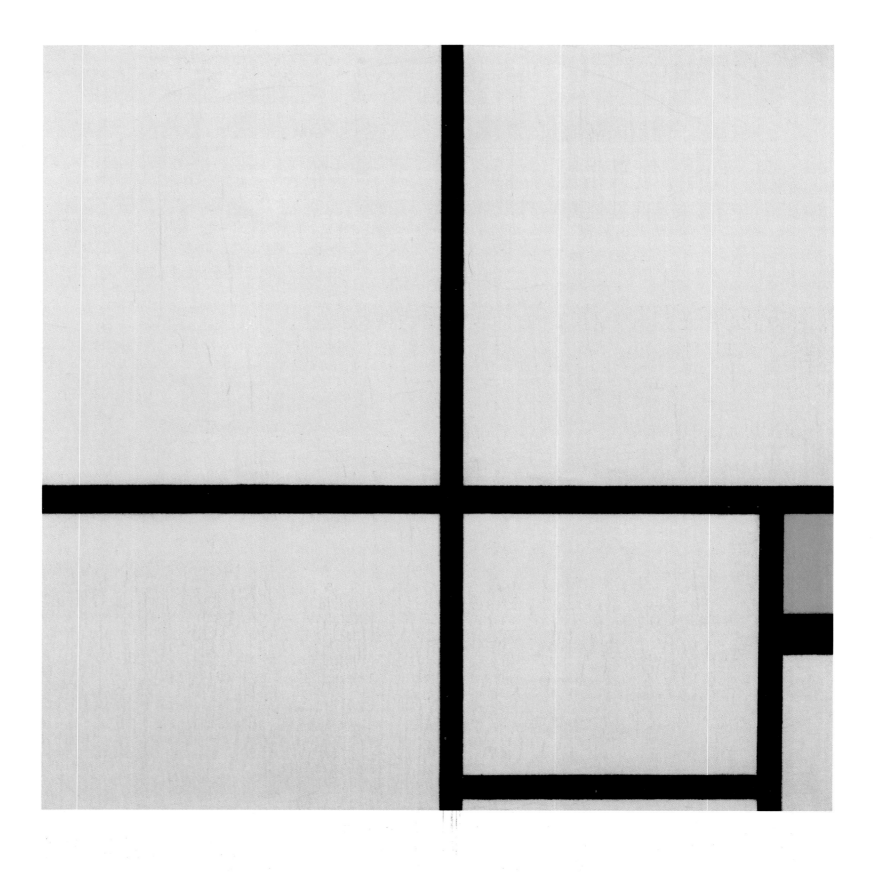

272

RE-AFFIRMATION AND REACTION: 1960's AND BEYOND

The purist artists who emerged in the early 1960s suppressed their means even further than the Abstract Expressionists had done. To become ever more factual and literal, they avoided all allusion and concerned themselves only with the nature and fact of art, an exploration that was the second of Mondrian's legacies to Americans.[1] Clement Greenberg, who interpreted the aesthetic of these artists so authoritatively that it was ultimately dubbed "Greenbergian theory,"[2] characterized the indispensable elements of their art as "the flat surface, the shape of the support, the properties of pigment."[3] What that critic defined as the "cardinal norms of the art of painting" were being "tested and retested," he said, "by successive generations of Modernist painters."

As if in demonstration, one group of painters in the generation following Abstract Expressionism explored "properties of pigment." Helen Frankenthaler sponged paint onto the canvas, Morris Louis poured it, Jules Olitski sprayed it, and Kenneth Noland brushed it — almost always onto unprimed canvas, so the color would sink into the material without variation. An exception was when Larry Poons troweled on the paint, in order to make his surfaces more palpably expressive.

A separate group explored "flat surface" and "shape of the support." In his paintings, Jasper Johns used intrinsically flat images, such as targets, flags, and maps; he drew a turned-back corner on one of his prints in order to demonstrate, with an ironic twist, the paper's flatness. Frank Stella covered his canvases completely with stripes to make their internal images conform with their external borders, and finally shaped the canvases so that their external borders were extensions of the internal images. Then he added texture and dimension to remove the surfaces from any extrinsic association. This brought the works even closer to the condition of constructions, conceived imaginatively rather than veristically.

In a curious reversal of AAA's aim in the 1930s, these artists prided themselves on following an American aesthetic. They still carried on the post-World War II pragmatic tendencies of the Abstract Expressionists, rejecting pre-war idealism and intellectualism. Nevertheless, since time and reflection had shown Abstract Expressionism to be both illusionistic and esoteric, the 1960s artists resolved, like Reinhardt, to "de-mythologize" painting. In doing so, they defied the "image" that even he had retained. Lucy Lippard

Mondrian, *Composition With Yellow*, 1930. Nordrhein-Westfalen State Art Collection, Dusseldorf.

wrote of Reinhardt (and of them) that "It may well be that his black paintings have marked the end of . . . an 'Art for Art's sake' position, since younger artists are pursuing Art for nothing's sake, or more precisely the thing, the Visual Sight, for its own sake rather than for Art's."[4]

Lippard was one of the critics who rose to preeminent positions alongside the sixties artists by interpreting their intentions. Greenberg, who was often called dean of these critics, defined the new geometric inclination as "Post-Painterly Abstraction," but he regarded its "hardness" as a twentieth-century reaction to the "softness of painterly abstraction," not as an inheritance "from Mondrian, Bauhaus, Suprematism, or anything else that came before."[5]

Lawrence Alloway approved the name "Hard Edge" (borrowed from California critic Jules Langner), because it designated "the new development which combined economy of form and neatness of surface with fullness of color, without continually raising memories of earlier geometric art."[6] Barbara Rose noted of Frank Stella and Donald Judd that: "Reacting against the metaphysical angst of Abstract Expressionism, these young artists are producing an apodictic, impersonal abstraction that is, nonetheless, derived from Abstract Expressionism rather than from European geometric art." She also quoted Stella as wishing "the whole European tradition . . . down the drain."[7]

Directly and by implication, Stella and other artists of this group renounced Mondrian and his "image." Being irreverent toward heroes and history, they refused to accept any connection with the older artist, not realizing that when they carried art to a "logical" conclusion beyond Reinhardt's, or when they reached for yet another "ultimate" statement, they did so in a tradition stretching from Cubism to Reinhardt by way of Mondrian's ineradicable agency.

If at too great a distance to be directly consequential, the basic practices as well as stated premises of the 1960s abstractionists were, in principle, remarkably like his. First, they had removed their art from any precedent in the past beyond their immediate forebears. Their art was rejective, to the point that the new style was dubbed "Minimalism," but without knowing, or acknowledging his example, the artists were echoing a precept that Mondrian had earlier articulated.

Second, the "new art," as it came to be called, was deliberately anonymous and impersonal, focusing attention away from the artist toward the work. This characteristic was a direct reaction to Abstract Expressionism, in which the artist's "hand" was said to be always apparent. Impersonality was new only as a group ideal, however, for Mondrian had sought a means that "annihilates individuals as particular personalities and thus creates the future society as a real unity."[8]

A third practice of the new abstractionists was to sustain an idea systematically through several canvases rather than in single units. The serialized result was related, in kind, to Mondrian's habit of painting sequential works in order "to find things out." Although the artist's consecutive ordering had rarely been viewed positively heretofore, now it was considered a process of "trial and error" that was just as viable in the final results as in its tracking record on canvas.

In his seminal essay mentioned earlier, Clement Greenberg had described a logical, "self-critical" process through which painting, along with other

390 View of Abstract paintings, in Van Abbe Museum, Eindhoven, Holland (this and the following were photographed by the author; unless indicated, title, date, and medium are unknown).

cultural expressions, had evolved toward elimination of all attributes not belonging essentially to itself. Greenberg concluded that "flatness alone was unique and exclusive to that art."[9] He was referring to a kind of color flatness, the unmixed, uninflected type of flatness used not only by Reinhardt and Newman, but by Ellsworth Kelly and Morris Louis.(390-393) This quality had first been proposed by Mondrian, however, when he wrote:

> color remains flat on a flat surface. It is not weakened by having to follow the modulations of the form; thus it is stronger than in morphoplasticism.

Along with flatness, the 1960s abstractionists employed several other devices that were all originated by Mondrian. These included "figure-ground equivalency", "determined space," and "objecthood." The elder artist had long before summed up the intentions behind Kenneth Noland's "concentric circles" and "chevron pictures."[10](394,395) "There must be an equivalence of plastic means," Mondrian had written: "Different in size and color, they should nevertheless have equal value." It was also his contention that the "reality" of space could be established "within the limited space of the canvas which can be completely determined by planes."[11]

391 Detail of Mondrian, *Compostion With Yellow*, 1930.

275

392 Morris Louis, *Number 1-71. Du #525*, medium and date unknown, in Van Abbe Museum, Eindhoven, Holland. © 1962, Morris Louis.

393 Detail of above.

396 Darby Bannard, *Allure-Allure*, 1961, oc,
(on loan, courtesy Tibor Nagy Gallery).
© Darby Bannard/ Licensed by
VAGA, New York, NY

397 John McCracken, *Plank NY 4*, 1970, polyester resin, fiberglass, plywood, Chicago Art Institute.
Courtesy of the Artist.

398 Frank Stella, Chicago Art Institute.

399 Detail of above.

In the 1920s, the artist first proposed his painting as a "new structure" that was "real in its abstraction since above all it has the goal of forming a work unequivocally as object."[12] Also in the 1920s, Mondrian took into account the whole shape of a canvas by referring to it as a "rectangular prism." The same principle was behind artists' actions in the 1960s, as when John McCracken exhibited a canvas by placing it on the floor and leaning it against the wall, (397) when Darby Bannard mounted two canvases side-by-side and projected one slightly beyond the other, (396) and when Frank Stella altered the shape of the canvas to coordinate precisely with its internal elements. (398,399) Characteristically, these artists were more explicit than Mondrian. Stella said, for instance:[13]

> My painting is based on the fact that only what can be seen there is there. It really is an object. Any painting is an object and anyone who gets involved enough in this finally has to face up to the objectness of what he is doing. He is making a thing.

There were obvious differences between these artists and Mondrian. In many cases, they acted almost in opposition to what they considered the older artist's arbitrary asymmetry, idiosyncratic employment of straight lines and right-angled, differentiated elements. Mondrian's and the Cubists' type of organization was now considered "old"; treating parts of the picture unequally made it "hierarchic." The "new" way was "wholistic," or "non-relational," as opposed to "relational." Lawrence Alloway stated the difference:[14]

> Relational refers to paintings like [those] of the earlier geometric artists which are subdivided and balanced with a hierarchy of forms, large–medium–small. Non-relational, on the contrary, refers to unmodulated monochromes, completely symmetrical layouts, or unaccented grids.

Such divergencies were as much reinterpretations of Mondrian's principles as his were of the Cubists'. Just as he could not have taken his direction without Cubism, which he realized did not accept "the logical consequences of its own discoveries," the new artists could not have taken theirs without Mondrian's ideas which they were simply carrying to further "logical" conclusions.

Reality as vested in nature become, finally, reality as vested in the work of art had a progressive, logical design that became didactic when carried by lesser artists to its denouement in Minimalism. Obviously, Mondrian was a key figure in this whole movement – now known by the name of Modernism. The difference between him and the Minimalists, who came at the very end of this movement, was that he never meant the pursuit of essentialized nature as coelesced with art to be a materialist dead end, proscriptive of content. Quite the contrary: Mondrian viewed his art as prescriptive for the future purification of humankind.

There was obviously no direct connection, but the generation of purist artists that espoused Minimalism also carried forward an ideal of autonomy similar to Mondrian's. Theirs had become a thoroughly logical and material quest, however, neither recognized as an ideal nor connected with any forebears. Several of the themes they followed consistently, especially when carried out in "serial" or "systemic" painting – such as color-flatness, figure-ground equivalency, and objecthood – had been conceived earlier by Mondrian. Even artists who reacted against, or "confronted," his determination of space by creating "field" paintings that seemed to spread beyond their frames were manifesting, conversely, a form of discipleship. So, too, were those who carried Mondrian's spatial logic into three-dimensional paintings that thrust into the actual space of a room and almost crossed the boundary into sculpture. Indeed, sculptors also followed a process of reduction similar to that of the abstract painters.

Minimal artists made their point loud and clear on the autonomy, or self-reference, of their art. They overlooked what Mondrian saw in his, however, which was the finite reflection of its infinitude. In their art, they saw only finitude.[15]

Clearly the Minimalist artists were aiming toward an ultimate reductability. One kind of limit invites its opposite, on a continuum with extremities that might be constructed arbitrarily from a statement of van Doesburg's: "Modern art is the direct medium between man and absoluteness." Michel

Seuphor had earlier characterized the opposing abstract directions that found their clearest exemplars in Mondrian and Kandinsky. "Kandinsky's merit lay in showing what marvels can be wrung from genuine freedom, and that the limits of the canvas allow of no excess. Mondrian's lay in his lesson of discipline and humility. Reducing his art to the simplest data ever used, he showed how spiritual stature grows with self-denial and how the poorest means are the purest, often the strongest".[16]

The Minimalists went so far toward the end that Seuphor defined as "calm organization," there was bound to be a turn toward his alternative of "directed fury." Actually, Mondrian had shown the way by rejecting the purity of his early works for the relative flamboyancy of his later ones. The earlier, "classic" period represented a paradigm of Modernism. Charted on a bell-curve, it began an ascendancy before him with Cézanne and Cubism, reaching its apogee with his Parisian corpus, and following a descending arc through Reinhardt toward its nadir with the Minimalists.

Late in his career, Mondrian grew disatisfied with a pivotal role in this scenario. Like other great artists who departed from the standard of their mature periods and risked being misunderstood by the very followers whose tastes they had formed, he launched into a version of his own style that far exceeded its established limits. Thus Mondrian created a new model for others to follow. There was specific information in his *Boogie-Woogies* for many artists to build on – notably Albers, Anuszkiewicz, and Jensen,[17] (400-402) – but the late paintings also provided a model of art's going "outside itself" when formalism proved too restrictive.

400 Josef Albers, Whitney Museum (unless indicated otherwise, this and the following slides were photographed by the author, in which case, title, date, and medium are unknown).

Most of the artists who went "outside" Minimalism extended the impetus of Dada toward outrageous pragmatism in order to counter an intellectualized movement with its opposite extreme. In earlier periods, Dadaists and Surrealists exploded the rationale of Cubism, Suprematism, *et al*, while Abstract Expressionists unbolted the "Euclidean prison of geometry" (the amalgamation of Cubism and Constructivism that dominated advanced American art during the 1930s and 1940s). As reaction followed a course of attenuation, it also begat reaction: Abstract Expressionism and its cathartic offspring Pop Art[18] disavowed geometric abstractionism but did not suppress it entirely. A latter-day form of this style ran its course toward Minimalism to become an ultimate statement of Modernism.

282

The Minimalist generation put forth collective, but meaningful, answers to Mondrian's question, "What is Art?" all the while demonstrating a logical consequence of one of Mondrian's missions – to clarify, purify, and ascertain the limits of artistic form. The most cherished ideal of the 1960s artists – freedom – realized in their pure surfaces, pure colors, pure forms, and pure space, had surely fulfilled Mondrian's dearest wish. "If we cannot free ourselves," he prophesied, "we can free our vision."[19]

The elder artist died before his mission was complete, but inevitably, there were those who would carry it forward. Inevitable, too, was an eventual caesura that would cause other artists to pause for rethinking and reevaluation. The lesson of history was as predictable for the future as it had been for the past: a systolic movement would be followed by a diastolic one, retrenchment by regeneration.

The "greening," or turning back from the absolute to humanity, appeared in myriad forms, subsumed under the rubrics of Pluralism in the 1970s and Postmodernism (or Postminimalism) in the 1980s. This posteriority was invigorated by the disorderly results of breaking away from "mainstream Modernism" and exploring in all directions. These included new versions, or revivals, of older styles such as Expressionism, Dadaism, Surrealism, and Pop, or the styles of individual artists who had been ancillary to the "mainstream." Even mainstream artists were treated to revisionary methodology.

As early as the 1960s, some artists had ceased to concern themselves solely with the visual arts and overlaid their efforts with other creative processes, from dance, theater, music, and cinematography; such efforts were now rampant. Another group of artists expanded their interpretations of art geographically, temporally, and/or philosophically. Ultimate materialists though they were, Earth Artists demonstrated idea as well as substance (with their documentation-sans-object), as did the Conceptualists, working only with idea, language, and/or documentation.

401 Richard Anuszkiewicz, *Knowledge and Disappearance*, medium unknown, 1961.
© Richard Anuszkiewicz/ Licensed by VAGA, New York, NY

402 Alfred Jensen, *The Doric Order*, center, and *The Great Occupation*, right, date and medium unknown.

Several artists who still retained the object animated it with event, movement, texture, and pattern and decoration. The latter elements, now joined in the initials "P&D" to designate the style that incorporated them, were time-honored female usages that had been suppressed as irrelevant by Modernists. Women took the lead (soon to be followed by men) in producing scintillating new versions of motifs found in folk and decorative arts, often in collages of actual materials and memorabilia. Many of the predilections that had been rejected by purist artists were present in the works of these and other Feminist artists who drew on historicism, eclecticism, and primitivism along with what were said to be the purely "feminine" inclinations of emotionalism, narcissism, and sensualism.[20]

Along with certain practices by women — i.e., making art based on ancient forms like needlework or china painting, more often done collectively in the past — there emerged art forms by other groups that had always been considered "minor," such as "blacks" and "native" Americans. Some artists (men and women) literally made themselves into art, "arousing" or "recording" their own bodies, or "dramatizing" them in multiple personae. On the other end of the intellectual spectrum was art based on critical theory, especially as espoused by the French linguists. One of the most influential was Jean Baudrillard, whose ideas about commodification, originality, and simulation spawned much theoretical and pragmatic interest.

Art historians and critics either lamented or accommodated what happened in the 1980s, as ever younger artists "opened Pandora's box and released all the demons that modernity had exorcised [finding] themselves enticed and seduced by every manner of fruit once forbidden by puritanical formalism." Contraverting Mondrian's and the geometric artists' equilibrated and neutralized surfaces, the Neo-Expressionists released garish color into their personalized, often aberrant narrations. It was apparent in the "International Survey of Recent Painting and Sculpture," with which New York's Museum of Modern Art opened its expanded facilities in the spring of 1984, that many of the new artists drew material from their urban environs. Sharply opposed to Mondrian, however, they used urban imagery, as the exhibition's curator Kynaston McShine made clear, "both straightforwardly and as a metaphor of decadence and decay." How different from Mondrian's exalted view of the metropolis was their "angst-ridden modern city become the delirious surround of consumer capitalism," in the words of Hal Foster.[21]

A leading interpreter of Postmodernism, Foster found two modes in the movement, the neoconservative that turned back to representation, and the poststructuralist that "deconstructed" modernist "self-criticism," as defined by Greenberg. According to this critics' critic of only a decade or two before, modernist artists had employed a "self-critical" mode in which they focused on "the characteristic methods of a discipline itself not in order to subvert it, but to entrench it more firmly in its area of competence." Poststructuralists reversed Greenberg's formula, using the same methods, "precisely, to subvert the discipline," according to Foster. Ironically, whether disavowing Modernism or deriving their momentum from it, there were members of both parties who invoked Mondrian as either the ultimate adversary or ultimate legitimizer of their claims.

"Poststructuralism" and "deconstructionism" were terms that had come into use originally in linguistics, as opposed to the "structuralist" theories of

earlier twentieth-century linguists who believed it possible to uncover an underlying truth or "objective reality" that both informed an interpretation of language and revealed it as a model of "universal governing principles." The "deconstructive" linguists (or philosophers), such as Jacques Derrida, began to question all previous forms of interpretation, particularly those which sought revealed truth. Derrida claimed that interpretations are, in themselves, interpretations; consequently, truth, if it exists at all, is multiple, various, and diffuse rather than singular, autonomous, and fixed. Interpretation, therefore must become active by substituting "incessant deciphering for the disclosure of truth as a presentation of the thing itself in its presence. . . . interpretation does not unveil established meaning but produces new meanings which had not previously been realized".

403 Susan Rothenberg, *Mondrian*, oc, 1984, private collection.

Derrida's theories and those of other "deconstructionists" had such pervasive power that they extended to all forms of language, or communication, including the arts. Thus art theorists as well as artists were soon drawn into the structuralist-deconstructionist dialogue.[22] Mondrian, the quintessential Modernist in his design for a universal system underlying both nature and art, obviously took his place among the Structuralists and was, consequently, a prime candidate for deconstruction, especially by artists who joined the polemic. For instance, Sherrie Levine "appropriated" Mondrian's style by copying a reproduction of an exemplary *Composition*, done in 1921,(404) in order to undermine its "most hallowed principles of . . . originality, intention, expression [a critic's words]."[23] Susan Rothenberg did not appropriate the elder artist's style so much as his dominion over modernity when she made him the central theme of four paintings.(403) She was said to be "awed by the Dutch master's rigor and control," and to be "playing on the irony of their confrontation," with her reduced images mired in unrestrained brushwork.[24]

A new generation of geometric artists, soon dubbed the Neo-Geos, deconstructed the affectations of earlier geometrists not by appropriation but by "simulation," a term that also came from a literary, semiological interpretation.[25] Neo-Geo artists, very much in the new, "textual" mood, deconstructed modernist geometric masterpieces by simulating certain characteristics without one-to-one reference to the works as a whole. A prime example was Peter Halley, who typically used linear planes to connect rectangular planes to one another and the edges of his canvases (a devise borrowed from Mondrian, but not with the elder artist's ideal of equilibrating matter,

404 Sherrie Levine, *After Piet Mondrian*, watercolor, 1983, Collection Eugene and Barbara Schwartz, New York. Courtesy of Barbara Schwartz.

structure, and space). Halley was said to be "self-critically" confronting earlier modernist canons about geometry (its "transcendental or mystical" association with Malevich, Newman, Rothko, and Mondrian), by being engaged with the mode without believing in its "transformative" value.[26] The artist described this intention in his own article, entitled "The Crisis of Geometry": "There can be only a simulacrum of art, not the 'real' thing resplendent with transcendental significance and referents. . . ." Not that his paintings lacked content; Halley claimed, in fact, that they depicted a model of the cells and conduits of post-industrial society's vastly complex electronics systems.[27] (405) Hal Foster interpreted these artists' motives, but he also reflected that making abstraction as a sign of itself was empty and rhetorical, quite different from the attitude of abstractionists who worked in "historical involvement with [painting's] material practices," he said.

405 Peter Halley, *Blue Cell with Conduits,*
medium unknown, 1986.
Courtesy of the Artist.

Several of the latter artists — some older, some younger geometrists — continued to demonstrate that Modernism was still viable, even though they, or critics, qualified their intentions as having nothing to do with forebears. By his own admission in historical "line with the abstraction of Malevich, Mondrian, Newman, Reinhardt and Rothko," Robert Ryman was said to slip the yoke of their "myths, manifestoes or protective irony," by making not what Mondrian called "pure painting," but what was now called "'plain'

406 Brice Marden *Summer Table,* 1972. Oil and wax on canvas. Whitney Museum of American Art.

painting, the expression of a pragmatic classicism" found in things rather than ideas. Brice Marden circumvented his abstract ancestors by claiming that the tripartite divisions of his minimalist panels were borrowed from Renaissance triptychs.(406-408)

Even though Feminist artists and critics often equated Modernism with masculine interests, there were still women artists whose work had a modernist look and feel. Agnes Martin's style, a subtle, personalized version of Modernism, was characterized in a 1979 catalog statement by mannerisms that would extend into her work of the decade to follow:[28](409,410)

> Softly laid out in pencils with the help of the simplest tools, her paintings are based on a minute division of their surfaces by systematic grid patterns. Within this seemingly austere technique there are multiple variations, the irregularities of lines and deviations in sizes of the elements in modular patterns endow her work with sensitivity and infinitely diversified pictorial surfaces.

407 Detail of above.

409 Agnes Martin, *Milk River*, 1963, oil on canvas, Whitney Museum.
© Agnes Martin

410 Detail of above.

Opposite page:
408 Brice Marden, *Elements I*, oc, 1982, Tremaine Collection.

411 Kenneth Noland, *Morning Pane*, medium unknown, 1972.
© Ken Noland/ Licensed by VAGA, New York, NY

The classic abstractionists of the 1960s who were still working in the 1980s tended to retain a closer association with their former styles and to compare earlier and later efforts more straightforwardly. In the 1970s, Kenneth Noland passed through a period of weaving stained-earth stripes around the edges of his rectangular and diamond-shaped canvases, much as Mondrian had interlaced the stripes (or attenuated planes) of his *New York City* paintings.(411,412) In the 1980s, Noland truncated his canvases by cutting off their corners non-symmetrically and articulating their resultant, diagonal edges with color.(413) He had taken the idea of treating canvases as essentialized objects from the older artist who, Noland said, had created a unique form of "strictly pictorial, abstract invention." "Abstraction forced artists to have to deal with the elements of making paintings more as stuff," he mused in an interview; "they liked the tactile quality of the stuff, the shaping of it, the reality of the materials, the nature of the colors — so, the illusionistic character of painting was almost eliminated."

412 Noland, Another Time, 1973.
72 X 72". Whitney Museum.
© Ken Noland/ Licensed by VAGA, New York, NY

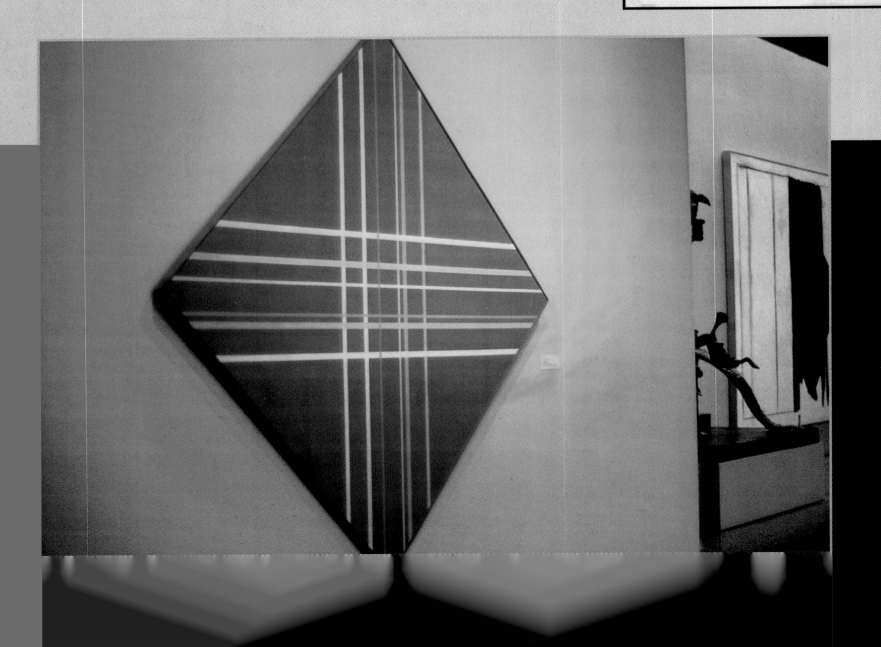

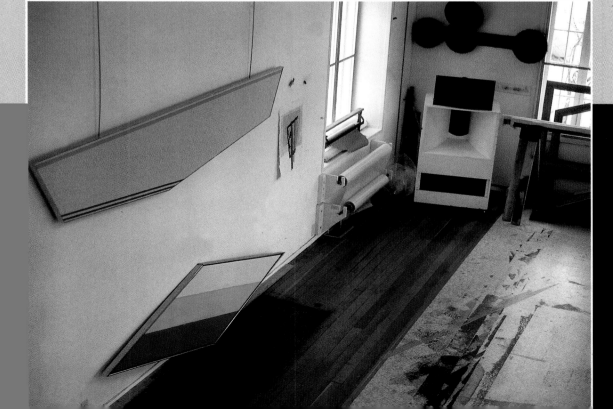

413 View of Noland's studio.
© Virginia Pitts Rembert

The artist was stating the Americans' case for Modernism. To him, it was about "stuff" and "efficiency," about bringing together the old poles of meaning and form, of motivation and content, that were in danger of being split into dichotomies again in some of the controversies surrounding Postmodernism. Quality should be the only criterion, he thought, but quality itself had become an issue, having been correlated by the Modernists with a single type of art, and then been discarded by the Postmodernists as implying a no longer viable value-judgment.

Throughout the 1970s and the 1980s, subsequent artists were completing and defining Modernism by the processes Robert Morris had outlined – of ignoring the style, extending it, or having a dialectical relationship with it. One way of extending Modernisms' implications was through continued experimentation with the object, space, reality, and their limits. An exhibition of 1980 in London's Hayward Gallery, that surveyed the art of the previous decade carried the concept of space far beyond the wall; just how far – and how it was still Mondrian's space – was suggested by the title "Pier + Ocean" and by an excerpt from the catalogue statement:[29]

> Piet Mondrian, in the paintings that have become famous under the title of *Pier and Ocean* and from which the title of this exhibition is borrowed, brought together the ordered – the man-made pier – and the unordered, the formless ocean, as a dualistic conception within a single pictorial space. . . . Open space can be nature, as physical or mental space; it may be political space; it may be culture, language, history. It is outer space, and it is also the inner space of memory and imagination.

"Open space" was presented variously in this exhibition. Some artists defined space in terms of the shape of the gallery, by framing the room, cleaving it, filling it with light and sound, or diagramming its walls. Others extended space, by projecting it outwardly beyond the gallery and by employing its concomittant, time, via serial or video photography. "Pier + Ocean" was a truly international exhibition, with representation from Britain, Belgium, France, Germany, Holland, Italy, Japan, and Poland; most of its artists were American, however.[30] (414,415)

414 . View in Pier + Ocean Exhibition, Hayward Gallery, London, 1980.

415. View in Pier + Ocean Exhibition, Hayward Gallery,
London, 1980.

By the mid-1980s, Frank Stella was proposing a different kind of space in painting from the surface space that had enthralled him in the 1950s and 1960s. Authoritative treatment of surface space had freed artists of the 1960s to make "a greater, more coherent, more understandable, and more clearly felt level of pictorial abstraction," he reasoned. It had been a failure to maintain the momentum set in the 1960s that had led to the stagnation of abstract painting in the 1970s. In the end, he felt that the antimaterialism of abstraction's northern founders must be invigorated with spatial energy drawn from the South, with an "assault on exterior boundaries, the possibility of dissolving conventional edging,"[31] as he was doing in his newer works.(416)

416 View in Frank Stella's New York studio.
© Virginia Pitts Rembert

Mondrian might well not have minded this seeming contradiction of his credo. Stella understood that the older artist had challenged Picasso's dicta and, in the end, his own. He wrote with great understanding of Mondrian's "sensationalism," as beginning with the application of pure color that reveals the intensity of hue as a pleasure and a tool in its own right, as well as a surprising conveyer of feelings echoing volume and mass. Bright, radiant light follows, created by a preponderance of white pigment and numerous high-contrast encounters with the black bars cutting across the painting's surface. The surprising light, emanating from a background which has the ability to assert itself as foreground, is hard to pin down, but it does seem to suggest that color travels as it radiates, which in turn suggests that color has some graspable pictorial substance of its own. Finally, Mondrian pulls it all together with rhythm, the painter's ultimate tool. *Broadway Boogie-Woogie* is a measure of all abstract painting.

Artists of the generations succeeding Mondrian had parted company from Modernism and its paradigm in Mondrian not only in style but in attitude. Whereas, to the elder artist, "everything should be the true expression of modern times," younger ones no longer put any idealistic connotation on modernity. They seemed to have rebuffed the old world of art, but were closer than they would have believed to Mondrian, who wrote:[32]

> It is right that a new generation should be opposed to convention and go its own way. . . . As long as freedom exists, progress can be continued. This does not mean that egoism is excluded. To a certain degree the difficulty of maintaining and creating an existence and livelihood requires it. Particular interest is one of the factors that prevents social life from being free. Art is disinterested and for this reason it is free.

Even if younger artists rejected Mondrian, they could not erase his patrimony nor could they relieve their art of idealism. Their creative act entailed both the effort and the emotion he had described, when he said:

> Even the most abstract art does not arise from an inner source alone. As in all art, its origin is in <u>the reciprocal action of the individual and environment and it is inconceivable without feeling.</u>

By negating old values such as beauty, they had uncovered new interpretations, of which Mondrian might have approved. "Beauty is relative because men are different"; he continued:

> The fact that the perception, feeling and conception of beauty continually progress, parallel with all progress, is too much neglected. Attachment to a merely conventional conception of beauty hinders a true vision of it. When the conception of beauty does not change in a progressive direction, there is something wrong in human life; it is either at a standstill or in regression.

Mondrian knew that the truly "conscious," or aware, artist must see beyond stylistic change. At least, he foresaw the change toward the opposite direction from his own, and his forecast was the most agile and least doctrinaire about its significance:

> It would be erroneous to limit modern plastic art to narrow frontiers. Two principal expressions exist: one of them uses more or less <u>naturalistic forms and colors</u>; the other employs more or less purified means of expression. These two expressions appear under different names, but all names are approximate, partial, and therefore misleading.
>
> It appears as though these two expressions oppose each other, but when we observe that in different ways both show the same search for freedom, then we see their unity. For all modern art reveals a <u>liberation from the oppression of the past</u>. . .
>
> Modern times create a transformation of reality; sometimes by means of freer composition, freer colors and forms (academic art, realism, surrealism) and sometimes by a more consequent transformation of forms and their relations (abstract art). Bound together by unchangeable plastic laws, the different tendencies of modern art continue the struggle for a more real establishment of the true content of art. But to accomplish this, freedom is necessary.

Mondrian once dedicated an essay *aux hommes futurs*.[33] Freedom was his greatest legacy to artists then and in the future.

CHAPTER SEVEN - REFERENCES

1 These legacies, as paraphrased from Mondrian's article "L'Expression Plastique Nouvelle dans la Peinture," *Cahiers d'Art*, 1 1926, pp. 181–182, are: the destruction of the ancient object-ground relationship through variants on his means, and the reinterpretation of the very meaning of a "work of art."

2 Actually, "Greenbergian theory" was only one of the terms used to associate the phenomena in 1960s abstract paintings (and Mondrian's before them) with the critic. See *Abstract and Program Statements*, published by the College Art Association, New York, 1991.

3 Clement Greenberg, "Modernist Painting," *The New Art*, ed. Gregory Battcock, 1973, p. 68, said to be reprinted from *Art and Literature 4*, Spring 1965. Since this essay has become a definitive source for precepts of Modernism, its original dates are important. Greenberg himself seems to have overlooked another early publication of this essay in *Arts Yearbook 4*, New York, 1961.

4 Lucy R. Lippard, essay in *Ad Reinhardt*, New York, 1967.

5 Clement Greenberg, "Post-Painterly Abstraction," *Art International*, Vol. VIII, Nos 5–6, Summer 1964, p. 64.

6 Lawrence Alloway, *Introduction to Systemic Painting*, New York, 1966, pp.13–14.

7 From *Readings in American Art Since 1900*, ed. Barbara Rose, New York, 1968. Rose quoted Stella from an interview with Bruce Glaser, published as "Questions to Stella and Judd," *Art News*, September 1966.

8 Quoted by Seuphor, *Piet Mondrian . . .* , p. 168.

9 Greenberg, "Modernist Painting," (see Note 3 above), p. 68.

10 The first quoted phrase is from Alloway (Note 6 above), p. 13, and those following are from *The Art of The Real: USA 1948–1968*, text, E. C. Goossen, catalog for the exhibition by that name held at the Museum of Modern Art, New York, 1968, p. 8.

11 Mondrian, "A New Realism," *Plastic Art and Pure Plastic Art*, The Documents of Modern Art, New York, 1945, p. 26.

12 Mondrian, "New Structure in Music and the Futuristic Italian Bruitists," *The New Structure* (Bauhaus Book 5, private translation), Munich, 1925, p. 32.

13 Rose, *Readings* (see Note 7 above), p. 179.

14 Alloway (see Note 6 above), p. 21, note 5.

15 Sometimes, their art's message was the "abject object" (Ivan Karp's term, proposed during a discussion with students at Birmingham-Southern College in 1969); however, when endowing an object with that special intensity that derived from crafting and ordering of pared-down parts, as with a Larry Bell vacu-form box, their message was the transcendent object.

16 Michel Seuphor, *Dictionary of Abstract Painting*, New York, 1957, pp. 19–20.

17 *Broadway Boogie-Woogie* had been in the collection of the Museum of Modern Art since 1936. *Victory Boogie-Woogie* was loaned for eighteen years to the MOMA by its owners, the Burton Tremaines. There, Emily Tremaine said, it "opened every door" for the several generations of artists who saw it. After the deaths of the Tremaines, the *Victory* went from the S.I. Newhouse, Jr. collection, New York, to the Mondrian collection in the Gemeentemuseum, The Hague.

18 Whereas Abstract Expressionist artists had thrust toward an out-and-out aestheticism, Pop artists barely escaped the banality of their sources. They dismissed the spontaneous gesturing of their antagonists in favor of repetition and polish, sometimes calculated as a wry joke on the "style informel," as was the case with Robert Rauschenberg's *Factur I and II*, and Roy Lichtenstein's *Big Painting*.

19 Mondrian, "Toward the True Vision . . . ," p. 15.

20 A salient example was Judy Chicago's monumental *Dinner Party*. Although this work broke with tradition through its exclusively female imagery and its parody and amplification of "The Last Supper" theme (as a table set for 39 women), it was traditional in several ways: by deploying the tendency of women to absorb their individual egos in group efforts (homemaking in an extended family, or quilting in a folk enclave), carried out here in a group endeavor requiring the energies of over 400 people; by reviving genre used heretofore almost exclusively by women, such as china painting and needlework; and by concentrating on women from prehistory to the twentieth century (actually referring to more than a thousand).

21 Hal Foster, *Recodings*, Port Townsend, Washington, 1985, pp. 90, 130.

22 Yves Alain-Bois is one of these theorists; he quickly related the dialogue to one of his chief interests, Mondrian. An example is his essay entitled "Piet Mondrian, New York City," (quoted in Chapter 4), in which, it should be said, Bois put some very "critically correct" thoughts into Mondrian's mind (that he probably did not think at all).

23 Gerald Marzonati, "Art in the (Re)Making," *Art News*, Vol. 85, No. 5, May 1986, p. 91.

24 Eliza Rothborne, "Susan Rothenberg," essay for catalog of exhibition at the Phillips Collection, Washington DC, 1985, p. 21.

25 "To simulate is to feign to have what one hasn't," but as in simulating (opposed simply to feigning) an illness, "the simulator produces 'true' symptoms," wrote the French philosopher Jean Baudrillard. "Simulacra and Simulations," *Jean Baudrillard: Selected Writings*, ed. Mark Poster, Stanford, 1988, pp. 167–168.

26 Jeanne Siegel, "Geometry Desurfacing: Ross Bleckner, Alan Belcher, Ellen Carey, Peter Halley, Sherrie Levine, Philip Taaffe, James Welling," *Arts Magazine*, Vol. 60, No. 7, March 1986, p. 26.

27 Foster, "Signs Taken for Wonders," *Art in America*, Vol. 7, No. 6, June 1986.

28 This description was in a biography of Agnes Martin in the catalog entitled *Constructivism and the Geometric Tradition*, New York, 1979.

29 "Introduction by Gerhard von Graevenitz," Pier + Ocean, catalog of the exhibition at the Hayward Gallery, London (May 8-June 22, 1980) and the Kröller-Müller Museum, Otterlo (July 13-September 8, 1980), London, 1980, p. 6.

30 The American artists included Walter De Maria, Douglas Huebler, Will

Insley, Fred Sandback, Joe Schapiro, Charles Simonds, Robert Smithson, Richard Tuttle, Lawrence Weiner, John Baldessari, Bill Beckley, Donald Judd, Sol LeWitt, Ed Ruscha, William Wegman, Carl Andre, Bruce Newman, George Rickey, and Kenneth Snelson.

31 Frank Stella, *Working Space*, Cambridge, Massachusetts, 1986, pp. 79, 24, 141 ,160. This book was based on Stella's Charles Eliot Norton Lectures, delivered at Harvard University in the academic year 1983–1984.

32 Mondrian, "Liberation from Oppression in Art and Freedom in Art and Life," *Plastic Art*, pp. 41-43.

33 Mondrian, "Neo-Plasticism, General Principle of Plastic Equivalence," Leonce Rosenberg Gallery, Paris, 1920, np., trans. Holtzman and James.

BIBLIOGRAPHY

INDEX

BIBLIOGRAPHY

(Selective supplement to the Chapter
References; primarily, in order of reference)

Chapter I:

Henkels, Herbert. *Mondriaan in Winterswijk, een essay
over de jeugd van Mondriaan, z'n vader en z'n oom*. The
Hague: Gemeentemuseum, 1979.
Bradley, Jay. "Piet Mondrian, 1872-1944,
'Greatest Dutch Painter of Our Time.' "
Knickerbocker Weekly. 14 February 1944.
de Gruyter, Josiah. *De Haagse School, Part I*.
Rotterdam, 1968.
Mondrian, Piet. "Toward the True Vision of
Reality." "Pure Plastic Art." "A New Realism."
*Plastic Art and Pure Plastic Art,, t he Documents of
Modern Art*. Ed. Robert Motherwell. New York,
1948. This, and the further listed writings by
Mondrian may be coordinated with their pub-
lished counterparts in Holtzman's and James's
*The New Art—The New Life: The Collected Writings of
Mondrian*, New York, 1986, designated by H/J,
followed by the page numbers, in this case H/J
338-350.
 "Dialogue on Neo-Plasticism," *De Stijl*, II.4
 (1920; written in 1919; an unpublished
 manuscript, this had no page numbers—
 numbered paragraphs or footnotes will be
 given.in other references from the same
 source). H/J 75-81.
 "Neo-Plasticism, General Principle of
 Plastic Equivalence." Paris: Léonce
 Rosenberg Gallery, 1920. H/J 132-147.
 "The General Principle of Balanced
 Structure." *The New Structure* (Bauhaus Book
 5, private translation). Munich, 1925
 (including German versions of his "Neo-
 Plasticism...," 1920, and four articles on
 architecture and music).
 "Introduction." "The New Plastic in
 Painting." *De Stijl*. 1917. H/J 28-30.
 "B. The New Plastic as Abstract-Real
 Painting: Plastic Means and Composition-

I." The New Plastic...." H/J 35-47.
 "C. The Rationality of the New Plastic-I."
V, VI. "The New Plastic...." H/J 40-47
 "D. From the Natural to the Abstract:
 From the Indeterminate to the
 Determinate-I.II VII, VIII." "The New
 Plastic...." H/J 47-69.
 "Supplement: The Determinate and the
 Indeterminate." XII. "The New Plastic...."
 H/J 70-74.
 "The New Plastic Expression in Painting."
 Cahiers d'Art 1.7 (1926). H/J 202-204.
 "Homage to van Doesburg," *De Stijl* 8.90
 (1932). H/J 182-183.
 "Plastic Art and Pure Plastic Art." *Circle*.
 London, 1937. H/J 288-300.
 Unpublished manuscript in his handwrit-
 ing. 1932. H/J 277-280.
 "The Realization of Neo-Plasticism in the
 Distant Future and in Architecture Today."
 De Stijl.5.1922.H/J 164-172.
 New Structure in Music and the Futuristic
 Italian Bruitists." *The New Structure*. H/J
 148-155.
 "The New Art—The New Life: The
 Culture of PureRelationships." 1931. H/J
 244-276.
 "Principles of Neo-Plasticism."
 Unpublished manuscript quoted in
 Seuphor, Michel. *Piet Mondrian:Life and Work*.
 New York, 1956. H/J 214-215.
Jaffe, Dr. H.L.C.. *Piet Mondrian*. New York, 1970.
 De Stijl: 1917-1931. Amsterdam, 1956.
Calvin, John .*Institutes of the Christian Religion*. II.
Philadelphia, 1928 (p.7).
Blavatsky. H.P. *The Key to Theosophy*. London, 1948
(p.2)..
Joosten. Joop."Abstraction and Compositional
Innovation." *Artforum*. XI.8. April 1973
(pp.55,56).
Blotkamp, Carel. *Mondrian: The Art of Destruction*.
London, 1994; New York, 1995.

Chapter II:

Clay, Jean. "An Interview with Denise René,"
Studio International. 175, 899 (1968) (p.195).
Troy, Nancy Joslin. "Piet Mondrian's Atelier."
Arts. 53, 4 (1978).
Doesburg, Theo van. "Élementarisme."
Abstraction-Création. I, 1932 (p.39) (author's
translation).

Mondrian, Piet. *Natural Reality and Abstract Reality, An Essay in Dialogue Form,* 1919–1920. Quoted from Seuphor. (pp.335-336) H/J 83-123.

Harrison, Charles. "Introduction" (pp.1-3). Bowness, Alan. "Barbara Hepworth" (p.5). *Unit I,* catalogue of exhibition reconstructing the 1934 Unit I Exhibition (originally in the Mayor Gallery, London). City Museum and Art Gallery. Portsmouth, England, 1978.

"Biography: Barbara Hepworth." Catalogue of exhibtion at Marlborough Gallery. New York, 1979 (p. 64).

Read, Herbert. "British Art, 1930-40" (from the original catalogue, *Unit One.* London, 1934) (pp.5-6), "A Nest of Gentle Artists" (from *Apollo.* September, 1962) (pp.7-8), and Summerson, John. *Ben Nicholson.* London, 1948 (p.65). Quoted in exhibition catalogue *Art in Britain 1930-40 Centred around Axis, Circle, Unit One.* Marlborough Fine Arts Ltd.. London, 1965.

Doesburg, Nelly van. "Some Memories of Mondrian." *Piet Mondrian,* catalogue of the Mondrian centennial exhibition (New York, Guggenheim Museum, and Berne, Kunstmuseum, 1971–1972). New York, 1971 (pp.67-73).

"Reminiscences of Mondrian: Barbara Hepworth." "Winifred Nicholson." "Ben Nicholson." "Naum Gabo." "Herbert Read." *Studio International.* 172, 884. December, 1966 (pp.287-292).

"Profiles: The Experience of Forms: I." *The New Yorker.* XLI (Dec. 11, 1965) (p.13). II. XLI (Dec. 18, 1965) (p.83).

Hoek, Els. "Mondrian in Disneyland." *Art in America.* 77.2 (1989). (pp.138,141).

Bois, Yves-Alain. "Lettres à Jean Gorin." *Macula.* 3 (1977) (p.133).

Alloway, Lawrence. "Art News from London," *Art News.* 54.6 (1955) (p. 10).

Harrison. "Mondrian in London," *Studio International.* 172.884 (December 1966) (p.285).

Bill, Max. "Die Magic den gestalteten Gegenstande." *Du* (June 1975) (p. 38)..

Dreier, Katherine S. Catalogue of the International Exhibition of Modern Art arranged by the Société Anonyme for the Brooklyn Museum. F1926/W1927. New York, 1926 (np.).

Bohan, Ruth. *The Société Anonyme's Brooklyn Exhibition: Katherine Dreier and Modernism in America.* Ed. Stephen Foster. Ann Arbor, Michigan, 1982.

Hamilton, George Heard. "The Société Anonyme at Yale." *Collection of the Société Anonyme.* New Haven: Yale University Art Gallery, 1941.

Gallatin, A. E. Catalogue of Gallatin collection (called at this time the *Gallery of Living Art*). New York, 1933 (np.).

Catalogue of Gallatin collection, called now the *Museum of Living Art.* Ed. George L.K. Morris. New York, 1940.

"Twelve Artists in US Exile." "Great Flight of Culture," *Fortune.* XXIV. 6 (December 1941) (pp.103,114,115).

Sandler, Irving. *The Triumph of American Painting.* New York, 1970 (p.15)..

M.D. "New Exhibitions of the Week: Thirty-nine Practitioners of 'Abstract' Art." *Art News.* 35 (April 17, 1937) (p.26).

Gurin, Ruth. "Toward a Fourth Decade." *American Abstract Artists, 1936–1966.* New York, 1966 (np.).

Morris, George L.K. "The Quest for an Abstract Tradition" (p.III). Holtzman. "Attitude and Means" (p.V). *American Abstract Artists.* New York, 1938.

The American Abstract Artists. New York, 1939 (p. I).

Jewell, Edwin Alden. "Our Annual Non-Objective Field Day." *New York Times.* March 12, 1939.

Chapter III:

Welsh, Robert. *"Landscape into Music: Mondrian's New York Period."* Arts. 40. 4 (1966)(p.33).

Ashton, Dore. *The New York School: A Cultural Reckoning.* New York, 1973 (pp. 117-119).

"57th Street in Review." *Art Digest.* XV.10 (February, 15, 1941) (p. 18).

Seuphor, Michel. *Piet Mondrian, Life and Work.* New York, 1956 (Charmion von Wiegand's descriptions of Mondrian's first painting to be shown in an AAA exhibition, quoted from Seuphor (p.181).

"Mondrian." *Art News.* XL.20(1942) (p. 26).

New York Sun.. January 23, 1942.

New York Times. January 25, 1942.

Herald Tribune. January, 25, 1942.

"The Passing Shows: Abstract." *Art News.* XLI (April 14, 1942) (p.28).

"Abstract Annual." *Art Digest.* 16.12 (March 15, 1942) (p. 18).

"Abstract Painting at NYU." *Art Digest..* 16 (March 15, 1942) (p. 9).

"Artists in Exile Hold Stimulating Show." *Art*

Digest. 16 (March 15, 1942) (p. 9).

Kraus, Felix H. "Mondrian, A Great Modern Dutch Painter." *Knickerbocker Weekly.* 2 (September 21, 1941) (p. 25).

Bradley, Jay. "As Ernst Remembers Mondrian." *Knickerbocker Weekly.* 2 (September 21, 1941) (p. 25).

"Reminiscences: Ben Nicholson." *Studio.* 172.884 (December 1966) (p. 290).

Tillim, Sidney. "Review of *Piet Mondrian…*". Michel Seuphor. *College Art Journal.* XVI.4 (Summer 1957) (p. 356).

Coates. Robert."Two Pioneers." *New Yorker.* XXI (March 3, 1945) (p. 71).

Janis, Harriet.. "Notes on Piet Mondrian." *Arts and Architecture.* 62.1 (January 1945) (p.29).

Further reviews in the "Mondrian" folder at the New York Public Library.

Chapter IV:

Mondrian, Piet. "L'Expression Plastique Nouvelle dans la Peinture." *Cahiers d'Art.* 1 (1926) (p.183).

Sweeney, James Johnson. "Painting." *Gallery of Living Art.* New York, 1933 (np.).

Mondrian, "Plastic Art and Pure Plastic Art," published originally in *Circle,* as reprinted in *Modern Artists on Art* (pp.115, 116, 122,125) (later published in *Plastic Art and Pure Plastic Art,* ed. Robert Motherwell, New York, 1945).

"A New Realism," as published in *Plastic Art and Pure Plastic Art* (pp.17,18,19,20,25).

Rosand, David. "Frame and Field: Notes on the Lesson of Degas." *Arts.* 47.5 (March 1967) (p.19).

Kaprow, Allan. "Inpurity." *Art News.* 61.9 (January 1963) (p.33).

Carmean, E.A.,Jr.Essay in *Mondrian: The Diamond Compositions.* National Gallery of Art. Washington, 1979 (pp.30-31).

Morris, George L.K., "Relations of Painting and Sculpture." *Partisan Review.* X.1 (Jan./Feb. 1943) (pp.66-70).

Mashek, Joseph. "Mondrian the New Yorker." *Artforum.* XIII.2 (October 1974) (p.58).

Bois, Yves-Alain. "Piet Mondrian, 'New York City'." *Critical Inquiry.* 14.2 (Winter 1988) (pp.241-272).

Champa, Kermit. "Piet Mondrian's 'Broadway Boogie-Woogie'." *Arts* (January 1980) (p.54).

Chapter V:

Morris,George,L.K.."The American Abstract Artists: A Chronicle, 1936-56." *The World of Abstract Art.* Ed. The American Abstract Artists.New York, 1957 (pp. 140-141).

Doesburg, Theo van."Introduction, Manifestoes Etc.," as quoted in De Stijl, catalogue published by the Stedelijk Museum, Amsterdam, 1951,(p.5).

Mondrian, Piet. "The General Principle of Balanced Structure," *The New Structure,* Bauhaus Book 5, Munich, 1925, p. 19 (private translation) (p.66)..M

Mellow, James R. "New York Letter." *Art International.* XII (May 15, 1968) (p. 66).

Lane, John R. "Harry Holtzman." Abstract Painting and Sculpture in America, 1927-1949." Catalogue of exhibition at the Carnegie Institute Museum of Art. Ed. John R. Lane and Susan C. Larsen. Pittsburgh, 1983.

"Ilya Bolotowsky." *Arts.* 38. 2 (November 1963) (p, 35).

Bolotowsky, Ilya. "On Neoplasticism and My Own Work: A Memoir." *Leonardo.* 2 (1969) (p.224,227,229).

Breeskin, Adelyn D."Ilya Bolotowsky." Catalogue of exhibition at Guggenheim Museum. New York (1973) (pp.11-12).

Campbell, Lawrence. "The Rule that Measures Emotion." *Art News.* 60.3 (May 1961) (np) .Reprinted in the catalogue *Burgoyne Diller:1906-1965.* New Jersey State Museum,.Trenton, New Jersey (1966) (np.)..

"Introduction" and "Burgoyne Diller Talks with Harlan Phillips." *Archives of American Art Journal.* 16.2 (1977) (14-20),.

Haskell, Barbara. *Burgoyne Diller.* Catalogue for exhibition at the Whitney Museum of American Art (1990) (pp.15-23).

Pincus-Witten. Robert. "Minneapolis: Burgoyne Diller." *Artforum.* X..6 (February 1972) (p.60).

Burnham, Jack. "Mondrian's American Circle." *Arts.* 48.1 (September-October 1973) (p.37).

Glarner,Fritz. Lecture at a New York school by the name of "Subjects of the Artists." (February 25, 1949) (np.).

Ashton,Dore. "Fritz Glarner." *Art International..* 7.7 (January 1973) (p.50,51).

Castleman, Riva."Fritz Glarner's Recollections." *Art International.* XIII. 9 (November 1969) (p.34).

"San Francisco, Fritz Glarner: 1944-1970."
Artforum. IX.6 (February 1971) (p.85).
Foreword to the catalogue entitled "34e
Biennale Venice 1968, Swisse: Fritz Glarner,
Hans Aeschbacher," np.
Rubinstein, Charlotte. *American Women Artists*. New
York, 1982 (p.297)
Schwab, Cindy. "Charmion von Wiegand." *Arts*,
53.4 (p.11).
Rowell, Margit. "Interview with Charmion von
Time Wiegand." (June 20, 1971). Catalogue of
Piet Mondrian Centennial Exhibition. Guggenheim
Museum. New York, 1971 (p. 78).

Chapter VI:

Hall, Lee. *Betty Parsons*. New York, 1991 (pp.
116-117).
Essay by Alice Mason in American *Abstract Artists*.
New York, 1938 (np.).
Foote, Lona. "Alice Trumbull Mason: American,
1904-1971," catalogue entry in Ann
Sutherland Harris and Linda Nochlin, *Women
Artists: 1550-1950* (New York, 1976) (p. 328).
Hughes, Robert . "Rediscovered—Women
Painters." *Time*. 109 (January 10, 1977)
(pp.60-61).
Essay by Marilyn Brown in catalogue for exhi-
bition on Two Generations of *Abstract Painting:
Alice Trumbull Mason, Emily Mason*.). Tulane
University. New Orleans (1982). Also included
in the same author's article *Three Generations of
Artists* (including Alice Mason's mother Anne
Train Trumbull and her sister Margaret
Trumbull Jennings, published in *Woman's Art
Journal* . 4.1 (Spring-Summer 1983) (pp.1-8).
Sidney Tillim. "New York Exhibitions: Voyagers
in 'Reality'. " *Arts*. 38.9 (May-June 1964)
(p.29).
Biederman, Charles. *Art as the Evolution of Visual
Knowledge*. Red Wing, Minnesota (1948) (PP.
X,324,367,366,402,448,449,454).
 Letter to the author, January 27, 1969.
Marckk, van der, Jan. "Landscapes by Whatever
Name" (pp.58, 60, 62), and Hedberg, Gregory.
"Introduction" (p.7), and Biederman. "The
Search: Paintings and Drawings 1927-1937"
(p. 29), in the catalogue *Charles Biederman: A
Retrospective*. Minneapolis, Minnesota (1976).
Getlein, Frank. "Biederman and the New Art."
The New Republic. 148 (February 16, 1963)
(p.28).

Kuspit, Donald, untitled essay in catalogue of
Biederman exhibition at Grace Borgenicht
Gallery, February 1-27 (1985).
Ernst, John. "Constructivism and Content."
Studio International. 171.876 (April 1966)
(p.154).
Holty, Carl. "Mondrian and Current Painting."
Arts Yearbook 4. New York (1961) (p. 74).
Sandler, Irving. "Dada, Surrealism and their
Heritage." *Artforum*. VI. 9 (May 1968) (p.27).
Rubin, William S. "Surrealism in Exile and
After." *Dada, Surrealism and Their Heritage*. New York,
1968 (pp.182, 183).
Holty, Letter to the author, January 1, 1969.
 Hunter, Sam. "The United States." *Art Since
 1945*. New York, 1962 (pp.280,295, 314-
 315).
Hess, Thomas. *Barnett Newman*. Catalogue for
exhibition at the Museum of Modern Art. New
York, 1971 (pp. 53.56.104).
Elderfield, John. "Mondrian, Newman, Noland:
Two Notes on Changes of Style." *Artforum*.
X.4(December 1971) (p.52).
 Seckler, Dorothy Gees. "Frontiers of
 Space." *Art in America*. 50.2 (March-April
 1962) (p. 86).
Butor, Michel. "The Mosques of New York, or,
The Art of Mark Rothko." Trans. Richard
Howard. *New World Printing*. 21 (1963)
Reprinted in *Inventory*. New York, 1968 (p.
260).
 Rose, Barbara. *American Art Since 1900*. New
 York, 1967 (p.179).
Rubin. "Jackson Pollock and the Modern
Tradition." *Artforum*. V.8 (April 1967) (p.22).
Friedman, Martin L. Introduction to the exhi-
bition catalogue, *The Precisionist View in American
Art*. Walker Art Center. Minneapolis. Minnesota
(November 13-December 25, 1960) (p. 53).
Reinhardt, Ad. "Twelve Rules for a 'New
Academy'." *Art News*. 56.3 (May 1957) (pp.38,
56).
 "Chronology by Ad Reinhardt." *Ad
 Reinhardt*, catalogue for exhibition at the
 Jewish Museum (November 23,1966-
 January 15, 1967), ed. Lucy Ed. Lucy
 Lippard. New York, 1967 (p. 19).

Chapter VII:

"Rethinking Modernist Criticism: The Legacy of Clement Greenberg." Session title at the College Art Association Annual Meeting, New York, 1991.

Rosenberg, Harold. "Defining Art." Reprinted from the *New Yorker* (February 25, 1967) in *Minimal Art.* Ed. Gregory Battcock. New York (1958) (p. 304).

Coplans, John. *Serial Imagery*. Catalogue for exhibition at Pasadena Art Museum. Pasadena, California (1968) (pp. 41,44).

Mondrian. "Plastic Art and Pure Plastic Art.. " *The Documents of Modern Art*. New York, 1945.

Morris, Robert. "Some Notes on the Phenomenology of Making: The Search for the Motivated." *Artforum*. 8.8 (April 1970) (pp.64,65).

Perlberg, Deborah."'Dance': Lucinda Childs, Philip Glass and Sol LeWitt." *Artforum*. XVIII.5 (January 1980) (p.52).

Larson, Kay. "For the first time women are leading not following." *Art News*. 79.8 (October 1980) (pp.68, 72).

Lippard. Lucy. "Judy Chicago's 'Dinner Party'." *Art in America*. 68.4 (April 1980) (pp. 114-126).

Bois, Yves-Alain. "Painting: The Task of Mourning." *Painting as Model*. Cambridge, Massachusetts, and London, 1990 (pp.xii,240-241).

Wheeler, Daniel., author of section on the 1980s in H.H. Arnason, *History of Modern Art*, New York, 1986 (pp.561, 644).

McShine, Kynaston. Introduction to catalogue of exhibition *An International Survey of Recent Painting and Sculpture* at the Museum of Modern Art. New York, 1984 (p.12).

Kraus, Rosalind. "The Essential David Smith." *Artforum*. 7. 6 (February 1969) (p.43).

Smith, C. Roy. *Supermannerism*. New York, 1977 (p. 62).

Risatti, Howard. *Postmodern Perspectives: Issues in Contemporary Art*. New Jersey, 1990 (pp.120-121, 129-130).

Taylor, Mark C. "DECONSTRUCTION: What's the Difference?" *Soundings*. 66.4 (1983) (pp 391-403).

Kraus. "Poststructuralism and the 'Paraliterary'." *October*. 13 (Summer 1980) (p.39).

Halley, Peter. "The Crisis in Geometry." *Arts* (Summer 1984) (p.111).

Tsai, Eugenia. "Peter Halley" and Crone, Rainer. " ' A Poem of Pure Reality,' 'Simile' as Unity of Conceptual Notion and Work." Trans. Martin Scutt. Essays in *Similia/Dissimilia.*, catalogue of exhibition on *Modes of Abstractions in Painting, Sculpture and Photography Today*." Columbia University. New York, 1987-1988 (p.107).

Starr, Robert. "Robert Ryman: Making Distinctions." *Art in America* 74. 6 (June 1986) (pp.96, 97).

Greenberg. "Modern and Post-Modern." *Arts Magazine*. 54.6 (February 1980) (p.97).

Milner, John. *Mondrian*. New York,1992.

Welsh, Robert P. *Piet Mondrian: Catalogue Raisonné of the Naturalistic Works (until early 1911)*. New York, 1998..

Joosten, Joop M. *Piet Mondrian: Catalogue Raisonné of the Work of 1911-1944*. New York, 1998.

Selected interviews, not listed in the text, with: Paule Vezelay, June 11, 1979 and June 6, 1980; Max Bill, June 20, 1979; Nelly van Doesburg, July 31, 1967; Cesar Domela, July 29, 1967; Vera Moore, July 27, 1967; Winifred Nicholson, June 13, 1979; Victor Pasmore, July 4, 1978; Nicolette Gray, July 17, 1976; Alan Bowness, several between 1967 and 1976; Silvia Pizitz,numerous between 1968 and 1990; Carl Holty, numerous between 1967-1972; Harry Holtzman, numerous between 1967-1985; Michel Seuphor, July 28, 1967 and September 18, 1995; Leo van Uitenbroek, March 1, 1967; Robert Welsh, December 4, 1967; Ad Reinhardt, March 15, 1967; Alfred Barr, Jr., March 14, 1967; Alan Bowness, July 17, 1967; Cesar Domela, July 29, 1967; Rose Fried, February 21, 1967; Arnold Glimcher, March 22, 1967; Sidney Janis, March 22, 1967;Joop Joostens, July 11, 1967; Lee Krasner, August 25, 1968; Kenneth Prescott, November 6, 1967; Emily Tremaine; March 27, 1967 and November 20, 1967.

INDEX
OF ARTISTS
AND WORKS

311. Glarner, sketch for Time and Life Building mural.
11.Fritz Glarner's studio-homesite, Huntingdon, Long Island, 1967.
12.Glarner in his Long Island studio, 1967.
13. Glarner in his Long Island studio, 1967.
307. Glarner's studio-homesite, Huntingdon, Long Island, 1967.
308, 309. Photograph of Glarner in his Long Island studio, fall 1967.
310. Glarner's Long Island studio, fall 1967.

Gorky Arshile :
177. *Garden in Sochi*, 1940–41.

Greene Balcomb :
171. *Green Diagonals*, c. late 1930s.

Halley Peter :
405. *Blue Cell with Conduits*, medium unknown, 1986.

Hélion Jean :
173. *Composition*, 1934.

Hill Anthony :
30. Anthony Hill in his Charlotte Street apartment-studio, London, 1978.
374-376 Anthony Hill's London studio, 1978 (photographed by the author).

Holty Carl :
6. *Of War*, 1942–43, third version of the original.
124. *In Flight*, 1942–63.
377. An "all-over" painting photographed in his New York studio, 1967.

4.Carl Holty in his studio on Mercer Street, 1968.
5.Holty's Mercer Street studio.

Holtzman :
223. *Sculpture* 1939–40.
225. *Square Volume with Green*, 1936.
226-227 *Horizontal Volume*, 1938-46.
228. *Vertical Volume, No. I*, 1939–40.
229. *Sculpture I*, 1940.
230. *Sculpture*, 1939–40.

7.Holtzman's reconverted studio-home, Lyme, Connecticut, 1985.
8.View in Holtzman's Connecticut studio, 1985.
221.Photograph of Harry Holtzman in his studio at Lyme, Connecticut, 1985.
222.View of Holtzman's Connecticut studio.
231-232. Photograph of Holtzman and Mondrian standing by Holtzman's *Sculpture I*, 1940 (c.1940–41).

Jensen Alfred :
402. *The Doric Order*, center, and *The Great Occupation*, dates unknown .

van der Leck Bart :
75. *Dock Labour*, 1916.

Levine Sherrie :
404 *After Piet Mondrian*, watercolor, 1983.

Lohse Richard :
32.Richard Lohse in his apartment-studio in Zurich, 1979.
33.Lohse is studio in Zurich.

Louis Morris :
392-393. *Number 1-71*. Du # 525.

McCracken John :
397. *Plank NY4*, 1970.

Malevich Kasimir :
174. Painterly Realism, 1915

Marden Brice :
406. *Summer Table*, 1972.
408. *Elements I*, 1982.

Martin Agnes :
409-410. *Milk River*, 1963.

Martin Kenneth :
31.Kenneth Martin's posthumous exhibition at Serpentine Gallery, London, 1985.

Mason Alice Trumbull :
358. *Out of the Valley*, 1956.
359. *Beside the Way*, 1930.
360. *Surface Winds* (horizontally) or *Suspension Points* (vertically), 1959.
361. *86th Street High #1*, 1967.
362. *Catalyst*, 1967.
363. *Formal Echoes*, 1967.
364. *Yellow Spring*, 1967.
365. *L'Hasard*, 1948–49.

Miró Joan :
176. *Swallow of Love*, 1934.

Moholy-Nagy Lazlo :
181. *Yellow Circle*, 1921.

Mondriaan Fritz :
44. Frits Mondrian at his easel.
45. *Landscape drawing.*
46. *Still Life with Fish*, 1893.

Mondrian Piet:
2, 142-146, 203-211. *Broadway Boogie-Woogie*, 1942–43.
3, 151-153-155, 212-220. *Victory Boogie-Woogie*, 1943–44.
47. *Still Life with Herrings*, 1893.

Read, Cecil Stephenson, and others of the "British Circle."
102. Katherine Dreier and Marcel Duchamp in Dreier's living room, 1936–37
106. Mondrian entry pages in Katherine Dreier's catalog for Brooklyn Exhibition, New York, 1926.
110. Albert Eugene Gallatin
116.Mondrian's first studio-homesite in New York, at 353 East 56th Street – no longer in existence: view north on First Avenue from southeast side of 56th Street.
117.View east on 56th Street toward Sutton Place.
131.Photograph of Mondrian in his first New York studio, fall 1941
133. First page of article: "Twelve Artists in U.S. Exile,"Fortune.
132. Mondrianesque page of above, p.115.
135. Photograph included in "Artists in Exile Hold Stimulating Show,"
136. Portrait of Mondrian in his first New York studio.
137. Mondrian and ìfriendsî at Helena Rubenstein's New Art Center, New York, 1942
141. Mondrian at work on Broadway Boogie-Woogie.
149. Mondrian's second studio-homesite at 15 East 59th Street (no longer in existence): looking east from Fifth Avenue on 59th Street.
150. Looking west on 59th Street toward the Plaza Hotel and Central Park from the entrance to Mondrian's apartment house.
156. Plan of Mondrian's last studio-apartment in New York (reproduced from Holtzman/James, The New Art – The New Life)
157-168 Mondrian's last New York studio.

Mondriaan P.C. :
39.P. C. Mondriaan, Sr, from photograph in archives of Mondrian Collection, Gemeentemuseum, The Hague
43.P. C. Mondriaan, Sr's print extolling the House of Orange.

Moore Henry :
26.Henry Moore's garden sculpture park, Much Hadham, England
27. *Butterfly*,1967.

Morris George L.K. :
170. *Composition No. 12*, 1939.

Newman Barnett :
385. *Day One*, oc, 1951, and Ulysses, 1952.
386. *Who's Afraid of Red,Yellow, and Blue? I*, 1966.

Nicholson Winifred :
21.Winifred Nicholson's home-studio, Carlisle, northern England, 1980.
22.Nicholson in the Carlisle cottage, 1980.
23.Nicholson's living room in the cottage in Carlisle, 1980.

Noland Kenneth :
394. Title and date unknown, Chicago Art Institute.
395. title unknown, Stedelijk Museum, Amsterdam.
411. *Morning Pane*, 1972
412. *Another Time*, 1973.
413. View of Noland's studio.

Picasso Pablo :
175. *The Kitchen*, 1948.

Pollock Jackson :
378. *Male and Female*, 1942.
379-380. *Cathedral*, 1947.
381. *Number 8*, 1949.

Reinhardt Ad :
388. *#88*, 1950.
389. *Black Painting*, 1960–66,

Rothenberg Susan :
403 Mondrian, 1984.

Rothko Mark :
387. *Number 16*, 1960.

Smith Leon Polk :
338. *Homage to 'Victory Boogie-Woogie,'* No.1, 1946–47.
340. Smith, Mondrianesque painting.
339. *White-White*, No.2, 1950.
337. Title unknown .
341. Title unknown.
342. *No. 7807 Hillhouse*, 1978.
343. *No. 7611*, 1976.
344. *No. 7621*, 1976.
345. *Black-White Repeat*, 1953.
347. *Expanse*, 1959, as seen hanging in Smith's New York studio
348. *Black Rock*, 1955.
349. Title unknown.
351. *Correspondence Blue-Black*, 1967.
353. *George Washington Bridge*, in New York studio, date unknown.
354-357. *Variations on Smith's Constellations.*

346.Photograph of Smith sketching the interlocking curves with which the covers of baseballs are sewn.
350.View of painting with "mortised" shapes hanging behind Smith.
352.View of paintings with variable interlocking formats and colors in Smith's studio.

Stella Frank :
398, 399.Title unknown, Chicago Art Institute.
416. View in Frank Stella's New York Studio.

Swinden Albert :
172. *Introspection of Space*, c. 1944–48.

Vantongerloo George :

273 $x2 + 3x + 10 = y2$.

Vezelay Paule :
24.Paule Vezelay at her home-studio in Barnes, south London suburb, 1979.
25.Vezelay Barnes studio, 1979.

von Wiegand Charmion :
312. *Orthodox Church in Moscow*, 1932–33.
313. *Moscow Room*, 1932–33.
314. *Railroad Siding, Croton-on-the-Hudson*, 1929.
315. *Non-Figurative Composition*, 1945.
317. *The Ka Door*, 1950.
318. *The Wheel of the Seasons*, 1957.
319. *The Magic Cross*, 1961.
320. *Desert Sanctuary*, 1959–60.
321. *Sanctuary of the Four Directions*, 1959.
323. *Heaven Within the Mountain*, c. 1955–56.
324. *The Joyous Lake*, 1955–56.
326. *The Image of Abundance*, 1956.
325. *The Golden Flower*, 1952–53.
328.*Abstract Tantric painting: Sri Yantra, Rajasthan*, late 18th century.
329. *Invocation to the Winter Goddess*, 1965–66.
330. *The Diamond Scepter*, 1966–67.
331. *Adi-Buddha*, 1967–68.
332. *The Chakras*, 1958.
334. *Kundalini Chakra*, 1968–69.
335. *Offering of the Universe*, 1963.
336. *The Paradise Gambit*.

14, 327. Charmion von Wiegand at the Buddhist shrine in her apartment-studio on East 33rd Street, 1967.
15. Von Wiegand's Exhibition at the Birmingham Museum of Art in 1980.
16. Von Wiegand in her apartment-studio in 1980.
315. Photograph of von Wiegand in her apartment-studio seated beneath her Mondrian painting.
322. View into von Wiegand's living room.
333. View into the von Wiegand exhibition at the Birmingham Museum of Art, 1968.

Exhibitions
15. Exhibition of von Wiegand's paintings at the Birmingham Museum of Art in 1980.
20. Reconstruction of original Unit One Exhibition (held at Mayor Gallery, London, 1934), in Portsmouth, southern England, 1978.
31. Kenneth Martin's posthumous exhibition at Serpentine Gallery, London, 1985.
34. View of Pier + Ocean Exhibition, showing Lohse's and Martin's paintings, Hayward Gallery, London, 1980.
37. View of Mondrian's Centennial Exhibition at the Guggenheim Museum, 1971.
103. Installation of International Exhibition of Modern Art at Brooklyn Museum, 1926.
169. View in first American Abstract Artists Exhibition, Squibb Galleries, 1937 ..
224. Abstract Painting and Sculpture in America 1927–1944 Exhibition at the Whitney Museum, 1985. (photographed by a menber of the whitney staff.
382.View of Mondrian Exhibition at Sidney Janis Gallery, New York, 1949.
383.View of Mondrian Exhibition at Sidney Janis Gallery, New York, 1953.
414-415. Views in Pier + Ocean Exhibition, Hayward Gallery, London, 1980

Unnembered pictures:

p.VIII. Birthday Card with Mondrian Design
p 0. Mondrian, *Composition with Blue, Grey and Pink*, 1913.
p.27. Mondrian, *Tree*, 1912.
p.147. Mondrian with Broadway Boogie-Woogie in his new York studio. c.1942-43
p.271. Mondrian standing near Theo Van Doesburg's painting, 1928.
p.272. Mondrian, *Composition with yellow*, 1930.